The Integral Feminist:
Madeleine Pelletier, 1874–1939

Feminist Perspectives

Series Editor: Michelle Stanworth

Published

Seyla Benhabib and Drucilla Cornell (eds), *Feminism as Critique*

Harriet Bradley, *Men's Work, Women's Work*

Felicia Gordon, *The Integral Feminist: Madeleine Pelletier, 1874–1939*

Susanne Kappeler, *The Pornography of Representation*

Liz Kelly, *Surviving Sexual Violence*

Judy Lown, *Women and Industrialization*

Henrietta L. Moore, *Feminism and Anthropology*

June Purvis, *Hard Lessons: The Lives and Education of Working-Class Women in Nineteenth-Century England*

Yannick Ripa, *Women and Madness*

Barbara Sichtermann, *Femininity: The Politics of the Personal*

Michelle Stanworth (ed.), *Reproductive Technologies*

Sylvia Walby, *Patriarchy at Work*

The Integral Feminist: Madeleine Pelletier, 1874–1939

Feminism, Socialism and Medicine

Felicia Gordon

University of Minnesota Press
Minneapolis

Published by the University of Minnesota Press
2037 University Avenue Southeast, Minneapolis, MN 55414
Printed in Great Britain

A CIP catalogue record for this book is available from the Library of Congress.

ISBN: 0–8166–1902–6 (HC)
 0–8166–1903–4 (PB)

The University of Minnesota
is an equal-opportunity
educator and employer.

Contents

Acknowledgements vii

Introduction 1

1 An *Enfant Terrible*, 1874–1896 7

2 Meritocracy and Elitism, 1897–1903 24

3 Psychiatry and Medical Practice, 1903–1906 51

4 Militant Feminism, 1906–1914 75

5 Feminist Electoral Campaigns and Socialist Politics, 1906–1912 104

6 Writing and the War, 1911–1918 132

7 The Russian Pilgrimage 153

8 Post-war Political Reaction and Feminist Politics, 1922–1932 172

9 From Activism to Fiction, 1925–1935 192

10 How Militants Die, 1933–1939 213

Epilogue 236

Notes 242
Bibliography 277
Index 289

Acknowledgements

This book had its origins in an MA dissertation in Modern European History written in 1985 for the University of East Anglia on the connections between the medical and feminist career of Dr Madeleine Pelletier. I wish to thank my college, Cambridgeshire College of Arts and Technology, now Anglia HEC, for having seconded me to study women's history. I was more than fortunate in my supervisor, Professor Richard J. Evans, who not only persuaded me initially to do research on Pelletier, and on completing my dissertation to turn it into a book, but by his positive and trenchant criticisms has been both supportive and educative. It is unlikely that this book would have seen the light of day without his persistent encouragement.

My second major and indeed overwhelming debt is to Charles Sowerwine to whom I wish to convey both my intellectual indebtedness and my gratitude for his generosity and friendship. His book *Les Femmes et le socialisme (Sisters or Citizens?)*, published in 1978, often cited in the following pages, broke new ground for research in French feminism and socialism. His immense generosity in providing me with a great deal of unpublished primary material from his own research, as well as the illuminating discussions we have had on Pelletier, cannot be repaid in any number of footnotes or acknowledgements. Where I have disagreed with some of his conclusions, it is largely thanks to the fact that he initially raised difficult and probing questions. I hope he

will feel that I have done some justice to Madeleine Pelletier whom he first rediscovered.

I also wish to thank my series editor, Michelle Stanworth, for her perceptive reading of the manuscript. Staff at the following archives have been most helpful: the Bibliothèque Nationale, the Archives de la Préfecture de Police, the Bibliothèque Historique de la Ville de Paris, the Institut Français d'Histoire Sociale, the Archives Nationales and the Bibliothèque Marguerite Durand. Nicole Gent offered translation advice and did invaluable picture research in Paris. I am grateful to Monique and Paul Dégez who made my visits to Paris so agreeable and who helped me to gain access to the asylums of Villejuif and Perray-Vaucluse. I wish to extend thanks to the Director of Villejuif and to Madame Dessaigne and Dr Gineste who gave me valuable information as well as to Monsieur Martin at Perray Vaucluse who showed me that hospital.

Finally Ian Gordon's enthusiasm, encouragement and critical acuity contributed immeasurably to this work and made it a project which I have thoroughly enjoyed. I want to thank him particularly for discovering Monet's *Rue Montorgueil* and for finding Sophie Berthelot's tomb in the lugubrious Panthéon catacombs. His reading of the manuscript, a time-consuming task, has been enormously appreciated. I am also indebted to my adult children: Clare Gordon for her overall encouragement and her practical help with the bibliography and Alex Gordon who first did research on Pelletier for me in Paris and is a mine of information on French syndicalist and anarchist history.

The author and publishers are grateful to the following for permission to use, and for their help in supplying, photographs:

Bibliothèque Marguerite Durand (plates 1, 6 and 8); Bibliothèque Historique de la Ville de Paris (plates 2, 3, 4, 5, 11 and 12); Roger-Viollet (plate 7); Réunion des Musées Nationaux, Paris (plate 9); Mary Evans Picture Library (plate 10).

Introduction

France, a country studded with monuments to its prominent citizens, has no memorial to Madeleine Pelletier, one of the most original and talented Frenchwomen of the early twentieth century. Born in 1874, Pelletier was a lifelong militant feminist in a culture which successfully repressed most feminist demands until after the Second World War. What, one wonders, were the social, economic, psychological and political conditions that formed such a woman? Where did she find the emotional and intellectual strength to leave her working-class home, to study medicine, to become the first woman psychiatric intern in France, to rise in the Socialist Party, to stand for parliament, to run a feminist journal, to campaign for contraception and abortion and to produce a formidable oeuvre in expository writing and fiction? How did she become a 'victim without defenders', who ended her life in a psychiatric hospital?[1]

The young Madeleine Pelletier told her mother one day that when she grew up she intended to become a general. The child had been thrilled by tales of Napoleon's heroic exploits. 'Women are not soldiers; they are nothing at all,' her mother replied drily, glancing round their dirty greengrocer shop and into the even dirtier family room behind it. 'They marry, cook and raise their children.'[2] Madeleine Pelletier's life can partly be understood as an effort to disprove this maternal prophecy. Born in a working-class, republican quarter of Paris, Madeleine grew up knowing both material and emotional deprivation. Her family and neighbour-

hood provided a precocious political education. The rue des Petits
Carreaux, in the second arrondissement, where the Pelletiers lived,
was a narrow, populous thoroughfare, a continuation of the rue
Montorgueil, which ran directly into Les Halles, the central
Parisian food market.[3] The Sentier quarter, which bordered on the
rue des Petits Carreaux, boasted streets and squares named after
Napoleon's Egyptian campaign of 1798 (Caire, Nil) which had
aroused great popular rejoicing in Paris. It was natural that
Napoleon, an icon of achievement through personal merit and
ambition, became one of young Madeleine's earliest objects of hero
worship. In addition, the neighbourhood where Pelletier's parents
ran a fruit and vegetable shop was the centre of a strong republican
tradition. During national festivities: 'The houses disappeared
under flags; all windows and lampposts were festooned with them;
firecrackers and even Roman candles were exploded.'[4]

Pelletier's childhood recollections are vividly confirmed by
Monet's two paintings of *La Rue Montorgueil* showing the
extraordinary level of popular republican enthusiasm during the
celebrations for the gala of 28–30 June 1878, held for the Great
Exposition of that year (see plate 9). It was the first *fête nationale*
to be permitted since the Franco–Prussian war and the Commune.
Monet's vibrant tapestry of red, white and blue strikingly reflects
the patriotic republican fervour manifested in this working-class
quarter.[5]

After leaving school at the age of thirteen, Pelletier 'ran wild' in
anarchist and feminist circles for some seven or eight years and
then studied for the baccalauréat examination on her own in order
to enter medical school. Qualifying as a doctor, she became the
first woman to enter the state psychiatric service. At the same
period she did research in anthropology and psychiatry, joined the
Socialist Party, where she rose rapidly in the party's ranks and
simultaneously headed a feminist group, La Solidarité des Femmes
(The Solidarity of Women). She edited a feminist journal, *La
Suffragiste*, campaigning for women's rights over a wide range of
issues: the right to work, to vote and, most daringly for the period,
for women to have recourse to contraception and abortion. Early
in her career she adopted a masculine style of dress and cut her hair
short, this at a time when cross-dressing appeared deeply shocking
even to feminist and socialist colleagues. A prolific writer and
polemicist, Pelletier also published fiction, and left, in addition, a

rich collection of letters and unpublished autobiographical material. These sources demonstrate a complex, often witty, ambitious and powerful personality. Throughout her life, Pelletier questioned, analysed and attempted to unravel the material and psychological determinants which enslaved both women and the working class. A knowledge of Pelletier's life illuminates not only the conflicts between socialism and feminism under the French Third Republic, but the difficulties of an exceptional individual attempting to construct a coherent feminist agenda. Her death was ironically in keeping with her embattled life. Arrested on an abortion charge in 1939, she was not tried, but incarcerated in a mental hospital, where she died within six months.

A sense of Pelletier's life as a Parisian, her migration from a proletarian to an intellectual milieu, illustrates the psychological distance she traversed from her childhood in the rue des Petits Carreaux to the freer world of the Left Bank and the Latin Quarter. For almost a quarter of a century, from 1915 until her death in 1939, she lived or worked within walking distance of the university of the Sorbonne. She had a surgery on rue Monge, just below the Mont Sainte Geneviève, which is dominated by the Panthéon, an enormous neo-classical monument dedicated, since the revolution, to 'the great men of France' and, through many historical reversals and changes of regime, to the spirit of the republic. In Pelletier's fiction the Panthéon became a symbol of the heroic masculine culture in which she hoped to participate. The republic's masculine ethos is well illustrated by the inscription in gold lettering on the base of the Panthéon's pediment: 'Aux Grands Hommes La Patrie Reconnaissante' (To its Great Men from a Grateful Country). It is scarcely possible to improve on a nineteenth-century guidebook's description of the surmounting frieze:

> The pediment contains a large composition in relief, by David, representing France, surrounded by, and dispensing honours to, some of the Great Men that have illustrated her [*sic*]. On her right hand are Fénélon, Malesherbes, Mirabeau, Manuel and David the painter. On her left are soldiers of the republican or imperial armies, with Napoleon in front. At the feet of France, History and Liberty inscribe the names of Great Men, and weave crowns to reward them. In the extreme corners, youths are studying to emulate the virtues of their predecessors.[6]

The iconography of the female figures on David's pediment, representing abstract nouns such as History and Liberty, who endow the heroes with honours, summed up the world of the Third Republic: an allegorical female order of abstract virtue set against an actual male order of soldiers, statesmen and artists.[7] Marat, Mirabeau, Soufflot, Voltaire, Rousseau and Hugo were all buried in the Panthéon. There is, however, one little-known exception to the 'great men'. Sophie Berthelot, the sole woman interred there, may be taken to exemplify women's role in post-revolutionary France. Her life can function as a counter-example to Pelletier's own. She lies buried in the Panthéon because, as the loyal wife of Pierre Eugène Marcellin Berthelot, the organic chemist and Minister for Education, and mother of his six children, she incarnated with her husband the virtues of family life, central to the ideals of the bourgeois republic. The couple were devoted to one another for forty-five years. When Sophie Berthelot succumbed to a heart ailment in March 1907, after a long illness, her husband, who had nursed her faithfully, died a few hours later. In deciding to honour Marcellin Berthelot with a burial in the Panthéon, the Chamber and the Senate, moved by this example of conjugal devotion, passed a special law (24 March 1907) permitting Sophie Berthelot to be buried with her husband. She was the classic exception which proved the rule. Women could not be 'great'; but while they were, as Madeleine Pelletier's mother had said, 'nothing at all', they could, exceptionally, be honoured for their connections with great men. It is not accidental that the only woman buried in the Panthéon is there not for her own achievements, but to represent the conjugal ideal.[8]

Madeleine Pelletier could be construed as the obverse image of Sophie Berthelot. Pelletier too grew up in a republican, heroic, masculinized, public culture, but, an instictive rebel, she struggled to free herself from the physical view of women as primarily reproductive mechanisms, and from the idealized female image. She aspired to participate in the public sphere and to receive the recognition of her country. She was part of that Europe-wide group of feminists at the turn of the century who saw themselves as exemplary figures, prepared to disprove the myth of women's inferiority. From her childhood, as we have seen, she had been intensely ambitious. For Pelletier, the Panthéon, with its glorification of national heroes, represented the Third Republic's promise

of careers opened to talent. This is clear in one of her short stories where the working-class protagonist undergoes an epiphinal moment on seeing the Panthéon looming above the rue Soufflot and, 'like Paul on the road to Damascus', resolves to transform his life by educating himself.[9] Pelletier, like her fictional hero, must have hoped to join, at least symbolically, that august company of 'great men'.

One could easily construct a roll of honour, if not a Panthéon, for women of Pelletier's generation, little known today and certainly unhonoured by public monuments, who gave themselves, body and soul, to the attainment of rights for women: rights for the suffrage, for physical exercise, for maternity care, for contraception and abortion, for divorce, and for legal equality, for control of their own property, for custody over their children, for better education, for trade union recognition and simply for self-respect. Such a roster would include among many others: Caroline Kauffmann, Arria Ly, Marie-Louise Bouglé, Hélène Brion, Elizabeth Renaud, Hubertine Auclert, Marguerite Durand, Jeanne Laloë, Jeanne Oddo-Deflou, Marie Pognon, Eugénie Potonie-Pierre, Nelly Roussel, Louise-Léonie Rouzade and Madeleine Pelletier. Individually and collectively these women frequently endured contempt and ridicule and often sacrificed their careers, their incomes, their health and even their sanity for their beliefs.[10]

When in 1949 Simone de Beavoir published *The Second Sex*, she undertook in part to constitute a history for women, who as a group had been ignored as agents of historical change. Yet, curiously, one of the most superficial aspects of her study was that which dealt with the generation of French feminists and suffragists which preceded her.[11] In 1949, writing from the perspective of a highly educated upper middle-class woman, Beauvoir, who had joined a seemingly classless (and even apparently gender-free) elite of intellectuals, mostly male, appears to have felt hostility to the image of feminism inherited from the turn of the century, an image of earnest women, in elaborate hats, with puritanical views. From her post-Second World War perspective, bourgeois feminists seemed faintly ridiculous, and socialist feminists (with the exception of heroines like Flora Tristan and Louise Michel) largely unknown. Furthermore, it was the case that the French suffragists were in the invidious position of having failed to gain the vote for women in the inter-war period. Because women's suffrage was

finally granted in 1944 by General de Gaulle, an important milestone in civil rights was perceived to be not the result of women's struggles, but the gift of a male politician.[12] Thus, in 1949, to Beauvoir, the early feminist movement seemed almost an irrelevance if not an embarrassment.

It could be argued that Beauvoir reflected the very masculinization of historical consciousness that her book was attempting to redress.[13] She did not seem to have known of the one French feminist precursor whose analysis of the female condition was as radical as her own, a woman who attempted to bridge the class divide between bourgeois and working-class feminists and who identified women's oppression among a complex series of issues: economic dependence, civil and legal disabilities, biological constraints and psychological subservience. Madeleine Pelletier, over a long career of feminist militancy, explored the peculiar nature of women's subordination, an analysis reborn and revalidated in *The Second Sex*.

Historical and biographical studies, such as this one, which attempt to fill lacunae in women's history, aim not only to illuminate the lives of less well known individuals, but to recover women's political and intellectual continuity and traditions. The founders of the French republic thought it important to legitimize the revolution and empire by a public glorification of its heroes, and studded Paris with monuments like the Panthéon and the Arc de Triomphe in order to rival the *ancien régime*. Women may not aspire to anything so grandiose, but both the exemplary and the typical figures from women's past and the contexts in which they lived are in the process of being rescued from oblivion by many hands. A little allegory may not come amiss. As Galignani's nineteenth-century guidebook has it: 'History and Liberty ... weave crowns to reward them.'

The contention of this contextual biography is that Madeleine Pelletier should not be seen as an anarchist, socialist, physician, anthropologist, psychiatrist *and* feminist, but that her feminism informed every sphere of action in which she participated. She was, in her own phrase, an 'integral feminist'. She spent her life attempting to integrate her feminism into the male political and professional spheres and into the newer scientific disciplines. Her vicissitudes, as well as her partial victories, illuminate the gendered social politics of an era, while her analyses of the nature and extent of women's subordination remain remarkably relevant today.

1

An *Enfant Terrible*, 1874–1896

Why does a given individual become a lifelong dissident and militant? Madeleine Pelletier whose feminism sought expression in her medical practice, in socialist and anarchist politics and in the women's suffrage movement was more radical in her demands than any feminist of her generation. As Anne R. Kenney has remarked: 'Pelletier the suffragist advocated violence; a physician she performed illegal abortions; a socialist she denounced the party's insensitivity to women, and in the age of the corset and the ostrich feather, she chose male attire and close cropped hair.'[1] Her radical feminism alienated not only the male medical establishment, as one might expect, but also her socialist and feminist allies. The key to the passion that motivated her and to the personal sacrifices she made in the name of justice, freedom and equality for women lay in her childhood passed in the Parisian working-class quarter near Les Halles. This district, much of which has now made way for the gigantic Pompidou arts centre, was then a maze of narrow, crowded streets centring on the great Parisian food market. Pelletier's reminiscences make clear that everyone in the neighbourhood knew everyone else. The shoemaker over the road and the pancake seller were as familiar as her own family. Children played or fought together in the streets. Neighbours gossiped over one another's concerns. It was in this world that Pelletier developed a precocious political consciousness.

In the opening page of her handwritten memoirs 'Doctoresse Pelletier', Pelletier declared: 'I can say that I have always been a feminist, at least since I was old enough to understand.' From an

early age, she realized the degree to which women were commonly despised:

> As a child the aphorisms expressing the low value accorded to women that arose every day in conversation shocked me profoundly. When, in my childish ambition, my head filled with stories of French history, I said that I wanted to be a great general, my mother rebuked me sharply: 'Women are not soldiers; they are nothing at all; they marry, cook and raise their children.'[2]

Madeleine, christened Anne, Pelletier was born on 18 May 1874.[3] The number of her brothers and sisters is uncertain. There are references to an older brother who left home when Madeleine was still very young and to a sister, who may have died in infancy. Pelletier's childhood was emotionally and economically bleak. Her parents, Anne (née de Passavy) and Louis Pelletier ran a fruit and vegetable shop, 38 rue des Petits Carreaux, in the second arrondissement. The shop occupied the front room, leaving the one back room for the family. The Pelletier establishment appears to have been typical of the marginal enterprises that served such working-class districts: more permanent than a market barrow, the shop was not a great deal larger.[4] To call Pelletier's parents petit bourgeois because they kept a shop would be stretching a point. Her father had probably been a cab driver but, paralysed by a stroke when Madeleine was four years old, spent most of her childhood in a chair in the back room.[5] She did remember excursions into Paris with him to see the new horseless trams and to visit the modern post office, but it was her mother who supported the family and dominated her childhood.

Anne de Passavy Pelletier ran the business and she had, apart from her two surviving children, according to her daughter, eleven miscarriages. Family festivities were rare. One such event when she was very young, which Pelletier recalled, may have coincided with the 1878 gala for the Republic commemorated by Monet. This was one of the few occasions that she remembered being well dressed: 'The earliest event I can remember is a walk in the Botanical Gardens. I was about four years old. A grey woollen dress and an Italian straw hat had been bought for the occasion. My little sister who was two had a similar hat.'[6] This outing, which culminated in the excitement of dinner out at a restaurant and listening to a café

concert, 'the singer dressed in pink', must have represented an unusual moment of prosperity in the Pelletier household. The overriding impression Madeleine preserved of her childhood was of the dark and dirty shop and the one-room family home which stank of unemptied chamber pots. Madame Pelletier was anything but a careful housekeeper. From these images of working-class family life, Madeleine retained the sense that the claustrophobic living conditions, the lack of ordinary privacy and the impossibility of cleanliness had created a dreadful prison for all its members. Working-class existence held absolutely no glamour in her eyes. Unlike some revolutionary socialists of her generation, for example Rosa Luxemburg, she did not credit the working class with any particular virtues.[7] She came to believe that, like women, the working class needed liberating from degradation. Poverty, in Pelletier's experience, did not enhance the character.

An illegitimate child, brought up in the Auvergne by foster parents, Anne de Passavy had as a baby been branded on the neck with the letter 'P' as a mark of her origin. Her daughter remarked of her: 'Like all illegitimate children, she believed herself to be of high birth.'[8] As a fervent royalist, in the early years of the Third Republic, Anne de Passavy was swimming against the republican tide in their working-class neighbourhood. Intensely and fanatically Catholic, she wore not merely a crucifix but a large image of Christ on her breast. If Madeleine Pelletier's autobiographical novel, *La Femme vierge* (The Virgin Woman) is correct, her mother used to flagellate herself in a kind of Jansenist fervour. On the other hand, her daughter recognized, she was intellectually superior to her husband:

> My mother was very intelligent, but totally uneducated; her clients called her Madame de Sévigné [presumably in mockery at her opinions which dated from the *ancien régime*]. My father was much less brilliant, but had great common sense. While my mother, very religious, was a veritable fanatic, my father was a sceptic. He used to say to me: 'The priests know no more than we do; when we are dead we are dead.'[9]

In *La Femme vierge*, Marie Pierrot's mother was almost certainly based on Madame Pelletier: 'She was a tall brunette with a high forehead, very beautiful in spite of her ill-kempt and dirty

appearance. She was much more intelligent than her husband, but although she ran the house and shop, Madame Pierrot maintained traditional prejudices about the role of women' (p. 22).

It was the spectacle of her mother's bitter life, the hard labour, seemingly endless pregnancies and religious zealotry with which she consoled herself, that made her daughter resolve never to lead a life like hers. Pelletier's rejection of her mother, to the extent of abandoning her name 'Anne' for 'Madeleine' in her teens, and rejecting 'femininity' altogether, may be seen to some extent as a tribute to the wasted talents of this remarkable and eccentric woman. Pelletier absorbed religious scepticism and republican principles from her father and the surrounding neighbourhood, but she knew that she owed her intelligence and her idealism to her mother.

Pelletier's parents represented, in effect, an archetype of the masculine/feminine split in religious and political opinions in post-revolutionary France, particularly under the Third Republic (1870–1914). This split was institutionalized in the educational system. Whereas boys, on the whole, were educated in state lay schools, many girls were still, in the 1880s and 1890s, educated in convent schools. Largely as a result of these educational–religious divisions the majority of French women were practising Catholics, though Anne de Passavy was more fervent than most. Many men would have been, like Pelletier's father, religious sceptics. In addition this religious–gender division had a political dimension.[10] Because devout Catholics tended to be pro-monarchist, religious belief and political reaction were seen from the republican perspective to go hand in hand. It appeared to most republicans that the church was fundamentally opposed to the republic.[11] Thus with the advent of the Third Republic in 1870, anti-clericalism and republicanism became virtually synonymous political attitudes. Anne de Passavy Pelletier, who called the 'République' the 'ruine publique' and refused to allow her daughter to celebrate the fourteenth of July, anniversary of the taking of the Bastille, was entirely consistent in her political and religious views. For her, as for many practising Catholics, the republic was a godless institution.

While the Pelletier family faithfully mirrored this gender division in religious/political culture, characteristic of the Third Republic, Madame Pelletier's religious and monarchical zeal was

exceptional, even by the standards of her own age, particularly in the working-class milieu where she lived, where one would have found strong republican and socialist sympathies. From behind her shop counter, she lectured her customers on religion and on the evils of the republic, not rendering herself popular in the process: 'Her profound beliefs, this attachment to religion, did not favour her trade. Her clients, who came to buy a kilo of potatoes, didn't want to hear a sermon; they preferred to buy across the street at the shop of a less opinionated competitor ... Her extreme right-wing opinions made her hated in the neighbourhood.'[12]

One of Pelletier's early memories was of the streets festooned with bunting for the fourteenth of July, a day that her mother said was dedicated to the assassins of Louis XVI. Madame Pelletier put up blue and white decorations with the royal fleur-de-lis. From an early age, Madeleine was aware that her mother's views were anathema in their district, that she was detested both for her slatternliness and for her politics. The nearby shoemaker called her a 'dirty Jesuit'; local children wouldn't play with Madeleine, taunting her with being the 'daughter of Jesuits'.[13]

Madame Pelletier's religious zealotry, though exciting remark and disapproval in her milieu, could be interpreted as part of a strategy of resistance. Her fanatical Catholicism arose partly as a response to her social inferiority both as a woman and as an illegitimate child. The initial 'P' branded on her neck, to mark her with her mother's name, served as a perpetual reminder of her outcast status. Her energy, her contempt for cleanliness, combined with her religious fanaticism, suggest a rebellion against her condition, although ostensibly she espoused the most conservative political and social values. For her, as for so many women under the Third Republic, which excluded them from political power and relegated them to the status of minors, the Catholic church was a refuge.[14] Though Catholicism fostered a patriarchal culture, it idealized women through the cult of the Virgin Mary. Further, as the historian, Michelet, noted with alarm, it offered women an authority figure, the priest, who competed with women's rightful lay authority, the husband.[15] Religion for Madame Pelletier must have represented an escape from the crushing conditions of her life; even the hellfire sermons which she declaimed at home to her daughter and chairbound husband suggested a vision of the world in which justice triumphed and the faithful were rewarded.[16]

Though Madeleine in her teens rejected Catholicism and all forms of religious consolation, she retained her mother's passion for justice and a belief in a better world. She also resembled her mother in her capacity for political passion and in her ability to maintain unpopular views in the teeth of ridicule and opposition.

Anne de Passavy did her best to indoctrinate her daughter in religious belief, both by taking her to church, and sending her to a convent school. Pelletier's early memories of church services were not at all unpleasant. The ritual, the altar decorations, the fine vestments were a glorious change from the sordid conditions of home. She recalled being taken to the festival of the Virgin Mary, to hear an evening sermon: 'The church seemed splendid to me – a blue hanging and blue flowers everywhere, the colour of the Virgin Mary.' Nevertheless she had nightmares from the priest's sermon on the fate of the damned in hell's abyss. She duly attended catechism class for her first communion and did wonderfully well, but she never was given a gold star: 'These were reserved for the little girls with well-kept locks who came to class in a carriage.'[17]

Pelletier remembered her first communion as a central event.[18] The nuns promised her a mystic revelation. The hymn the youthful communicants sang in church suggested the messianic possibility of transcendence:

> Mon Bien Aimé ne paraît pas encore,
> Trop longue nuit durera-tu toujours?
>
> (My beloved still has not come
> Too long night, will you last forever?)

As an adult, Pelletier came to believe that the long night of human misery would only be lifted through a socialist transformation. But until her first communion she thought that the revolution in human possibilities was to come through religious grace. The eagerly awaited event proved to be a bitter anti-climax. No revelation was vouchsafed to Madeleine; life went on very much as before. Religion, the child observed, with candid realism, did not even make her mother a kinder person.[19]

Priestly authority was further undermined by events. Her mother's shop was the meeting place for a prayer group, 'the devout of Nôtre Dame de Bonne Nouvelle', a clutch of elderly women dressed in black who spent much of their meetings in

gossip. Pelletier listened avidly: such and such a newsvendor sold 'red' (revolutionary) magazines; a pious girl belonging to the Catholic youth group, 'the children of Mary', was six months pregnant by her priest. Pelletier recalled her naive amazement:

> But papa, is it possible for a priest to have a child?
> *Of course – priests are men like others.*
> But it's very wicked.
> *Certainly – but do you think people only do what is right?*[20]

In 1881, at the age of seven, Pelletier began attending her first school. Her mother had put off sending her because the child was kept in too filthy a state. 'Going to school implied a clean, washed and combed child, all of which went completely against [my mother's] habits.' Pelletier said that she was taught to read by her father, and at school, possessed of a formidable intelligence and good memory, she shone at recitations. Written work was a trial, however. Her handwriting was clumsy, and her fingers, unused to holding a pen, botched everything. She was also made painfully aware that her head lice and her dirty clothes did not endear her to the nuns or to her fellow-pupils. The dirt and disorder of home infected everything: 'In class I wasn't liked. I was dirty, badly dressed. Horrors! I had lice. They swarmed on my head and fell on the table. What a contrast with the little Labbé girls, daughters of a confectioner, impeccably dressed with big collars of white lace.'[21]

The nuns at her school recognized Pelletier's undoubted intellectual ability and encouraged her mother to allow the child to continue her education after primary school. Madeleine, however, elected to leave at twelve years old. A number of factors seem to have influenced her decision, surprising in an individual who, throughout her life, showed a passionate attachment to learning and who was never happier than when engaged in study. The first was that she felt school to be a hostile environment. The nuns might recognize her capacities, but mockery of her poverty rankled. Furthermore by the age of twelve Madeleine was not easily curbed by discipline: 'I was a precocious child and had a very independent character. Any order for which the reasons were not explained to me, threw me into revolt.'[22]

Finally, puberty was a traumatic event. Pelletier had long been

aware of the basic facts of reproduction, but not as they applied to herself. As the anecdote about the priest and the girl communicant illustrates, sexual relations were freely discussed in her milieu. She knew that children experimented sexually and that the pretty young woman who wore elaborate clothes and lived in a nearby flat was someone of whom her mother deeply disapproved. But she was unprepared for the menarche. Both her novel and her memoirs refer to it as a pivotal event. Marie Pierrot, the heroine of *La Femme vierge*, is described as she discovers she has started her first period one day at school. Totally ignorant of its significance and believing she is dying, she rushes to tell a nun. The latter forbids her to speak of the unmentionable topic and sends her home. Her mother is no more enlightening. In the end the girl goes to her father who attempts to console her by explaining that she is now a woman 'like her mother'. Pelletier recalled: 'It was my father who initiated me in sexual matters; I was twelve years old and I was beginning a woman's life.'[23] The phrase 'my father initiated me' has been taken to mean that her father sexually abused her.[24] The context of the comment and the parallel account in *La Femme vierge* suggest, on the contrary, that her father wished to reassure her about her first period as a natural and inevitable event. The inference of sexual abuse seems entirely unjustified, given Pelletier's generally positive image of her father, her lack of hostility towards men, as men, and her frankness on sexual questions. In any event, the effect of her father's intervention was quite different from his intention. She responded with shock and disgust, especially on discovering that her mother shared this condition. The menarche symbolized Madeleine's sense of women's physical entrapment in the process of nature. Menstruation, she felt, was part of the biological system which had reduced her mother to the drudge and slattern she was. To discover that her mother and indeed all women suffered from this monthly bleeding, of which people seemed ashamed, confirmed Madeleine's fear, probably long held, that women's condition itself was a degradation: 'I had never felt love for my mother but I felt a certain respect for her. At this moment I lost it, imagining her to be like me, and I felt a disgust which remained with me for a long time.'[25]

To Madeleine, the biological imperative governing women, represented by the menses, appeared both a revolting physical trait and, in a confused way, a sign of women's inferiority. She carried

the conviction of the link between women's reproductive function and their social subjection through to her adult life. As an adult, Pelletier espoused celibacy; in her own case it was fundamentally a political act, but based on an emotive refusal to participate in her mother's fate. Unlike her friend, the Toulouse feminist Arria Ly, whose feminism had its foundations in a physical horror of sexuality (see pp. 88–91), Pelletier's experience of puberty did not turn her against men but against the female reproductive destiny. It confirmed her in her suspicion that it was women's biology which transformed them, for reasons she did not entirely understand at the time, into objects of shame for themselves and others.

Pelletier almost certainly identified with men in so far as she espoused a life of intellect, political action and professional activity. As will become clear in the analysis of her utopian novels, she tended to see most women as in fact, though not in essence, inferior. She admired many of her male colleagues, enjoyed the cut and thrust of debate and admitted to wishing she were a man. Her puberty crisis crystallized her unease about the status of women. To some extent her career can be interpreted as unravelling the consequences of her rejection of the female experience as she saw it played out in her mother's life. Her feminism involved a constant questioning of the extent to which women's biology conditioned not just their bodies but also their minds to subjection. The onset of puberty remained in Pelletier's mind as the moment when she was confronted with 'being a woman'.[26] It is significant that she herself, in her autobiographical writing, saw it as a pivotal event. Much of her life was devoted to proving that she was not a woman, in the sense that this implied traditional female activities. It was at about this time that she rejected her mother's name, Anne, and assumed the name of her own choice, Madeleine.

Madeleine Pelletier's active political career began at the relatively tender age of thirteen when she started attending evening meetings of feminist and anarchist groups. She later ascribed to her character Marie Pierrot the anecdote of reading a novel entitled *Feodora the Nihilist*. Feodora, an example of unsubmissive girlhood, is shown going to the bad by falling in with dangerous radical groups. When Marie reads this admonitory work, she rejects the moral and identifies entirely with Feodora. She too would become a revolutionary. One may feel some sympathy for the beleaguered Madame Pelletier who viewed her daughter's nocturnal outings

with alarm. Girls, she thought, could want to go out at night for only one reason. Madeleine would render herself unmarriageable, and a good marriage was the only secure future that she could envisage for her daughter. Madeleine, indignant that her motives were misinterpreted, seems to have quarrelled bitterly with her parents.[27]

The feminist group which she frequented met at the rue de Turenne. Its best known member was Astié de Valsayre, an upper middle-class feminist who in later life embraced ultra-nationalist opinions. When Pelletier first met her, however, she would have described herself as a socialist feminist. The group was composed largely of women with independent means and aristocratic names.[28] Pelletier soon became aware that their emancipated way of life was made possible by their financial independence, a lesson not lost upon her. One of the burning issues discussed by the group was whether women should learn swordsmanship. Astié de Valsayre was known to have fought a duel against an English-woman on the field of Waterloo.

Why was duelling at this period a feminist issue? Already in the 1880s and 1890s it might have seemed a quaint anachronism, but the duelling question formed a part of a larger debate about women and sport; indeed the whole concept of physical exercise for women was still considered radical.[29] Though working-class women exercised in the sense that they performed heavy physical labour, exercise and sport as leisure or health promoting activities were largely reserved for men. Further, feminists who advocated that women learn fencing, and that they had the right to challenge men to a duel, were not just advocating self-defence and healthy exercise, they were asserting one form of equality. The convention of duelling requires that a duel can only be fought between social equals. Under the *ancien régime*, an aristocrat could, without loss of honour, refuse the challenge of a commoner. In post-revolutionary France women were in a similar position to the lower social orders under the *ancien régime*. To learn swords-manship, then, was a means of proving strength and courage; to engage in a duel with a man would be to attain, however bizarrely, recognition of equality.

All this was the theoretical case. Pelletier suspected, however, that the feminists advocating fencing for women had mixed motives. Though she admired Astié de Valsayre's prowess, she

noted that one of the arguments adduced in defence of women fencing was that it aided pectoral development:

> They spoke among other topics of sport and especially of fencing. Astié de Valsayre had fought in a duel with another woman. I thought this noble. Nevertheless, the arguments they used to defend the right of women to engage in fencing didn't appeal to me at all. They maintained that there was nothing like fencing for the development of the breasts. Reduced to a means of better breast-feeding, fencing lost all its nobility in my eyes.[30]

In this early analysis of the confused priorities among feminists, Pelletier confronted a phenomenon that she would encounter throughout her life. Feminists themselves seemed trapped in what she called 'demi-féminisme'. On the one hand they sought equality and independence and railed against the inferior status of women; on the other, they were almost obsessively concerned with pleasing men:

> Fencing, whose aim is destruction, is something less noble than breastfeeding which gives life. Nevertheless, I had a confused notion that in order to free women it was necessary to change their habits. Furthermore it remained true that the right to duel should be demanded, like all other rights, because it is a right and not under the hypocritical pretence of developing a femininity which had only brought women slavery.[31]

It was during this period that Pelletier began wearing a version of masculine dress, though it was somewhat later that she cut her hair short, an even more provocative tactic. If *La Femme vierge* can be taken as reliable evidence, there was pressure from her mother to behave and dress like a 'young lady' with a view to attracting a husband. Instead she wore a high, starched collar, a tailored jacket, a cravat and a straight, rather than a flounced skirt. As a young woman, Pelletier had regular features, bright eyes and could have been considered pretty. The description in chapter 2 of her heroine, Marie Pierrot, corresponds closely to early photographs of Pelletier: 'fine hair, black eyes, straight nose, erect figure.'

Madeleine's refusal to conform to contemporary expectations in dress reveals her sensitivity to another question which she iden-

tified as a political, feminist issue, that of dress reform and the
language of dress. The *belle époque* (the 1880s and 1890s) marked
new heights, or depths, of complexity in feminine fashion. For
upper-class and middle-class women, an elaborate underpinning of
whale bone held up a superstructure remarkable for covering the
legs with voluminous skirts, the buttocks with a deforming bustle,
and uncovering much of the breast to the masculine eye. Working-
class women imitated the finery of their 'betters' as far as their
means would allow. Proust's elegaic descriptions of Odette Swann
walking in the Bois de Boulogne convey the aesthetic and sensual
pleasures these fashions inspired in men.[32]

The style that most offended Pelletier was the *décolletage*. By
wearing low-cut dresses, she felt that women were allowing
themselves to display their breasts like so much meat for sale,
implying abject servitude. Though she adopted celibacy as a
political attitude, Pelletier was by no means puritanical about
sexual questions. Her point about women's sexual display was not
that it implied liberation, but the reverse. As things stood, women
were only valued by others, and indeed only valued themselves, in
so far as they were sexually attractive to men. And in a society
where women were entirely dependent on men, legally, economi-
cally and politically, sexual visibility was part of the commodifica-
tion of sex – women displayed themselves and were sold off to the
highest bidder. Pelletier's complaint about 'demi-féministes' was
directed at women like Marguerite Durand (1865–1936), founder
of the feminist daily newspaper *La Fronde*. She was friend or
mistress to several important radical politicians, a former actress,
and a very beautiful woman, who saw no contradiction between
glamour and feminism. As Pelletier put it pithily, if unkindly, to
Arria Ly: 'I do not understand how these ladies don't see the vile
servitude that lies in displaying their breasts. I will show off mine
when men adopt a special sort of trouser showing off their . . .'[33]

It was for the above reasons that in the late 1880s Pelletier, to
the dismay of her more cautious minded feminist friends, began to
adopt a form of modified masculine attire. 'My costume says to
men; I am your equal.'[34] In spite of the example of women like
George Sand in the previous generation, who had worn trousers
and smoked cigars, the notion of masculine dress for women
remained profoundly shocking, even and especially to professed
feminists. Pelletier recalled their reaction: 'My tailored suits and

my starched masculine collars seemed to them an unheard-of audacity. It was, some of them said, to go against nature and to damage feminism. And nevertheless I was still wearing my hair long; what would they have said if I had dared to cut it?'[35]

The idea that there could be anything 'natural' about women's clothes at this period is as revealing of received prejudice as is Pelletier's admitted hesitation in wearing her hair short. By the mid 1890s she had taken the plunge, cropped her hair and brilliantined it in a 'masculine' style. But it is noticeable that photographs of Pelletier in the 1930s show her with somewhat longer, and wavy hair. In the post-war era, short hair had been generally adopted by women and was no longer a political signal. What seemed to Pelletier's contemporaries an unpleasant eccentricity in dress and coiffure was in fact her response to an early psychological analysis of women's oppression. The elaborate and restrictive clothes of the 1880s and 1890s not only advertised, Pelletier believed, women's servility to men, but encouraged submission. Throughout her career her mode of dress aroused male hostility, among socialists, anarchists and her medical colleagues. It was through the language of clothes that she visually challenged male supremacy.[36]

> My short hair, my high collars, my ties, held a far greater place in anti-feminist gossip than my concept of women's emancipation. Ah, yes, I love to publicize my ideas, to wear them as a nun wears her crucifix, or a revolutionary wears his red rose . . . I wear these external marks of liberty in order that they may say, even proclaim, that I want liberty.[37]

On occasion Pelletier dressed entirely as a man, discovering that she could walk unmolested through the streets of Paris, whereas as a woman this was impossible. She found the transformation gratifyingly comic: 'When dressed as a man, I pass along un-noticed. Streetwalkers address me as "mon gros" (big boy). I feel flattered. I would prefer "mon mince" (slim Jim) but one can't make oneself over. If I had more money, I would take up an identity as a man in some provincial town.'[38] Though she may have nourished fantasies of living as a man, it was even more of a fantasy to dream of living in the provinces. Pelletier was in many respects an archetypal Parisian, who remained stubbornly in Paris and tied to her French roots when other countries might have seemed more

welcoming to her political or feminist beliefs. This passage offers one of the few personal comments that Pelletier vouchsafed on her own ambiguous sexuality. She believed that in the then state of society, all sexual relations, whether within or without marriage, were exploitative. Sexual abstinence was, therefore, in her view the only way to refuse to participate in oppression. 'In society as it is, virginity is the best choice between virginity and slavery.'[39] However, she acknowledged that her lay celibacy was an exceptional attitude, and she did not recommend it as the feminist norm, or for the majority of women:

> Like you, I won't marry, and it is likely that I will never take a lover, because under present conditions sexual relations are a source of debasement for a married woman and of contempt for the unmarried ... but such a way of life, you understand, cannot be recommended as the definitive life for women; it is the consequence of the unjust situation in which they find themselves.[40]

Pelletier was not in fact eccentric in defining lay celibacy in women as an act of revolt, though she may have seemed so in carrying out her programme. The ideology underpinning marriage was the chief plank in the structure that excluded women from politics and most from higher education and the professions.[41] Because marriage was perceived as a natural rather than a social institution, it proved particularly resistant to reform. Patrick Bidelman argues that the control of women by men in the marital home was one of the most pervasive and subtle forms of masculinism. It had:

> a single over-riding objective: to encourage all women to see domestic life as the only legitimate way to experience their assumed unique and eternal feminine nature. In thus presuming a fundamental link between social role and innate characteristics, masculinism resembled nothing so much as a form of racism in which the presence of female genitalia prefigured a common, unindividualized social destiny for half a population.[42]

To challenge the institution of marriage by deliberate refusal, as Pelletier did, was to challenge more than marriage, it was to attack the basis of the masculinist ethic.

However much Madame Pelletier might have disapproved of her

daughter's feminist leanings, as a monarchist she would have been even more appalled by her visits to anarchist groups.[43] Madeleine Pelletier herself said of her introduction to this milieu: 'I also frequented anarchist groups where I had been taken by chance. I wasn't really an anarchist. I have never been able to conceive of society without government.'[44] What attracted Madeleine to the anarchists was her belief that they shared her own passion for individual liberty, which her life had up to then denied her. Anarchism had the advantage of preaching self-help for the working classes but rejecting the atomistic view of society based on the detached individual of classical liberalism.[45] Throughout her career, Pelletier maintained a libertarian concern for the rights of the individual with a strong commitment to collective solutions to social needs.

In spite of the views of utopians such as Fourier which her anarchist friends theoretically espoused, Pelletier recorded that they were not sympathetic to her feminist leanings, especially to the view that women should campaign for the vote. Since anarchists were opposed to any form of government, including representative government, and therefore to the election of representatives, they opposed women's suffrage, which Pelletier, still in her teens, already believed crucial to women's emancipation: 'I tried in vain to explain to them that political suffrage, in spite of being perhaps an illusory goal, was a stage women must pass through to free themselves. They were not interested, not differing in this respect from other men; they held women to be inferior creatures.' The anarchists also mocked her for refusing to practise free love and to take a 'compagnon' or lover. They called her a sexless Joan of Arc, a red Virgin: 'In fact the fate of the women anarchists didn't appeal to me. Taken up, then dropped, they were passed from one man to another; they dragged babies around, since the means of avoiding pregnancies were not well known. That wasn't the future I was looking for.'[46] In this form, Pelletier reasoned, sexual liberation for women only meant a new kind of slavery. It was emphatically not the future she sought. She remembered where that road had led her mother.

By far the most remarkable person Madeleine met at these meetings was Louise Michel (1830–95), the legendary heroine of the Commune, who had fought on the barricades and had subsequently served at least seven years in prison, much of it in the New

Caledonian penal colony. Pelletier remembered her as an impress-
ive, generous but strangely pathetic figure:

> She was tall and thin. Her most notable characteristic, the nobility
> of her expression, blotted out her ugliness. She was always poorly
> dressed, the effect of indifference rather than lack of money, for she
> earned a great deal from her lectures which were always packed. But
> she took no care of her person, forgetting to comb her hair or to
> wash. Furthermore, when she had a bit of money, there was always
> someone to come and take it off her. And she could not say no – she
> felt obliged to sustain her reputation. It was understood that the
> 'Good Louise' did not know how to refuse and she was capable of
> taking the shirt off her back to help someone.[47]

Madeleine saw in Michel a type of mystical revolutionary whom
she admired but also distrusted. She had seen enough of mysticism
in her mother. Both in her socialism and her feminism, Pelletier
characteristically sought rational arguments to support her views.
With the example of her mother before her, she had misgivings
about convictions based on emotion rather than on logic. She
eschewed enthusiasm, even in her writing style, preferring irony
and understatement in her narrative stance. Yet Pelletier recog-
nized that Michel's speeches were powerful precisely because they
were emotive. They evoked the misery of the poor, freezing in
slums, of children without bread. Michel's vision of the revolution
was of an apocalyptic transformation of society:

> In her mind this revolution was something mystical, it was a force
> of nature; in the images that always decorated her speeches, Louise
> Michel compared it to a torrent, an avalanche, an earthquake, to a
> flood tide that submerges everything. At bottom, although Louise
> Michel called herself an atheist, the revolution was for her a kind of
> divine justice.[48]

Michel also exemplified another problem for Madeleine. Michel
had not campaigned as a feminist but as a revolutionary socialist;
she told Pelletier that though she was a feminist, the woman's
movement was too narrow and she had accordingly sought
political action within the broader framework of male politics.
This division between male revolutionary socialist politics and
middle-class feminist politics was one that Pelletier tried to bridge

throughout her career. But she, too, like Michel, recognized that to declare oneself primarily a feminist was to run the risk of marginalization where significant action was concerned.

Pelletier's bohemian political education continued for seven or eight years. Though she read widely, she became increasingly convinced of her own ignorance. In the late 1890s, when she was in her mid-twenties, she decided that the road to personal freedom lay through education, and accordingly began to prepare for the baccalauréat with a view to studying medicine. Her higher education and the beginning of her medical career will be the subject of the next chapter. The thirteen-year-old who had defied her parents to go to evening meetings of anarchists and feminists had outgrown rebellion and needed a new focus. Pelletier's remarkable energies would not be contained in mere talking shops: 'I wanted to leave the milieu that my birth had placed me in and I thought I could succeed by entering the intellectual world.'[49]

2

Meritocracy and Elitism, 1897–1903

When in the late 1890s, Madeleine Pelletier, then in her mid-twenties, decided to return to her studies, she followed the meritocratic road characteristic of the French Third Republic. But whereas success through personal effort was a mark of the age – one notes Madeleine's childish admiration for Napoleon and her early ambition to be a general – the individual success ethic rarely applied to women: 'Social betterment through education is an original feature of this period ... The boursier, the clever scholar from the poor family, gaining the highest positions in the state by his talents, stood in France, like the myth of the self-made man in America, as the symbol of a society in which advancement was open to all.' Just how 'open to all' advancement in French society was is indicated by the same historian's candid observation on the following page: 'Women read little, rarely went out, were kept out of controversies and were generally more under the influence of the clergy, and the men seem to have shown little concern over this.'[1] It is not perhaps surprising that 'men seem to have shown little concern over this.' On the question of confining women to the domestic sphere, there was complete agreement between laity and clergy, anti-clericals and clericals, conservatives and liberals.

If men were not concerned by women's domestic incarceration, many women, including Pelletier, were. From an early age she had consciously refused to conform to the domestic role. Intensely ambitious, she believed strongly in her own intellectual powers. She formed part of the group for whom Gambetta in 1872 coined

the term, 'les capacités', those who used their intellectual talents to rise in the social hierarchy and attain professional qualifications. In a period when the prestige of science was at its height, education was seen as the chief tool for human progress. Yet although Pelletier's decision to pass the baccalauréat and to study medicine implied the ethic of individual success, her studies did not lead her to abandon her class or gender loyalties. Like many professionally successful women of her generation in France, England and America, she saw herself as a representative figure, her achievements opening a path for other women. One may disagree with Marilyn Boxer's comment about her: 'While disdaining bourgeois morality, she adopted the bourgeois faith in education and herself pursued a typically bourgeois path of upward mobility.'[2] It seems harsh to castigate Pelletier for taking the one path open to her to gain economic independence. She embraced the intellectually elitist standards engrained in the French educational system, while dissenting from its class bias. It would be true to say, however, that throughout her career she evinced a conflict between intellectual elitism and social egalitarianism. But she remained suspicious of middle-class attitudes, particularly in other women, and resented the patronizing tone she often detected in their praise of her: 'I felt condescended to by the leaders of other feminist groups who would say, "You are a very worthy person." I felt like hitting them.'[3] Though she eventually entered a middle-class profession, Pelletier never conformed to the ladylike norms of behaviour expected of her. Her often acerbic comments on the professional and scientific community, recorded in her novels and journals, mark her detachment from the bourgeois values of the medical profession that she had laboured so hard to join.

Studying for the 'bac' was itself an almost insurmountable hurdle. Madeleine's father had died sometime in her teens; her decision to continue her studies imposed another burden on her hard-pressed mother, who nevertheless agreed to provide her daughter with food and lodging at a time when she must have hoped that Madeleine would have started to earn her own living, or better still, to have married advantageously:

I decided to prepare my baccalauréat all alone. In a distant future, I planned to study medicine, but only as a possibility. My mother, who was my sole remaining relative, was very poor and, though she

might wish to, could never give me sufficient money. At this time
study enthralled me, or rather the desire to succeed, for the
baccalauréat texts were not exactly amusing. I stopped going to
[political] meetings without regret.[4]

The baccalauréat, which Madeleine studied for at home in the
family back room, was the competitive examination which allowed
entry to university. Normally students followed an intensive
course of study at a *lycée*, or academic secondary school. French
public secondary education for girls was far more advanced than in
England at the same period, but was not equivalent in range of
provision to that of boys. While state secondary schools for girls
had existed since 1880, lycée instruction for girls was still markedly
inferior to the training offered to their masculine counterparts.
Although women were allowed to sit the 'bac', they were not
formally prepared for it; most who passed did so through private
tuition. Pelletier, studying on her own, was unusual in her poverty
and determination, but even middle-class girls faced a struggle. The
ambivalence in this system of instruction, providing lay education
for women but only of a restricted nature, related to the desire to
make women useful educators of their families but not to challenge
men's dominance.[5] As the Minister for Public Instruction, the
educational reformer Victor Duruy, expressed it in a letter to the
Empress Eugénie in 1866:

> The Empress will note that in France there is no higher education
> for women. I don't wish to turn them into 'blue-stockings', but the
> mother's influence on her son's education and on the direction of
> his ideas is too great not to make it disquieting to see women remain
> strangers to the intellectual life of the modern world.[6]

Thus for women in France at the turn of the century, education
did not aim to develop their individual capabilities but to train
them to be more interesting wives and better informed mothers.
Pelletier, like many other ambitious women of her generation, saw
the possibilities of the existing educational provision in a different
light. Never entertaining the idea of a matrimonial future, she
conceived of education for herself and for women generally as a
way of establishing intellectual equality between the sexes through
women's entry into the professions, and to equip them to enter the

political arena. Education was the path to power. If it was a bourgeois preserve, it need not be restricted to the bourgeoisie.

It is worth reminding oneself of the difficulty of the role of autodidact that the young woman had undertaken. With virtually no class instruction, little money for books or encouragement at home, she ploughed her way through the syllabus, ultimately passing the examination on 21 July 1897, and even receiving a distinction. Her excellent memory, powers of analysis and her sheer determination made her a good examinee. The hurdle of the 'bac' overcome, there remained the question of how to survive financially as a student if she were accepted at the medical faculty. She was unwillingly driven to admit her financial straits to a sympathetic professor at the School of Anthropology. Through his intervention, Pelletier was awarded a scholarship worth 600 francs per annum from the Paris municipal council, to read medicine. A year later, on 19 July 1898, she passed the PCN, the preparatory certificate in physics, chemistry and natural sciences and was ready to embark on her medical studies.[7]

It may seem surprising, given the low civil status of women in French society, that they were admitted to the Paris medical faculty at all, and indeed had been from as early as 1868. In the late nineteenth century, medical education for women became one of the litmus tests for liberal educational provision in many advanced industrial countries. The struggle to qualify as a medical doctor had been pioneered by the American, Elizabeth Blackwell, who overcame enormous opposition to gain a medical degree in 1849 from the University of Geneva in the state of New York. In England, Elizabeth Garrett qualified for the medical register by passing an examination for the Society of Apothecaries, but in 1862 was refused a degree by the University of London, which did not open its doors to women until 1877. Garrett eventually came to Paris to complete her medical education and joined the first intake of women medical students in 1868.[8]

The admission of women to the French medical faculties can be interpreted as a pleasing historical accident. In a country where the Napoleonic Code defined what could and could not be done in almost every sphere of life, no one had had the foresight to forbid medical education to women. When in 1866, Madame Madeleine Brès petitioned the Dean of the Medical Faculty, Monsieur Wurtz, to be allowed entry to medical studies, she met with unexpected

success. Wurtz supported her application and referred it to the
Council of Ministers; among its members was Victor Duruy, who
had pioneered secondary education for girls. A tied vote at the
council was resolved by the Empress Eugénie, who voted in favour
of women's admission to the medical faculty.[9] Thus, though the
climate of opinion in France was genuinely hostile to women's
rights in the broadest sense, the lack of formal institutional barriers
allowed women to obtain medical degrees before it was possible in
England and while it was still difficult in North America.

Opposition to women continued in the medical profession as a
whole, however, as to the positions women were, or were not,
allowed to hold, and in the psychological barriers they faced. The
latter are almost certainly reflected by the fact that the admission of
women to the Paris medical faculty produced no flood of French
applicants. In 1868 there were four women medical students
enrolled for the first year: Madame Brès (French), Miss Garrett
(English), Miss Putnam (American), Mademoiselle Gontcharoff
(Russian). The high ratio of foreign women students continued to
be the pattern for many years. Russian women in particular, denied
higher education at home, flocked to Paris. But few young
Frenchwomen dared enter the medical preserve. In 1882–3, there
were nine French women medical students at the University of
Paris and thirty-six foreign women. By the year 1900 when
Pelletier was engaged in her medical studies, the imbalance had
begun to level off. The number had leapt to 179, of whom 81 were
French and 98 were foreign. One should note that at the same date
there were 3,746 male medical students at the Sorbonne of whom
3,366 were French and only 380 were foreign. However this was an
improvement on the law faculty which in 1900 had no women
students, though in the following year it had six, none of them
French.[10]

In her memoirs, Pelletier said little about her experiences in the
medical faculty from 1898 to 1903. She would have been required
to sit five major examinations, and to submit a thesis. At the same
period, she carried out research in anthropology and published a
number of articles. Having begun her medical studies in 1898,
Pelletier undertook her first clinical practice in 1899, spending one
semester at Trousseau and the second at the Necker Hospital, both
in Paris. On 4 April 1900 she passed her first examination for the
Doctorate, with the commendation of 'good'. In 1900–1 she had

two further internships at the Laenec hospital, also in Paris. Professor Reclus there noted that her work was 'meritorious' and showed great effort, but indicated that she was experiencing some difficulties, 'Ne s'est pas encore débrouillée' ('Not sorted out yet'), indicating problems, perhaps, with organization or study technique. She passed these probationary stages with good marks, although on 21 February 1901 she failed the physiology paper in the second examination, thus bearing out Professor Reclus's warning. She resat in May and squeaked through with the mark 'average'. Her third set of examinations, for 'operating medicine and topographical anatomy', were passed with 'fairly good' and 'good', but she fell down in her practical on anatomical pathology, gaining only another 'average'. There remained the fourth and fifth examinations as well as the clinical training period at the lying-in hospital at Badelocque. There her professor declared (15 October 1902) that she had carried out her duties with 'exactitude, zeal and subordination', the standard formula commonly employed in the clinical context to denote approval. The year 1903 brought another diet of examinations in April, May and July, which she passed, though not brilliantly. Finally on 28 October 1903, Pelletier submitted her thesis, 'The association of ideas in acute mania and in feeblemindedness'. Her examiners included Professor Alix Joffroy, her teacher at Sainte-Anne hospital, who had noted that she had made real progress and who was also probably responsible for first awakening her interest in psychiatric medicine and in psychological analysis generally; they declared themselves 'extremely well-satisfied'. At the end of her gruelling medical course, Pelletier had produced a distinguished piece of research.[11]

One can gain some personal insights into Pelletier's medical training from her novels, educational writing and letters. In spite of the time spent in clinical practice, she felt medical students lacked practical experience:

> At present, it is possible to become a doctor without knowing the skills of manipulation, without ever having opened an abscess, done an intravenous injection or used forceps, etc. When after six years of study you set up in practice, you realize that you know practically nothing of what you are supposed to know. Fortunately your patients can't judge, you hide your ignorance and it is on the patients that you do your apprenticeship.[12]

Pelletier was not alone in finding contemporary medical training inadequate. The nineteenth-century shift of medicine from an art to a science, under the impetus of Claude Bernard, led to sustained attempts from 1876 to the First World War to make medical training more science based. However, the rapid growth in student numbers was not matched by increased resources. Students clamoured for better practical training in hospitals and student demonstrations became a feature of the medical faculty before the Great War.[13]

In Pelletier's utopian novel, *Une Vie nouvelle*, the hero Charles Ratier enters the medical faculty as a mature student after the great revolution which brings communism to all of Europe. It is possible to infer from his university experience an image of what Pelletier thought student life should ideally be like. For Ratier, packed lecture halls and rote learning for examinations have been replaced by small tutorials and continuous assessment. However, his sense of the independence of student life and the pleasures of intellectual discovery are conveyed, one suspects, from Pelletier's own recollections.[14] She indubitably experienced great mental liberation during her student days.

The death of Madame Pelletier in this period must have left its mark on her daughter. Pelletier's time as a student had also coincided with her escape from the maternal home. In both her novels, the scenarios of a happy personal existence include a modest and clean apartment for one person (the ideal of autonomy) with a convivial community structure to draw on, a superior form of student life. Pelletier's childhood left her with a burning desire for independence and self-respect and a hatred of family life. It was not, in her eyes, the fundamental supportive structure of society but a rotting sore which infected and corrupted individuals. Her mother's death freed her from the shadow of the dreaded family.

However, Pelletier found some aspects of student existence far from ideal. Not only was medical training insufficiently clinical, but she began to regard the whole predominantly male university milieu as conservative and often profoundly anti-woman. 'I don't like scientists much. Outside their specialism, which is only a superior trade, they are conservative and timid.'[15] In the supposedly equal intellectual atmosphere of the Sorbonne, able women, she thought, were confined to the less prestigious jobs, especially in

teaching, creating in effect a two-tier educational system: 'There is a very strong current of anti-feminism among university lecturers ... They attempt to close the university to women in order to confine them to a [secondary] teaching level which will be inferior to that of men.'[16] And years later she reflected bitterly on the sexual pressures felt by women in a scientific milieu: 'What if I were to tell you that, even at the Faculty of Science, about the only way for a woman to succeed is to sleep with a professor.'[17]

There is little doubt that harassment, direct and indirect, was part of the French woman's university lot, particularly if she did not conform to the expected norms of dress and behaviour. Madame Brès, the first woman to enter the medical faculty, was especially recommended for her irreproachable deportment.[18] Dr Marthe Bertheaume, writing in 1923 and recalling medical training at the turn of the century from a non-feminist perspective, referred disapprovingly to some women medical students, especially Russian ones who wore men's clothes, dark glasses and who spoke bad French. She believed that women could be either wives or doctors but not both, and that it was essential for women doctors to retain their feminine image. A young woman like Madeleine Pelletier would have been an embarrassment to those conscientious and conformist women who hoped to enter the professions without in any way discomposing men. One can at least acquit Pelletier of the crimes of wearing dark glasses and speaking bad French, though her French was probably far more colloquial than that of her middle-class colleagues.

Anthropology

Pelletier's major enthusiasm from the time of her baccalauréat studies was the new science of anthropology. It was an interest which throws significant light on her intellectual development and demonstrates how she attempted to find a scientific basis for the study of human behaviour within which to locate feminist theory and practice. Both her medical and anthropological studies confirmed her bias towards the scientific/positivist current of French thought. Probably partly in reaction to her mother's mysticism, Pelletier sought throughout her career to find justification for her political beliefs within scientific paradigms. Physical anthropolo-

gy, the new science of human beings in the context of evolutionary thought, was where she began. 'I was at this time a disciple of the School of Anthropology. I proclaimed myself with pride to be the pupil of Charles Letourneau.'[19]

As a relatively new discipline, anthropology offered the possibility of comparing human cultures from a positivist perspective. But the new convert did not find everything plain sailing in this milieu any more than she had at the medical faculty. Always defensive about her poverty, her cheap clothes and lack of social connections, Pelletier found or saw rejection everywhere:

> I nurtured all sorts of hopes there, which were broken like many others. Obviously they realized that I wasn't just anybody, but I had the misfortune to be a woman, and on top of that I hadn't a bean. One of the professors advised me to commit suicide, because without family connections and without money it was certain that I would never succeed in anything. I said to myself that humanity's progress in kindness had not grown much since the *pitechanthropus erectus*, whose skull had just been discovered.

Then there was the sexism:

> On another occasion I was advised to go in for flirtation as the only way for a woman to succeed. 'Be a politician's mistress. When he is finished with you, he will find you a job.'[20]

Pelletier concluded: 'I found this ignoble; I still find it so today.' Her professor's reported remarks may well have been intended flippantly. But for the young student who perceived all around her that most women were entirely dependent on men, and who felt herself economically so vulnerable, such advice had a ring of cruelty. She was also up against the powerful system of personal patronage which characterized French scientific and academic life.[21] She discovered that the 'old boy network' meant precisely that.

French physical anthropology at the turn of the century might have seemed an unlikely intellectual haven for a young woman fired with anarchist and feminist ideas. The Anthropological Society of Paris had been founded by Paul Broca, professor of clinical surgery, in 1859.[22] The strong links between the Anthropological Society and the medical faculty continued to be a feature of

the anthropological circle and probably explains Pelletier's intro-duction to the milieu. Among its other activities, anthropology pioneered techniques in craniometry, or skull measurement, which served to articulate a clear hierarchy of cultural values. In Broca's words: 'In general, the brain is larger in mature adults than in the elderly, in men than in women, in eminent men than in men of medioce talent, in superior races than inferior races.'[23] The mem-bers of the Anthropological Society in the early years tended to be, like Broca, republican liberals, anti-monarchical and anti-clerical, but they would have been conservative on a number of social questions, that is they would have subscribed to a belief in the sanctity of private property and to the maintenance of social order through the traditional family.[24]

Both racialist and misogynistic views became strongly institu-tionalized in anthropological discourse.[25] Thus Broca in 1868 argued that unchecked female militancy, for example, would produce a 'perturbation of the races' and effect a diversion from the orderly process of evolution. One task that nineteenth-century anthropology set itself both in France and in England was to scientifically 'prove' female inferiority.[26]

Social-evolutionary theory followed one of two models, the Lamarckian or the Darwinian. Since Pelletier's mature writing on criminology, socialism and feminism reflects both strains, one may examine the way in which the evolutionary debate developed in the French context.[27] Neo-Lamarckian theory enjoyed a revival in the 1870s with the development of the doctrine of 'transformism', the reputed ability of an organism to adapt to a changing environment and to pass on learned adaptations to future generations. The notion of transformism became enshrined in the anthropological, psychological doctrines of the period, as will become clear in examining Pelletier's research in these areas. On the other hand, Darwin was also an inescapable influence and the idea of evolution, however understood, took on distinctive political colourations, becoming a central metaphor in political and social theory as well as in literature. Historical and sociological theories rapidly absorbed evolutionary language.[28]

Broca's relative liberalism, was ignored by his disciple Gustave Le Bon, who carried forward the implications of many of his theories. Le Bon was known for his work on crowd psychology and his belief in the inferiority of women. His views bear recording

as part of the anthropological culture in which Pelletier found
herself:

> All psychologists who have studied the intelligence of women, as
> well as poets and novelists, recognize today that they represent the
> most inferior forms of human evolution and that they are closer to
> children and savages than to an adult, civilized man. They excel in
> fickleness, inconstancy, absence of thought and logic, and incapac-
> ity to reason. Without doubt there exist some distinguished women,
> very superior to the average man, but they are as exceptional as the
> birth of a monstrosity, as, for example, of a gorilla with two heads;
> consequently we may neglect them entirely.[29]

However, by the 1890s the Anthropological Society, too, had
evolved, which explains why Pelletier found it so attractive. A
materialist, positivist, evolutionary and freethinking approach was
in vogue. When Pelletier began to frequent its meetings in about
1900, the society was led by two liberal anthropologists, Charles
Letourneau, professor of sociology at the School of Anthropology
(and secretary to the Society of Anthropology from 1887 until his
death in 1902), a socialist and author of numerous works on social
evolution, and Léonce Manouvrieur, another neo-Lamarckian,
who directed Pelletier's early research in craniometry.[30] Letour-
neau, a popularizer of anthropological theory, was the first to
kindle her intellectual enthusiasm. He offered, in evolutionary
terms, a model of what society might become, that is, both free and
socially cohesive. Further, he criticized the institution of marriage.
Little wonder that Pelletier proclaimed herself his disciple.

Letourneau saw the gradual evolution of society as towards
collective harmony, combined with individual freedom. He
thought that evolution in human society operated in accordance
with libertarian principles. Nature was on the side of liberty.
Examining a seemingly immutable social institution like marriage,
Letourneau looked forward to monogamous unions of affection
rather than of legal contract. Ever-increasing individual liberty for
women as well as men was, Letourneau argued, the movement of
history. Society would collectively take on the responsibility for
the nurture and education of children. Like other social anthropo-
logists (Bachofen, Morgan and Bebel) Letourneau saw the compa-
rative study of cultures at different historical epochs as illuminat-

ing the possibility of positive change in human institutions. Marriage, historically based on the subjection of women in order to ensure the transmission of inherited property, could be understood as part of social evolution rather than as a permanent or natural state.[31] As with species, so with institutions. Letourneau's writing had a profound influence on Pelletier. Within this evolutionary paradigm, Pelletier was able to justify women's emancipation as a scientific probability.

While frequenting lectures at the School of Anthropology, Pelletier also read widely in English and continental authors who embraced evolutionary models. Encouraged by Letourneau, she tackled Marx's *Capital*, though she did not enjoy the experience: 'Marx went to great trouble to complicate things which are perfectly simple,' she remarked heretically.[32] In many respects, Pelletier remained more of a neo-Lamarckian socialist than a Marxist. She interwove evolutionary language into all her work and showed little interest in dialectical theory.[33]

Pelletier's first work in anthropology lay in the field of craniometry, the theory that a correlation existed between the size and shape of the skull and intelligence. Though more sophisticated than Gallian phrenology from which it took its origins, craniometry retained some phrenological convictions, namely that the shape and size of the skull reflected the brain and that brain size related to mental ability. Pelletier was introduced to the field at the very end of the period of craniometrical respectability. By the beginning of the twentieth century it was already being attacked as a pseudo-science, particularly in England. Pelletier's own research threw up many of the contradictions facing anthropologists who based their theories on the seemingly irrefutable basis of craniometric measurement. It was becoming evident that the objective science of measuring skulls concealed not only a hidden value system but also massive logical and empirical inconsistencies. Pelletier attacked the values, though she participated somewhat uncritically in the method.

Between 1900 and 1902, Pelletier carried out research under Manouvrier, who had done much, as his obituary writer R. Anthony was engagingly to put it, 'to rehabilitate the female brain', opening careers for women in scientific, liberal and administrative professions.[34] Among those women he encouraged was Madeleine Pelletier. Under his direction, she published three research articles

on craniometry; the first suggested technical modifications of the Broca cephalic measurement system, whereas the second and third were analyses of a collection of fifty-five Japanese skeletons to determine the relationship between skull capacity and the body size in different races and between the sexes.[35]

Pelletier's work on Japanese skeletons focused on what in anthropological circles had come to be called the elephant problem. If, as craniologists suggested, the absolute size of the brain, or cranial volume, was the measure of intelligence, then the elephant or the whale would logically be the most intelligent of living creatures.[36] This objection had been fully recognized in anthropological debates for some forty years, but instead of forcing scholars to question the assumptions on which craniometry was based, it led to ever more complex systems of measurement. Different parts of the brain or skull were held to denote superiority or inferiority depending on their degree of development. For example, it was argued that the true facial and skull type for women should properly resemble that of a child. Where this did not occur in 'ugly women, intellectual women, women with large brains or large facial bones', these could be discounted as freaks or exceptions.[37] Thus the elephant problem could be ignored in relation to women or to 'inferior races' by relying on the concept of the norm. If empirical evidence was forthcoming that some women were intellectually superior to most men, this could be interpreted as atypical. Furthermore, women with large brains were said to be weak, prone to hysteria and to have a tendency to mental illness. Paradoxically, where women demonstrated intellectual superiority, their very intelligence constituted a craniometrical argument for the high proportion of women residing in mental hospitals, the high suicide rate among women and the absence of women of genius.

Manouvrier, directing Pelletier's research, did not at this stage reject craniometry, and therefore, in the interests of sexual equality, took a second or relativist line of argument. He suggested that the overall weight or body size of the organism in relation to the brain was the crucial determinant. Though the relatively small size of Napoleon's brain, for example, could be accounted for by his small stature, there was a clear *reductio ad absurdum* to the relativist argument, namely that a person who lost weight would become more intelligent. The fact that, in spite of such widely

acknowledged objections as the elephant problem and the relativist argument, craniometry remained a serious science for nearly half a century points to the way in which theories, once institutionalized within the scientific/technological community, are difficult to dislodge. Nevertheless, the relative weight argument was useful in craniometrical terms for arguing against the inherent inferiority of women.

Within this context, Pelletier set to work to measure her Japanese skeletons. With fifty-five male and female skeletons, she sought to show that in terms of cranial and jaw development (their evolutionary complexity, as it were) the female skeletons were more evolved than the male (that is, showed fewer 'primitive' traits). One notes that the judgements about what was evolved and what was primitive rested on crude racial typology. In Pelletier's analysis, the women's skulls in proportion to their height and weight were larger and heavier than the men's; the inference was, therefore, that women were both more highly evolved and more intelligent than men. 'The relative weight of a woman's brain', she concluded, 'is greater than that of a man.'[38] She went on to argue that the decline in brute strength in human beings, far from being a sign of decadence, was evidence of an evolutionary shift from muscle power to brain power. In this evolution, women were in the vanguard of progress: 'The phylogenetic development of European women is to European man what the latter is to the negro; in other words, women are more advanced in somatic [physical] evolution because superior somatic characteristics are also those of muscular weakness.'[39]

One notes how the notion of racial hierarchies, virtually unchallengeable at this time, was incorporated in her argument. Pelletier's rationale for women's physical 'weakness' was logically suspect, as it would seem to follow that the weaker the person the stronger the brain. On the contrary, even contemporaries pointed out that apparent intelligence differences between classes and sexes could partly be accounted for by the fact that the stronger, richer and better nourished groups were generally more successful in the attempts at intelligence measurements.[40] Thus Pelletier's argument, though gratifying in the context of combating craniometrical misogyny, and though it did challenge the view that women's relative muscular weakness was a mark of inherent inferiority, was not in the long run germane to the feminist debate. However, one

has only to recall Le Bon and Broca's claims about women's physical, moral and intellectual feebleness, which was a standard rather than an eccentric idea, to see why Pelletier was anxious to make such demonstrations.

Pelletier's next piece of anthropological research had the dubious honour of being attacked by Karl Pearson and his school of biometricians at University College, London, as part of his successful attempt to discredit craniometry as a science – not perhaps the way one would most wish to win an international reputation.[41] Pelletier carried out her research in conjunction with a colleague, Nicholas Vaschide, who worked at the Villejuif insane asylum. Vaschide, a Roumanian, was also a member of the Anthropological Society of Paris, and was section head of the experimental psychology laboratory at Villejuif from 1900 to 1907. He died of tuberculosis in 1907, aged thirty-three, possibly a victim of the high rate of tuberculosis endemic among the hospital's patients.[42] Though Pelletier collaborated with him, she does not mention him by name in her memoirs. He may have been the source for Charles Delage, the hero of her play *In Anima Vili*, who was also tubercular and a dedicated scientist.

Vaschide and Pelletier's joint study, 'Les Signes physiques de l'intelligence', cannot be accounted a success but it has considerable historical interest, marking the end of a phase of statistical measurement.[43] In it the authors attempted to correlate skull shape to intelligence in a group of primary school children at Villejuif, a working-class suburb of Paris, using the method of measuring auricular height rather than the method relying on mere skull size. The study began with an uncritical acceptance of the now familiar argument of racial development: 'The brain of the European is larger than the negro's or the Australian's [aborigine's], who on average are less intelligent than the European' (p. 2). However, when faced with 140 primary school children aged six to thirteen, this seemingly easy assertion was soon compromised by the perception that, although it was possible to measure skull size and auricular height, there was no valid intelligence test for the children save the already existing judgements of their teachers. Pelletier and Vaschide recognized that such adult estimates might be biased in favour of diligence or skill in rote learning. They therefore introduced a simple intelligence test, examining the children's ability to remember numbers in a series. But the number test

revealed very little difference between the previously denoted intelligent and unintelligent children. For all the graphs, charts and tables amassed in this study, nothing was really proven about the relation of auricular height to intelligence, as the authors were uneasily aware.

One must wonder why Pelletier took part in the project. She may have been attracted to it by the possibility of finding a technique for diagnosing intelligence in socially disadvantaged children. Yet this aim too was problematic. In the event, the study told against girls: the comparison of head measurements supported the theory of the intellectual inferiority of women. When one considers that by 1903–4, the time of the publication of 'Les Signes physiques', Pelletier was a well known figure in feminist circles, her choice of research subject seems bizarre. On the other hand, as a junior member of staff in the mental hospital, she was keen to engage in research projects in order to build up her reputation. Further, she needed a strong list of publications to rise in the psychiatric service. There is little doubt that 'Les Signes physiques' must have presented Pelletier with both methodological and ideological problems.

Fortunately for her feminism, perhaps, the study was effectively demolished by Pearson and his colleagues who were engaged in demolishing the whole statistical basis of craniometry.[44] Pearson, a biometrician who lectured at University College, London, was unlike most craniometricians in that he was a qualified mathematician. Politically, his views resembled those of his more advanced French colleagues, Letourneau and Manouvrier; he was a free thinker, a socialist and a believer in the emancipation of women. He was sufficiently well known in socialist circles to be attacked by Lenin as an 'empiro-criticist' – a materialist empiricist who concluded that science was the reflection of a subjective, sense-based world.[45] As a mathematician he was aware of the arbitrary, statistically suspect and value-laden assumptions behind the seemingly objective measurements of craniometry. Pearson employed two women researchers, Alice Lee and Marie Lewenz as co-authors. In 1902, Lee, Lewenz and Pearson published an article in which they demonstrated that there was no correlation between skull capacity and intellectual power. They briskly dismissed Pelletier and Vaschide's 1901 progress report on 'Les Signes physiques': 'Frankly, we consider the memoir is a good illustration

of how little can safely be argued from meagre data and a defective statistical theory.'[46] Attacking Pelletier and Vaschide's use of auricular height measurement, they argued that 'the discovery of M.M. Vaschide and Pelletier that the auricular height of school children is related to their intelligence seems to us quite incorrect for English boys and unproven, owing to defect of material and method even for French children.'

By 1906 the whole complex system of craniometry of which Pelletier's research had formed a small part had been effectively discredited. However, the craniological debate had considerable socio-political if not scientific importance. As with theories about insanity and crime, craniometry was an early attempt at differential psychology, ranking the worth of human beings by their physical attributes. Now only of interest in the history of science as a pseudo-science, craniometry demonstrated how a discipline could rationalize the existing social state. Social, racial or sexual inequalities could be legitimized within a scientific discourse: 'inferior races', women and the poor were subordinated in the social hierarchy by natural selection, not by human agency. Had Pelletier continued to flourish under the umbrella of craniometry, her political convictions would almost certainly have come into conflict with her scientific work. As it was, her scientific 'failure' with Vaschide freed her from a tissue of contradictions. Yet if craniometry was an intellectual cul-de-sac, social anthropology as a whole, for Pelletier, was not. Letourneau and Manouvrier's legacy was to mark her subsequent polemical writing firmly with evolutionary concepts.

Pelletier offered an illuminating analysis of the significance of anthropology in relation to feminism in 'La Question du vote des femmes' (1908). Outlining the principal objections to women's suffrage, she cited those who opposed all feminist demands by basing their objections on the inherent inferiority of women: 'A great deal of ink has been spilled over women's inferiority. Anthropologists, looking to science for a justification for their disdain for women, as well as for their hatred of burgeoning feminism, claimed, in about 1860 [no doubt a reference to Broca] that the female brain and skull were inferior.'[47]

Pelletier then reviewed the counter-arguments, that on the measurement scale employed by anthropologists themselves, women could be shown to be, if anything, superior. However, she

concluded that this so-called superiority was merely a sign of less muscular development in women and bore no necessary relation to intelligence. It was similar with the relative weight argument, she acknowledged, in recognition of the attacks of Pearson and his colleagues: scientific knowledge was too limited to assess the precise relationship between body and brain size and intelligence. She concluded that instead of basing intelligence judgements on anthropological data, scientists were better advised to observe people in society, where one found both intelligent women and stupid men, and stupid women and intelligent men. When anthropology based its judgement on racial and sexual typology, little or nothing was revealed about human potential: 'The real inferiority of the average woman is not an essential inferiority but a lack of information caused by an education which represses rather than develops her. The proof is that as soon as any form of intellectual activity ceases to be forbidden to women, the female mind develops in this area.'[48]

Thanks to her experiences in the Anthropological Society, Pelletier had educated herself in the scientific arguments for women's inferiority as well as fashioning counter-arguments. This was all training in a broadly political debate. One conclusion characteristic of Pelletier throughout her career was that if women were to be judged not inferior to men then neither were they to be judged superior. She avoided the idealization of women common to the church, to Romantic mythology and to Positivism (as in Auguste Comte) as well as to many feminists, who suggested that women's superior virtues would purify social life. For Pelletier the case for equality was founded on Enlightenment principles of justice and concepts of human rights, not on the proposition that women were essentially better than men.

Freemasonry

Between 1900 and 1906, Pelletier, encouraged by her colleagues in medicine and psychiatry, launched a campaign to open freemasons' lodges to women. The connection between freemasonry and feminism in France formed a significant subplot in the women's emancipation struggle.[49] Freemasonry had become influential in France in the eighteenth century; it is estimated that before the

French Revolution of 1789 there were some 100,000 French freemasons. The movement helped to disseminate Enlightenment culture, propagating theories of philosophical materialism, Newtonian science and greater social equality. Yet in both English and continental freemasonry women were specifically excluded. For example Anderson's masonic constitution of 1723 reads: 'No Bondmen, no Women, no immoral or scandalous men.' Women as described in eighteenth-century masonic tracts, were held to be unreliable and therefore unsuited to be the guardians of masonic secrets. Yet there were exceptions to the masonic rigour of excluding women. Records exist of a mixed lodge in The Hague in 1751 of women and men in which the 'sisters' were fully equal members. However this lodge was apparently not recognized officially by the Grand Lodge. Other mixed lodges established in Europe at later dates were also not accepted by the official masonic movement. What were termed adoptive lodges also appear to have existed since 1775 in France. These were all-women lodges presided over by the master of a regular masonic lodge. The Lodge of Candour, formed under the constitution of the Grand Orient of France, had among its aristocratic members the duchesses of Chartres and of Bourbon, the Princess Lamballe, Countess Polignace, the Countess of Choiseul Gouffier and the Marchioness of Coutebonne. In addition, adoptive masonry is said to have flourished in Holland from 1801 until 1810, when it was banned by the main lodge.

In the late nineteenth and early twentieth centuries, masonic activity seems to have attracted women in France, England and the United States who had links with theosophy and were also involved in the women's suffrage movement.[50] In France, in 1893, the liberal feminist Maria Desraismes founded a mixed lodge, La Grande Loge Symbolique Écossaise, whose one chapter was named Le Droit Humain (Human Rights). The adjective 'Scots' for this lodge was not unusual, relating to traditional links between Jacobites and continental freemasons. Mixed lodges were tolerated but not encouraged by the main lodges, in France as elsewhere. But aside from these few exceptional mixed lodges, French freemasonry as an official body remained closed to women. This was the situation that Pelletier sought to change.

It seems clear that Pelletier's initial enthusiasm for freemasonry arose from the movement's combination of social egalitarianism,

intellectual curiosity, theoretical receptivity to new ideas and, especially marked in nineteenth- and early twentieth-century France, anti-clericalism. The preface to *L'Acacia*, the freemasons' journal, in which Pelletier occasionally published, painted a glowing picture of an intellectually vigorous and tolerant society where all ideas could find a hearing. What better place for the notion of equality between the sexes, one might be tempted to think? *L'Acacia*, after setting out the antagonism between Catholicism ('authoritarian and conservative') and freemasonry ('liberal and progressive'), spelled out the freemason's credo:

> Freemasonry asserts: Opinions on first and final causes of the world and of human life are personal questions. Everyone should be left in liberty to profess what pleases them, or rather what their minds conceive to be true. We, say the freemasons, welcome among us men of all opinions and beliefs; we encourage friendly links between them; we accustom them each to tolerate the expression of the other's antagonistic ideas. . . . We believe that this life should be the best possible for all those who live it, from the physical, moral and intellectual point of view. We believe that the constant improvement in the lot of all should be the aim of the development of political institutions, of the sciences and arts and of the moral elevation of intellectual culture.[51]

Pelletier hoped to effect women's entry into masonic lodges as part of a campaign of opening up fields previously closed to them. Further, such membership would give women experience in debate, in public speaking and allow them to learn about political life from which they were otherwise excluded. Entry into masonic lodges was a way of beginning women's political education. Pelletier described the masonic milieu in approving terms:

> Freemasonry, the great, coherent, disciplined political-philosophic organization, is on the whole closed to women; but a mixed freemasony has grown up beside the main movement, which is not openly recognized, but which is nevertheless tolerated. Feminists who lack, or who have never had religious belief should not hesitate in affiliating themselves, for it is here that one can the most easily gain a political education.
>
> Freemasons' politics are in reality very general. Lectures given at lodges tend to be on theoretical topics such as 'pensions for

workers' or 'the income tax'; in short all the reforms currently in the process of being carried out. For a woman ... who has never been to an electoral meeting, these general questions will be much more interesting than the personality and party political questions dealt with in the major political parties. Furthermore, the meetings, by their special ritual, are much calmer than political meetings. It is extremely rare for members to dispute with one another; the most humble member may speak, and if the lodge is well disciplined the speaker is listened to regardless of the value of what is said. It is evident that women can speak freely in mixed lodges. In Paris there is a mixed lodge, the Stuart Mill, founded especially for the political emancipation of women.[52]

Pelletier's hospital supervisor at Ville Evrard, Dr Paul-Maurice Legrain, encouraged her to enter a mixed lodge in order to campaign for the desegregation of all lodges.[53] In 1904 she joined the Grande Loge Symbolique Écossaise. Pelletier brought with her Louise Michel, a prestigious figure who, she hoped, would advance the cause of all women for masonic membership. It would also seem from the above quotation that she joined the appropriately named 'Stuart Mill' lodge. But Pelletier's campaign fell foul of some unpleasant incidents when a male freemason introduced a prostitute, or a woman whom Pelletier considered to be of dubious morality, into the lodge. She objected, with acrimonious results. The famed freemason's discipline appears to have broken down in this case. Sexual imbroglios were a certain way to discredit the principle of mixed lodges.[54] Though she remained a lifelong freemason, Pelletier ceased her most active involvement after 1906. By then she had decided that feminist militancy must be pursued in other fields.

Genius and Criminality

Many of Pelletier's medical and anthropological colleagues were freemasons. One link between the two milieus was the belief in encouraging the exceptional individual, the 'man of genius'. Though socially democratic, freemasonry was an intellectually elitist organization, hence its attraction for Pelletier, who believed in a hierarchy of intellectual merit rather than a hierarchy of birth or property. This belief in the exceptional individual seemed

challenged in the 1870s by the proponents of Lombrosian degeneracy theory. Many members of the School of Anthropology, however, rejected Lombroso's theory that both criminals and geniuses were born and not made. In 1876 Lombroso had published *L'uomo delinquente* in which he claimed to be able to detect born criminals from physical signs. Developing the logic of his work on criminals, Lombroso in 1891 published 'The Man of Genius' in which he argued that geniuses possessed a series of physical abnormalities, and that, moreover, the exceptional qualities of genius implied malfunction or degeneracy.[55] Geniuses, rather than being considered exceptionally favoured, showed according to Lombrosian categories signs of degeneracy and instability.

Strong resistance to the determinism and pessimism inherent in Lombroso's theories had early made itself felt in French anthropological circles. Here the neo-Lamarckian transformist emphasis of French anthropology was crucial, stressing the environmental factors affecting crime and, indeed, sometimes permitting the creation of genius. Members of the School of Anthropology, among them Manouvrier and Legrain, attacked Lombrosian theorists at its Paris congress of 1889, as well as at the Brussels congress of 1892, objecting to statistical and logical inadequacies.[56] Legrain's account of the Brussels Criminal Anthropological Congress of 1892 summed up the orientation of French anthropology at the turn of the century. Legrain located anthropology squarely in the debate on evolution, and as being opposed to theories of innate human qualities. Human beings, he suggested, were part of an ever-changing evolutionary pattern. Anthropologists saw morality and therefore crime, as relative to each society. Morality evolved with civilization. The criminal must be understood to some extent as the product of his environment. Social factors were as important for understanding behaviour as heredity. According to Legrain's account, Lombroso had scarcely any defenders at the conference.[57]

It was within this context that Pelletier wrote three pamphlets to popularize the issue of genius and degeneracy in relation to libertarian and feminist politics. Though written over a number of years, one may consider the three together. They are *La Prétendue Dégénérescence des hommes de génie* (The Supposed Degeneration of Men of Genius) (Paris, n.d.), 'Le Génie et la femme', *La Suffragiste*, July 1913 (Genius and Women), and *Les Femmes*

peuvent-elles avoir du génie? (Can Women Have Genius?) (Paris, n.d.). One of her two unproduced plays, though dating from the post-war period, also concerns genius and crime. *In Anima vili* (In a Vile Soul) throws a revealing light on the elitist assumptions Pelletier may first have imbued from freemasonry, which in this play take on a Nietzschean flavour, and which continued to figure in her writing.

La Prétendue Dégénérescence des hommes de génie linked the popularity of Lombroso's theory of the man of genius among doctors and psychologists to the materialist bias of the day. Pelletier thought that the anti-idealist position of materialists and positivists meant that individuals were judged as never before in terms of their physiques. Formerly, she observed, it was an individual's mind which was considered significant:

> It was known that Napoleon was small, that Chopin was tubercular, that Musset was an alcoholic and that Auguste Comte had been mad, but all these weaknesses only constituted unimportant attributes in the image that the public and even scholars had of great men. For everyone, Napoleon, Chopin, Musset and Comte were above all a grouping of ideas and deeds. (p. 2)

Her pamphlet also ridiculed the statistical weaknesses of Lombroso's arguments; while it was true that some geniuses went mad, most mad people were not geniuses. 'It simply shows that genius is not immunized against madness any more than it is against tuberculosis or cancer' (p. 2). Further, all the degenerate moral and physical qualities alleged of men of genius (Lombroso listed shortness of stature, rickets, pallor, receding foreheads, large heads, stammering, left-handedness, sterility and epilepsy) could be found equally in ordinary persons who were neither geniuses nor insane.

The real focus for Pelletier's critique, however, were the conservative political implications that followed from Lombrosian theory. It implied, she said, a hatred of difference. Conformity was seen as a virtue. Denial of genius, she thought, was, finally, a denial of the freedom to think differently from others:

> The man of genius does not resemble other men. Gifted with a more active brain, he carries his intelligence into everything; where other men blindly follow routine, he thinks: this is the source of those

eccentricities which psychologists reproach him with. These eccen-
tricities make him into a man who, in addition to his superiority, is
different from others, and this is what his fellows will not forgive.
Intellectual superiority alone would have made him admired by the
ordinary man; the difference in behaviour makes him hated.
Consciously or not, the man of genius proclaims himself by these
differences to be of a special essence; and this appears to those
around him as the mark of the most monstrous pride. The
inhabitants of Avignon smiled, one is told, in a mocking fashion at
an eccentric gentleman who strolled everyday through the streets of
their town. This eccentric was the great John Stuart Mill. (p. 7)

Pelletier was almost certainly thinking not only of the person of
J. S. Mill, but of the passage in *On Liberty* concerning the tyranny
of the majority where Mill suggests that eccentricity and deviance
of any sort are tolerated only with difficulty by society at large.[58]
In Pelletier's view, scientific orthodoxy, in the Lombroso pattern,
threatened to stifle intellectual creativity.

Pelletier's attack on Lombrosian theories was a preparation for
the subject that really lay close to her heart and was the subtext of
La Prétendue Dégénerescence, namely that of the capacity and
potential of women. Could women, contrary to the claims of
conservative anthropologists, rise to the heights of the greatest
male minds? In 'Can women have genius?' and Genius and
women', Pelletier reviewed the traditional arguments alleging
women's inherent intellectual inferiority. One common allegation
was that women had not produced great figures in music, painting,
architecture, drama and so forth. If women were really the equals
of men, so ran the argument, where were the female Mozarts,
Michelangelos and Napoleons? This 'evidence' of innate female
inferiority was in turn taken to justify the exclusion of women
from male pursuits. Pelletier, employing the anthropological argu-
ments of transformism, suggested that individual genius was the
product of centuries of social conditioning. Under the present
social system, women's intellectual, and indeed physical develop-
ment, was so hampered as to make any true judgement of their
intellectual and artistic potential impossible. In any case (a point
made by Mill) exclusion from civil rights did not operate for men
on the basis of their intellectual capabilities.[59] Lack of genius was
not a rational basis for exclusion from citizenship. Finally, Pelletier
argued, women lacked an intellectual tradition; theirs was a

tradition of inhibitions: 'How can one expect women, who until recently have been forbidden to perform all intellectual work – a ban that is only now slowly being lifted – how can one expect women to contribute to the unfolding of works of genius?'[60] And it was evident that the past inhibitions could not necessarily be overcome even by exceptional individuals:

> Genius is not the grace of the Jansenists; inventions do not emerge fully fledged from the brain. If Newton discovered gravity, it was because he was an astronomer. If Claude Bernard discovered the function of the liver, it was because he was a physiologist. If Napoleon had been an entomologist instead of a general, he would never have conquered Europe.[61]

If genius was a catalyst of civilization, as Pelletier also claimed, to what extent should superior individuals be obliged to conform to social laws and customs? In her drama about scientific experiments on humans, *In Anima Vili, ou un Crime Scientifique* (1920), she examined the question of whether the superior intellect could be considered free from moral restraint. The play juxtaposed arguments on the sanctity of human life with arguments on the duty to advance human knowledge. The Nietzschean overtones were striking: 'Law and morality are for ordinary men and circumstances, *we* are extraordinary men ... let us rise to the heights where we find ourselves placed' (p. 13).

The plot concerns three scientists, Paul Bernard, the man of genius 'persecuted by the envious', and his two subordinates, Charles Delage, of superior intelligence and with a tendency to tuberculosis (a combination of Pelletier and Vaschide?), and Georges Wagner, intellectually inferior to the others, a bourgeois. Delage functions as the authorial voice. The setting is a psychological laboratory, stacked with skulls of dogs on whom Bernard has performed experiments. After a short opening debate on the moral status of vivisection, about which Delage has qualms, Bernard enters to announce a new project, namely to pursue brain research on live human beings. The three men debate the question of 'men of genius'; like Raskolnikov in *Crime and Punishment*, they ask whether Napoleon, as an exceptional individual, had the right to sacrifice the lives of others.

Both assistants, Delage and Wagner, exclaim with horror at the

prospect of taking human life, even in the interests of scientific advancement. Delage, however, loyal to his master, offers himself as an experimental victim; he is refused by Bernard as being too useful to science. But by the second act all the characters have accepted that a crime must be committed if science is to advance. They accordingly kidnap a passing drunkard and perform an experiment whereby Bernard anaesthetizes the patient, inserts electrodes in his brain and succeeds in projecting the man's thoughts and memories on to a screen, a sort of externalized version of phrenology. The experiment is brought to an abrupt end by an aerial bombardment (the play is set during the First World War). Society's willingness to sacrifice millions pointlessly is contrasted with the controlled and useful experiment initiated by Bernard. The curtain falls as Bernard ghoulishly accepts Delage's renewed offer of himself as an experimental victim:

Bernard: This time I consent to let you serve as subject.
Delage: Ah, Master, the exteriorized mental image, what an admir-
 able discovery!

This was indeed self-immolation for science. One cannot take it altogether seriously, however – Delage's doglike devotion resembles too much the canine victims who already litter the laboratory, reminding us that the less brilliant Wagner had told him he was hypnotized by his master. This drama revealed Pelletier's attraction to ideas of individual superiority. The imagined experiment also showed her continuing interest in psychology. But the megalomania of the scientist was not endorsed any more than was the Great War, described as raging outside the laboratory.

Pelletier's views on genius can be understood as part of her intellectual elitism, itself a product of the French educational system, and encouraged in freemasonry. As a practising psychiatrist, she would have been aware of how easily unusual behaviour could be classified as abnormal; her attack on Lombroso reflected her sense of a prevailing climate of conformity. The idea of genius enabled Pelletier to justify those who, like herself, put forward ideas not in sympathy, with contemporary standards.

Madeleine Pelletier's further and higher education showed her intellectual adventurousness. In her late teens and early twenties she threw herself into a remarkable course of formal and informal

study. Not only did she, with the most minimal financial resources, pass the baccalauréat and go on to gain a medical degree, she also explored political and intellectual avenues where she hoped to pursue her overriding objective, the emancipation of women. Anarchism and anthropology, freemasonry and eventually socialism, all promised an anti-establishment position from which she could hope to exert a lever on the power structure. However she discovered that each supposedly radical or revolutionary alternative was deeply, if sometimes unconsciously, embedded in masculinist ideology. The idea of sexual equality might have seemed to follow from the revolutionary republican slogans of 1789, Liberty, Equality, Fraternity (*sic*), but they involved a silent exception, women. Pelletier's maturity was devoted to pursuing the twin goals of liberty and equality for women. But even sorority was to prove elusive.

3

Psychiatry and Medical Practice, 1903–1906

When Pelletier finished her medical training in August 1903, her first priority was to establish herself professionally, not an easy task for any aspiring but impecunious young practitioner and especially problematic for a woman. Women doctors faced difficulties in attracting patients, in particular female patients, who reputedly preferred more 'authoritative' male doctors. A survey carried out by *La Fronde* in 1901, when Pelletier was still a student, showed general satisfaction of women doctors with their profession but also elicited many complaints about male colleagues and the narrowness of medical societies. Further, the respondents claimed, patients often expected women doctors to charge less. General practice was difficult for women unless they went into paediatrics; in state medical posts, women could do better, but many were part-time and badly paid.[1]

Though medicine was a growth area, like any other private business it required capital. To attract patients who paid well, one needed good premises and connections.[2] One way forward for young doctors in Pelletier's position was to enter some branch of the state medical welfare service, often on a part-time basis. Medical welfare posts with the Conseil de Surveillance de l'Assistance Publique, for example, had been opened to women doctors by competitive examination, the *concours*, for interns in 1881, and in 1885 for externs. In the early years after she qualified, Pelletier held

at least three posts, possibly simultaneously. She did emergency night duty ('assistance médicale'), she ran a small private practice and finally she won a three-year posting as a psychiatric intern.[3]

It is illuminating to read Pelletier's account of what night duty for the 'assistance médicale' involved. An undated article entitled: 'Against alcoholism: a night doctor', which described her nocturnal sorties for the service, probably reflected the influence of her mentor Legrain, who had campaigned actively against alcoholism:

> Often between midnight and three in the morning I am abruptly awakened by the bell. A night-duty policeman has been sent to call me for an 'urgent' patient. Sometimes it is indeed an urgent case: so urgent that the patient is dead before I arrive. Medicine is not a cheerful profession ... I go, as one may well imagine, into some terrible hovels: pallets without sheets, where a half-dozen fully dressed children wallow in filth. I am hardened therefore to the sight of misery but on this occasion, nevertheless, the shock was such that the impression still endures.

Summoned one night by a man, accompanied by a policeman, and brought to a pitch-dark alley, Pelletier called for lights while her guide muttered helplessly over and over again, to her amusement, 'Ah *merde*, here's the doctor come and no light.' She eventually obtained a lantern and mounted to the room where the sick person lay:

> I was sickened on entering by a terrible odour. I had never seen such filth: old rags, rusty pots, empty bottles, broken chairs. In the middle of this rubbish sat two adult males, with filthy faces, and on a pallet bed covered with blackened rags, an old woman sitting with dishevelled hair, her face and body as black and filthy as the rags of the mattress ... I noticed the old woman's language; her sentences rang out clearly in comparison to the mumbling of the two men, her sons. She told me she had formerly been a primary schoolteacher and had taught for twenty years. 'It was my husband's evil ways that brought me here.' Possibly, but the empty bottles stuffed in the corners led one to think that she was also the author of her own misery.[4]

This passage affords a glimpse into Pelletier's working life and reveals the sort of day-to-day experience she faced as a young

practitioner. The scene described here, though more extreme, was not unlike the environment from which she herself had managed to escape. Her final comment about the old woman – 'she was also the author of her own misery' – was revealing. The extent to which both women and the working class colluded in their degradation shaped Pelletier's analysis of social reform. Enabling people to overcome self-destructive impulses became part of her political agenda.

When Pelletier began practising medicine, she set up shop in a two-room flat, rue de Gergovie, boasting a kitchen and a reception room, which doubled as her bedroom at night. Here was unheard-of luxury and privacy, but the plaque she displayed on her door announcing her name and surgery hours failed to attract patients.

> I furnished it more or less badly with secondhand furniture which I revarnished myself. Double cretonne curtains in bright colours. Everything was clean; it smelled of fresh paint, I was enchanted. Below I put up an enamelled plaque: 'Doctoresse, Tuesday, Thursday and Saturday, 2–4.' I was ready. But clients were slow in coming. Though I stayed at home religiously at the hours indicated, no one came. In three months the only patients I looked after were a baby on the fifth floor and my concierge in labour.[5]

In later life Pelletier waxed ironic about her first forays into private practice. She had learned something fundamental from her mother's preaching to unwilling customers, namely not to reveal her political and feminist opinions to her patients. Her working-class clients, she knew, would neither approve nor have any interest in such eccentricities. Even when her medical practice was more securely established, she admitted to not mixing her professional and her political concerns: 'I never say anything about feminism to my patients; the people whom I look after know nothing of my opinions, unless they insist on knowing them. And one must do this, because otherwise it would be impossible to earn a living.'[6]

No matter how gratifying it was to have her own flat, Pelletier found her professional inactivity tedious as well as financially disastrous. In 1903, in order to expand her professional horizons, she applied to take the examination for an internship in the psychiatric hospital service. In her fourth year of medical studies,

she had served at the Sainte-Anne psychiatric hospital under Dr
Joffroy, the doctor who had praised her progress and who
probably first kindled her interest in psychology.[7] He also directed
her thesis and presided over her oral examination where the jury
had pronounced itself 'extremely well-satisfied'. Pelletier had
further prepared herself for a psychiatric career by serving as a
locum at the Villejuif asylum for some months in 1901–2 under Dr
Edouard Toulouse, who held a senior post at the hospital, had
feminist sympathies, was a freemason and was the author of
numerous psychological studies, including an analysis of Émile
Zola. Pelletier gave the following account of her motives for
entering the psychiatric service:

> I wanted to compete for the Internship for Insane Asylums. I was
> very interested in psychology and hoped to discover its laws ...
> Furthermore, there was a little salary [attached to the post] which
> was a help for a poor student. The salary would help me to wait for
> patients who still were slow in coming, especially to a woman
> doctor.[8]

The advantage of such part-time official appointments lay not only
in the additional income generated (in this case 1,200 francs per
annum), but in the fact that new private patients would probably
be attracted by the prestige accruing to doctors who held official
posts.[9]

Pelletier's application for the *concours* ran into immediate dif-
ficulties. Though she successfully registered for the examination,
having the appropriate medical qualifications, she was denied
permission to sit it on the grounds that all candidates were required
to hold political rights. This requirement presumably existed to bar
lunatics and criminals, and women. Women were almost certainly
the perceived danger that the profession was attempting to exclude.
'It was feared they would not have enough power to control
maniacs and the feebleminded.'[10] This explanation appears ing-
enuous, to say the least, since asylums routinely employed female
nurses who had more contact with violent patients than doctors.

A stirring account of Pelletier's banning from the examination
hall appeared in *La Fronde* of 2 December 1902. The incident was a
milestone, being her first public feminist campaign:

> Midday at the Hôtel de Ville, in front of the entrance to the hall
> where the competitive examination for the internships of the

Asylums of the Seine took place. The roll was called. A number of young men came forward, presented their letters permitting them to sit the examination and entered one by one into the hall. 'M. Maujan,' the porter called. M. Maujan came forward, fumbled in his coat pockets, his jacket, his trousers, emptied them, turned them inside out and found nothing – no letter. 'Never mind,' declared the porter paternally, 'Go in anyway.' Everyone had entered. There only remained a girl, small with an ironic gaze and a determined air. She came forward in her turn. 'Your letter,' said the porter, haughtily barring her way. 'I haven't got one, but I am enrolled, and anyway M. Maujan [didn't have one].' At this moment from the depths of the hall a vague and shifty-eyed person rushed forward. He planted himself firmly [in her path] in the attitude of an angel at the door of an earthly paradise and said categorically: 'You will not enter, Mademoiselle.' 'Am I to understand that you are formally forbidding my entrance?' 'Formally.' 'So be it. But for my part I am absolutely determined to exercise my rights. I will make a public protest against the injustice done to me.'[11]

We can appreciate Pelletier's shrewd political sense of how to gain maximum publicity from an incident and her determination to embarrass the authorities. The article, though signed by a *La Fronde* reporter, gives the impression from the eyewitness account it offered, of being dictated by Pelletier. It highlighted the favourable treatment afforded the feckless Monsieur Maujan, before revealing the unfairness of the treatment shown to a girl with an 'ironic gaze and a determined air'. Pelletier had not, of course, been unprepared for the drama. Her appearance at the examination hall was a deliberate public protest, as she had already received an official letter from the Préfecture de la Seine telling her she was not eligible. She knew in advance she would be turned away:

29 Nov. 1902

Mademoiselle,

The Prefect has examined the dossier of the 'Concours d'Internat en Médicine' in the Public Insane Asylums which will take place on the first of December and after attentively examining the request that you sent him, he has judged that according to the clear terms of Article III of the Administrative Order of 4 December 1900, it is not possible for him to give you the special entry form which, according to the notice of 9 October last, confirms admission to the

Concours and should be presented in order to take part in the written examination.

I have the honour to inform you of this decision,

G. Durance, Director of Departmental Affairs[12]

Pelletier was not the first woman to have attempted the examination. A few years earlier a Polish student, Mademoiselle Toblowska, was admitted and given the title of provisional intern, but after her success the regulations had been amended to exclude women. The ruling which affected Pelletier was Article III of the Regulations for the Office for the Insane: 'The candidates, in order to be enrolled for the concours must enjoy their civil and political rights.' A civil servant with whom Pelletier had discussed the problem had revealed the rationale underlying this regulation: 'Do consider, Mademoiselle. Interns in insane asylums have the right to sit [further] examinations, first for assistant registrar, then for registrar or asylum director. A woman running an insane asylum! Don't you see what a monstrosity that would be?' Article III expressed the anxiety of some members of the psychiatric profession to maintain state psychiatry as a male preserve.

Not everyone in the medical hierarchy agreed with this view. *La Fronde*'s reporter collared the members of the jury, or examinations board, as they left the hall and discovered that all seven expressed themselves opposed to the 'arbitrary exclusion of Mademoiselle Pelletier'. Various reasons were offered for the existence of the infamous Article III, invented according to Dr Bourneville to keep out Mademoiselle Toblowska, who was not only a woman, but a foreigner as well. He accused the bureaucrats of being both nationalists (chauvinists) and anti-feminists. Dr Toulouse, from the Villejuif asylum, strongly supported Pelletier's candidature. 'Mademoiselle Pelletier has spent a period in my service as a locum at Villejuif, and I have been able to assess her capacity.' The same article quoted a professor of medicine at a Parisian hospital as affirming that: 'I believe that women can render as good service in a hospital as a man', citing Miss Putnam of New York lately graduated from the medical faculty of the Sorbonne and Mrs Anderson (Elizabeth Garrett) in London. 'As for Mademoiselle Pelletier, although I don't know her as well, I know her to have a very well balanced, intelligent mind, to possess uncommon energy and I believe she would make an excellent intern.'[13] Pelletier had

successfully rallied her friends and supporters to speak on her behalf:

> I started a campaign in the press. One can scarcely imagine what that simple sentence meant in terms of snubs, interminable waits in newspaper waiting rooms, culminating in not being received, empty promises; all this to a penniless girl. Finally I succeeded; I became an intern and on top of that, I was famous: my picture appeared in the papers![14]

Pelletier's campaign, was entirely successful; rather than defend an untenable position, the authorities backed down, permitting her to sit the *concours*. It only remained for her to pass it. *La Fronde*, as we have seen, supported Pelletier handsomely: 'Thanks to the intervention of *La Fronde*, this rule [the non-admission of women to the *concours*] was suppressed. Madeleine Pelletier sat the exam this year and was accepted as an intern ... This is therefore a new victory won by women, a victory to which our paper has powerfully contributed.' [15]

Pelletier successfully passed the competitive examination on 3 December 1903, a year after her first thwarted attempt. She came sixth in the ranking of eleven successful candidates. A Mademoiselle Constance Pascal, who had not pursued a feminist campaign but who had entered the *concours* as soon as the barriers were down, came eighth.[16] Pelletier's victory led her chief supporter at Villejuif, Dr Toulouse, to write an article on the more general implications of her success.[17] It could, he suggested, be interpreted as one of those symbolic victories which served to dramatize the contradictions of women's position under the Third Republic. Women had been able to become doctors. Now they could qualify as psychiatric interns. Once they were members of the state psychiatric service, they could, in theory, rise through the various grades to become heads of asylums, a development entirely in line with the general movement towards women's emancipation. As though bearing out his contention, Mademoiselle Pascal did eventually become an asylum director.[18]

But, as Toulouse made clear, a striking anomaly arose in the case of such a doctor if she were to become director of an asylum and to marry. In her professional life she would be in charge of a large budget, she would order expenditure and engage and dismiss staff. At home, however, as a married woman, she would be, legally

speaking, an incompetent. Under French law, she could neither acquire nor sell goods nor dispose of her property without her husband's authorization. If her husband happened to be a hospital employee, or otherwise under her authority in the hospital service, she would nevertheless not have the free disposition of her own salary as director without his consent as her husband. Furthermore she would owe him obedience at home.

Toulouse's hypothetical domestic drama served to show the contradictions of a culture where women could, by the turn of the century, attain, though admittedly with great difficulty, some high posts of professional responsibility, but where they were treated as far as the law was concerned as minors or incompetents once they had entered the married state. Pelletier's first victory over the medical bureaucracy was rightly seen, as *La Fronde* pointed out, as a victory for all women. Toulouse concluded that 'the admission of women to the posts of directors of medicine of asylums will clearly reveal all the social inequalities that arise from the mere difference of sex.'

Nineteenth-century French Asylum Provision and Treatment

The French mental health service which Pelletier joined in 1904 was one of the most comprehensive in Europe, and reflected the widespread growth in psychiatric internment during the nineteenth century.[19] The law on the insane of 30 June 1838 laid out the rules for the public administration of mental illness. It provided for special public hospitals (asylums) to be built in all departmental areas to contain and cure mental patients, for the training and pay of psychiatrists and for committal procedures. Both public and private hospitals were to be subject to regular inspection, and patients records were to be kept both by hospitals and by the local administration or prefecture in order to avoid arbitrary detention or maladministration. Patients were to be committed under two headings: by *placement d'office*, in which a patient was placed in a hospital on the initiative of the police and doctors; or by *placement volontaire*, under which the patient was placed in an asylum by his or her relatives with medical backing. In the first instance, the expense of maintaining the patient was born by the state, in the second, by the family. There was no provision

for patients themselves to seek treatment voluntarily, nor any consistent way of gaining state psychiatric treatment short of detention in a mental hospital.

Villejuif asylum, one of the psychiatric hospitals in which Pelletier trained, illustrated many of the problems associated with the remorseless growth of the French asylum population after 1838. Built for 1,384 patients, by 1932 it had some 1,900 inmates, with consequent overcrowding and impoverishment of care. This pattern was repeated in most psychiatric institutions. This growth in the asylum population was commonly blamed on the 'infernal bustle, the constant anxiety, the wearing effect of modern life, whose rapid rhythms bring instability and mental problems.'[20] Whether one thinks that more and more people were driven insane by the strains of modern life, or whether one concludes that the very existence of the asylums ended by attracting and defining their clientele, the fact was that the numbers of the certified insane soared.

Once inside a hospital, it was not easy to get out, particularly if institutions encouraged behaviour appropriate to the mad. Though patients placed in an asylum by their relatives could be withdrawn by appeal to a special tribunal, if asylum doctors were unconvinced of the patients cure they might attempt to transform the *placement volontaire* into a *placement d'office*. In one important respect, mental patients were worse off than penal prisoners; their 'sentence' was indefinite and related not to a given act or crime, but to the sort of people they were and to the tendencies they displayed. Legally, mental patients qualified as minors and their goods were administered by the state.

It has been argued that the law of 1838 created institutions which actually retarded development of psychiatric practice in favour of the growth of administration.[21] In addition, psychiatric hospitals became repositories for the mentally handicapped. Families of afflicted patients were capable of abandoning their relatives in Paris, knowing that they would be picked up by the police and sent to the asylum, and under the *placement d'office* would not be any further expense to their relations. In this sense mental hospitals replaced the old poorhouses, or hospices for the indigent. Repeated attempts to modify the law of 1838, made in 1869, 1872 and 1907, to provide for judicial review of a patient's incarceration, were unsuccessful. We will see that Pelletier herself was to become

the victim of such psychiatric imprisonment. The law remained virtually untouched until 1968, when modifications were introduced relating particularly to the category of *placement volontaire*.[22]

French psychiatric practice at the turn of the century was strongly influenced by physical anthropology in its treatment of mental illness, as can be inferred from the links already noted between the School of Anthropology and practising psychiatrists. Pelletier's background in anthropology was a natural preparation for work in psychiatry and indeed many members of the Anthropological Society, like Vaschide, worked in psychiatric hospitals. In choosing to specialize in psychiatry, Pelletier had moved into an expanding field where evolutionary, sociological and anthropological theories of the day were being experimentally tested. The patients themselves were sometimes treated as little more than experimental animals, as for example in research done on hypnotism or Charcot's famous exhibitions of female hysterics at the Salpêtrière women's asylum.[23] We will see that Pelletier's experiment, carried out under Dr Marie, on the injection of saline solution, or 'sea serum', into people with acute mental conditions reflected this dubious experimental quality.

Although psychiatric practice was largely based on degeneracy theory – the idea that the mentally ill inherited pathological strains from their ancestors and suffered from brain lesions – much therapeutic care practised in the asylums was in principle still based on the notion of 'moral treatment' pioneered by Pinel, Esquirol and Morel, the eighteenth- and early nineteenth-century psychiatric reformers, and this in spite of the fact that by the turn of the century the efficacy of such therapy was in doubt. Physical treatments were also routinely employed, bleeding, purging, cold baths and so forth.[24] Observation of symptoms was elaborate – records for the early 1900s which I have scanned in the Villejuif archives, for example, were impressive in their diagnostic and symptomatic detail. Cure, on the other hand, was considered problematic, based on the presumption of 'lesions', or degeneration in brain tissue. Nevertheless, cures were sometimes pronounced, as in the case of an alcoholic at Villejuif who, having murdered his wife, was deintoxicated and eventually released. One favoured treatment for excitable patients was the fresh air cure, transposed from the treatment of tubercular patients (many asylum

patients were, of course, tubercular as well as suffering from mental illness). This therapy was enthusiastically described by Dr Victor Parent of the Ayr asylum:

> At the Ayr District Asylum all new inmates are systematically put to bed in the open air, even those patients in the most dangerous and active states. This system combines the advantages of confinement to bed and treatment in the fresh air; . . . the patients are laid out during the day, except in exceptionally bad weather, under the specially built verandahs; . . . there is a rapid calming in mental and nervous troubles; in addition the physical state improves promptly. . . . The length of treatment varies, rarely being more than a month.[25]

The idea that mental patients needed confinement to bed reveals the medical model on which much treatment was based. Briand, the director at Villejuif, found the bed treatment especially valuable for women patients. There were also, however, commendable attempts to give patients a taste of liberty, suggesting that asylum staff were well aware of the negative image of the asylum as prison. Country walks with accompanying staff were encouraged. Buildings and grounds were designed to give a feeling of openness. Thus a report of 1889 waxes lyrical on the beauty of Villejuif's grounds, followed by a a glimpse of the inmates lined up for inspection by a visiting party:

> From the moment of entering the establishment, the visitors were immediately favourably impressed with the great interior courtyard which was vast and abundantly planted with flowers. They were pleased to recognize that this asylum bore no resemblance to a prison; everything was light and airy. First to be visited was the big parlour where the various categories of the insane were lined up against the wall, each numbered according to a methodical classification agreed by the Congress of Mental Medicine.[26]

This annual inspection could be interpreted as an embodiment of the positivist ideal, nosology reigning supreme. The insane could be understood because categorized by number, relating in turn to a description 'agreed by the Congress of Mental Medicine'. The dream of order over the disorder of irrationality can rarely have been better displayed. Here was a zoo of insanity and mental

disability, neatly catalogued. Like craniometry, the ordering of mental illness by 'methodical classification' provided an illusion of scientific knowledge.

Such was the psychiatric service in which Pelletier had succeeded in enrolling. Starting in February 1904 she did three *stages* as psychiatric intern in three different hospitals of the Paris region: from February 1904 to January 1905, she served at Ville-Evrard, under Dr Paul Maurice Legrain; from February 1905 to January 1906 she was at Villejuif under Dr Eduoard Toulouse; and in February 1906 she began work at Sainte-Anne under Dr Paul Dubuisson.[27]

A young intern entering a psychiatric hospital was crucially dependent for inspiration, encouragement and the opportunity to do successful research on his or her medical and psychiatric director. At Ville-Evrard, Pelletier was fortunate in having Dr Legrain to oversee her work. A keen freemason, it was he, as we have seen, who urged her to join a mixed lodge. Legrain formed part of the nexus of freemasonic, rationalist, anti-clerical reformers, devoting himself particularly to the problem of alcohol abuse. At Villejuif, too, Pelletier had a medical director of liberal sympathies in Dr Edouard Toulose (1865–1947) who supported her campaign to sit the psychiatric *concours*. Like Legrain, Toulouse was a freemason and social reformer. He created the laboratory of experimental psychology at Villejuif in 1897 and became *médecin en chef* at the asylum in 1898. He was active in reforming the nursing service and worked towards the establishment of psychiatric outpatient clinics, a plan finally realized in 1921. In 1936, he succeeded in having asylums renamed 'psychiatric hospitals' in an effort to overcome the stigma attached to the former label. He probably influenced Pelletier by his views on the need for state maternity care and generous maternity and child allowance schemes.[28]

Pelletier herself, for reasons which will become apparent, had little to say about her internship, and what recollections she had were largely negative:

At the asylum, the male interns warred with me constantly, so I only came for my morning shift. It wasn't possible to work at [experimental] psychology there. The daily work was dominated by the nursing staff who looked with astonishment at this strange

animal, a woman doctor, no different from a man. As for the director of the hospital, he was primarily engaged in signing papers. I soon lost heart.[29]

This judgement may have hinged on a number of factors but harassment of female doctors and students was certainly a fact of medical life wherever women have attempted to enter medicine. Pelletier's dress code must have aroused even greater hostility than was the norm among male medical students.

What kind of institutional world would the young intern have found at the turn of the century? Villejuif asylum (now the Centre Hospitalier de Villejuif) where Pelletier did one of her *stages*, was typical of the asylums of the period. Opened on 6 April 1884, the hospital was originally intended for non-violent patients. At its largest Villejuif had nearly 3,000 patients;[30] today the numbers have fallen to 1,200 residents, with emphasis on outpatient services and community and domicilary care. Located in a south-eastern working-class suburb of Paris, the asylum was in an area of market gardens, tree nurseries and piggeries. The resident population of flies which duly infested the institution proved a serious health problem for some years.

The hospital buildings were handsome and substantial. Faced with white stone, each *pavillon* or wing was connected to other buildings by a covered walkway. The whole complex was surrounded by a high wall. Within this enclosure, the buildings, courtyards, flower borders and avenues of trees set in some twenty acres of grounds were impeccably kept. Two statues graced the courtyards; the most striking was of Hermes, the god of healing, identifiable by his winged hat and caduceus, supporting a fainting female figure, a splendid example of the iconography associated with mental illness, showing frail femininity supported by a healthy and divine masculinity.[31]

According to its director, Dr Briand, writing in 1909, the hospital's early difficulties were not so much the patients as sanitary questions, a confirmation of the view that asylums inevitably became primarily administrative as opposed to therapeutic centres. Hygiene problems were enormous. Lice and flies abounded and tuberculosis and influenza took their toll. Neither staff nor patients were immune. Heroic efforts to discourage pests were undertaken, with patients being assigned to decontamination

teams. The hanging of metal screens in 1902, shortly before Pelletier's time there, greatly reduced flies and the high incidence of eye infection among patients. The very real physical problems of simply keeping a thousand or so mental patients clean and in reasonable physical health while preventing attempts at escape and suicide were among the staff's chief preoccupations. As a result, mental therapy tended to take second place. Physical labour was seen as an important mode of treatment; the most capable male inmates worked on the asylum farm, the women in the laundry. As Elaine Showalter has suggested, the occupations assigned to the patients were part of an effort to teach them appropriate gendered behaviour.[32]

Psychiatric Research

In spite of finding the asylum environment hostile, Pelletier did some work of significance for her own development. Her writing on psychiatry (four articles and her doctoral thesis) can be read within the context of the French psychiatric tradition, which was still firmly attached to somatic explanations for mental disorders. Two of Pelletier's articles were purely mechanistic in orientation, but the other two, like her thesis, demonstrated a broader interest in general psychology.[33]

In one experiment, Pelletier and her supervisor Dr Marie injected saline solution into twelve selected mental patients in order to establish whether their mental/physical balance would be restored by being in contact with the primeval element of sea water. One can say little for the statistical rigour of the experiment. The improvement which the researchers claimed for the twelve patients, for whom there was no control group, could simply have resulted from the extra attention they received. Assuming a purely somatic origin of mental illness, Marie and Pelletier produced a theory akin to that of medieval humours in attempting to restore mental harmony by a process of re-establishing a physical equilibrium.

Far more impressive than these dubious efforts, and indeed predating her internship, was Pelletier's dissertation, 'The association of ideas in acute mania and in feeblemindedness', which arose out of her interest in psychiatry initiated by her *stage* at Sainte-

Anne Hospital. This work linked philosophical questions to psychiatric clinical practice and revealed quite a different orientation from the two articles noted above. It was Pelletier's most theoretical work, forming the basis for her views on the psychology of gender. This thesis offered a good example of how theories in associationist psychology and evolution were applied in psychiatry. Taking as her model the English associationist school, Pelletier argued that the mind could be understood as operating under physical laws in the same way as any other material phenomenon. The dissertation gave evidence of a wide background in philosophy and revealed Pelletier's interest in linking normal and abnormal psychology. The insane were not to be considered 'degenerate', a race apart. Rather, they exhibited in their mental configurations the same laws that applied to the sane. A study of abnormal psychology, therefore, had relevance for an understanding of normal people. Psychiatry could become a laboratory for the more general study of human psychology.

What the positivist model adopted by Pelletier did little to explain were the causes of, or the cures for, mental aberrations. It may be noted, however, that although Pelletier was rigorously materialist in her analysis, in terms of therapy, as evinced in the case histories she related, she seems to have encouraged communication with the patients and was attuned to their constructions of experience. In therapeutic practice, she was not far from Freud's 'talking cure'. As she put it, she was used 'to questioning the mad into whose skins one must enter if one wants to know anything'. Entering into the skins of the mad was by no means the characteristic therapeutic procedure of the period. Charcot's technique with his hysterical patients, for example, had been to observe and analyse their physical behaviour, not what they said. What such patients might say was considered of little interest since they were manifestly insane.[34]

According to the laws of association, on which Pelletier's thesis was based, ideas were provoked by other ideas belonging to the same system. Thus linked ideas A–B–C might engender a series A–B–Z by contiguity, contrast etc. Such an explanation was held to account both for the persistence of ideas contrary to experience and for the possibility of adaptation and change. The application of the laws of association to mental excitation did not explain why people fell ill, but it made the process of their illness comprehensi-

ble; it placed all mental phenomena within positivist categories, rather than relegating the mad to a degenerate, subhuman classification.

Pelletier advanced the view that the laws of association applied to and could be analysed in patients exhibiting acute mania who on first sight appeared to hold no consecutive ideas. In spite of the garrulousness and seeming incoherence of maniacs, the laws of association could be observed in their speech and actions. Most patients in mental hospitals, Pelletier remarked, observing the largely working-class origin of asylum patients, had restricted backgrounds and therefore restricted patterns of association. The same ideas and expressions emerged again and again in their conversations. But even sane people, she noted, constantly repeated themselves without noticing it. Detailing her conversations with a number of patients, Pelletier was able to show that their seemingly incoherent ideas nevertheless formed clusters of associations. Her conclusions on the working of the law of association in mania can be summarized as follows:

1 Mania is limited to ideas already engrained in the personality.
2 The system of association persists in mania, though in an attenuated form.
3 The maniac [and this would include paranoid and schizophrenic patients] tends to externalize his or her ideas, that is, to hear voices or to 'know' that their thoughts are overheard.
4 Recent events tend to modify the maniac's ideas.

Pelletier suggested that mania demonstrated the result of a severe weakening of the process of psychic co-ordination. What her study did not do was to attempt to explain causal factors.

Particularly striking in this dissertation were the references to contemporary philosophers and psychologists, both as evidence of Pelletier's wide reading and as showing her awareness of the debates on the mind/body question, on ideas of adaptation and evolution, and on the political implications of the materialist and determinist theories of causation. 'The association of ideas' owed a major debt to John Stuart Mill's *An Examination of Sir William Hamilton's Philosophy* (1865). Mill would have figured in Pelletier's feminist pantheon for his *The Subjection of Women* (1869), but her concern here was with his exposition of asso-

ciationist psychology. His approach was vigorously anti-idealistic. Human knowledge was relative; there was no absolute or objective knowledge: 'All we know, including notions of space, time and all objects, are the result of mentally investing objects with sensations which the laws of our mind construct. Our only knowledge of things is of the impressions they create in our mental consciousness.'[35] There was no self which existed prior to experience. The mind or ego was a synthetic creation in time, a synthesis formed out of the world of experience, according to certain patterns of association. Mill maintained that the mind could be understood not in terms of theories of innate character but according to the law of the association of ideas based on the law of differences.

The theory that the law of association of ideas had universal application and that all systems of ideas, mad or sane, were equally the product of the law of difference and of resemblance, raised the problem of distinguishing one order of mental activity from another – fantasy from logic, reasoning from madness. Pelletier followed Spencer's view that they could be ranked according to the levels of awareness and concentration. (However paranoid patients could demonstrate perfect command of both.) Pelletier also referred to Bergson's evolutionary theory of mind, then very much in vogue: 'Monsieur Bergson has rightly insisted on the fleeting and elusive character of the states of consciousness. He has shown how it evolves through life.'[36] This notion of mental change and variability according to the influence of psychological states, which in turn might depend on social conditions, suggested a developmental model of the mind in preference to a static and predetermined one. This would have continuing relevance for Pelletier's socialist and feminist concerns.

Pelletier's further articles in psychiatry, 'L'Echo de la pensée et la parole intérieure' ('Echoes in the mind and interior speech') (1904) and 'Les Membres fantômes chez les amputés délirants' ('The phantom limb syndrome in deluded patients') (1903), though technical studies of particular disorders (the relationship between hearing voices and thinking aloud, and the effect of the phantom limb syndrome on paranoid patients), have some general interest. The first article 'L'Echo de la pensée' developed a theme which became increasingly prevalent in Pelletier's writing, namely that superior mental endowments represented the highest form of

evolutionary adaptation. In the second article, 'Les Membres fantômes', by assessing the way the so-called 'normal' illusion of the phantom limb syndrome was integrated into a paranoid patient's total world-view, Pelletier was concerned to determine the physical cause of a powerful illusion (nerves, brain function) and to relate it to an abnormal mental state which could nevertheless exist in normal people. Here again the link between the two states was crucial. Pelletier argued that thanks to the laws of association, sane people, like the insane, often held incoherent and contradictory ideas which they were reluctant to abandon, even if such ideas were rationally untenable. Most people exhibited what she called the 'incoherence of the individual': 'People construct theories, then a few seconds later they come out with an opinion which entirely contradicts it.'[37] This incoherence did not add up to madness, since ordinary acts and ideas remained co-ordinated, but it was manifested whenever one analysed prejudices.

Already, in her dissertation and other psychiatric research, Pelletier had laid a conceptual groundwork for her feminist writing, located philosophically in the English liberal tradition. Still tied to a standard psychiatric methodology, Pelletier stressed a materialist and evolutionary picture of the mind. She followed Mill and Spencer in rejecting an essentialist theory of personality. Though the question did not directly arise in this study, it was implied that the fixed qualities of mind ascribed to groups or individuals in the social-anthropological theories of Le Bon, for example, with their conservative implications, could be modified. Dynamic associationist theory which rejected essentialism was, like evolutionary theory, to serve as a central metaphor for social change and for feminism.

Professional Difficulties

The psychiatric hospital world that Pelletier had fought so hard to join offered an assured career, the chance to do research in an expanding field and an outlet for philanthropic or reformist leanings. In after years Pelletier was to express disillusionment with the service itself, and with the possibilities of doing research, and to complain of harassment by male interns. This negative judgement was coloured by what was to be her greatest profession-

al disappointment, her failure to pass the next *concours* for a permanent post as an asylum doctor. For as Dr Toulouse had suggested, once launched on that stage of the promotional ladder, Pelletier could have hoped to become a respected figure in research, to follow the social-reformist road of Legrain and Toulouse and even, in time, to become the director of an asylum. But she did not pass, and her failure raises a number of questions about her career as a feminist in psychiatric medicine, as well as highlighting the difficulties faced by a self-educated, working-class woman in a largely bourgeois milieu.

The year 1906, in which she sat and failed the *concours*, began auspiciously. Pelletier was assigned to Sainte-Anne for her final probationary period and early in the year put in her application for the 'Concours d'adjuvat' to become 'médecin-adjoint des asiles des aliénés', the post which would have given her tenure in the psychiatric service. As with her first application for the *internat*, she was initially turned down but then in February suddenly given permission to sit the examination for March.[38] This was another first for a woman, and Pelletier seems to have had few doubts about her chances of success. The press report dated February 1906, probably written by her, betrayed no qualms as to the outcome:

> Dr Madeleine Pelletier, intern at the Villejuif Insane Asylum, has just obtained permission from M. Mirman, the Director of Public Welfare, to take part in the next *concours* for insane asylum doctors. She is the first woman admitted to this examination, through which the medical directors of insane asylums are recruited. The work of Dr Pelletier which concentrates on the functions and malfunctions of the human brain, fits her very well for such a career. Mlle Pelletier is also an active feminist. Among her most remarkable works one notes, 'The supposed degeneracy of men of genius' and 'The supposed psycho-physiological inferiority of women'. She has just been elected president of La Solidarité des femmes, where she succeeds Caroline Kauffman.[39]

The examination proved to be a disaster, though she only failed by a narrow margin of four points. Pelletier received twenty-six points out of fifty where the passmark was normally thirty. Was there discrimination involved? It is unlikely that there could have been anything overt or she would have protested. Joffroy and

Dubuisson were both on her jury and seem to have been well-disposed towards her. For her research work she received only six marks out of ten, in spite of the amount of her published work. (Nevertheless this would have represented a 60 per cent on that section.) We know that her dissertation had been very well received. On the other hand, the work done with Vaschide had been demolished by Pearson and duly reported in the *Revue scientifique*; and that carried out with Dr Marie on skull regeneration did not have a good reception at The École d'Anthropologie.[40] Pelletier's comment, 'the male interns warred with me constantly – it wasn't possible to do [experimental] psychology there', suggested deeper difficulties than the examination itself.

When one looks over her previous medical examination record, it seems clear that Pelletier, who had largely taught herself up to the beginning of her medical studies, and who had impressed her teachers and professors with her intellectual abilities and drive, nevertheless must have struggled at every stage to gain her medical degree. But her excellent dissertation and the fact that she passed the *concours d'internat* well, testified to her academic capacity. When she applied for the second concours, she may have assumed that, as with the first application, there would be a year's delay before she would be called to sit the examination. In the event, permission was granted almost immediately, leaving her inadequate time to prepare. Another contributory factor to her failure may well have been her increased feminist and socialist activity. By 1906 she was deep in politics, engaged simultaneously as secretary of La Solidarité des Femmes and as an active member of the Socialist Party (see chapters 4 and 5). A possible reference to this aspect of the question can be found in *Une Vie nouvelle*, where the protagonist, Charles Ratier, having returned to the medical faculty as a mature student, remembered previously having failed his exams because he was too involved in political struggles.[41] Was Pelletier here recounting her own case? Her political activism, while overcoming the isolation and boredom she experienced both at the hospital and in her private practice, could have cost her the concours.

Finally one must speculate whether her visible feminism, particularly her dress code, marred her chances. There is some evidence that this might have been so. In 1903, when Pelletier came sixth in the *concours d'internat*, Mademoiselle Pascal, as we have noted,

came eighth. Pascal had made no pretensions to feminist sympathies and had enrolled for the concours after Pelletier's specifically feminist battle to gain admission had been won. For the second concours, Pelletier was granted exceptional permission to sit it in March 1906. Subsequently on 2 August 1906, a formal decree was passed lifting all barriers against women in the psychiatric service. Mademoiselle Pascal, less precipitate than Pelletier, bided her time and passed the examination in 1908. She was outstandingly successful and eventually became director of the psychiatric hospital of Maison Blanche, just the career Toulouse had sketched out for Pelletier. But like Madame Brès before her, Pascal was considered 'womanly' by her male colleagues and did not visibly challenge gender norms.[42]

It may seem curious that Pelletier was not offered a second chance at the concours, which she had so narrowly failed to pass. Resitting examinations or resubmitting failed theses was a staple part of the French examination system. It is also noticeable that Pelletier did not explicitly mention this failure in her memoirs, suggesting that the disappointment bit deep. She felt throughout her professional career that she had missed her true vocation in research. At the end of her life, when paralysed and helpless, she dictated a list of her 'scientific and psychiatric articles'. Those works were among the achievements for which she wished to be remembered. Her failure to win a permanent post in psychiatry was one of her greatest regrets. It was no accident that her fictional hero, Ratier, was imagined succeeding as a brilliant research scientist. At the age of thirty-two, Pelletier had lost her chance of material and professional security.

In 1904, while still at Villejuif, Pelletier published her first avowedly feminist pamphlet which also contained a critique of the scientific community in which she moved. It serves as a useful epitaph to this first phase of her career. 'La Prétendue Infériorité psycho-physiologique des femmes' ('The supposed physical and psychological inferiority of women') applied the fruits of Pelletier's studies in evolutionary theory, physical anthropology and psychology to an explicit critique of the male scientific establishment and the scientific case for women's inferiority.

The main focus of Pelletier's anthropological analysis concerned the prejudices harboured against women among the supposedly enlightened and culturally evolved intelligentsia, especially the

scientific community: 'Like other men, scholars are imbued with
the ancient contempt for women, an ancestral legacy from the
period when muscular force was everything: it isn't surprising that
they read women's inferiority into anatomy, physiology and
psychology.'[43] Deploying the data of her research on Japanese
skulls and skeletons, she showed that the contention of anthropo-
logists like Broca and Le Bon about the supposedly simian nature
of women's skulls could be shown to be false; it was in fact men's
skulls that more closely approached those of the apes. This was not
to argue that women were superior to men, but that they were
more evolved. Similarly the question of brain weight was not
decisive, but relative to the entire size and mass of the organism:

> The greater the mass to be moved, the more the brain centres must
> be voluminous, and that is why the brain grows in proportion to
> height and organic mass. M. Manouvrier, who is anything but a
> feminist, has successfully shown the error into which anthropolog-
> ists have fallen in this respect, in trying to find in the relative
> smallness of a woman's brain the proof of her intellectual
> inferiority.[44]

The dig at Manouvrier, seen by his colleagues as a supporter of
women's emancipation but by Pelletier as 'anything but a femin-
ist', suggests that Manouvrier may have been the professor who
discouraged her from pursuing a career in anthropology. Certainly
he did not enjoy the esteem she accorded to Letourneau.

But the most insidious argument of the intellectual anti-
feminists was that inferred by analogy with the alleged anato-
mical and physiological weakness of women – namely women's
intellectual and moral inferiority. Here Pelletier cited the sup-
posedly scientific pronouncements of writers like Le Bon, Broca,
Janet and even Schopenhauer. 'Women have been accused of an
inferiority of will as well as of the moral sense'; 'Women, it is said,
lack a sense of honour.'[45] In effect, she said, these prejudices
revealed a certain truth. They reflected the fact that two different
value systems operated for the two sexes. Boys were trained to
exert their energy, to conquer the world. Girls were trained to be
helpless and to find a male protector. Women's weapons of
survival within this value system, Pelletier suggested, were 'dis-
simulation, cowardice, falsehood'. These qualities, though despic-

able in themselves, were the consequence of women's position; they were the female means of struggle. Women must realize that in modern society, their true strength lay in cultivation of the intelligence; they would then not need the weapons of deceit.

In this analysis, Pelletier accepted that women in their actual behaviour were, as a result of social conditioning, on the whole morally inferior to men. But she hoped to harness evolutionary arguments, often used against women, in their defence and for their transformation. Perhaps the most original aspect of her discussion was her demonstration of the way in which prejudice, once incorporated into a scientific paradigm, was virtually unassailable, because it appeared to be objective fact. Indeed the hierarchy of races and civilizations to which Pelletier herself subscribed at this period was one such disguised prejudice. (It is noticeable that by the 1930s, in *Une Vie nouvelle*, she attempted to separate the concept of cultural 'advance' from that of racial superiority. In her new communist utopia, France still had colonies and spread its cultural benefits to Africa, but racial prejudice was eradicated. This suggests that Pelletier's thinking on racial issues had evolved, possibly thanks to her friendship with Leo Poldès and her awareness of the problems of anti-semitism.)

'La Prétendue Infériorité psycho-physiologique des femmes' offered a critique of current scientific orthodoxy on women, employing an evolutionary model to argue against the purportedly scientific assessments of women's inferiority. Pelletier's attack on the underlying anti-feminism of the scientific community was the opening broadside of her feminist battle and expressed many of the frustrations she must have felt as a woman working in the anthropological and psychiatric fields. In *L'Association des idées*, Pelletier had remarked on the phenomenon of the 'incoherence of individuals', people who held simultaneously rational and irrational views on the same question without necessarily being thought insane. The scientific defence of female inferiority, Pelletier believed, was one such example of incoherence, of the way prejudice could enshrine itself in a seemingly objective scientific discourse. In analysing prejudice and received ideas, Pelletier offered not only an anthropology of women's position in society, but she used her psychological training to deconstruct the attitudes of 'enlightened' men.

Between 1903 and 1906 Pelletier moved towards a synthesis of

her psychiatric, anthropological and feminist positions. She confronted the pervasive anti-feminism of the medical and social sciences on their own ground. The fact that today research in skull size remains largely of historical interest does not devalue Pelletier's attack on the assumptions behind craniometrical measurement of men and women's skulls, or her exposure of the invalid inferences drawn from such supposedly objective criteria. Her subsequent work, concentrating on the social and historical determinants of women's actual inferiority, would nevertheless remain marked by the psychological and anthropological models that had first awakened her enthusiasm as a young medical student.

4

Militant Feminism, 1906–1914

Background to French Feminism

To devote a chapter to Pelletier's feminist activity is to some extent a contradictory enterprise since her entire career was a conscious struggle towards feminist goals. However, an account of her involvement in feminist groups, especially in La Solidarité des Femmes, of which she became secretary in 1906, illuminates aspects of French feminism in the early part of the century, the goals feminists pursued and the difficulties they encountered within the French political system. As noted in chapter 1, Louise Michel had alerted Pelletier to the danger that activity in purely feminist groups tended to marginalize the politically ambitious woman. This helps to explain why Pelletier pursued two simultaneous, but inter-related, aims from 1906 to 1914: the organization of feminist militancy in women's suffrage groups, and socialist politics. She viewed her feminism as a political activity to be pursued through a variety of strategies. This chapter will consider her active feminist involvement, and the next her efforts to pursue feminist goals within the framework of the Socialist Party.[1]

In a pamphlet of 1908, 'La Tactique féministe', Pelletier set out her programme of feminist objectives: first to build a mass feminist movement, and second, to infiltrate major political parties. Because she recognized that feminism needed a mass base, Pelletier conceived of the movement as transcending class and party. Though she was arguably correct in her analysis, she underestimated the

fragmented and isolated nature of women's social experience. Beauvoir, a generation later, would analyse the problem in terms appropriate to Pelletier's situation:

> women lack concrete means for organizing themselves. They have no past, no history, no religion of their own; and they have no such solidarity of work and interest as that of the proletariat. ...
> They live dispersed among the males, attached through residence, housework, economic condition, and social standing to certain men
> – fathers or husbands – more firmly than they are to other women.
> If they belong to the bourgeoisie, they feel solidarity with men of that class, not with proletarian women.[2]

Pelletier agreed with her fellow socialists that women were oppressed by class, but regardless of class women were in addition oppressed by men. Her feminist and political activism tried to address this double predicament.

La Solidarité des Femmes was not typical of French feminist groups, having a more radical cutting edge than the generality of feminist organizations. Compared with both Britain and the United States, French feminism at the turn of the century was less militant and could boast far fewer active members. Feminists were largely drawn from the urban and specifically Parisian middle classes and from anti-clerical, Protestant or Jewish backgrounds. The strong Catholic orientation of the majority of French women ensured that feminist ideas would seem antipathetic to most. Pelletier's hopes for a mass movement to legitimize feminist demands foundered ultimately on the rock of Catholicism.[3]

French feminist struggles in the late nineteenth and early twentieth centuries necessarily operated within the context of post-revolutionary male politics. The granting of universal male suffrage in 1848 meant that all men participated, at least theoretically, in government. Compared with America and Britain, this relatively early achievement of male suffrage had the paradoxical effect of making the attainment of women's suffrage more difficult. Whereas in Britain women suffrage campaigners could make common cause with the disenfranchised working class, and in the United States with slaves, in France women had few reliable allies in the male community.[4]

How was masculine hegemony under the more egalitarian and

anti-clerical ethos of the Third Republic legitimized from the 1870s onwards? On the one hand, religious justification for women's subjection was preserved intact within Catholicism; on the other, in the lay world, new scientific and aesthetic paradigms were developed to justify sexual inequality, in this case not ordained by God but by nature. As we have seen in the anthropological arguments, it was possible to suggest that women had failed to evolve in the natural scheme of development, and therefore that in relation to men they had, in fact, regressed. Similarly in Romantic mythology woman was identified with nature and contrasted with progress. Nature/woman was cyclical and immutable; progress, in which men participated, was linear.[5]

The earliest phases of French feminism in the 1860s and 1870s were moderate in character. The suffrage was not sought, being considered a contentious and dangerous demand. Feminists focused on women's civil disabilities. The cautious pragmatism of these early campaigners arose initially because even under the more liberal phase of the Second Empire, political expression was thwarted; subsequently, in the 1880s and 1890s, it was because under the Third Republic many middle-class feminists were anxious to dissociate themselves from what were considered to be the excesses of women participating in the Commune (Louise Michel and Paule Minke, for example). In addition, the monarchist majority in the Chamber of Deputies in the 1870s ensured a highly conservative political climate.[6]

Feminist Groups and Male Politics

The likely political affiliation of feminist groups was a complex issue, based on class and religious differences. On the whole, Catholicism and conservatism were hostile to organized feminism. Though some Catholic women's groups existed, these were moderate and largely philanthropic in aim. The natural political allies for feminists were the Liberal Republicans on the one hand and the Socialists on the other. Often when historians refer to organized feminist groups under the Third Republic, they are understood to mean bourgeois feminists. The reasons for this are twofold. On a practical level, for a woman to function as an active feminist (as opposed to holding feminist sympathies) it meant that she needed

economic independence, a point Pelletier clearly recognized when frequenting her first feminist group in her teens: 'This path [of liberation] wasn't accessible to me; One needed to be completely free ... and to have money.'[7] In practice, therefore, most women with the means and leisure to join feminist groups either had private incomes or were self-supporting, often in such professions as teaching or medicine. In addition, working-class women often found the class divide between themselves and bourgeois feminists too wide to cross, as became clear at the International Congress on the Condition and Rights of Women of 1900.[8] There socialist representatives were outraged that their middle-class sisters rejected a resolution calling on employers to give women domestic servants a day off a week, a dramatic illustration of the way bourgeois feminists identified with their class rather than with their sex. Nevertheless, many so-called bourgeois feminists, like Brion, Kauffmann and Pelletier, had strong socialist sympathies or were active members of trade unions or of the Socialist Party. They campaigned within feminist groups partly because of the difficulty of pursuing feminist goals within socialist politics.

Socialists, on the other hand, argued that there should be no alliance with bourgeois class enemies and that therefore socialist women should not collaborate with middle-class feminists. For many socialists, feminism was considered an issue which diverted energy from the class struggle. They argued that female emancipation would result from the triumph of the working class and the destruction of capitalism. Under such conditions, female solidarity was immensely difficult, if not impossible.

Further to the right of the political spectrum, republicans did, in theory, subscribe to the idea of universal suffrage. Was not the slogan of the revolution, 'Liberty, equality, fraternity'? Republican liberal principles were interpreted as providing justification for feminist demands. But this theoretical republican commitment to equal rights was wrecked on the twin shoals of masculine prejudice and a distrust of women's voting intentions, which were held to be invincibly conservative and therefore a danger to the Republic. Though most middle-class French feminists were republicans, few male republicans were pro-feminist. It was alleged by the republicans that women were the unwitting agents of the 'black peril', namely the Catholic church.[9] When in the period between 1900 and 1922 republican feminists campaigned for the vote, they found

themselves accused by male republicans of undermining the demo-
cratic state by opening the door to a conservative backlash from
the very women they were supposed to enfranchise. The religious
and political divisions of France ensured that the chief political
context for organized feminism was bourgeois republicanism but
that feminism's natural constituency, the majority of middle-class
women, would be alienated by the anti-clerical orientation of the
Republic.[10] Republicanism provided a home for feminism, but it
simultaneously and successfully repressed its development.

The turn of the century produced a growth and regrouping of
feminist organizations, followed by a series of congresses repre-
senting an optimism that many feminist objectives were close to
achievement. In 1900 three separate women's conferences were
held in Paris, reflecting respectively, Catholic, moderate and
militant feminist opinion. Madeleine Pelletier attended the con-
gress organized by Maria Pognon, leader of the French League for
Women's Rights.[11] Pognon had taken over the League's leadership
from the moderate, Léon Richer, in 1892 and devoted her energies
to campaigning for complete sexual equality, including the suf-
frage. Accounts of the resolutions passed by delegates fail to
convey adequately tha atmosphere of hostility among feminists
themselves in which such meetings were often held, or the courage
required to speak before jeering male interlopers. Pelletier well
remembered the atmosphere of dissension and intimidation:

> It was at about the same time that a congress was held at the
> Learned Societies, presided over very energetically by Maria Pog-
> non. She was opposed by feminists who put it about in the congress
> hall that she ran a bawdy house and followed a profession which
> sullied her honour and that she should not preside over a congress.
> The congress was stormy – male students came to heckle. . . . They
> shouted, 'Back to the kitchen', 'Back to mending your socks', not to
> mention the cartloads of obscenities borrowed from their medical
> studies.[12]

The public ridicule in the press and the personal insults that
feminists like Pognon and Pelletier regularly faced accounted to
some extent for the difficulty feminist groups had in attracting
recruits. Women who identified themselves by their clothes or by

their actions as favouring a more independent life for women were attacked as morally profligate. The respectability of feminists, in an age when moral virtue and sexual chastity were held to be indivisible for women, became an important issue. Much of the seeming puritanism of feminists can be explained by this double pressure. Anti-feminists construed feminists' demands for liberty as meaning sexual licence. Pelletier's anecdote about the insults suffered by Pognon revealed one aspect of the psychological pressures under which militant feminists laboured. Feminists' fears of appearing disreputable made them reluctant to join public demonstrations or even to attend evening meetings. How, Pelletier wondered, would women ever be politically educated if they were always constrained by the fear of social stigma:

> The free life which men lead, even omitting their sexuality, seems immoral to even the most apparently liberated women. Thus it is extremely difficult to hold evening meetings, and when one succeeds, women leave by eleven o'clock, no matter how interesting the discussions might be, so strong are their prejudices about feminine respectability. Even older single women who live alone believe themselves obliged not to go out too often because their concierge and their neighbours might speculate about their virtue.

Then in a revealing insight about her own situation as a single woman:

> Therefore a woman who lives without a man gets terribly bored. . . .
> I know that boorish men harass young women who dare to think they have a right to walk in the streets, but it is better to risk a gross insult from time to time than to pass one's life within the four walls of a room.[13]

Such tensions need to be borne in mind when considering the organizational capacity of French feminist movements.

Early twentieth-century feminist activity can be divided into four main areas of concern: women's pay and conditions of work, including the right to work (that is to join hitherto male professions or trades); social and philanthropic questions (including prostitution and alcoholism); civil and legal disabilities suffered by women under French law (where the greatest gains for women were in fact achieved); and finally, the suffrage.[14] This last goal

became the central preoccupation of organized feminism in Europe, the United States and Australasia in the first two decades of the twentieth century.[15] Its importance rested on the perception that without the suffrage women could never take their place as 'persons' within a contractual system of society, could never function as citizens, and would in effect remain powerless because they would lack a civil existence. If hopes which feminists rested in the suffrage as the instrument of liberation and of the transformation of society proved too sanguine, without the vote fundamental reforms would have been unlikely. It seemed to French feminists in the pre-war period that the goal of the suffrage was within their grasp. In the event, women's suffrage was not achieved until it was granted by decree under de Gaulle in 1944–5. Nevertheless, when Pelletier became secretary of Solidarité des Femmes in 1906, women's suffrage, though an ambitious goal, seemed possible.

The Feminist Circle

Pelletier told the story in her unpublished autobiography, 'Doctoresse Pelletier', of how she was recruited to Solidarité in 1906 by its secretary, Caroline Kauffmann. It was in the early and penurious days of her medical practice:

> One winter evening, when it was raining hard, I suddenly heard a ring at the door. My heart leapt with joy as I went to answer it. I seem to remember that my entire capital consisted of three francs; even before the war, this wasn't much. Who knows, perhaps someone was coming to ask me to deliver a baby – a job worth fifty francs, a fortune! It was an elderly lady with white hair . . . soaked to the skin. . . . I am not a patient, I am Caroline Kauffmann. I run a feminist group, La Solidarité des Femmes. I am growing old. Furthermore, I need to travel to Alsace to look after various business concerns. I need someone to preside over Solidarité. I had thought of Elizabeth Rénaud, but she is more of a socialist than a feminist and this wouldn't do. So I thought of you. I have read interviews by you in the newspapers, you opened the doors for women to work in the asylums, a splendid achievement. Would you agree to succeed me?[16]

Pelletier may have dramatized this incident with hindsight, but it

would appear that the appeal from Kauffmann came at a time when boredom and poverty combined to make her eager for new challenges – though she was apparently recruited before her failure at the concours in March 1906. Elizabeth Rénaud (1846–1932), referred to by Kauffmann, was a co-founder with Louise Saumoneau (1875–1949) of the Groupe Féministe Socialiste (GFS). A moderate Jaurèsian socialist, she advocated co-operation with republicans and saw women's oppression operating across class lines. It is interesting that Kauffmann, who had socialist sympathies, found her 'more of a socialist than a feminist' and too left-wing for the clientèle of Solidarité.[17] However, Pelletier, who was soon to gravitate to the revolutionary wing of the Socialist Party, must have given Kauffmann equal cause for concern.

What sort of group was La Solidarité des Femmes? Pelletier described it in the following ironic terms:

> I knew the group; thirty-odd women all speaking at once … Nevertheless it was an attractive proposition for me, by which I mean a way of raising my spirits. More than from poverty, I suffered from isolation and depression. In my flat, I was dying of boredom, from looking at the gloomy rue de Gergovie, which had few passers-by. The group … would be a diversion.[18]

Pelletier seems to have had early misgivings about the feminist troops which she proposed to lead into battle; they seemed an unlikely vanguard to overthrow masculine power. They may have reminded her of her mother's prayer group, those pious women dressed in black. Still, revolutions had to start somewhere. With her customary energy, Pelletier turned to the task of organizing the members of Solidarité into something more than a talking shop.

Of the seventeen principal women's rights organizations existing in France in 1900, Solidarité has been listed as 'Republican' in the political spectrum and militant suffragist in the feminist groupings.[19] Nevertheless this categorization is deceptive as Solidarité also had strong socialist sympathies, though it was not an official Socialist Party organization. The group had been founded in 1892 by Eugénie Potonie-Pierre, who in the same year had organized a federation of women's groups, La Fédération Française des Sociétés Féministes. When she died suddenly in 1898, the secretaryship (a non-hierarchical title for 'leadership') of Solidarité passed to Caroline Kauffmann.

The title Solidarité des Femmes effectively dramatized the internal contradictions besetting organized feminism in France. Solidarity, the necessary precondition for an effective feminist movement, was a hope rather than a reality. Kauffmann's motto on the group's official letterhead expressed their aspiration: 'To achieve solidarity with others is to add incalculable forces to the force that one already possesses.'[20] Feminists mirrored the population at large in being deeply divided by religion and class. In addition they showed all the symptoms afflicting socially marginalized groups by engaging in feuds both political and personal. Factionalism was common. Active feminism meant committing often precarious financial resources to a dubious cause. Bourgeois feminists with their own incomes, such as Hubertine Auclert, Madame Remember or Marguerite Durand, devoted whatever resources they possessed to running journals, hiring halls, organizing demonstrations. Working women like Pelletier, Rénaud, Saumoneau and Bouglé (founder of a remarkable collection of feminist documentation) contributed from their own earnings and made substantial financial sacrifices. To print posters and leaflets, to finance feminist journals, even to hire rooms for meetings were major undertakings. Though marginal groups in male politics (anarchists, early socialists, etc.) would have faced similar difficulties, one is struck by the toll feminist activity took on the mental and physical health of its adherents.[21]

Another source of social tension for declared feminists was their definition as subversive persons by the state. The degree of surveillance is evidenced by the thoroughness of police reports taken at feminist meetings, the interviews with neighbours and the dossiers of arrests – all ironically of great usefulness to historians – and it must have imposed its strains. Feminists like Auclert and Pelletier were routinely investigated, particularly if they had socialist or pacifist sympathies. After 1918 Pelletier was refused a passport thanks to her pacifist, communist and anarchist connections. Feminist groups were infiltrated by police spies, as is attested by the excellent feminist files in the archives of the Paris Prefecture of Police. As early as 1899, for example, one finds the police spy with the code name Foureur proposing a scheme to his superiors of joining feminist meetings in London, which were attended by Louise Michel and other anarchists: 'The advantage would be twofold: to make contact with English anarchists and at the same

time one could also doubtless discover what certain women in France, whose conduct appears suspicious, are up to.'[22]

In 1901 we find Foureur reporting on the dangers posed to the public order by 'socialist feminists' like Marie Desraismes. Desraismes, a moderate republican could only by the wildest stretch of imagination be described as a socialist. Foureur further warned of the grave consequences of feminists' demand for the right to work. And commenting on Marguerite Durand's newspaper, *La Fronde*, he characterized feminism as an anarchist plot (a charge which would have been incomprehensible to the loyally republican Durand) because *La Fronde* was instrumental in organizing trade unions for women workers.

Strains on individual feminists, thanks to their social marginalization, the relative poverty of many and the probable knowledge that they were under surveillance, produced a string of physical symptoms. Kauffmann, a propagandist for physical fitness, suffered from a weak heart. Arria Ly, the Toulouse feminist, complained continually of ill health and showed signs of mental instability. In addition, because they saw themselves as carrying the torch of liberty for all women, these feminists were pitiless in judging one another's weaknesses. They could not afford to be silly, slipshod or, in the climate of the day, lax in sexual morality. This explains the seeming contradiction of Pelletier, for example, when she preached women's sexual emancipation but herself led a strictly celibate life.

The feminists with whom Pelletier was associated, not all of them members of Solidarité, formed a remarkable group. A few, like Marguerite Durand, moved in artistic and political circles and attained prominence; some, like Arria Ly, were briefly notorious; but many lived out obscure lives. Most were women of limited means inspired by a profound sense of social injustice.

Hubertine Auclert (1848–1914) belonged to an older generation of feminists.[23] From a moderately wealthy provincial background, she devoted her financial resources and her campaigning abilities to feminism, and in 1876 became leader of the group founded by Léon Richer, Le Droit des Femmes, whose title she changed to the militant, Le Suffrage des Femmes. More radical than Richer and Desraismes, Auclert called for equality in every sphere, for the right of women to work and for women's suffrage. Like Pelletier a generation later, she attempted an alliance with socialists, claiming

that women and the working class suffered from a similar sense of oppression. But she feared that the socialists, like the republicans, could only understand equality as a masculine prerogative. Auclert can be credited with putting the question of women's rights on the socialist agenda. She contributed to *Le Prolétaire* and ran her own journal *La Citoyenne* ('The female citizen', an ironic title with echoes of 1789, because French women were not citizens in any sense involving rights). To many middle-class feminists, anxious to maintain an unblemished image of respectability, Auclert seemed far too militant. She was a passionate advocate of equality: 'Almost from birth I have been a rebel against the oppression of women.'

Auclert was one of the first feminists to practise civil disobedience. As early as 1880 she undertook a series of protests against the Napoleonic Code, interrupting marriage ceremonies at the town hall to explain to the brides and grooms that by marrying under the code, which demanded that the wife obey the husband, they were in effect agreeing to the enslavement of the wife. On one such occasion, 29 April 1880, she was arrested at the *mairie* of the tenth arrondissement. The police report provided a revealing summary of the official perception of feminism: 'We regard Hubertine Auclert as afflicted with madness or hysteria; an illness which makes her look on men as her equals.'[24] The police officer's solemn and naive linkage of feminism and hysteria summed up perfectly the social climate in which feminists operated.

On 3 May 1908, at the age of sixty, Auclert made common cause with Pelletier in one of the very few 'violent' demonstrations of the period. As a protest against the continued exclusion of women from the suffrage, a group led by Auclert attempted to force their way into a number of polling stations. Eventually, Auclert succeeded in entering one station and overturning a ballot box. It appears that Pelletier had gone home before this last successful assault, but the newspaper illustration of the incident incorrectly showed Pelletier as the main perpetrator of the outrage – suggesting that her reputation as a feminist agitator was already well established. Auclert was fined sixteen francs, the standard charge for such incidents of civil disobedience. But official disapproval was as nothing compared to the reaction of moderate feminists, who roundly denounced her illegal tactics.[25] Auclert responded by formally renouncing violent protest at the feminist congress of 1908. She was a remarkable fighter, who lacked sufficient troops.

Caroline Kauffmann, who recruited Pelletier to Solidarité, was born, like Auclert, in the 1840s. From a Jewish and free-thinking background, she came to feminism via an unhappy marriage.[26] She had no professional training but held the title of 'Inspectrice honoraire du travail des enfants'. She was active in the physical culture movement and founded La Ligue Féminine de L'Éducation Physique. In the war years she, like many of her generation, became involved with spiritualism, a source of contention between her and Pelletier. A republican with socialist leanings, Kauffmann hoped that education would bring the end to class conflict. But like Pelletier and Auclert, she was capable of militant public protests. In 1904, the year commemorating the hundredth anniversary of the Napoleonic Code, Kauffmann invaded a celebratory banquet by climbing into the gallery of the banqueting hall furnished with a supply of balloons and a male confederate to inflate them. Written on the balloons was the slogan: The Code Crushes Women. Kauffmann released the filled balloons over the astonished diners, repeatedly shouting her slogan before being arrested by hastily summoned police. This form of feminist guerrilla activity, while not typical of French feminist activity as a whole, was undertaken by a small but militant minority. Though these manifestations may have sought to imitate the methods of the English suffragettes, to characterize them as violent seems an exaggeration.[27] In France, even marches, well established in the canons of English suffragist militancy, were considered shocking and were sparsely attended. An intervention like Kauffmann's would have appeared to most feminists to be in appalling taste. But there were many examples of isolated acts of defiance, which attracted some publicity, a magistrate's fine and a strong dose of ridicule.

Some of Pelletier's other associates were on the 'moderate' wing of feminism, for example, Jeanne Oddo-Deflou, who belonged to Solidarité but who also ran the Groupe Français d'Études Féministes. She campaigned principally for changes in the civil law, and did not for many years support the suffrage campaign, deeming it politically inopportune. However by 1906, perhaps influenced by Pelletier's militancy, she was converted to the cause of women's suffrage. She succeeded in having a law on paternity adopted by the French parliament, one of the few feminist victories of the period.[28] Pelletier defended her to Arria Ly, who appears to have objected to the fact that Deflou was married: 'No, I won't speak to

Oddo [about your criticism] – it seems to me that one mustn't quarrel among feminists, they already have enough of a tendency to do so.'[29]

Another close associate of Pelletier's was Madame Remember, the pseudonym of Louise Beverley Dupont (1845–1925), whose private fortune contributed to the journal *La Suffragiste* which Pelletier founded in the winter of 1907–8 and which appeared monthly until the war. Its aim, as the title indicates, was to campaign for the vote. Over the years, Remember appears to have quarrelled bitterly with Pelletier, Ly and Kauffmann. Their disagreements were partly financial and partly concerned with Remember's understanding of feminism which was strongly anti-male. Pelletier was impatient of her position: 'I don't consider her a feminist. She has a persecution complex and believes she has cause to complain about a man, so engages in feminist activity to annoy him.'[30]

Pelletier was prickly about accepting patronage for *La Suffragiste* and worried about keeping editorial control. She claimed to have about 500 subscribers, or rather, as she said, 500 people who paid once for a subscription of one year or six months. Since Remember gave financial support, she had the right to get her articles printed. Pelletier despaired at the line they took:

An old woman, Remember, who wrote an article for every issue which took up half the journal, was the cause of my receiving quantities of critical letters. Her articles were above all anti-masculine. . . . The underlying reason was that at fifty years old she had fallen in love with her doctor; he stole her money and disappeared, hence her anger. And it was a lasting anger. On tramways and trains she forced men to put out their cigarettes. She was constantly snubbed; she liked that. . . . Remember's articles betrayed too much of a personal grudge, but she paid for half of the printing.[31]

Letters from Pelletier to Ly provide another version of these disagreements; Remember apparently had criticized Pelletier's independent mode of life and, by extension, her morals. Pelletier stoutly defended her right to go out alone and to do as she chose:

Obviously I go to the theatre fairly often; that is my business and not hers. I never go into places of ill-repute and even if I did go in

order to see what goes on, I wouldn't see any harm in it. I am an independent woman and not a slave. From the moment that one doesn't live like a rat in its hole ... Remember thinks it is obvious that one is a profligate. I need a great deal of activity. I am made for political struggles; since I am rejected on all sides because I am a woman, I amuse myself as best I can in order not to die of despair.[32]

Remember shared with another colleague of Pelletier's, the Toulouse feminist Arria Ly, a deep-seated antipathy to the male sex.[33] This current of sexual politics was one to which Pelletier was strongly opposed. In her view, many women came to feminism, as was natural, by way of disastrous personal relations with men, but it did tend to give their feminism an inappropriately subjective quality. The most dramatic example of such a position can be found in Arria Ly.

Arria Ly (1881–1934), the pseudonym of Josephine Gondon, was a remarkable personality and one of the few important non-Parisian French feminists. Pelletier's letters to her, spanning a period of some twenty years, offer priceless insights into their lives as feminists. Intelligent, strikingly beautiful and emotionally unstable, Ly incarnated the conflicts facing French women who attempted to break out of the prison of masculine ideology. Lacking Pelletier's robust attitude towards life, or her ironic perception of herself and others, Ly threw herself into a series of courageous but hopeless vendettas. Like Pelletier, she advocated virginity as a political stance. But in her case it was probably primarily a horrfied response to her sexually sheltered youth.

Ly was born 24 March 1881 at Corrignans in the Lot region and lived out an apparently idyllic childhood with her parents on a small country estate. She was kept in complete sexual ignorance until the age of twenty-two, a state of affairs not unusual at the time for girls of her class. The belated discovery of the anatomical difference between the sexes and what was involved in human reproduction appears to have traumatized her. In 1904 her father, an inventor, died in a Grenoble hospital. Ly became convinced that a Dr Girard, who had looked after him, was guilty of negligence. She complained first to the police and then, when they refused to prosecute, shot Dr Girard, wounding him in the ear. She was acquitted at her trial and returned to Toulouse with her mother, from whom she was henceforward inseparable.

In 1911 she again achieved public notoriety by challenging Prudent-Massart, the editor of a Toulouse newspaper, to a duel. Like a number of Parisian feminists in 1908 and 1910, she had announced her candidacy for the legislative elections and, campaigning against marriage for all women, had been accused of lesbian tendencies by one of the newspaper's reporters. A bitter public polemic ensued. The quarrel had begun with a violent anti-feminist article in the *Rappel de Toulouse*. Though the reporter, Cassales, was sent away on a long trip to cool off, Prudent-Massart, his editor, defended him vigorously and attacked Ly's contention that women should never have sexual relations with men, even in marriage. In August 1911, Ly challenged first Cassales and then Prudent-Massart to a duel. When the latter refused (though he agreed to fight a man if she would depute one), Ly publicly accused him of cowardice. On 2 September, Massart organized a public meeting to protest against Ly's views on virginity. In the middle of his speech, Ly mounted the platform and slapped him across the face. In the ensuing uproar, she was arrested. She had, however, the satisfaction of a retraction from Massart, who denied that he had ever meant to imply that she was a lesbian. 'The two adversaries were reconciled.'[34]

With her mother, Ly then moved in 1913 to Estarvielle in the Hautes Pyrénées, a traditional peasant community where her feminism appeared even more bizarre than in Toulouse. On one occasion she and her mother were victims of a charivari, a mock serenade, organized by local men. During this period Ly founded a newspaper, *Le Combat féministe*, and corresponded with other feminists, especially in Paris. She campaigned against the institution of marriage and in favour of virginity, not, as in Pelletier's case, as a political tactic, but because she considered marriage to be physically and mentally degrading to women. 'Nothing will ever give a married woman back the prestige, lost forever, of her virginal purity.'[35]

After the war, Ly migrated to Florence, where she taught in a French school. Her combative behaviour continued unabated in Italy. In 1924, while reading a feminist publication in a public park, she was insulted by a Fascist officer. Ly responded by striking him and challenging him to a duel. Again she was denied satisfaction, sent to prison, then subsequently transferred to a psychiatric hospital. She was released after ten days, thanks to diplomatic

pressure. In spite of her expressed hostility to men, she remained until her death in correspondence with her doctor, Cristoforo Rizzo, who had befriended her at the asylum. Subsequently expelled from Italy, Ly and her mother moved to Zagreb where she taught French and in time became director of the École Française. She appears to have been successful in her professional life, though always prone to pick quarrels. A long and vitriolic correspondence on the subject of a noisy typewriter forms a puzzling if psychologically revealing aspect of her personality.[36] Like Pelletier, Ly cropped her hair; both she and her mother wore long coatlike dresses, something like painter's smocks, as a version of semi-masculine dress.

Madame Gondon, Ly's mother, also adopted a strong separatist position; it is difficult to imagine what role Monsieur Gondon, even deceased, played in their family drama. The devotion of mother and daughter was intense; Ly referred to Madame Gondon as 'sister'. They took pleasure in questioning gender stereotypes, filling scrapbooks with cut-out figures from magazines of men and women in every variety of dress, transposing men's heads on to women's bodies and vice versa. The result was ludicrous but revealing, comically exposing the body language of gender.[37] Among the books Ly wrote jointly with her mother were, to give the translations, 'Rape', 'Abortion', 'A Girl's Nightmare or The Discovery of Sexuality', 'Before the Appearance of Masculine Vice on Earth', and 'Suicide'.

Pelletier herself published articles by Ly in *La Suffragiste* while dissociating herself strongly from Ly's views. 'I will print your article to show I have nothing against you, but it will certainly harm my paper.' A positivist to the core, Pelletier wanted to base feminism on rational and scientific principles. This was not to deny the importance of subjective feeling, but she thought feminism should be founded on the principle of equality not, as she interpreted Ly's stance, on a hatred of men.[38] Furthermore, it was an error to believe, as some feminists appeared to do, that women were somehow superior to men in their intrinsic moral being: 'Despised in society by men who alone are legislators, journalists, editors, they suffer from their disappointed hopes and have little love in their hearts, as one can readily understand, for the sex that blocked their path. They, therefore, in their disillusionment, opposed women to men and proclaimed their sex the most

worthy.'[39] She agreed that women's peculiar historical circumst-
ances had produced the virtues of their condition: 'As the slavery
in which the Jews have been maintained over centuries has
incontestably developed qualities of industry and economy, so the
special condition allotted to women has not produced only
faults.'[40] If women had more common sense and a greater propen-
sity to charity, this was largely due to their inferior position in
society.

Pelletier accepted that in the period of feminist struggle there
would always be a few women, inspired by a loathing of males,
who could be used as the shock troops of the revolution. But
tactically this hatred could do feminism no real good. As she wrote
Arria Ly in 1908:

> One must not say and, above all, write everything that one thinks if
> one wants to be a propagandist. What are the anti-feminists, and
> even the lukewarm feminists, going to think . . . of a girl who would
> commit suicide rather than to consent to sexual relations with her
> husband. They will say we are abnormal, half-mad and that we
> defend an unnatural and dangerous doctrine, since it would lead to
> nothing less than the end of reproduction. I believe, and I tell you as
> your friend, that you are mistaken in your ideas. This is the
> feminism of Renooz and Cleyre Yvelin pushed even further. . . . It
> arises from resentment. . . . Such women take refuge in woman-
> hood. They declare it is superior, and overwhelm masculinity with
> their contempt. Feminism should not be a feeling but an idea born
> of reason. We don't despise men and we don't hate them either, we
> simply demand our rights. If they don't want to give them to us, we
> must protest by all possible means, and if necessary inflict as much
> damage as possible on the adversary, but solely because he is the
> adversary and not by virtue of sexual hatred.

Then turning to her own choice of sexual renunciation:

> Like you I will not marry and it is likely that I will never take a
> lover, because under present conditions sexual relations are a source
> of debasement for the married woman and of scorn for the
> unmarried. Since I am a woman and have not wished to educate my
> genital senses, my virginity is not a cause of suffering and I am
> convinced of having chosen in life the path that suits me best. But
> such a life, you must understand, cannot be recommended as
> definitive. It is only the consequence of the unjust situation in
> which women find themselves.[41]

Another important feminist of Pelletier's circle was Hélène Brion, the friend who visited Pelletier in the asylum before she died, and who represented another strand in a varied group of activists.[42] Born in 1882 at Clermont Ferrand, the daughter of an officer, Brion was orphaned early in life and brought up by her grandmother in the Ardennes. She trained as a primary school teacher, and soon began campaigning for union rights for teachers. She became secretary to the Federation of Teachers' Unions in France and the Colonies. She was secretary of an orphan asylum and member of the committee of the Confédération Générale du Travail (CGT). A committed socialist, she joined the Groupe des Femmes Socialistes for a time and was archivist for the socialist section of the Pantin district of Paris. Like Pelletier, her path to socialism was through feminism. She, too, published a journal, *La Lutte féministe* (The Feminist Struggle). A pacifist, she was tried for pacifist agitation in 1917. She had two children by a Russian émigré and spent many years after the war compiling a vast 'feminist encyclopedia'.[43] It was Brion who recorded Pelletier's short account of her childhood.

Pelletier's Feminist Programme – La Solidarité des Femmes

Solidarité was not a large group, perhaps fifty to a hundred members.[44] Pelletier saw her first task as awakening her flock's political consciousness. She was installed as secretary at a formal ceremony where she gave an inaugural address:

> The day of my 'installation' arrived. In the magistrate's court of the Saint Sulpice town hall, there were as many as fifty people. Caroline Kauffmann introduced me. 'We need,' she said, 'youthful energies to reinvigorate feminism.'
>
> I made my speech which I had learned by heart. In my opinion feminism needed to move away from vague ideas about the social value of the mother and housewife; away from the parallels drawn between feminine virtues and masculine vices. We are not the enemies of men, we want equality; that is all. One question takes precedence over all the others, the right to vote; and it is towards this end that feminist action should be directed.[45]

The response to her first speech as secretary was encouraging: 'A

young lawyer said to me: "Lead us to victory." I felt my heart pound. For a moment, I give my word, I thought victory had come.' But it proved easier to dream of radicalizing her troops than to do it:

> I soon realized that I was not going to lead the members of the Solidarité des Femmes to anything at all. Victory? They would first have to have wanted it; what they wanted, above all, was to pass their time pleasantly. The majority were middle-aged widows or divorcees; they had small private incomes and were looking for something to do in the afternoons. When they weren't at our meetings, they went to public lectures at the Sorbonne, or at the medical faculty.[46]

Not only, in Pelletier's view, did these women treat feminism as a pastime or like any other cultural activity, they also displayed all the limitations of middle-class gentility. She felt alienated by the class gulf between herself and her members. She had retained the speech cadences and many of the expressions of her working-class childhood; she was emphatically not 'a lady' in the bourgeois sense. As an unsympathetic reporter described her at an electoral meeting in 1910: 'She speaks without pretence of eloquence with commonplace words, sometimes of the people, with awkward and often vulgar gestures.'[47] Pelletier saw the problem a little different-ly: 'My members and I clash like day and night. Thanks to my work I have broken through several social barriers; I know what I want and I get it. They have lived in [bourgeois] families, receiving the genteel education that was given to young middle-class girls of their day . . .'[48]

In a letter to Arria Ly in 1911, Pelletier analysed the gulf between bourgeois and working-class language and the way in which popular linguistic usage reflected women's subordination. Language itself seemed to devalue women. Pelletier's upbringing, as well as her largely working-class medical practice, had given her insights into a linguistic realm inaccessible to most middle-class feminists. She was convinced that language had a profound effect on shaping attitudes. She was close enough to popular language both to employ it in political discourse and to expose, where appropriate, its sexist implications. To Arria Ly, whose own childhood had been a model of the sheltered environment for a 'jeune fille', she explained the metaphorical extension of the terms

for sexual intercourse in the active or passive voices:

> I don't know if you are aware of the slang (vulgar) terms for sexual love, but I know them as a doctor; they all proclaim the inequality of the partners. To practise coitus in argot is expressed as 'baiser' [to screw, fuck, lay] for the man, and 'être baisé' [to be laid] for the woman. 'Baiser' is never used in an unfavourable sense, but 'être baisé' other than its principal meaning, which is to fulfil the female role in coitus, signifies by extension to be fooled, to be duped. 'Je suis baisé' men say, which means, I've made a mistake, I've been had, I've been duped by so and so.[49]

Certainly her own use of argot, even of a non-obscene variety, would have surprised her middle-class contemporaries. Pelletier's interest in popular speech may also have stemmed from her anarchist involvement. The anarchist press, for example, employed the language of popular culture to appeal to a working-class readership and to promote working-class solidarity by stressing the autonomous and anti-bourgeois culture of the 'people'. Pelletier's letters and diaries were peppered with colloquialisms which would have been unthinkable to a woman brought up in a bourgeois milieu. Her loyalty to her class origins in linguistic terms was indubitably one of the gulfs which separated her from other feminists. But there were also disagreements of an intellectual order. In Pelletier's view, many of her members had joined Solidarité in response to some personal misfortune, and as a result lacked any broader political or social understanding: 'Many hate men, as women do who have suffered from them in the course of their lives. One had her dowry squandered by a husband who speculated with it, gambled or drank it away; another found herself rejected when she turned forty. Her husband divorced her to take up with a younger woman.' Such a woman was driven to feminism because she had lost her place in the social hierarchy. Another was the former mistress of a government minister: 'cast off and, on top of everything else, locked up in an insane asylum because she was creating a scandal. "Ah" [she used to say] "if only men would do their duty – we ask nothing more; we don't want to be men."' Pelletier entirely disagreed: 'On the contrary: we must become men, socially speaking. Men will never do their duty; they will support you [as a mistress] and you are dependent on them. When they tire of you, they throw you out.'[50]

All women were prostitutes in their relations with men, Pelletier argued; even in marriage, women were prostituted and would be until they gained political, social and economic equality. When women could earn their living in all the male occupations, divorce would no longer be a catastrophe. Women should not exist through men, but by their own efforts. But in propounding such ideas at Solidarité, Pelletier came into conflict with ingrained class attitudes: 'What I was demanding was a transformation of the world and they didn't want it. They wanted laws protecting women so that they could live a little better without in any way challenging their fundamental class position.'[51] As she also found within the revolutionary Hervéiste wing of the Socialist Party, the appetite for a true sexual revolution was not strong even in groups which considered themselves radical. Pelletier, however, perceived that the demand for sexual equality, carried through to its logical conclusions, had class as well as sexual implications. Where women benefited from class privilege they had little wish to relinquish it, or, finally, to relinquish their dependence on men. Her disillusionment with the lack of revolutionary potential in her feminist circle was further increased by the disinclination of her adherents to follow the road being blazed by the English women's suffrage movement and to resort to large public demonstrations and to civil disobedience. The women of Solidarité were not revolutionaries, she perceived, but members of the bourgeoisie, conditioned to respectability and to avoiding ridicule.[52]

In spite of Pelletier's dismissive estimate of Solidarité's activism, she and Kauffmann pushed through a number of militant actions in 1906, the year of her inauguration. The day of 18 March saw them leading a suffrage rally at the Musée Social with Hubertine Auclert, to coincide with the elections.[53] The demonstration set off from Pelletier's flat, rue Gergovie, and she ruefully wondered how her neighbours and patients would react: 'What would they think of a woman doctor who, instead of contenting herself with bleeding her patients, organized subversive marches.'[54] The rally was followed by a procession composed of demonstrators in hired carriages and a horse-drawn platform with women distributing leaflets. The advantage of this technique, Pelletier noted, was that it made their numbers look larger. They had 'ten carriages for twenty francs – a fine procession. The demonstrators carried multicoloured posters on which we inscribed our demands. Hubertine

Auclert had chosen as slogan: Suffrage for Women!. I carried: Women must vote! This the least cultivated man in the street could understand, whereas "suffrage" would mean nothing to him.' On another banner she proclaimed: 'Women are subject to laws and pay taxes. We want universal suffrage and not unisexual suffrage.' They were greeted by predictable insults from the street crowds, 'classic dismissals to the kitchen and to sock mending'. 'Oh those eternal socks,' Pelletier sighed, 'what a sign of women's subjection – if only we could replace them with something else.'[55]

Pelletier and Kauffmann also staged a suffragist protest at the Chamber of Deputies. On 3 June 1906, after obtaining visitors' passes from a socialist deputy, Adrien Meslier, they climbed into the gallery and showered the chamber with leaflets. The consternation of the male deputies, many of them veterans of Vaillant's bomb attack of 1893, was considerable. Though arrested, Kauffmann and Pelletier were not charged, the government having decided it best not to give women's suffrage the further publicity of a trial. Meslier, who had given them passes, was outraged.[56] Pelletier had made an enemy in the socialist ranks.

In the same year, with Pelletier's encouragement, members of Solidarité put up suffragist posters in the street. This seemingly innocuous activity produced examples of physical intimidation: 'One joker emptied my pot of paste on my head and an elderly member of our group was stabbed in the arm with a hat-pin, by a woman who no doubt clung to her slavery and didn't want anyone to free her from it.'[57]

Finally on 24 December 1906, she and Kauffmann led a group of women suffrage demonstrators to lobby the socialist leader, Jaurès, in the Chamber of Deputies. At this juncture Pelletier still hoped to enlist active socialist support for the suffrage question. She was fighting on two fronts, having also become a militant socialist in the same year (see chapter 5). But she discovered that socialist enthusiasm for women's suffrage was distinctly lukewarm; party leaders were preoccupied with the question of proportional representation and considered the demand for women's votes 'inopportune'.[58]

The Suffrage

Though in the course of her career Pelletier campaigned on a whole range of feminist issues, before the First World War she concentrated largely on votes for women, both in active campaigning and in articles for socialist and feminist journals. This theme was illustrated by her article 'La Question du vote des femmes' (1908), which examined the question of women's suffrage both from a historical and an international perspective.[59] Tracing women's demands for political representation back to the 'great revolution', Pelletier characterized modern feminism as dating from the new political awareness unleashed by the events of 1789. Though it was true that prior to the Revolution individual women had protested against their lot, they had done so, she suggested, as individuals. Feminism as a concept was a product of the vocabulary and thought structures of the French Revolution. This argument was designed to legitimize feminism within the French revolutionary, republican tradition. Yet, she continued, in all the revolutionary political activity in which women had taken part, they had done so in solidarity with the men of their class, not with their own sex. The real problem for women was to achieve sexual solidarity.

Pelletier's most revealing analysis concerned the English women's suffrage movement of which she had firsthand experience. In the summer of 1908 Pelletier and Kauffmann had been invited to take part in the women's suffrage demonstration of 21 June in Hyde Park, when Millicent Fawcett's National Union of Women's Suffrage Societies had organized a huge public demonstration which marched to Hyde Park from the Embankment.[60] The numbers, estimated at 500,000, formed one of the largest open-air protests ever seen in Britain and were intended to counter the government's charge that most women (and men) were indifferent to the issue of women's suffrage.

In London, Kauffmann and Pelletier stayed with Miss R. M. Billinghurst, a severely disabled woman who attended suffragette marches in an invalid's tricycle.[61] The French visitors were able to witness the impressive organization that made the Hyde Park rally possible. Pelletier noted with envy the virtually military discipline with which the suffragettes were organized. Seven separate marches converged on Hyde Park; each participant had detailed

orders. Everyone wore the suffragette colours, green, white and purple. The French delegates joined the procession at Westminster Bridge at 1.30 p.m. and proceeded to the mass rally and speeches at Hyde Park. It was the sort of occasion that Pelletier knew was needed to put the French women's suffrage movement on the map, but one almost impossible to reproduce in Paris.

Pelletier and Kauffmann kept in touch with their English hosts and heard the sequel to the Hyde Park rally. When it provoked no concessions from the government, the Women's Social and Political Union organized a further deputation to the House of Commons on 30 June. This proved to be a less peaceful occasion, as Miss Billinghurst wrote to Kauffmann in a mixture of bad French and excited English, but full of the drama of the occasion:

> It's a pity that you were not in London on June 30th. Mr. Asquith did not wish to receive our deputation to the House of Commons. During the afternoon and that evening, all the men of London (I think) came to Parliament Square to see us *force* our way to the House of Commons through the band of police. And as the ladies were arrested and led through the streets, the men tried to rescue them and shouted, 'We won't have our women imprisoned.' 'Hurray for the brave suffragettes.' 'Shame on Mr. Asquith.' 'Shame on the Government.' ... Twenty-seven of our ladies have been arrested and the sentences very hard. We have some struggles before us yet but the working men are enthusiastically on our side now and members of the government will be forced to take our demand seriously which they do not at present. ... You will come, won't you, the day that they give us the vote to rejoice with us, and I hope you will succeed as soon as we do.[62]

The Times reported the event very differently:

> In one way, at least, the invitation of the WSPU to the people of London to assemble outside the Houses of Parliament yesterday evening 'in their thousands' fulfilled its purpose. For the invitation was responded to in a manner which even the most sanguine suffragist cannot have foreseen. The approaches to Palace Yard were blocked for hours together by an immense mob. To suppose, however, that these enormous crowds had assembled to show sympathy with the woman's suffrage movement would be the wildest absurdity. They had come merely for a cheap evening's entertainment, and they had about as much sympathy with the

women whom they came to see run in as the people who flocked to the Roman amphitheatre had with the wretches who, for their diversion, were thrown to the lions.[63]

Billinghurst's letter points to an advantage enjoyed by the British feminists, namely significant working-class support for women's suffrage. Even making allowances for Billinghurst's enthusiasm, it was true that the British suffragettes were able to link their cause to that of working-class disenfranchisement, whereas in France no such alliance existed.[64] The Pankhursts' early political training in socialist politics had given them both working-class backing and hard experience in the hurly-burly of open-air meetings, marches and other tactics to achieve publicity. Pelletier was enormously impressed by the discipline, courage and mutual support mechanisms that the British women's suffrage movement had developed: 'Not only do women to support their cause hold meetings and form associations, they also demonstrate in the streets and have on several occasions tried to invade Parliament.'[65]

Pelletier suspected, probably rightly, that in France the quasi-military regalia of the British suffragettes would attract ridicule. Marchers were asked to wear white dresses with purple and green favours – the WSPU colours. There was a uniformed fife and drum band; Mrs Drummond, commander of the march and addressed by the title of General, led the way resplendent in cape, epaulettes and a military hat, astride a horse. But in spite of these potential absurdities, Pelletier acknowledged that the English feminists had succeeded in creating a cohesive and impressively large movement:

But in all this there was cohesion, conviction, devotion and this is an enormous gain. The most ordinary work of the humblest militant is noticed and praised in public by the leaders. If a suffragette goes to prison, she is given a celebration on her release, and presented with an engraved diploma which attests her devotion to the cause. If she does nothing more than wear on her blouse the badge, Votes for Women, she is congratulated on her courage for facing up to hostile comments from rude passers-by. ... They bring to the cause whatever energy they can; how few activists in masculine political parties can say as much. Without any doubt, one may affirm that the state of mind reigning among the 'Suffragettes' is unknown in France, not only among feminist organizations but in the great male political parties.[66]

Pelletier praised the English movement again in a letter to the suffrage campaigner and educational reformer, Ferdinand Buisson, who was gathering information for a wide-ranging report on the women's suffrage question which he presented to the Chamber of Deputies in 1909:

> As for London I will announce your visit to Mrs Pankhurst: she is the best known of the feminist leaders. She speaks French well enough to make herself understood. . . . England is certainly the European country where organization is the strongest. I marvelled at what I saw, and speaking impartially, I must admit that nowhere in the male or female political organizations that I have attended have I found so much discipline and so much devotion. If I had Pankhurst's troops, I would certainly attempt a violent demonstration.[67]

The English visit showed Pelletier what could be done with efficient organization and a mass base, but also how far French feminism was from achieving these goals.

Electoral Activity

In the first decade of the twentieth century French feminism faced a number of internal and external obstacles: competition among groups, lack of financial resources, class divisions, apathy on the part of the majority of French women, a hostile press and an indifferent legislature. Whereas in Britain the great public gatherings such as the Hyde Park march of 21 June 1908 seemed to show that, contrary to politicians' allegations, significant numbers of women were not apathetic about the vote, French feminists could not realistically hope, by 1908, for this degree of response or solidarity.[68] Other tactics than mass demonstrations were called for. In 1908 a woman reporter from the newspaper *Le Matin*, Jeanne Laloë, volunteered, largely as a publicity stunt for her newspaper, to stand as a candidate in the municipal elections. In the event, her candidature became a serious focus for suffragist propaganda. Laloë was supported by the feminist lawyer Maria Vérone, who had pointed out that the electoral law did not explicitly exclude women candidates, though of course women were excluded as electors. It was during Laloë's campaign that

Pelletier and Auclert staged their protest of invading polling stations, and Auclert succeeded in overturning a ballot box.

Following this incident Pelletier decided on a further demonstration of her own, to take place on 10 May 1908. She resolved to march to a polling station, demand admittance and if excluded, as she certainly would be, to throw stones at the windows.[69] She recognized the lack of enthusiasm of her fellow activists for direct action, however:

> During the next elections I had the idea of leading Solidarité to break the windows of a polling booth. I explained my fell plan to the group and naturally they did not approve. Marching in the street seemed vulgar to them; this was something suitable for working-class women. A respectable woman should stay at home ... a demonstration in the street could only harm the cause, especially with this violent character.[70]

Her members' fears that they might be identified with the working-class women of former revolutionary struggles illustrated how far Solidarité was from being a militant feminist organization and how little hope Pelletier had of copying the tactics of the English suffragettes. One of her members objected that stones thrown at windows might wound someone inside the building and proposed replacing stones with potatoes. Pelletier exploded:

> Potatoes! People would think we want to *feed* the voters. I would carry stones, let those who loved me follow me. I knew that even with stones we wouldn't do much harm. At the throwing of the first stone, we would be arrested. I didn't really hold out for inflicting much damage. For propaganda purposes, the gesture was enough.

Their procession set off:

> There were about ten of us at the rendezvous, rue de l'Arbalète. I threw my stone at a window pane, shouting at the same time – 'Women must have the vote.' The window broke but without hurting anyone and there we were, another feminist and I, led to the police station, rue Dante.[71]

All the members of Solidarité came to support Pelletier the day of her court appearance, as well as members of Auclert and Oddo's

groups. Waiting her turn in the courtroom was an education in itself, Pelletier recalled:

> There were a lot of cases of thefts, frauds and pilferings that went in before me and I realized how hard justice is on 'little people'. An unfortunate working girl, guilty of having solicited, was given three years in prison. And no respect from the magistrates. The president of the tribunal made jokes at the expense of the unhappy accused – I was disgusted.

When Pelletier's turn arrived, the president became jovial: 'It was clear that feminism was a change from stealing potatoes . . . which had outraged him a moment before. He asked me to explain the motives for my action and I explained them. Sixteen francs fine.' But the real cost came from her fellow feminists: 'The leaders of the feminist groups saw these childish pranks as outrages. They made me look like a revolutionary who would stop at no form of extremism and violence.'[72]

Pelletier's autobiography, 'Doctoresse Pelletier', written in the early 1930s, played down her revolutionary militancy: 'In theory I am a revolutionary, in practice I only kill the lice that my patients make me a present of from time to time.'[73] This was not the persona she had adopted in writing for *La Guerre sociale* (Social War), some twenty years earlier. Nevertheless, it is also true that even before the war she avoided actions which would land her in prison. This stone-throwing incident, the most violent of her political protests, resulted only in one broken window pane, and a fine. However Pelletier gained her point of winning press publicity: even the London *Times* reported the case:

> A French suffragist, Mme Madeleine Pelletier, was condemned today in the Paris Police Court to a fine of 16f (12s. 6d.) for making a disturbance in a public office. On May 10 last, during the balloting for the municipal elections, she was one of a group of ladies who visited different quarters of Paris to demonstrate in favour of women's suffrage. On one occasion, they tried to penetrate into a polling booth, but were prevented by the police. Mme Pelletier thereupon threw a stone at one of the windows and broke it. Before the Court she declared that her act was meant to teach women the ABC of revolt.[74]

Laloë's campaign in the ninth arrondissement, which had stimu-

lated this feminist electoral militancy, could be considered a success. Her meetings attracted large crowds (two thousand on one occasion) and while the campaign was trivialized in the popular press, it brought the issue of women's exclusion from politics to public awareness. Though suffragists were barred by the police from the final count, it was estimated that Laloë won 987 votes, or 22 per cent of the total, an impressive achievement. However, her candidature emphasized the split between the moderates like Vérone, who sought gradual and legal reforms, and the radicals like Auclert and Pelletier who thought that the time had come to emulate the English suffragettes and resort to direct action.[75] One effect of Laloë's campaign was to make Pelletier and other feminists determined to stand in the elections of 1910. Pelletier worked at her political base, hoping for the backing of the Socialist Party when the time came for her to put herself forward as a candidate.

5

Feminist Electoral Campaigns and Socialist Politics, 1906–1912

The six-year period between 1906 and 1912 saw Pelletier taking part in a wide range of political activity. Having lost the chance to rise in the psychiatric service, and limited in professional terms to a career as a neighbourhood general practitioner (*médecin de quartier*), she turned her energies to the dual arenas of feminist and socialist politics. Among historians Pelletier has attracted particular attention for her rapid rise within the Section Française de l'Internationale Ouvrière (SFIO – French Section of the Workers' International) in the years 1906 to 1911.[1] It has been argued that the simultaneous pursuit of feminist and socialist goals posed an insoluble problem for Pelletier and that as a result her feminism was largely divorced from her socialism.[2] Whereas the first contention seems undeniable, the second contradicts Pelletier's clearly expressed political/feminist programme. A glance at the 1906–12 chronology alone shows continuous reciprocity between her feminist and socialist activity. While genuinely committed to socialist goals by revolutionary means, Pelletier sought on the one hand to broaden the socialist agenda of social justice to include women, and on a tactical level to appropriate socialist electoral machinery for feminist ends. After she failed to gain endorsement as a socialist candidate in a winnable seat in 1910, she retired from party militancy – but she did stand as a socialist candidate again in 1912 and attended a post-war national congress as a delegate in 1922.

The Socialist Context and Political Militancy

The SFIO was not a monolithic body but was composed of a number of different factions, ranging from reformist parliamentarians to revolutionary socialists. Unified in appearance, Pelletier remarked, socialist factions warred between one another for dominance in the party.[3] Ambitious recruits to the Socialist Party would join a faction within which they could hope to make their mark. Movement from one faction to another was not uncommon. In 'La Tactique féministe', written in 1908, Pelletier suggested that one of the paths women should pursue in order to gain the vote was 'to infiltrate existing political parties'. 'Therefore, in order to succeed in publicizing my ideas on women's suffrage, I had to carry through my effort to acquire personal influence, in a purely political context.'[4] Given the fact that in principle the Socialist Party accepted women as equals, this seemed the obvious place for women to achieve feminist aims. However, women in the party were, she suggested, seen primarily as appendages of male friends or relations. It was difficult to be accepted on one's own merits. The feminist must therefore find a group within the party where she could exert influence.[5] One notes the pragmatic rather than the ideological thrust of Pelletier's programme. In pursuance of these aims, Pelletier belonged to the Guesdiste faction of the SFIO from 1906 to 1907; while from 1907 to 1911 she was active within the Hervéiste wing. What did these groups represent and what were her motives in joining them?

The Guesdistes, led by the Marxist, Jules Guesde, held that the destruction of capitalism would in itself bring about an end to social abuses, such as the subjection of women.[6] After evincing early sympathy in the 1870s for women's rights as a major socialist issue, Guesde later adopted the position that feminist campaigns were a diversion from the class struggle. Women's emancipation must await the revolution.[7] This 'no jam today' position of feminism became a not untypical socialist attitude. In addition, the role of women in Guesdiste circles was understood in traditional terms. For example, Paul Lafargue, a disciple of Guesde and son-in-law of Marx, who wrote extensively on the woman question, exalted women as the guardians of maternity in the new society. Nevertheless, as Pelletier admitted, it was some gain that Guesde and Lafargue affirmed sexual equality as an ultimate goal.[8]

In describing her early introduction to socialist circles, Pelletier disclaimed any knowledge of political theory, and with her medical background she appears to have approached it with scepticism:

> I sometimes went to big socialist meetings. There it was said that capitalism carried in itself the seeds of its own destruction. That small businesses were disappearing, taken over by big business. The audience clapped enthusiastically; doubtless they understood. I didn't understand very much even though Letourneau had made me read *Das Kapital* by Karl Marx, which I found a huge effort.

Pelletier thought that Marx simply complicated simple questions and made a mystery of the obvious: 'That workers are exploited has been evident from the beginning of time. There is no need to write hundreds of boring pages to demonstrate it.' Pelletier's impatience with Marx may have reflected the lack of Marxist orientation in French socialism, her own background in anarchism and her feeling that abstract political theory ignored concrete experience of social deprivation, such as she herself had known. For her own political credo Pelletier called on the Jacobin tradition of Robespierre:

> All that I know is that I am in favour of social justice and that I rather lean towards the doctrines of Robespierre, a radicalism pushed to its limits. [I am in favour of] the abolition of inheritance, free education at every stage, generous subsidies for children, old people and the ill, no more class distinctions, no more worship of money. Intelligence and work should be the only means to success.

However, Pelletier considered that the revolutionary tradition, though theoretically part of the ideology of the Third Republic, was dead, and in any case, this tradition had always enshrined an anti-feminist bias: 'The Radical Party has long since forgotten Robespierre's programme and in any case, if I decided to knock on his door, he would have no use for me; he didn't care for women.'[9]

Here Pelletier touched on a key problem facing French feminists. Those political parties with a commitment to social equality, the Radical Liberals and the Socialists, gave little more than lip-service to women's rights. In neither party was the woman question a pressing issue.[10] Though women who became socialists were allowed to mix in 'real' politics, they were well advised to

forget their feminism. Pelletier, often impatient of the limitations of the bourgeois feminist milieu, might say: 'Louise Michel is right, feminism is too narrow'; nevertheless she found that socialism proved an equally problematic field of action.[11]

Women in the Socialist Party faced both institutional and psychological barriers. With regard to the former, most deabtes in the party sections (such as the one Pelletier joined) centred on electoral tactics. Since women could not vote, and a voter's registration card was needed to participate in electoral meetings, women could not take part in such debates and could be little more than passive spectators. Secondly, the atmosphere of the meetings, as Pelletier discovered, was that of a male club, an intimidating experience even for politically experienced women. Pelletier who felt strongly that women should educate themselves in the techniques of public speaking, and did not favour separate women's political sections (though in 1908 she toyed with the idea), nevertheless recognized the difficulties placed in the way of women's active political participation.[12]

Pelletier's own account of her entry into the Guesdist faction suggests that chance played a considerable role. She was acquainted with a Socialist deputy, Fournier, who introduced her as a new member to the fourteenth section of the SFIO, which represented the area of the rue de Gergovie where Pelletier then lived. Here she began her education in political factionalism. The fourteenth section, in Pelletier's account, was split between the Jaurèsians (parliamentarians of the Socialist right) and the Guesdistes, to the left. Though finding meetings anything but comradely, she agreed to give a lecture, in which she discussed class consciousness from the point of view of social evolution:

> I had always had a strong feeling for justice and had just discovered that society is composed of classes. Formerly I had thought that there were simply inequalities in fortune. I discovered that, depending on whether one was born a bourgeois or a worker, particular manners, feelings, ideas, and even a particular anatomy, were created in an individual. I gave a lecture on this topic entitled 'The Anthropology of Class'.[13]

However, this anthropological and transformist perspective, the fruit of her work with Letourneau and Manouvrier, was not

appreciated by the comrades. The notion of an evolutionary and cultural, as opposed to an economic, critique of society was foreign to their political thinking. Pelletier, who was eager to see the politics of activism, began to be bored by the procedural minutiae of meetings. When, therefore, a member of the Guesdiste faction offered to recruit her to the Guesdistes, she could not but be tempted: 'I had nothing against the Guesdistes, they seemed to me more truly socialist; the Jaurèsians were little more than advanced republicans. And even if I did not agree with everything within Marxism, I understood the necessity of the socialization of the means of production in order to abolish class differences.' But when it came to feminism, for Pelletier the crucial test of a political philosophy's credibility, even the supposedly left-wing Guesdistes made objections:

> K. explained to me that my 'votes for women' was totally without interest; socialism would free women, but before [the revolution] one must not instigate a battle of the sexes – this would be deviationism. But if I wanted to draw up a motion on women's votes, he would give me the opportunity to present it to the National Congress which was to be held in six months time at Limoges. . . . I was delighted.[14]

This, thought Pelletier, was the moment that would see women's suffrage taken seriously by a major political party. Attaching herself to the Guesdiste faction, whether or not she agreed with every aspect of their policy, seemed a valid tactic to pursue in order 'to put the question of women's votes on the agenda of the national congress.'[15]

Events were to prove her too optimistic, but initially in 1906–7 Pelletier's efforts to advance feminism within the party appeared brilliantly successful. Indeed 1906 was a year of intense activity. Early in the year she had become secretary of 'Solidarité, in March she and Kauffmann led a suffrage march and in June they had their leaflet demonstration in the Chamber of Deputies. In spite of the anger of the deputy, Meslier, noted above, she continued to gain influence with the Guesdistes, to such good effect that by the summer of 1906 she succeeded in having a resolution for women's suffrage adopted at the fourteenth section of the SFIO, where it was passed on to the federal committee and then to the national

commission. November saw Pelletier as a delegate to the annual SFIO congress at Limoges charged with proposing a motion on women's suffrage to be included in the Socialist Party manifesto. She there made a powerful and convincing speech to the assembled delegates; her motion was overwhelmingly endorsed, with only six votes against.[16] This victory, which in personal terms was certainly remarkable, turned out as Pelletier herself recognized to be more apparent than real:

> My motion passed almost unanimously; but I knew precisely how theoretical this agreement was. No one wanted to vote against political rights for women because these rights were in the original socialist programme; in any case, feminism was an 'advanced idea' and one would have appeared reactionary in publically opposing it. But they were careful, in spite of agreed resolutions, to try nothing to arouse public interest in the question. I knew it would be so . . . and if I had insisted that feminism be discussed and approved by the party, it was in order to get press publicity and thereby to move public opinion.[17]

Pelletier's Limoges resolution was not followed by any significant parliamentary initiatives. Concerned that the party was continuing to ignore the woman question, she and Kauffman led a deputation of seventy feminists to the Chamber of Deputies in December, where they were received by Jaurès, the leader of the Socialist parliamentary group. It turned out to be another case of empty promises, 'a refusal artistically wrapped up in sugar and honey.'[18] However, their deputation did get press coverage, even internationally, with an arch, but not unsympathetic, article in *The Times*:

> The British movement in favour of women's suffrage is evidently contagious. On Friday, a group of women advocates of female suffrage made their appearance at the Chamber of Deputies, waylaid the Minister of Labour, M. Viviani, as he was entering the Palais Bourbon, surrounded him and refused to let him go until he had promised that they should be formally received by some of the Parliamentary groups. He good-humouredly arranged an immediate audience with the Socialist group. These ladies who belong to a society known as 'La Solidarité des Femmes' found the Socialist Deputies more than gallantly inclined to listen to their claims, and as an upshot of this interview, the Socialist group has agreed to

bring in a Bill demanding electoral eligibility for women and extending the privileges of French law to womankind. The campaign has already begun and the newspapers are taking it seriously.[19]

Though one cringes at the obligatory skittishness of the comment 'more than gallantly inclined', nevertheless it was significant that the reporter considered women's suffrage to be both newsworthy and a serious political issue. 'Electoral eligibility for women' in France, however, was to prove a distant goal.

Pelletier's description of one such lobbying of deputies was less glowing than that of *The Times*. Her deputation from Solidarité, she recalled, waited interminably in the Chamber ante-rooms; finally a Socialist deputy appeared to tell them that their demand for the suffrage was not convenient. Since at this period the Socialists, still a minority party, were campaigning for proportional representation, from the perspective of their parliamentary representatives the attempt to win the franchise for women was seen as an unwelcome diversion, as the deputy made clear in his excuses:

> Certainly, ladies, I am on your side. You know, Pelletier, I've always been a feminist. I engage in a lot of propaganda for your ideas ... but an amendment [on women's suffrage] just now – is inopportune. ... Hubertine Auclert said she had heard it all before – for thirty years she had been lobbying in this way and every time she had been told the moment was 'inopportune' for women's suffrage.[20]

In the end, they persuaded a Radical deputy, Monsieur Pourquery de Boisserin, to move an amendment allowing women to vote for the 'conseils de prud'homme', a municipal council appointment concerned with boards of labour. This was theoretically a significant step because it accepted the principle of women's electoral capacity. But, as Pelletier noted sceptically, the Chamber could relax; nothing fundamental had changed.

In an even more discouraging index of the Socialists' commitment to feminism, the party's annual report of 1906–7 made no mention of the women's suffrage question, nor did the subcommittee set up to consider the matter ever meet. It has been suggested that Pelletier made no explicit protest within the party on this

failure.[21] Yet one wonders what else her lobbying of the Chamber represented if not a frontal attack on the parliamentary policy of inaction? On 17 June 1907 she marched for a second time to the Chamber of Deputies with a group of English suffragettes, where they succeeded in obtaining another interview with Jaurès.[22] Most of Pelletier's political energies in the year 1906–7 seem to have been concentrated on moving women's suffrage on to the parliamentary socialist agenda. She was in addition prepared to seek parliamentary assistance from almost any source, including the Radicals, as the amendment moved by Monsieur de Boisserin illustrated.

In July 1907, still determined to jog the dormant consciences of her Socialist comrades, Pelletier spoke again at the Federal Congress of the Seine on women's suffrage, and received permission to present the Limoges text in favour of the suffrage a second time at the annual conference of 14 August 1907, at Nancy. She must have hoped that a reaffirmation of the resolution would result in parliamentary action. At Nancy she spoke eloquently, countering the arguments usually advanced against the practicality (rather than the principle) of giving women the vote, namely that women's votes would be overwhelmingly conservative and lead to a restoration of monarchical rule and church influence. Women, when politically educated, would not, Pelletier affirmed, unleash the black peril (the church-led forces of conservatism). She attacked the argument put forward by the Hervéistes (the revolutionary and anti-parliamentary faction), who were opposed to electoral and parliamentary co-operation with the Republic and in favour of revolutionary change. Like the anarchists, the Hervéistes opposed extension of the 'useless' suffrage to women. Pelletier argued powerfully that the working class had shed blood in a series of revolutions to gain the vote, which they clearly had seen as important, even if now they found it insufficient. How could working-class men ask women to forego something they had fought for themselves?[23] Her resolution, though opposed by some speakers, again passed, but with no greater effect than its predecessor. Pelletier quoted one delegate as saying: 'I hope you realize that we vote in favour of your motion because votes for women has no chance whatever of succeeding. If it had, you would see some real opposition.'[24]

The year 1907 was politically packed. From Nancy, Pelletier travelled to Stuttgart to attend the conference of the Congress of

the Socialist International on 17 August; it included in it the first International Conference of Women Socialists under the direction of Clara Zetkin of Germany. Pelletier was one of eight women delegates sent by the French Socialist Party.[25] At the Stuttgart conference she had the opportunity to meet European socialist women, particularly those in the German Social Democratic Party (SPD) and to witness the effects of that party's remarkably successful organization of women.

In the early 1890s, Clara Zetkin had been the moving force behind the creation of women's sections within the SPD. A disciple of Bebel, she linked proletarian and women's subjection but argued that the gulf between bourgeois and proletarian women was unbridgeable. Zetkin played down any 'feminist', or diversionary, tendencies within the Socialist women's sections. Nevertheless, the SPD went much further than the French Socialist Party in supporting votes for women, equality in education and the professions and equal pay for equal work.[26] Individual women within the SPD achieved positions of prominence, notably Zetkin and Rosa Luxemburg. The latter, indeed, illustrated clearly the feminist/socialist split. Luxemburg took no interest in feminism as a movement and opposed contraception (as did many French socialists), on the grounds that as large a working class as possible was needed to fight the revolution. On the other hand, if not identifying herself as a feminist, she showed that a woman was capable of revolutionary and political distinction.[27] She haunted Pelletier as an example of a successful political woman who nevertheless scorned feminism.

At the Stuttgart conference, Pelletier found herself confronted with an articulate, highly organized German women's socialist group which rejected outright all co-operation with bourgeois feminists. Yet Pelletier, a socialist of the far left and anything but middle class herself, was simultaneously the leader and representative of what would have been classified as a 'bourgeois' feminist group, La Solidarité des Femmes. Pelletier believed it was essential for feminists to co-operate across class lines and therefore that socialist women should keep links with bourgeois feminists. On this occasion she indubitably found herself in the minority. The Stuttgart conference passed a resolution calling for universal women's suffrage but also forbidding Socialist women to ally themselves with bourgeois feminists. In the context of the already

thin ranks of French women socialists, this was in Pelletier's view to doom feminists to forego the hope of forming a significant political force.[28]

In after years Pelletier retained considerable scepticism about German women socialists, tinged, perhaps, with envy. They seemed to her to have sought and gained invidual political power for themselves, but not for their sex. She saw them to some extent as sex traitors, as feminists like herself were accused of being class traitors:

> Under no pretext should a feminist prefer the political party into which she has entered to feminism itself, for if she serves the former, she belongs to the latter ... A woman, like any other individual, can be a socialist, a republican or a monarchist according to her convictions; but above all she should be a feminist.[29]

Prominent SPD women, Pelletier believed, were the reverse, socialists before feminists. When writing in the post-war period about the Weimar Republic, Pelletier commented wryly on the careers of German socialist women who had succeeded because they had *not* been feminists. Women who had argued during their whole political lives that women's place was in the home and that the industrial bosses had committed the worst of crimes by giving them jobs in factories had risen to become parliamentary deputies and even ministers. Such women were also careful not to appear sexually liberated. Pelletier described them with a satirist's eye:

> Rosa Luxemburg wore a long dress, long hair, a little veil and flowers in her hat. Clara Zetkin did the same. At that time [1907] women wore long pins that held their hats on to their chignons. When Clara Zetkin spoke to the conference, the amplitude of her gestures made her hat sway from side to side which gave a comic effect. Laura Lafargue, the daughter of Karl Marx [and wife of the apparently pro-feminist Lafargue] was sometimes chosen as vice-president of the congress. She always appeared with her face covered by a heavy veil. ... She was no longer young and ... believed that women should not allow themselves to be seen when they could no longer appeal to the strong sex.[30]

By the summer of 1907 and even before the end of the conference season, Pelletier had already decided to change tack

within the Socialist Party. Discouraged by her chilly reception in the fourteenth section and the fate of her two impressive but fruitless resolutions on women's rights sponsored by the Guesdistes at the national congress, and sceptical about the parliamentary socialists, she moved in July of 1907 to the Hervéiste wing of the SFIO.

The Hervéiste Period, 1907–1911

If, as seems the case, Pelletier had joined the Guesdistes largely because they were willing to sponsor her women's suffrage motion, allying herself with the Hervé faction represented a significant shift to the left and a clear ideological commitment. The Hervéistes seemed to Pelletier at this period to be true socialists, committed to revolutionary action and untainted by the parliamentary opportunism of the Jaurèsians (which Pelletier had seen in action when she lobbied the Chamber) since they refused parliamentary collaboration.[31] Gustave Hervé, a passionate anti-militarist and anti-patriot, was founder and editor of the journal, *La Guerre sociale* . He was the most revolutionary of the French socialists and sympathetic to syndicalists and anarchists. Yet when Pelletier joined the Hervéistes in July 1907, she had certainly not received much feminist endorsement from them. Indeed in the spring of 1907, *La Guerre sociale* had published two vitriolic articles against feminism, one of them attacking the sexual mores of Marguerite Durand, and in June 1908 had expressed hostility on the subject of the English suffragettes. Pelletier protested to the paper and elicited a response from Hervé who defended the right of his contributors to oppose feminism if they so wished but added that he himself saw no reason to refuse women the vote, though it was a meaningless goal.[32]

With this tepid encouragement one may wonder why Pelletier decided to pursue a political career in the Hervéiste ranks. Did she separate her socialist and her feminist objectives? One must first take into account her disillusionment with her comrades in the fourteenth section, who encouraged her to propose resolutions secure in the knowledge that when passed they would never be acted upon. Then there were the positive attractions of Hervéisme. For many years, since her anarchist period, Pelletier had had

contacts with and been sympathetic to revolutionary ideology. Hervé was in addition an individual of considerable magnetism. Another factor which would have influenced Pelletier was the fact that many Hervéistes supported the neo-Malthusian campaign of Paul Robin for birth control. Most importantly, Pelletier was politically ambitious. The Hervéistes were a small faction where she could hope to make her mark. Looking at her political and feminist activity at this period, it seems likely that her chief desire was to achieve a position of power within the party in order to advance feminism, although she was, in addition, committed to revolutionary action. In later years she came to doubt her own revolutionary fervour, but some of her articles for *La Guerre sociale* endorsed terrorist methods.[33]

In the period 1907 to 1910, some fourteen of her articles in *La Guerre sociale* attacked the parliamentary socialists' alliances with the Radical Party and the reformist policies of Jaurès. Pelletier's particular strength as a journalist lay in her psychological analyses of the dual process of co-option and corruption undergone by Socialist deputies in the Chamber. In her analysis, it was not individual deputies who were particularly venal but the party's participation in an electoral and political system that would inevitably corrupt them. Though she satirized individual deputies such as Basly, who had moved from revolutionary socialism to accommodation and reformism, such men 'merely retained the pettiness of the average man...'[34] These portraits form the groundwork for her fictional representations of political arrivistes (see chapter 9). Overall, Pelletier was loyal to the Hervéiste position that socialists should work towards the total transformation of society. The present republic, she declaimed in her articles, was no longer worthy to be defended and should be destroyed: 'Far from thinking of helping the Radicals to save Marianne, it would be better to begin to encourage the possibility of co-operating to strangle her.'[35] Thus within the Hervé faction she set to work, possibly with the model of Rosa Luxemburg before her, to become an influential party member. Clearly, for a woman the arena for action could only lie within the party's administrative machinery since a parliamentary career was not possible. Yet as Pelletier was to discover, real policy was decided in the parliamentary party.

From her brief experience with the Guesdistes, it was evident to

Pelletier that 'going on' about women's issues at socialist meetings would produce polite or less polite yawns. In 'La Tactique féministe' in 1908, she described how a feminist should lead the fight from within by making herself visible and appreciated within the party, educating herself on political questions, speaking up at meetings and finally:

> As for feminism, [the feminists] will speak sparingly about it and certainly not out of turn. Let her concentrate above all on being a 'good' activist, a member whose opinion counts; as a consequence, she will acquire authority to argue for the particular demands of her sex. It goes without saying that if feminism is raised, she should defend it with all her power.[36]

Although this tactical view remains persuasive, this is not to say that Pelletier was not sincere in her revolutionary enthusiasms. What does become increasingly clear in this period is that she began to question the effect the revolution might have on the gradual evolution of feminist gains which she believed to be occurring in contemporary society. These conflicts were evident in the series of articles written between 1907 and 1910, where hints of the contradictions of her position as a revolutionary socialist and a feminist continually emerged.

A striking aspect of Pelletier's articles in *La Guerre sociale*, where she adopted an intransigent revolutionary militancy, was the fact that other themes not necessarily in harmony with her anti-parliamentary and revolutionary stance, surfaced. For example, in 1907, attacking Guesdisme for a loss of revolutionary purpose, she ironically described Guesde's opposition to neo-Malthusianism and accused him of anti-feminism:

> No feminism, that would displease the worker who rules his wife by kicking her; in demanding votes for women seriously, one might perhaps lose some male votes. 'Citizenesses, the bourgeoisie tore you away from your cooking pots to drag you into its factories; let your husband vote for you and when we [the Socialists] are masters, we will return you to your kitchens and your brats. Your dresses are now made of cotton; they will be of silk. Let us have your men.'[37]

On the other hand, the same article argued that socialists must

choose between reform or revolution, the latter being the only genuinely socialist position. Electoral action led to reformism. This conclusion made the claim for women's suffrage in the middle paragraphs appear incoherent, to say the least, demonstrating the irreconcilable conflicts that Pelletier experienced between socialist and feminist action.

Another significant aspect of her political journalism was her recourse to evolutionary metaphors rather than more Marxist economic explanations to describe the class struggle. In a revealing analysis of the capacity of capitalism to survive in a changing economic and political climate by adopting a policy of gradual reform, Pelletier characterized the bourgeoisie as imitating the colouring of its host plant (the working class) like a parasite: 'Like worms which take on the colour of plants at whose expense they live, the bourgeoisie dresses itself in the colours of socialism: perched on socialism like a parasite, it simultaneoulsy sinks its fangs into its flesh and inoculates it with poison'[38] Elsewhere, in a psychological metaphor, the working class through its passive acceptance of betrayal by its Socialist deputies was alleged to show, as a class, the masochistic tendencies visible in some prostitutes who enjoy being beaten.[39]

Pelletier also wrote two articles which arose directly out of her experience in psychiatry. The first, 'Être Apache', which appeared in *La Guerre sociale* in June 1909, examined the petty criminal type from the perspective of social revolt, a theme similar to that of her play *Supérieur!* (1923). She recalled how at Sainte-Anne she had once been asked to interview a youth whose father wanted him committed in order to prevent him from stealing and mixing with bad company. Aside from providing an insight into the abuses of the *placement volontaire* system, Pelletier suggested that the *Apache*, or hoodlum type, represented an individual who legitimately rebelled against his proletarian condition. Prison, the young man told her, was better than a life of monotony in a factory. In a rare reference to her psychiatric internship Pelletier remarked: 'In my mind rose the image of my supervisors, those doctors with large private incomes, honoured, decorated, only moderately gifted men for the most part, but who had taken care to be well born.' She debated whether she should judge her *Apache* the way she knew her medical colleagues would judge him: 'I who came from the common people and as such should have been

condemned to mediocrity by these bourgeois; should I defend them?' She concluded that the *Apache* morality, though anti-social, represented a legitimate act of revolt in an unjust society.

The second article on a psychological theme, entitled 'Sadisme at Masochisme', examined both class and gender issues in relation to sexual deviance and made reference to Pelletier's experience of sexual disorders at Sainte-Anne. Based on the case of a sadistic wife-beater, a Monsieur Parat, who had recently been committed to an insane asylum, Pelletier focused in her article on the question of the wife's complicity in her own torture.[40] She compared Madame Parat's apparent acquiescence in her enslavement to what she saw as the willingness of the working class to accept degradation: 'I don't feel sorry for this woman. In the same way that I feel no pity for the working class, undergoing without protest the oppression of the bourgeois minority.' Pelletier compared the gender and class determinants of dominance and servility: 'Few men can be Napoleons – most men content themselves with mistreating some poor woman. Women, by dint of hearing and reading that for them voluptuousness lies in slavery, come to wish to be dominated and mistreated by a man.'[41]

She was wary, however, of the sex-linking of active and passive behaviour. Masochism was not necessarily feminine, she observed, nor sadism necessarily masculine, and she cited as evidence the many brothels that catered for male masochists. She construed psychosexual deviance as being largely of social origin, the product of a leisured and decadent culture. Gender difference could equally be understood as a social rather than a biological construct.

Although the majority of Pelletier's articles for *La Guerre sociale* debated socialist tactics, she did not hide her feminism. For example, in an article on neo-Malthusianism, 'Faut-il repeupler la France?', class and gender bias was her main focus of attack. The bourgeoisie, she alleged, widely practised birth control, leaving it to the working classes to breed cannon fodder. She appealed directly to working-class women on feminist grounds: 'We say to women: it isn't true that you are only a machine for reproduction. Equal to men, you are above all individuals who have the right to live your life.'[42]

Finally, following her own advice in 'La Tactique féministe' that 'whenever feminism is raised as an issue, the feminist should defend it with all her power', Pelletier in 'Les Suffragettes et

L'Humanité' defended the violent tactics of the English suf-
fragettes against the ridicule poured on them by the socialist
newspaper, *L'Humanité*. Commenting on the suffragette who had
horsewhipped Mr Churchill, Pelletier called it 'a legitimate act of
revolt, given that Mr Churchill was one of the most ferocious
adversaries of feminist demands.' She recalled her own visit to
England the previous year and Mrs Pankhurst's initial reluctance
to resort to violence:

> The English suffragettes have not always been in favour of violent
> protest. When, a year ago, having gone to London, I suggested to
> Mistress [sic] Pankhurst, their leader, that she invade Parliament
> with her twenty thousand feminists, she protested: 'Women', said
> she, 'should not use violence; persuasion alone was their weapon',
> etc. etc. At the present time, now that they are being condemned to
> ordinary prisons and to hard labour, now that they are being
> force-fed, when they, like Russian revolutionaries undertake hunger
> strikes, English women are beginning to think that against those
> who systematically refuse to negotiate there are other methods than
> persuasion.[43]

This call for feminist militancy may be compared with a similar
theme elaborated in the same year in 'La Tactique de l'attentat',[44]
which put the case for selective political assassination. It was
Pelletier's most explicit call for acts of terrorism; they could, she
claimed, at moments of social crisis have a decisive effect on events.
Militant socialists should not shrink for sentimental reasons from
following the logic of revolutionary militancy.

We shall see that when Pelletier visited the Soviet Union in 1921,
she expressed grave doubts about violent revolutionary methods,
as well as scepticism about the revolutionary intentions of the
French left. But in the 1907–1910 period she undoubtedly spoke
the language of militancy and might have liked to apply such
methods to the feminist struggle, though her feminist protests were
in fact purely symbolic. Were her articles for *La Guerre sociale*
largely tactical efforts to please her faction or was she genuinely
committed to revolutionary violence? In the long term, her
socialist militancy was probably more inconsistent than her
feminism.

Revolutionary Theory and Action

Within the Hervéiste faction, Pelletier succeeded in impressing her colleagues with her debating skills and organizational capacities. So well was she established that by April 1909, at the national congress held at St Etienne, she stood up to both Jaurès and Vaillant in debates, arguing against reform and in favour of militancy. She was nominated as Hervé's successor to the CAP (the Commission Administrative Permanente, the executive of the SFIO) and in the autumn, when Hervé was sent to prison (where he remained until 1912), Pelletier took his place. Here was rapid advancement for a neophyte, let alone a woman. Her decision to join a minority faction seemed to have been fully vindicated.[45]

In spite of her success in gaining an important position in the socialist hierarchy and her militant articles in *La Guerre sociale*, Pelletier early showed doubts, not about socialism but about revolution as the best means of achieving social justice for women and for the proletariat. In 'Le Féminisme et ses militantes', published in the same year that she gained her place on the CAP, she constructed a critique of the organizational weakness of French feminism and outlined what a feminist's attitude towards male politics ought to be.[46] She pointed out that some women were at present (1909) attracted by the anti-parliamentary politics of the left and had therefore renounced the aim of women's suffrage. This was a version of her own experience in Hervéiste circles, where such women were 'perfectly aware that the men of the parties of the far left are no better disposed to them than the moderates'. As a feminist, Pelletier made it clear that she thought women's political allegiance could move in any direction. Women could be libertarians, socialists, syndicalists or pacifists, whereas they really should be primarily feminists (p. 23). However, Pelletier concluded, women could at least learn political radicalism from men; they too should fight for their rights, with violence if need be.

In 'Le Féminisme et ses militantes', Pelletier attempted to understand women's political apathy in the context of her own socialist experience. She dwelt on the difficulty of rousing the aspirations of oppressed groups: 'Of the millions of workers who would have so much to gain and nothing to lose in the transformation of the social order, how many socialists are there? It is not

astonishing to find only the most lukewarm militancy among women' (p. 25). Whatever her successes or failures in socialist politics, the party had provided an education in organizational power structures, and speaking in her socialist capacity, Pelletier, like many of her generation, believed the revolution was imminent and necessary. But would it be favourable to feminism? Two years of work in the Hervéiste faction had left her less than sanguine. Groups on the left would tolerate feminism as long as it was not a central issue, indeed as long as nothing fundamental changed in the relationship between the sexes (p. 26). Although it was true that a few individual women such as herself had succeeded in the ranks of left-wing parties, the men of these parties were more anti-feminist than the bourgeoisie currently in power. Pelletier concluded on a curious note for a committed revolutionary: 'feminism can base most hope in social stability, but how long will social peace last?' (p. 26).

If one focuses on the doubts emerging in 'Le Féminisme et ses militantes' about Hervéiste revolutionary aims, one can conclude that Pelletier no longer felt, if she ever had, that the emancipation of the proletariat through violent revolution could be trusted to bring about women's emancipation. A revealing incident when Pelletier first took up her place on the CAP crystallized these problems. Thinking perhaps that this was the moment to affirm her conquest of a woman's place in a hitherto masculine political preserve, Pelletier 'realized an old dream' and went to a meeting of the CAP dressed in male garb. The effect was predictably disastrous. Cross-dressing to her Socialist comrades could only mean one thing. Pelletier, always clear about her own motives, was shocked at the interpretation which her clothes evoked. 'A ... comrade did a cartoon of me soliciting as a pederast on a Berlin street. A fancier in a pointed helmet followed me, stunned by my rear-end sex appeal.' This was a jibe at Pelletier's short and stout physique. The caption read: 'And this is why Madeleine ...' 'This brute', said Pelletier, 'could only imagine that one dressed in men's clothes for libidinous reasons.' However, one comrade did get the point. 'This at least,' he said to her, 'is equality.'[47]

Like the cartoonist who lampooned Pelletier as a transvestite, most post-Freudian readers, even in an age of unisex dress, equate appropriation of another sex's dress code as evidence of displaced sexual desire. It is difficult to know whether Pelletier would have

read her cross-dressing in this way. From an early age, she had adopted male dress as part of her battle for equality. No firm evidence has come to light that she identified herself as a lesbian, though it was assumed by some of her contemporaries that she was one. For example a police report dated 2 February 1916 remarked: 'Madeleine Pelletier is considered to have rather particular tastes, and is thought of in the society she frequents as a lesbian.'[48] It is also true that she explicitly identified with the male sphere of action and felt trapped by her gender, lamenting on one occasion: 'Oh why am I not a man; my sex is the worst misfortune of my life.'[49]

One imagines that as an early reader of Freud, Pelletier would have understood the implications of her masculinized appearance. If, under the masculine order, power in the social imagination was reduced to the phallus, which is turn was both concealed and suggested by masculine dress, then to affirm such a dress code was to affirm power and equality.

The question of masculine and feminine dress and its implications transcended the question of Pelletier's personal preferences, however. One of her most perceptive pre-war essays, *L'Éducation féministe des filles* (1914) analysed the social conditioning of girls and how society constructed gender through dress and manners. She argued powerfully that dress reform for young girls would be crucial to their emancipation. Anticipating the work of Beauvoir and subsequent feminists, Pelletier looked at the social creation of the 'eternal feminine'. Though arguing for a feminist education for women, Pelletier recognized at the outset that education was not an individual affair, but the product of a whole culture. It was not practical to educate an individual girl in a non-sexist way; a fundamental shift in social attitudes was required:

> It is almost impossible to bring up a child by ideas which are in opposition to the mass of society. The feminist mother will have against her her husband, her parents, her servants if she has any, her friends, neighbours, the school, passers-by in the street; in short all of society. Even if she had the necessary energy to resist them all, she would still fail, for her child would abandon her to go along with the majority.[50]

Education needed to be defined in the broadest sense, where

dress could be identified as one of the first crucial formative influences, decisive in developing girls' bodies and characters.[51] Dressed like boys, girls would enjoy freedom of movement denied them in the restrictive skirts, stays and shoes of female fashion; they would learn both physical and mental freedom. Feminine clothes, from childhood on, not only constrained women, they were exhibition frames to show them off as so much flesh for purchase. But it was not enough to picture women as merely the passive victims of external conditioning. Pelletier was struck by the extent to which women themselves constructed their daughters in the image of their own femininity, which for Pelletier was synonymous with inferiority. To a great extent, she believed, women collaborated in the continuing enslavement of their sex. Thus Pelletier's ideas for educational reform for women centred less on academic syllabuses than on changing their social conditioning, redrawing their psychological map and giving them knowledge of, and therefore power over, their own bodies.

A substantial portion of Pelletier's analysis focused on women's need to respect themselves both physically and intellectually, a process that should begin in early childhood. Personal appearance was more than a matter of dress codes; it involved the child's bearing and social confidence:

A disproportionate pride is harmful, makes us antipathetic to others and antagonizes people. But one must teach a child to have confidence in itself and to make others appreciate its value. The child will be taught to hold its head high, the body straight, to look at others straight in the eye, and to speak its opinion frankly without worrying about its audience.[52]

What today has become known as 'assertiveness training', Pelletier identified as a central requirement for girls' education. How else to overcome the debilitating effects of the conditioning in humility, coyness and modesty, which were really a training in inferiority?

The theoretical case which Pelletier put for dress reform was given practical expression in her own life. She disguised herself in male attire when she wished to walk in Paris unmolested. Here was a uniform that granted liberty and safety. 'I was freed from being followed in the streets at night – whereas a young woman would be accosted at every step.'[53] Freedom from fear, from harassment,

from humiliation and intimidation, these were some of the invisible male freedoms won by her recourse to male garb. But when she was recognized, mockery and the brutality of her colleagues were the price she had to pay. A more pragmatic, cautious and diplomatic individual would not have risked shocking the sensibilities of her comrades. Perhaps she could not believe, until she tested them, that as socialists they would deny her the rights they took for granted for themselves and for which they proclaimed the coming revolution to free humankind.

In retrospect, Pelletier rather belittled her achievement in becoming a member of the CAP, in which she was mistaken. She had succeeded in learning the rules of political manipulation and had applied them effectively. She was fearless in public debate, as her taking on of Jaurès and Vaillant demonstrated. Yet she felt that her tactic of attaining power as a woman within the party hierarchy came to nothing tangible:

> Hervéism has few adherents, that is why I rose rapidly in the ranks, and in eighteen months, thanks to proportional representation, I arrived at the summit of the party hierarchy. The theoretical summit. In practice, the CAP directs nothing; only administrative problems are submitted to it. Leadership was in *L'Humanité* and the parliamentary party.[54]

When Hervé was imprisoned in 1908, Pelletier visited him at the Santé. She was depressed by the psychological effects produced on the inmates, particularly, she noted, the effects of sexual abstinence. The visitors were shepherded into a huge hall:

> Where some hundred people are seated on cane chairs ... a dim light falls from the high windows on the dark grey walls ... an unpleasant odour of mice is everywhere. All the political prisoners are there: the hall has the appearance of a bordello; the prisoners' mistresses are seated on their knees. Of course I know that prison includes privations, but all the same my faith in the revolution cooled remarkably at the sight of this sex-starved band. I said to myself that these are opportunists and not convinced revolutionaries and if ever they triumphed they would not wish for anything better than those now in power whose places they took.[55]

One finds here another indication of Pelletier's revolutionary

doubts. Whom would the revolution profit? Not, she feared, women. It was not the aims of socialism that Pelletier questioned but the capacity of the working class to carry out its liberating mission.

The 1910 Legislative Elections

Four years in the SFIO, two of them in a position of considerable responsibility on the CAP, must have led Pelletier to hope that the party would give her some reward. Though an anti-parliamentarian, she sought to fight a winnable socialist seat in the 1910 legislative elections. After the unexpectedly favourable publicity accorded to Laloë in the 1908 municipal elections and her success in winning over 20 per cent of the vote, both Radical and Socialist feminists planned to build up propaganda for women's suffrage by putting women forward as paper candidates for the legislative elections of 24 April 1910.[56] Pelletier, however, wished to stand in a potentially winnable seat and announced her intention of contesting the fifth arrondissement (the Latin Quarter), a socialist area. She declared her candidacy withour prior consultation with her party, evidently hoping that they would either approve her candidature or at least not contest it. If a woman were actually to be elected and were subsequently denied entry to the Chamber of Deputies because of her sex, this would be a striking piece of propaganda for the women's suffrage movement. From the perspective of the SFIO, however, to allow Pelletier to stand would have meant losing a safe seat. Reprimanding her for having put her name forward in the fifth arrondissement without permission, the party selected her instead for the intensely conservative seat of the eighth, in the Madeleine quarter. Socialists were not going to be accused of refusing to endorse women candidates; instead women were given candidacies in hopeless constituencies.

Nine women stood as candidates that year in Paris, among them Durand, Auclert, Véronne, Kauffmann and Pelletier. Pelletier's electoral district was held by the conservative monarchist, Denys Cochin, who in 1906 had polled 7,058 votes to the socialist's 263. This was scarcely an enlivening prospect for the new socialist candidate. Nevertheless Pelletier approached her campaign with zest. She welcomed any opportunity to mount a public platform as

a woman, seeing it as valuable propaganda, and she relished the drama of campaigning, even deriving enjoyment from the heckling. Her campaign address was intended to appeal primarily to the servant class, virtually the only working-class people in the quarter.[57]

Pelletier had feared that her audiences at election rallies would prove much more difficult than her Socialist comrades at party meetings. There she had a professional and political reputation in the party, here, among butlers, coachmen, valets, cooks – no socialists or feminists in sight – she was only a strange woman doctor. Her tactic was to suggest that as a woman candidate she represented the result of a natural process of social development. 'Telling them all about the evolution of women towards independence, I presented myself as an example of this evolution.' Her audiences attacked most aspects of the socialist platform, but she claimed to suffer no anti-feminist reaction. 'Even if the law's injustice made me ineligible as a candidate, I at least wanted my candidature to be taken seriously like a man's. In this I succeeded. They swallowed my feminism, so to speak, almost without noticing.'[58]

In the admittedly unlikely event of being selected, she promised that she would agitate for a minimum wage for domestic servants and statutory time off. She declared herself in favour of equality in educational opportunity and a graduated income tax. This was centrist socialist policy, as was her promise to fight for socialist or collectivist principles within parliament until such a time as capitalism was defeated. Her party minders dissuaded her from mentioning the revolution though she managed an attack on militarism. Her campaign address was certainly not in the Hervéiste mould. Standing for parliament was in any case not an activity the Hervéistes could have sanctioned. Pelletier was fighting as a feminist socialist for the principle of women taking part in political activity. The Hervéist anti-parliamentarians did not even report her campaign in *La Guerre sociale*. Pelletier's efforts, even in this hopeless constituency, were not without some modest success. She received 340 votes out of 8,698 (4 per cent), 77 more than the socialist candidate at the previous election. As many as 340 people in a highly conservative area appeared to think that a woman was capable of representing them in parliament. In a socialist district, she believed, it would have been 2,000.

Two other contemporary accounts of Pelletier's campaign are worth noting, one by Edouard Le Page of *L'Eclair*, who had attended a rally where both Pelletier and Marguerite Durand spoke, and the other by the feminist Oddo-Deflou for *La Fronde*.[59] Le Page's facetious and sniggering tone was characteristic of the reporting of feminist questions by the mainstream press; his portrait of Pelletier was particularly unflattering: 'She was not yet a man or any longer a woman. She was a hybrid creature, a man on top, by reason of her short hair, hat, white tie, high collar and jacket, a woman beneath by her skirts.'

Le Page claimed that Pelletier spoke without eloquence and with commonplace, popular expressions and gestures, yet he admitted that she held her audience. He seemed astounded that she preached socialism, though she was the socialist candidate, and that she spoke of the hostility between classes. All this was unwomanly. In spite of the heavy irony expended on her socialist programme, the implication being that a woman could not seriously be considered to have political ideas, he admitted that Pelletier made a powerful speech. He compared her unfavourably with the next speaker, Marguerite Durand; she, tall, blonde and beautiful, with harmonious gestures and an easy address, seemed to express to the enraptured reporter a 'supernatural feminism'. Here was no unsettling talk of class warfare, but of class reconciliation via feminism, by which he apparently meant 'femininity'. The contrast in styles between Pelletier and Durand was, indeed, telling. Pelletier wished to indicate by her costume as well as by her speech that feminism, like socialism, would mean fundamental changes in society. The Durand model of feminism suggested that men would treat women better without any real shift in power relations. Women would always be 'womanly'.

In assessing the effectiveness of this campaign, it is useful to recall the level of argument about women's competencies and rights obtaining at the time. It was still commonplace to claim that women were inhibited by their biology and their emotions from speaking in public and that they were incapable of sustained effort in the public sphere. Every time women candidates succeeded in delivering a speech in public, every time they demonstrated effectively in the streets, or a woman fulfilled a public or professional function, they gave the lie to the claim of incapacity. Thus Deflou's article concentrated on the significance of the 1910

elections for feminism. She stressed the point, insufficiently appreciated by male observers habituated to participating in the political process, that women experienced extreme difficulty in overcoming their conditioning against appearing in public. But here at last, Deflou felt, in 1910 women could stand on a public platform without fear that their moral reputations would be compromised. This was itself a major advance.

The 1910 elections almost certainly precipitated Pelletier's break with the Hervéistes. It was already becoming clear that Hervé was veering to the right, and with the advent of war he transformed himself, like many other members of the Second International, into a fervid nationalist, abandoning both his pacifism and his internationalism. Pelletier announced her break with the Hervéistes in June 1910, soon after the elections. Although she was designated by the CAP as a delegate to the Women's Socialist Conference (part of the Congress of the Socialist International) in August in Copenhagen, she did not attend, almost certainly because she no longer represented the Hervéiste faction. By 1911 she had lost her place on the CAP.[60]

Pelletier's own account of her break was somewhat confused as it conflated a number of disagreements that occurred from 1906 onwards. Hervé had often reproved her over the question of dress, claiming that Louise Michel, who succeeded politically, dressed like any other woman.[61] In another version of the same issue Pelletier attributed her difficulties to a Socialist, Rappaport, who, although he had endorsed her candidacy in 1910, was horrified by her masculine clothes. She claimed that colleagues accused her of being more of a feminist than a revolutionary. 'I won't call myself anti-feminist in order to please people who only want justice for themsevles.'[62] Pelletier also alleged that her demonstration to shower the chamber with leaflets (1906), for which she was censored by the eighteenth section, lost her her place on the CAP, an error in chronology, since she only joined the CAP in 1909. But what seems indisputable is that Pelletier rubbed against the grain of her Socialist comrades on many issues. She was intransigent on the questions that mattered to her: 'I would never retract on a question I felt was important.'[63]

The conflicts confronting feminists within socialist politics and working-class organizations were vividly illustrated for Pelletier and other feminists in 1912–13 by the Couriau Affair. This trade

union dispute offered a paradigm of many of the difficulties experienced by women in the context of French syndicalism and socialism.[64] Although between 1890 and 1914, women formed less than 10 per cent of trade union membership in France, they constituted between 34 and 37 per cent of the workforce. This serious under-representation of women in the trade union movement reflected male hostility to women as competitors in the labour market as well as a traditionalist view of women's domestic rôle. The Couriau Affair was a watershed in the effort to link women's emancipation to the class struggle, involving as it did the attempt of a woman to gain recognition in a hitherto all-male trade union.

Emma Couriau, a printer and married to a printer, had applied in 1912 to join the Lyons printers' union, the Syndicat du Livre. She was rejected by the union on the grounds that women's wages undercut men's and that, in any case, a woman's place was in the home. In addition, her husband, Louis Couriau, was expelled from the union for allowing his wife to work. Though the CGT backed Emma Couriau against the Lyons print union, her strongest support came from feminist groups, spearheaded by Marguerite Durand's *La Fronde*. The case was perceived by feminist contemporaries as a classic example of 'hominisme'.

Pelletier in the December issue of *L'Equité*, entirely devoted to the Couriau Affair, focused on the general question of women's relationship to the trade union movement and to socialism. She affirmed women's right to work as the fundamental condition for liberty under any economic system. Nothing would be achieved for women without economic independence:

> To restrain women from working in a capitalist society is to condemn them to the horrors of prostitution. As for restraining women's right to work in a socialist society, I dare to hope that one would not find many socialists to wish it. Otherwise, the first duty of women would be to combat socialism with all their might, for the half-liberty which they enjoy in civilized countries today is a thousand times preferable to the role of 'beasts of pleasure and of reproduction' which certain people wish to give women under socialism.[65]

This article underscored Pelletier's doubts about the relevance of syndicalism, imprinted as it was with its Proudhonian misogynistic

legacy, and of socialism as then understood, to women's emancipation. The print workers of Lyon had succeeded in giving the lie to Bebel's claim that the working class was more enlightened than other classes in relation to women. Competition for wages made women workers not the allies but the rivals of working-class men. It seemed evident that socialist theories about unifying the working class did not apply across gender lines.

Pelletier's scepticism lay with socialist practice rather than with socialist theory. Unlike German socialist women, she was unwilling to forgo feminist goals until the revolution was achieved. In the SFIO, as in freemasonry, Pelletier had fought to integrate not to separate men and women's activities. She remained a socialist, as she remained a freemason, but although she stood again as a candidate in 1912, her period of greatest activity and influence in the SFIO was over after 1911.[66]

When Pelletier joined the SFIO in 1906 there was no movement within the party comparable to that in the German SPD for recruiting women to socialism. As an individual, therefore, she sought political power within party factions which she believed could be used both for the party and for feminism. The electoral campaigns of 1908, 1910 and 1912 did provide an important forum for feminist publicity. The optimism feminists felt in the period from 1908 to 1912 was based partly on increasing parliamentary and international support for the suffrage case and partly on feminists' growing self-confidence. It seemed to their generation that persuasion, international example and propaganda would move the Republic to grant the vote to women. Their hopes collapsed on the outbreak of the Great War.

Pelletier's break with Hervéisme in 1910–11 seems to have represented a moment of taking stock. Significantly, in the same year, she published her first full-length feminist text, *L'Émancipation sexuelle de la femme*.[67] Developing themes that had already emerged in her journalism, Pelletier began to articulate a psychological theory of women's subordination and a programme for feminist action. She became one of the first important theoreticians of the feminist movement, drawing on her training in medicine, psychiatry and evolutionary anthropology. She shifted the debate on women's rights from the question of legal and political reform to a consideration of the social and sexual origins of women's oppression.

The 1906–11 experience demonstrated that Pelletier was not prepared to succeed in politics at any price, though she may well have been tempted by careerism. *L'Émancipation sexuelle de la femme* may partly be interpreted as a gesture of defiance to her socialist comrades. It affirmed that women's issues and their analysis did not presently appear on the socialist agenda. Her attempt to construct a feminist theory can be seen as an amplification of that agenda. Pelletier did not reject socialism, but she believed that much of the socialist analysis of society based on wage relations did not begin to address problems of women's economic and psychological subordination and their slavery within the context of reproduction and of the family. Her subsequent career as a writer and as a militant feminist explored the implications of a genuinely socialist vision for women and men.

6

Writing and the War, 1911–1918

Between 1911 and 1914, Pelletier published a series of books and pamphlets on a wide range of topics: sexual emancipation, abortion, female education and social justice. These texts, coming after her period of active involvement in socialist politics and her polemical articles for Hervé's *La Guerre sociale*, represented a shift in direction. They reflected the fruits of her work in socialist politics, in feminist groups and her professional experience as a doctor, particularly in midwifery, as well as constituting an explicit critique of socialist ideology in so far as it affected women.[1] Pelletier also re-established links with anarchist circles, largely in the context of her interest in neo-Malthusian or birth control issues.[2]

Pelletier earned her living largely from her work as medical officer for the Postes et Télégraphes from which she derived an annual income of 1,800 francs, a poor salary by professional standards. Her salary was certainly above the poverty line but barely merits the adjective 'comfortable'. Her own medical practice was estimated by the police to have brought in negligible earnings, and her rent at 55 rue Damrémont, her home and surgery until the war, was 850 francs per annum, a high proportion of her income. To offer a comparison, before the First World War, Hubertine Auclert had a private income of between two and three thousand francs a year. Steven Hause describes her economic position as 'comfortable, secure and independent'. A maximum wage for a skilled cabinetmaker would have been 2,100 francs.[3]

Until the war, Pelletier's economic position continued to be precarious.[3]

The year 1911 saw the publication of *L'Émancipation sexuelle de la femme*, which encapsulated Pelletier's attempt to link women's civil and legal subordination (as for example in her articles in *La Suffragiste*) to women's sexual subjugation. *L'Émancipation sexuelle* located women's emancipation not merely in the reform of legal statutes, but in the fundamental reorganization of sexual attitudes. On a practice level, however, Pelletier recognized that the law was the objective expression of women's social and psychological subordination. The Napoleonic Code enshrined the double standard whereby, for example, a wife who committed adultery was liable to two years imprisonment and could be divorced by her husband, whereas adultery in husbands brought no legal sanctions and little social disapproval.[4] The effect of the double moral/legal standard and the virtual economic ownership of women by men meant that there was little difference between prostitution and marriage; in both cases women were effectively sexual slaves. Her medical experience further coloured her views of women's subjection within marriage: 'In maternity hospitals, doctors deliberately prolong the stay of patients. They know that once a woman has returned home, she will have to submit to her husband, in spite of [medical] advice to the contrary.'[5] Her obstetrical training had taught her the reality of men's sexual authority, demonstrated by women's repeated and debilitating pregnancies as well as their proneness to sexually transmitted disease, of whose origin most women were completely ignorant.

Pelletier concluded that the sexual emancipation of women implied a radical restructuring of the family unit and the abolition of the traditional patriarchal family. Though in this she followed both anarchist and socialist thinking, like her mentor Letourneau, she placed the case for the dissolution of the family in a neo-Lamarckian evolutionary framework. Family life, she argued, was anti-evolutionary: it fixed a monotonous and rigid pattern of existence which partly explained the extremely slow rate of social progress: 'If the social cell, instead of being the family, were the individual, if each person, sure of finding minimal subsistence from the state, were less hesitant in moving their tent, the variety of life would be more lively, more intelligent and all of society would gain.'[6]

The Abortion Question

The most contentious section of *L'Émancipation sexuelle* concerned abortion. In Pelletier's view, the crucial step in challenging the patriarchal family was to establish the right of women to control their own fertility. Her manifesto on abortion, *Pour l'abrogation de l'article 317. Le droit à l'avortement*, first appeared as part of *L'Émancipation sexuelle de la femme* in 1911 and subsequently in a separate pamphlet in 1913. The title referred to the paragraph in the Criminal Code which made abortion illegal and punishable by a prison sentence.[7] The importance that Pelletier attached to abortion in the context of the feminist struggle is indicated not only by the fact that she reprinted the text several times, and wrote newspaper articles on the subject, and letters to Arria Ly defending abortion, but also by the strong presumption that she herself administered abortions, in effect as propaganda by the deed for feminism.[8] Pelletier's pamphlet forms an interesting chapter in the history of neo-Malthusian propaganda in France. As will become evident, (chapter 8) after the First World War attitudes against contraception and abortion hardened; the law of 31 July 1920, for example, made all contraceptive propaganda illegal. Pelletier could not safely have published *Le Droit à l'avortement* after 1920.

In the context of contemporary feminist and socialist politics, Pelletier's advocacy of abortions on demand and her insistence that women had a right to control their own fertility appeared extremely radical. Abortion was a taboo issue for many feminists. Pelletier grounded her discussion in a biological-evolutionary framework, examining the way different species reproduced and the function of reproduction in the survival and development of species:

> Among civilized peoples, the development of sexuality is out of all proportion to the needs of reproduction ... Whereas in the animal species the sexual need only appears at certain times of the year, it has become continuous in the human species. Far from being limited to marriage, love extends far beyond it; from puberty to old age man gives himself to love freely outside of the conjugal bond; the reproductive intent is completely banished from this freewheeling career devoted to sexuality. When a baby arrives it is a lamentable accident.[9]

In human society, where women were subordinate, love as pleasure was, however, effectively restricted to men: 'As long as women are considered to be inferior beings, one may say that love is reserved for the male sex. Woman is only an instrument for man's pleasure; he consumes her like a fruit.'[10]

However in the evolution of social mores, women were at long last beginning to demand the right to enjoy sexuality like men. Though there were many social obstacles to the free expression of pleasure for women, of a legal, moral and psychological order, these were dwarfed by the great natural obstacle, the likelihood of pregnancy. Maternity subjected women to a form of natural inequality by their inability to enjoy sexual activity with freedom. Burdened with a child, a woman became dependent on the male for her livelihood. The solution to this problem lay in state support for unmarried and married mothers, contraception and, failing that, legally available abortion. Pelletier agreed that abortions were dangerous if practised after the third month, or by midwives careless in antisepsis. But properly performed, she argued, abortion was a perfectly safe operation. Its dangers were entirely associated with the illegality which forced many women to attempt abortions on themselves, or to resort to unscrupulous practitioners, often with disastrous results.[11] Pelletier used her medical experience to lend authority to her arguments; but there can have been few qualified doctors who would have risked their reputations by publically espousing the pro-abortion cause.

Pelletier's advocacy of abortion was a clear challenge to the pro-natalist lobby which had been urging measures on the government to encourage the flagging birth-rate ever since France's defeat in the Franco–Prussian War. In relation to its European neighbours, the French birth-rate had been in decline since about 1820. Though the population as a whole grew in absolute terms, partly as a result of greater longevity, the rate of increase had slowed down. In 1816–20, for example, there were 329 births per 10,000 inhabitants; by 1906 these had fallen to 202 births per 10,000. In the wake of 1870, a pro-natalist campaign was launched to 'urge women to fulfil their demographic duty'.[12] It was alleged that France faced the 'spectre of depopulation' and that family virtues were being weakened; depopulation, the pro-natalists urged, brought the importation of foreigners and with them foreign ideas, namely those of the English neo-Malthusians.[13] Anarchist tendencies, it

was claimed, were further weakening the family as was clear from
the anarchist Paul Robin's group, La Régénération Humaine.
Robin, for example, had stated, 'It is up to women and women
alone to decide whether or not to carry the terrible burdens of
maternity.' For the pro-natalists, Pelletier's pamphlet, combining
as it did feminist, anarchist and neo-Malthusian elements and
arguing that the individual had an absolute right to control her/his
reproduction, represented a serious challenge.[14]

However, Robin and Pelletier were not representative of all
anarchist opinion. The leading French anarchist Elisée Reclus, for
example, was horrified by neo-Malthusianism which he believed
was elitist.[15] Nor can responsibility for the decline in the birth-
rate, which certainly continued in France, be blamed principally on
the neo-Malthusians. There existed and continued to exist wide-
spread unofficial and clandestine recourse to contraception and
abortion, practised more successfully in France than in England or
Germany, this is spite of the opposition from the church and from
the patriotic lobby. The efforts of the neo-Malthusians were geared
to decriminalizing contraception and abortion, to making con-
traceptive techniques available to the working class and to freeing
women from excessive maternity.[16] Though identified by pro-
natalists as the source of the problem, the scale of contraceptive
practice in France, especially among the middle class, suggests that
neo-Malthusian propaganda can only have had a marginal effect on
an already well established practice.

While agreeing that the conditions for maternity needed radical
improvement, Pelletier's case for abortion and contraception was
in essence a libertarian one. Women should not be forced to gestate
and give birth against their will. In entering the debate on birth
control, Pelletier not only tackled a subject most feminists prefer-
red to avoid, she was also out of step with her own profession.
Though many French doctors by 1850 were prepared to carry out
therapeutic terminations, they were generally hostile to abortion as
a form of birth control.[17] Pelletier's defence of abortion put her at
odds with both mainstream feminists and with the medical profes-
sion.

Pelletier also found hostility to birth control among socialists,
not least from her revolutionary colleague, Hervé, who asked
rhetorically: 'Must France be allowed to die? Neo-Malthusianism
is in the process of emptying France.'[18] Hervé's paper *La Guerre*

sociale, however, supported the neo-Malthusian position and advertised works on contraception. Pelletier was active in attempting to persuade socialists of the virtues of the neo-Malthusian position:

> I have often wondered why the PSU [Parti Socialiste Unifié] showed itself hostile to neo-Malthusian propaganda. . . . Paul Robin in effect made neo-Malthusianism into a genuine social system . . . A reformer of a sort, he mainly wanted to improve the workers' lot by limiting the demand for work through a wise limitation of proletarian fertility . . . understood in this way, neo-Malthusianism was in some sense a separate party from socialism . . . But voluntary birth control is not necessarily linked to a social theory. However one envisages a future society, it remains true that at the present time it is easier for a working-class family to feed two children than six.[19]

It was no good, Pelletier suggested, asking the working class and women within that class to await the revolution before their situation changed. The poor had the possibility within their own hands of improving their condition by practising family limitation. As for the idea mooted by many socialists that it was important to breed as large and as discontented a proletariat as possible in order to bring about the revolution, Pelletier believed that this was to sacrifice individuals to a problematic future, and the individuals particularly sacrificed were women.[20] Furthermore, workers brutalized by a life of incessant labour and crushed by endless numbers of children were incapable of being effective members of the Socialist Party:

> Certainly the main aim of the Socialist Party ought always to be the dissemination of its doctrine – but why systematically renounce educating militants; why not teach them the advantages of not drinking too much or of producing too many children? Recruiting isn't enough, the Socialist Party . . . will be as strong as its members, who by their intellectual and moral worth will be able to institute an elite in the heart of the proletariat.[21]

On this as on many issues Pelletier was, if not a reformist, at least a pragmatist. In addition she demonstrated an elitism visible from her earliest contacts with freemasonry and also attributable to her own position as a self-made intellectual. One of the contradic-

tions running increasingly through her egalitarian political commitment was her conviction of the necessity for an intellectual and a moral ruling elite. The tensions between the two tendencies became a marked feature of her work.

Finally, Pelletier's indictment of childbearing and unwanted motherhood gained force from her medical experience in working-class districts and from memories of her own mother's repeated miscarriages. The physical disabilities of motherhood, which she saw every week in her surgery, were never mentioned, she noted, by those who idealized maternity. Women in pregnancy were subject to sickness, digestive troubles, fatigue and lethargy, which culminated in the suffering of labour. Condemned to prolapses and varicose veins, their legs in bandages, many women became walking invalids, their individuality sacrificed to the species in the name of reproduction.[22] Unrestrained motherhood ensured that women could never exercise sexual or intellectual liberty or gain equality.

Yet in spite of Pelletier's libertarian call for women's sexual emancipation, it underscored paradoxes in her own life. While arguing for women's sexual freedom, she, like many feminists of her generation, considered that individual feminists could not afford to transgress accepted sexual mores lest their aim of political and civil liberty should be construed by their opponents as a mask for licentiousness. Pelletier accorded to herself the right to dress and behave as she chose, but in effect led a life of principled celibacy. In addition she was quite pitiless in her demands on women in public life. Perhaps the most striking example was her attitude towards the physicist Marie Curie.

Pelletier both admired and envied Curie, who had succeeded brilliantly in an area where Pelletier had once hoped to make her mark, namely in scientific research. At the turn of the century, Curie was the byword for the highly talented woman in a hitherto entirely male profession. Indeed Pelletier had referred to her as an example of the cultural evolution of feminism in her campaign speech of 1910. However in private Pelletier was caustic about Curie's diplomatic avoidance of an explicit feminist commitment. Though Curie did belong to a non-militant feminist group, the Conseil International des Femmes, which had some 70,000 members, Pelletier considered her to have made the avoidance of overtly feminist issues the price of her success in a man's world.

The recipient of two Nobel Prizes, Curie's public image was that of the tireless worker, the devoted wife and mother, and, with the tragic death of Pierre Curie in 1906, the inconsolable widow. Thus, though a successful women in a hitherto all-male field, she did not in any fundamental way challenge sexual stereotypes. However, in 1910–11 it was sensationally revealed that after her husband's death she had become involved in an affair with Professor Langevin of the Collège de France, a married colleague with four children. When the story broke in the popular press, the resulting scandal focused largely on Curie rather than on Langevin. Curie's sex, her mores and her Polish nationality were all held against her. Nationalism, xenophobia and misogyny allied themselves in her vilification.[23] Pelletier too was outraged but for different reasons. Measuring everything by one standard, she resented what Curie's imprudence would do to the feminist movement:

> Mme Curie's case is maddening; it already has caused me to quarrel with a family of freemasons and landed me with a number of bitter reproaches; as though it were my fault, or the fault of feminists that Mme Curie is sleeping with M. Langevin.
>
> In any case, as you may know, Mme Curie claims that she is not a feminist. Her case will obviously do a great deal of damage to our cause; it will be said, it is being said, that the first time a place is made for a woman [in the highest academic circles] she conducts herself like a whore. She should have been more discreet in her relations with this gentleman. But women lack dignity. Here is a case that proves my thesis [about sexual emancipation]. When sexual love has been emancipated, Mme Curie can sleep with whomever she likes, she will no longer harm feminism.[24]

In Pelletier's view, though feminism implied the destruction of the patriarchal family, individual feminists and talented women carried a special responsibility to ensure that their behaviour was above reproach in a patriarchal system. In effect, feminists needed to be saints or ascetics.

By 1914, Pelletier's feminist demands went far beyond the suffrage and were more radical than almost any other French feminist of her generation.[25] Many of her views paralleled those of German feminists like Marie Stritt, president of the Federation of German Women's Associations, who in 1907 called for the abolition of state-regulated prostitution, the introduction of equal

education, equal pay and equal suffrage, or Helen Stocker, who advocated contraception, legalized abortion, equality for unmarried mothers and for illegitimate children.[26] But in France, Pelletier's efforts to argue for reform in the abortion law gained little support from feminist groups or from socialists. Her analysis of patriarchal society and her attack on the structure of the family were too radical for most feminists to support. Though her intellectual enthusiasms appeared to have survived the disappointments she had experienced, she was well aware of her limited effectiveness. 'I decidedly was born several centuries too early.'[27]

The War Years

For socialist feminists like Madeleine Pelletier, the 1914–18 war marked the end of one form of broadly revolutionary optimism. When the European socialist parties opted for patriotic nationalism rather than for support for the Second International, the possibility of international proletarian solidarity collapsed and, with it, the avoidance of war based on the concept that a united working class would refuse to take arms against itself. Like the Socialist International, the international and pacifist character of feminist movements was transformed. Many feminist groups like Solidarité disbanded, others supported the war effort. Pelletier commented acidly: 'I haven't propagandized for feminism for the past eleven years in order to end up knitting socks. I prefer not to hold meetings of Solidarité any longer.'[28] Pacifists faced severe punishment. The socialist Louise Saumoneau was imprisoned in the Saint Lazare prison for prostitutes for distributing pacifist leaflets. Hélène Brion was also prosecuted for pacifist agitation.[29]

At the outbreak of the war, Pelletier gave up her flat in the rue Damrémont, closed her surgery and took rooms in Elizabeth Renaud's *pension*, 10, rue Berthellet. Renaud was a feminist and socialist militant, formerly a member of the Groupe des Femmes Socialistes, who had gained over 2,000 votes in the 1910 elections when she stood as a Socialist in the Vienne. She ran a small boarding house known as a centre of left-wing activity. According to Marx's grandson, Jean Longuet, it was a 'veritable foyer of propaganda and socialist controversy'.[30]

We are fortunate in possessing Pelletier's records of her war

experiences from a fragmentary but gripping diary which she kept between 25 August 1914 and 27 September 1918.[31] Unlike her autobiography, 'Doctoresse Pelletier', which is a political rather than a personal work, the War Diary recorded her moments of intense depression, as well as her war adventures. Thanks to her profession and to her buccaneering spirit, Pelletier witnessed events that would normally have been accessible only to her male contemporaries. She was evidently fascinated by the psychological impact of war on the civilian population when, seemingly overnight, rabid patriotism and spy mania surfaced in otherwise level-headed and inoffensive people. The War Diary was both a personal record and a psychosocial study.

Pelletier undoubtedly went through the equivalent of a spiritual crisis in the early days of war. The failure of socialist hopes, the proscription of pacifists, the personal danger suspect individuals like herself laboured under and the virtual collapse of the women's suffrage movement, all contributed to her malaise. Yet her attitude to the war was ambivalent. A convinced pacifist, she had argued for conscription for women. And from a feminist perspective one bonus was evident – the war provided employment for women in the traditionally male work sector: 'War becomes a paradise for working-class women. Never have they been as happy, at least from a material point of view. Never have they earned so much money.'[32] Women became metalworkers, chemists, tramway drivers, at least for the duration of the war; they experienced new possibilities. Traditional arguments suggesting the natural unfitness of women to perform 'male' functions began to look altogether untenable.

The first year of the war was particularly frustrating for Pelletier. She had applied to serve at the front in the army medical corps, which would have allowed her to see action at first hand and to win another 'first' for feminism as a woman army doctor. But neither her political nor her medical contacts succeeded in obtaining her a post. Militarism even seemed to exacerbate male prejudice:

Unfortunately the war is anti-feminist because women are excluded. ... I have tried to move heaven and earth to be assigned to an ambulance corps but without success. Guesde, now a minister, when I asked him to take advantage of his spell in power to achieve

a little victory for feminism by sending women doctors to the armies, replied that if I thought that a minister had any power I was greatly deceived and that, in any case, he had plenty of other fish to fry.[33]

Even worse, in Pelletier's opinion, many feminists had taken on traditional women's service roles. She had so often heard feminists recommended to 'get back to their sock mending' by anti-feminists that such activities enraged her, even if they might have had some utility: 'Marguerite Durand and M. Vérone knit pullovers, probably thinking that this advances the cause of feminism.'[34]

While lobbying ministers unsuccessfully to be allowed to join the ambulance corps, Pelletier enrolled with the Red Cross. As a professional woman, Pelletier disliked the amateur status of a volunteer doctor and she resented the real or suspected patronage afforded her by the largely upper middle-class volunteers: 'I was welcomed more or less like a dog in a game of skittles because I didn't have my own car and a manservant. Far too many devoted souls volunteer; all the rich or middle-class women want to be nurses.'[35]

For her first assignment with the Red Cross, Pelletier was sent to Nancy to look after the wounded and there she experienced a frightening example of the new climate of suspicion and spy mania: 'My masculine appearance sufficed to call up a crowd of some two thousand persons howling around me; an old woman seized me violently by the jacket; I owed my rescue to climbing into an officer's car.'[36] The two thousand persons might have been an exaggeration; still, Pelletier had certainly found herself in the midst of a hostile mob, purely on the basis of her masculine appearance. In another incident she was arrested by a suspicious police offer for speaking to someone on a tram. She despaired for civil liberties.[37]

As a student of psychology, Pelletier was fascinated by the brutality that war allowed ordinary people to express from behind a civilized veneer. Though patriotism seemed to increase political consciousness, it also produced more unpleasant responses. Suspicion had become an almost universal attitude:

24 August 1914

The word 'war' arouses patriotism: everyone is excited about the events, people talk of nothing else. Even women know all about the war and discuss it like men.

But in general bad feelings surface more than good ones. Mlle Ollier, an old feminist, an entirely inoffensive person, and *deaf* to boot, had been commanded by the mayor of the village of Yens, where she has a little house, *to abstain from all demonstrations since we are at war*. Because she spent several years in America and has a vaguely British air, that is enough to turn her into a German and to justify harassing her. (War Diary, p. 1)

War fever seemed to suggest that cultural evolution was an illusion; barbarism lay just beneath the surface. As if in illustration of this thesis, Pelletier overheard an elegantly dressed woman comment to her husband that all German prisoners should be killed outright. Another well-dressed man, on being told about an officer killed on his horse, commented that the horse was more valuable than the man, being harder to replace. As Pelletier described it in her War Diary, friend, S, speaking of spy mania, remarked: 'It is better to kill ten innocents than to allow one guilty person to escape.' (p. 5) The value accorded to individual life and liberty, to which Pelletier had pinned her hopes of cultural evolution, had evaporated overnight. As a former colleague, now in the army, said to her: 'I no longer exist, I am only a number with which one can do what one likes.' (p. 2)

By 25 August 1914 Pelletier had returned from Nancy to Paris and showed signs of deep discouragement. Her journal became more introspective. She recalled her symbolic action of the previous Bastille Day when, in an effort to recapture the euphoric national holidays of her childhood, she had bought fireworks and set them off, to the astonishment of the other lodgers at Madame Renaud's *pension*:

> I wanted to seize anew a memory of my early childhood; I am so unhappy that I look for the fugitive joys of the past. On those long ago 14th of Julys we set off lots of firecrackers and when they went off we shouted: 'Long live the Republic!' The Republic then seemed to me something very fine and strong that exploded like a detonation. With my firecrackers in my hand, I think how absurd it is to run after phantoms. The Republic will never, never again shine forth. (p. 3)

Holding her pathetic reminders of burnt out republican festivities, Pelletier meditated on her own powerlessness – she would never be an actor in significant events. 'I am poor and alas I am a woman.'

The firework incident readily lends itself to psychoanalytic interpretation.[38] The *pétards*, phallic symbols of power and of the 'masculine' republic, crystallized Pelletier's feelings of exclusion from the male arena. This incident poignantly expressed her sense of powerlessness based on the double bind of class and sex. In her blackest moods, she felt herself doomed to insignificance and futility.

In spite of such moments of near despair, Pelletier continued to record with a keen interest the more bizarre symptoms of war fever. Human behaviour was endlessly fascinating – war was a new psychological laboratory. For example, a normally inoffensive colleague, Dr Buillance [or possibly Buillar, the script is unclear], was abruptly transformed into a violent chauvinist:

> As I was saying, in accordance with accepted ideas, that I would not make any distinction in treating wounded French and German soldiers, he told me that . . . I was a wicked Frenchwoman, that I merited death and made a gesture with his hand as though to shoot me. One must, he said, execute the wounded enemy, blow out their brains; then seeing that after all he was going a bit far, he said there were ways of avoiding caring for the enemy and that I should save my care for the French. (War Diary, pp. 3–4)

Pelletier remarked drily of these symptoms, unexpected to say the least in a medical colleague: 'war is a great experiment in human psychology.'

The xenophobia exhibited by her colleagues was shared by the public at large. It was accompanied, even in Paris, by the kind of hysterical crowd behaviour she had witnessed at Nancy:

> 28 August:
>
> This morning, because I have short hair and am a cyclist, a policeman asked me for my papers. I showed them to him; he turned them over and over while a crowd gathered. Already a man was commenting that I didn't look 'sympathetic'.

The incident was resolved when a socialist comrade in the crowd vouched for her identity. But Pelletier, though accustomed to sexual harassment, was shaken:

> All this discourages me. Women's emancipation will never come.

Formerly my emancipated appearance only brought on cries of 'cazzi' [Italian: prick, cock] from layabouts. Now I get arrested because I don't look sufficiently servile, like other women. Obviously I was born several centuries too early. (pp. 6–7)

One of the most dramatic sections of Pelletier's War Diary described the near capture of Paris by the Germans and the battle of the Marne. By 31 August 1914, the German armies had advanced so close to the capital that the government fled to Bordeaux. The Prime Minister, Poincaré, issued a proclamation on Thursday, 3 September, assuring the populace that everything had been done to ensure their defence. As his government fled the city leaving its inhabitants to their fate, Poincaré appealed to them to stand firm: 'Frenchmen! Be worthy of these tragic circumstances; we will obtain victory in the end.'[39]

On 6 September the Battle of the Marne began, which did succeed in halting the German advance westwards, and by 13 September the Germans had been forced into retreat. This was the closest their troops were to come to Paris, within some twenty-five miles of the capital.[40] Paris itself was under a blackout; everyone who could leave attempted to do so. In her diary entry of 4 September Pelletier noted symptoms of panic as the government fled:

The siege of Paris is feared. The government is off to Bordeaux; in my ministry [Postes et Télégraphes] it is all chaos and confusion. There is a baby in the treasurer's office; a crowd of civil servants rush in to be paid, trotting about in great haste, crying that Paris is in flames. The most exaggerated fears haunt the minds of even educated people. Socialists say that they will all be shot as being held responsible for the defeat. The railway stations are under siege; people fight one another to get on trains. The common people are not afraid. The old remember 1870 and they reassure the young: a siege isn't so terrible – if there are bombs, we will go into the cellars, that's all. (p. 7)

She told how, one evening, she had witnessed a military parade watched by a huge crowd on the Boulevard Saint Michel:

The blacked-out city seemed to await a catastrophe. Luminous trails of searchlights looking for zeppelins swept the sky. A man in rags

threaded his way through the crowd: 'Ah, well,' he said in a
sepulchral voice, 'since we must croak, we might as well croak
straight away.' I had the feeling that something dreadful and
inevitable was imminent. The boulevard was barely lit, the
quaysides not at all. The silhouette of Notre-Dame stood out
tragically beneath the moon. (p. 8)

As the troops filed past, she was struck how even in this moment
of national and personal crisis the soldiers showed little human
solidarity. The sad comedy of the sexes continued unabated as the
men casually insulted women in the crowd:

'Does granny have good tits, then?' The women answered their
obscenities, the 'cazzis', with words of pity – 'poor things, it was a
sad time all the same.' A young woman in front of me allowed
herself to be kissed by at least a hundred men. She was a woman of
easy virtue, that was clear, but even so, her kisses were not
salacious. She thought she was performing a good action; giving
men about to risk their lives some courage. (p. 9)

The Question of Courage

What was human bravery? Was it merely lack of imagination or a
positive quality? Was it a male prerogative as anti-feminists
claimed? Were men more courageous than women or more rash?
Pelletier's desire to serve at the front lines and to see women
drafted into the army was partly conditioned by the wish to
destroy the old arguments about separate male and female natures
with regard to courage, just as she had argued against separate
concepts of intellect. Examples of bravery recorded in the War
Diary suggested that most so-called courage was elicited under
duress or showed that the person involved had not appreciated the
danger undergone. For example, she noted that the boasting of the
soldiers going off to the front was strangely modified after the
battle. Three riflemen whom she spoke to on a tram when they had
returned from the front showed no enthusiasm for 'glory'.

Ah, they said to me, this wasn't anything like fighting in Morocco.
Moroccans surrender straight away; this here war is dreadful. We
were in a trench fighting about one Frenchmen to two Germans.
Our captain sent an order on a bit of paper through the trenches;

and we read that we had to hold out until death. You can imagine how we felt.[41]

The Battle of the Marne raged for eight days along some 174 miles of the Marne from Meaux to Verdun via Chalons. On 8 September, Pelletier saw troop trains and wagons carrying wounded pass through the suburbs of Paris. By 11 September she had formed the plan of going to Meaux and visiting the battlefields for herself. This project, courageous for a journalist or an accredited observer, was extraordinary for an unaccompanied woman civilian. Aside from satisfying her curiosity, and aiding the wounded, Pelletier was almost certainly testing her own courage. 'The most efficacious antidote to fear is the habit of danger,' she had written in *L'Éducation féministe des filles.* On 11 September her Diary records her journey to Meaux by train, where she hoped to help the wounded. Her humanitarian enthusiasm was quickly dampened, however, by the insulting remarks she received from Algerian marksmen. She felt humiliated: 'Ah what a misfortune to be a woman; yes, misfortune; for I hate my disdained and oppressed sex! On the whole it has what it deserves: the most liberated women are only partially free' (p. 11).

Pelletier turned her anger against her sex, as she frequently turned her scorn against the working class. Were it not for her sex, she as an individual could have freely chosen her role in these events. She hated the status of degradation more than she hated the oppressor. Nevertheless some soldiers, catching sight of her Red Cross insignia, cheered her passage. Anger gave way to irony when she considered her espousal of the role of helper to suffering humanity. When she reached Meaux, the inhabitants were still visibly terrified by the scenes they had witnessed. Pelletier took soundings of their reactions to the battle: 'A courageous servant in front of the inn calmly tells how a shell exploded near her. The bravery of simple people is to a large extent made up of incomprehension of the danger.' Leaving Meaux, Pelletier cycled to Senlis, passing through Vareddes and Barcy, two villages that had been badly hit. The countryside around Vareddes, seen in the gathering dusk, was fearsome:

Vareddes: I crossed a wood devastated by the battle; tree trunks cut in two by shells, branches knocked down to the ground. Further on, the dead buried along the road; it is dark, I walk on the

battlefield, look for a fragment of a shell, I step over graves; all of a sudden I am jostled – for a second I was stupidly afraid; but reason returned; if something moved it was because someone wasn't dead. . . . I waited but nothing more, doubtless a scavenging animal. (War Diary, 16 September, pp. 12–13)

The following day she went on to Barcy which had been in the centre of some of the hardest fighting. Gravediggers were out on the vast grey plain. Every five metres she saw a French corpse and the occasional German one. They looked like dolls dressed as soldiers. Contemplating the fallen, the soldiers who should never, according to socialist theory, have banded together to fight their fellow workers, Pelletier's despair and anger at the collapse of the Socialist International surfaced. The working class was not capable of transforming society. As she had previously raged against women's servility, here she attacked the victims of the war:

At bottom these people have got what they deserved; humanity is stupid. Haven't I warbled enough in every key to the workers that they must have a revolution in order to free themselves; I only succeeded in frightening them and now they are dying in any case and it's not in order to emancipate themselves, it's for the opposite reason. (p. 13)

But her meditations on the vanity of human effort – 'Ah, everything is vanity, progress doesn't exist' – were nicely undercut by the emergence of the sun, which seemed to give the lie to her more cynical reflections. She was heartened by the resilience of the inhabitants of Barcy. People were reorganizing themselves and Pelletier was touched and amused by their reactions to the battle: '"Barcy, you understand", a peasant said to me "was the bull's eye of the battle." He almost seemed proud of the fact' (p. 14).

The 20 September diary entry recorded her impression of Senlis. Most of the houses had been destroyed, piles of stones and corpses were still in the streets. Inhabitants wept as they recounted tales of pillage. Cycling from Senlis to Crepy en Valois across an open landscape, she saw a German airplane flying low overhead. She thought her final hour had arrived: 'Intense funk; what the devil am I doing in this mess. Nevertheless, if I had stayed at home I would have seen nothing. Still, if he chucks a bomb at me, my life ends here. Tough luck, I can't hide and no houses nearby – nothing

for it ... in the end he ignores me and goes – I breathe again' (pp. 14–15). This was Pelletier's equivalent of a baptism of fire. Through the somewhat bravado tone of this writing emerges both her fear and her courage in overcoming it. Nevertheless, the battlefield with its lifeless forms provided a haunting terror of personal annihilation. The sense of her own transience and the imminence of death fill these pages.

Although Pelletier may have satisfactorily proved to herself that in visiting the battlefield and exposing herself to possible German fire she displayed 'masculine' courage, the whole idea of martial valour did not survive the accounts of soldiers back from the front. In Paris she heard anecdotes from a friend of battlefield behaviour that spoke of the desire for survival, not of heroism. A rifleman who claimed to have murdered German prisoners casually told a story about cannibalism:

'You understand,' the rifleman said to him, 'on the battlefield there was nothing to eat. We were hungry, so we cut off a bit of Prussian and cooked it; it was very good; one would have said it was mutton.' (War Diary, 29 September 1914, pp. 18–19)

A year later, 20 December 1915, Pelletier was noting in her diary how popular perceptions of the conflict had altered. War was no longer news, rather it formed part of the fabric of ordinary life, like politics in peacetime. Anti-German sentiment had abated; one heard less about the *Boches* and their wicked Emperor. Cinemas showed detective films again instead of war films. However the cost of living had risen by one third. All in all, Pelletier thought, people had accustomed themselves to a new reality. Her final diary entry simply noted a reaction to bombardment:

Frequent and dangerous airplane raids. A concierge, 5, Avenue Thenard, failed to turn up in the catacombs during the alert. She stayed in her bed and put the photograph of her son, killed in the war, under her pillow. She thought that since her son had been killed, she ought to be saved. (27 September 1918)

Here was an example of the psychological phenomenon that Pelletier had examined in her days as a psychiatric intern, the incoherence of the individual – the ability of rational minds to maintain quite irrational ideas without, for all that, being judged

insane. Indeed the concierge's action suggested a need to create some sustaining belief in times of crisis. For Pelletier, whose faith in 'scientific' socialism was badly shaken, the spectacle of a renaissance in irrational belief systems during and after the war was particularly depressing. When militant socialists like Elizabeth Renaud turned to religion (she joined the Seventh Day Adventist Church) or feminists like Caroline Kauffmann to spiritualism, it seemed to signal to Pelletier a retreat from reason to the atavistic stage of superstition. Human progess was indeed a myth.

Pelletier's War Diary allows one a rare glimpse into her inner life. Most of her writing, even her autobiography, was couched in an ironic and objective mode. The war effected a dramatic rupture in the structures of thought which she had built upon in the previous decade. In neo-Lamarckian anthropology, in psychiatry, socialism and feminism she had seemed to find models for change in human institutions. Liberty seemed to be allied with evolutionary progress via scientific socialism. But witnessing the effects of the war on ordinary people, Pelletier saw society regressing to a state of psychic as well as of physical barbarism. The culminating effects of her political disillusionment in the SFIO, the weaknesses of feminist militancy, and finally the collapse of the Socialist International, produced a fundamental change in her perceptions. Her chilling remark, 'At bottom, these people have got what they deserved', revealed the extent of her despair. Once she had hoped that women and the working class possessed revolutionary potential and that they might forge a common agenda. The war seemed to show that she was wrong; subordinate groups would continue to be manipulated by existing elites, and to be sacrificed to the interests of those elites.

Pelletier's profound depression at the implications of the war for international socialism was mirrored by other female activists. Angelica Balabanoff, the Russian socialist, remembered the Austrian declaration of war on Serbia: 'Our feelings of hopelessness and despair mounted steadily . . . the passivity of the workers was taken for granted.' Rosa Luxemburg, who passionately believed in the capacity of the workers to struggle for the ideals of international socialism, was thrown into a state of misery when these same workers embraced patriotism and militarism almost overnight. Clara Zetkin is thought to have contemplated suicide.[42] In Pelletier's case, however, such despair was mitigated by her native

scepticism. She had never held an idealistic view of the working class, perhaps because unlike Zetkin, Balabanoff, Luxemburg, Kollontai and even Louise Michel, hers was a proletarian background. Her desire for a feminist and socialist revolution stemmed from her hatred of the degradation in which women and the working class lived, a degradation she knew only too well by experience.

Though socialism and feminism seemed lost causes in the war years, Pelletier retained a keen interest in politics. As a police report of June 1916 showed, she also continued to attend socialist and pacifist meetings, disagreeing profoundly with those French socialists who became nationalists during the war. It is alleged that she walked out of one such meeting after a dispute with a fellow socialist because he had embraced a ultra-nationalist position.[43] Finally, as she often did in a state of crisis, Pelletier threw herself into a renewed intellectual challenge, enrolling for a degree in natural sciences at the Sorbonne in 1914 and specializing in chemistry. 'As for me, I am reading for a science degree. I burrow away at chemistry at the Sorbonne; this distracts me.'[44] Chemistry, unlike political theory, had the charms both of discovery and of certainty:

I have always loved chemistry. It is an exact science where there are still things to discover and where one has the feeling of walking towards the unknown, the new. I remember having attended, quite by accident a few years ago a lecture by Moissan. He spoke with great eloquence. Behind his desk, where his electric furnace shed a blinding light, he looked like a magician and I felt stabbed to the heart when remembering that I had given all my energies to sterile babblings at meetings instead of, like him, pursuing great work.[45]

At such moments, Pelletier must have regretted her commitment to political activism which had effectively closed off a career in pure science or the chance of rising in the medical profession. Had she kept her opinions to herself and not 'wasted time' at endless political meetings, she might have continued in psychiatry and might have attained a position of eminence. All this she felt when in a pessimistic frame of mind. But it is clear that Pelletier, like her mother, had a passionate commitment to the propagation of her beliefs. In spite of railing against the stupidity of women and of the

working class, she did not abandon her militancy in favour of personal success. During the war years, indeed, her ability to channel her energies into a new intellectual sphere when events turned against her showed that she had enormous capacity for renewal. The Great War was, however, a watershed as far as scientific and political optimism was concerned.

In 1933 Pelletier wrote what was in effect an obituary for her early hopes and those of her radical revolutionary generation. In her autobiographical novel, *La Femme vierge*, her protagonist quoted Goethe's injunction to 'March towards the light'. She then questioned humanity's capacity for progress: 'But to believe people capable of a grand plan which transcends the limits of their existence, was to over-estimate them. No – there was no light. There was only the life of each individual, a rather narrow path and to which one must adapt oneself as well as possible.'[46]

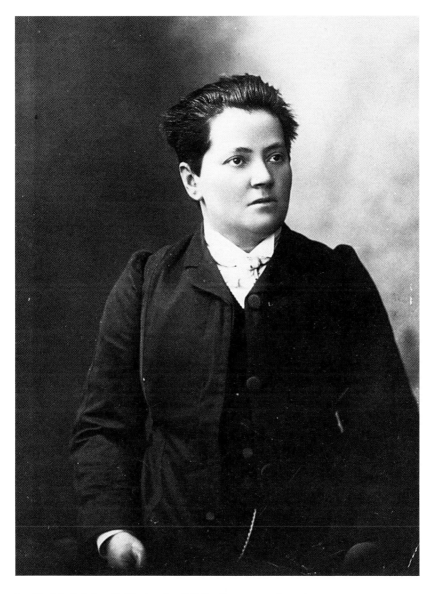

1　Dr Madeleine Pelletier (*c*. 1906). One notes her close-cropped hair and cravat.

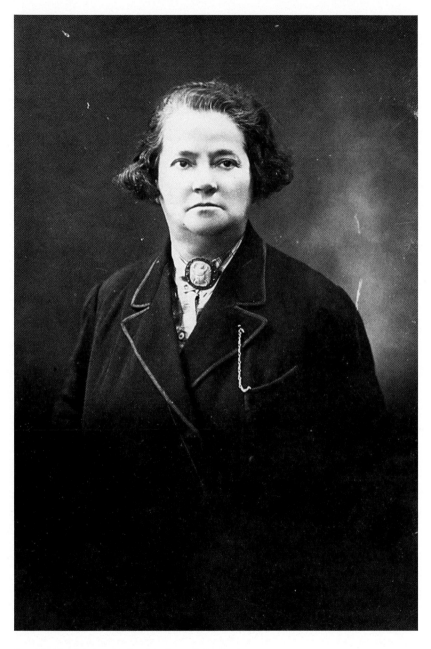

2 Dr Madeleine Pelletier (*c*. 1930). In the post-war period her hair was longer, but the dress style was uncompromising.

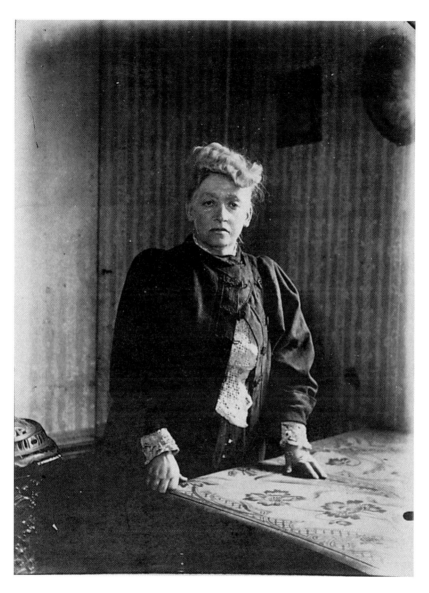

3 Madame Caroline Kauffmann.

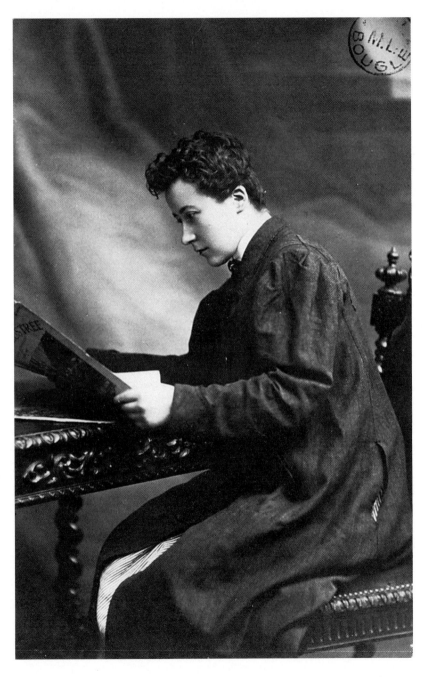

4 Arria Ly at 30. Her long smock was a version of non-feminine dress.

5 A page from the scrapbooks kept by Arria Ly and her mother,
transposing gender stereotypes.

6 Marguerite Durand, founder and editor of the feminist daily newspaper *La Fronde*.

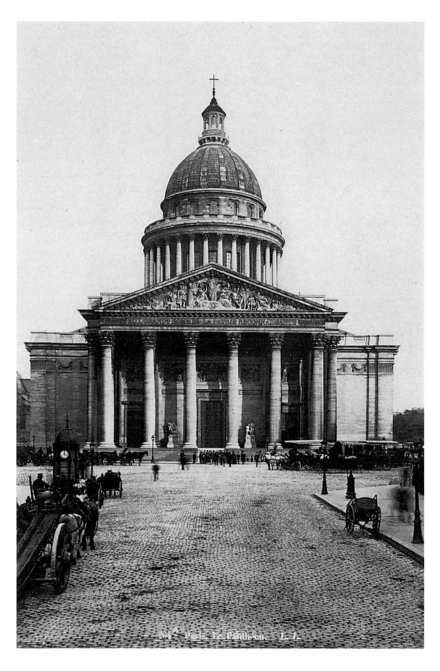

7 The Panthéon, showing David's frieze commemorating the 'Great Men' of France.

5ᵉ Année. — Nᵒ 40. Juillet 1913.

Droit au Travail *Droit de Vote*

LA SUFFRAGISTE

Revue Féministe Mensuelle

DIRECTRICE :

Dʳ Madeleine PELLETIER

SOMMAIRE

1ᵒ Le génie et la femme............ Dʳ Madeleine Pelletier

2ᵒ Le suffrage en Angleterre........ Irlandaise

3ᵒ L'os à ronger.................. Athos

4ᵒ Patriotisme et Féminisme.

Le Numéro : **25** centimes

ABONNEMENTS :

Un an.................... **3** fr. | Six mois................ **1** fr. **50**

Etranger : Un an........... **4** fr.

BUREAUX : 55, Rue Damrémont, Paris

Téléphone 569-64

8 Masthead and title page of Pelletier's magazine La Suffragiste.

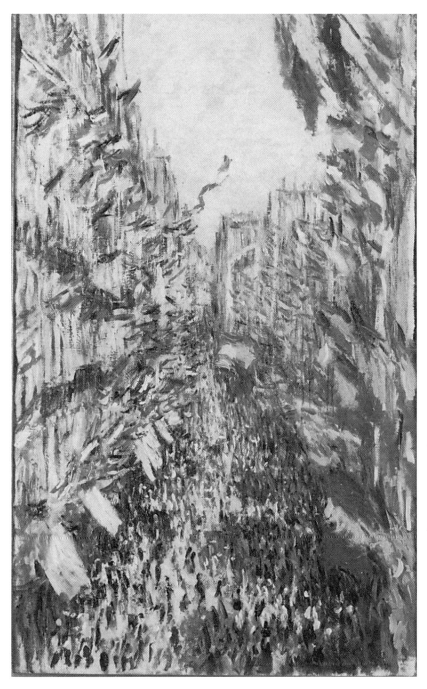

9 Claude Monet, *La Rue Montorgueil, fête du 30 juin 1878*. The
republican enthusiasm conveyed by the flags confirms Pelletier's account
of her neighbourhood.

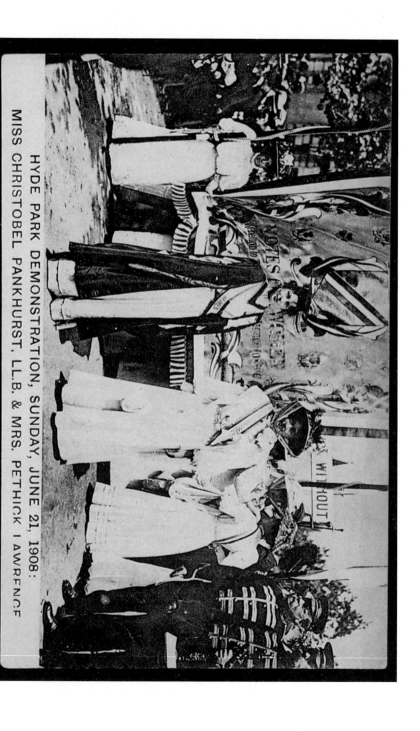

HYDE PARK DEMONSTRATION, SUNDAY, JUNE 21, 1908:
MISS CHRISTOBEL PANKHURST, LL.B. & MRS. PETHICK LAWRENCE

10 The suffragette demonstration of 21 June 1908 attended by Madeleine Pelletier and Caroline Kauffmann.

Doctoresse Pelletier

Memoires
D'une
Féministe

——————

Avril 1933

11 Title page of Pelletier's autobiography.

12 Opening page of Pelletier's autobiography: 'I can say that I have always been a feminist ...'

7

The Russian Pilgrimage

Under the dark streets . . . there are cellars where people weep, lament and die.

Mon Voyage aventureux en Russie communiste, p. 188

When the war ended, Pelletier reopened her surgery in the Latin Quarter, a district much loved since her student days. She found a ground-floor flat at 75bis rue Monge, between the Mont Sainte Geneviève and the Jardin des Plantes. She also continued with her appointment as medical doctor for the Postes et Télégraphes begun in 1906.[1] The post-war economic collapse had badly affected many bourgeois feminists who had formerly enjoyed financial independence, a problem reflected in Pelletier's correspondence at this period. She petitioned Marguerite Durand to find work for Arria Ly, who was now in financial straits. To Ly she wrote that Madame Remember, her former contributor to *La Suffragiste* with whom she had had an extended fued, was ruined and sold flowers in the street. Madame Renooz, too, was living in poverty.[2] More fortunate because professionally trained, Pelletier continued to earn her living adequately and even increased her financial security. However, as prices had soared while incomes diminished, she eventually had to abandon her relaunch of *La Suffragiste*, begun in 1919, when printers' costs became prohibitive.[3]

On the political front Pelletier, in common with most of the French left, was heartened by the revolutionary events in Russia. Here at last, it seemed, was the revolution that socialists everywhere had been awaiting. Pelletier allied herself to the Bolshevik cause with enthusiasm and in the winter of 1919–20 used *La Suffragiste* as a platform for pro-soviet propaganda. In the same year she rejoined the socialists and was a delegate from the Seine

Federation to the Congress of Tours, where she voted in favour of joining the Third (Communist) International. She contributed articles to the feminist paper *La Voix des Femmes*, which was sympathetic to the Communist Party:[4] 'When the Socialist Party joined Moscow, I became active again ... I have begun to give a few lectures, thanks to *La Voix des Femmes* which for the moment is a little centre where lecturers are recruited.'[5] In addition she wrote for the anarchist newspaper *Le Libertaire*, while dissociating herself from many of its views: 'Finding no newspaper for which I could write, I have accepted collaboration with *Le Libertaire*, whose secondary ideas I share: anti-militarism and neo-Malthusianism, etc., but not the main point, namely the possibility of a society without a state.'[6]

Pelletier decided to undertake a pilgrimage to the USSR in 1921. While making detailed arrangements for the journey in May of that year, she encountered a number of official and unofficial difficulties. The French authorities, no doubt basing their refusal on her pacifist, feminist and socialist connections, denied her a passport. The soviet authorities, for their part, demanded endorsement from the French Socialist Party (the Partie Socialiste Unifié, the new Socialist Party affiliated to the Third Communist International in 1920) before allowing her to visit Russia. To gain party backing Pelletier had to undergo an interrogation about her socialist credentials from party members for whom she seems to have cherished no very cordial feelings. To Arria Ly she admitted grudgingly that socialists were becoming less hostile to feminism, though they still thought women belonged in the home. Nevertheless she appears to have received sympathetic treatment from the party.[7]

In the end the lack of a French passport did not deter Pelletier from making the journey. She decided to cross the breadth of Europe and at least five frontiers without one, and to depend on a network of socialist and communist comrades to spirit her across national boundaries. She gave a graphic description of her Russian visit in *Mon voyage aventureux en Russie communiste*.[8] Her journey proved to be a comedy of errors, interspersed with real dangers, in a sea of unbelievable tedium. From Paris to Moscow took her six weeks, 'an adventurous voyage' indeed.

To what extent did Pelletier consider herself a genuine revolutionary when she set out for Moscow? On the one hand it seemed

to her that the Russian experiment was the fruition of dreams of revolutionary socialism. On the other, Pelletier's previous revolutionary experience in the ranks of the Hervéistes was, as she herself recognized, entirely on the level of ideas. 'I understood that I was only a theoretical revolutionary, and that I lacked guts.'[9] But it was not entirely a question of courage; her expedition to the battlefields of the Marne had shown that she didn't 'lack guts'. It was rather than on the Russian journey she was forced to confront the full implications of revolution, to consider what insurrectional violence meant and to attempt to square revolution with her pacifist beliefs.

Her previous political training could be divided into three main phases, none of which were entirely superseded; her anarchist period, the Hervéiste period, and feminism. She almost certainly saw the latter as the most truly revolutionary of the three strategies for social change. Feminism also had the advantage of being the least inherently violent movement, though, as we have seen, Pelletier had espoused civil disobedience and damage to property as a tactic in her electoral campaigns: 'Feminism can never go too far: what it asks is something precise: the complete equality of the sexes from the political, economic and social points of view.'[10]

As was clear from her dress code and hairstyle, Pelletier believed it was essential to publicize her feminist views through her appearance. This tactic resembled her mother's determination to flaunt her religious and monarchist opinions in their republican, working-class neighbourhood: 'Yes! I like exteriorizing my ideas, carrying them upon me as the nun carries her Christ, or the revolutionary his red rose. I wear these exterior signs of liberty in order that they say, that they proclaim, that I desire freedom.'[11] How was this feminist who advertised her politics so vividly by her clothes to travel inconspicuously across Europe without a passport? Pelletier modified her mannish appearance in order to pass as an ordinary woman – 'a woman like any other' – and wore a wig to hide her short hair. Disguised as a respectable middle-class woman, she scurried unremarked through the French–Swiss customs, a virtually invisible figure. For the first time in her life she ruefully acknowledged the usefulness of being thought of no importance thanks to her sex. From Switzerland to Frankfurt she was put in the care of a surly guide, provided by the Communist Party, who jettisoned most of her luggage and confiscated the

revolver she had brought for self-protection. Lacking identifica-
tion papers, she lived in fear of being stopped by the police. In
Basle, unable to register in a hotel where she would have had to
produce a passport, she stayed in her guide's squalid room, afraid
to sleep in the filthy sheets. This was to be the first of many such
nights.[12]

Her Swiss guide proved to be a mixed blessing and anything but
comradely. There were unreasonable demands for money and
scenes of pointless brutality. In *Mon voyage aventureux* she
described how, on one hot and humid day, the car they hired from
Lorrach to Fribourg was surrounded by a cloud of insects:

> My companion caught them and ripped off their heads saying: 'Ich
> bin bolchevik'! I tried to make him stop, because I think even an
> insect has a right to life, and I tried also to make him understand, in
> my bad German, that Bolshevism wasn't what he supposed. My
> efforts were in vain. My companion was a young brute and I found
> him more and more antipathetic. (p. 15)

When they arrived in Frankfurt, her insect-hating Bolshevik
announced his intention of going with her as far as Berlin. At this
Pelletier baulked. She could manage far better without him, she
said. He in turn threatened to denounce her to the authorities if she
did not give him 2,400 francs. Pelletier, showing considerable
resourcefulness, decided to call his bluff, pointing out that if he
denounced her, he would be arrested as an accomplice. In the end
'the sympathetic young man told me that if I gave him 500 frs and
my gold watch, I would be delivered from his presence. I gave in –
what else could I do in my situation?' (p. 19).

To travel through Germany and Eastern Europe so soon after
the war was a revelation. In Berlin, Pelletier was surprised to find
food plentiful in the shops in spite of the German defeat. After an
early morning arrival, she feasted on sausages at a charcuterie.
Later she was warmly received by a member of the Communist
Party's women's section who knew her by reputation and who
praised her decision to go to the USSR: 'Ah Madeleine Pelletier,
you do well to go to Russia; all militants should go on this
journey; you will return transformed' (p. 22). Here was consola-
tion for her misfortunes with her Swiss guide: 'enthusiasm seized
me. Is it really a superior life that will be found there? I hoped so,

since I was going, but I was not certain. This woman's words galvanized me. If the ideal was really there, what did the loss of a little money matter? I felt prepared to brave everything' (p. 22). Even more heartening, in Berlin the party officially accorded her permission to travel to the USSR and promised that guides and financial assistance would be forthcoming.

The difficulties facing an illegal traveller were not purely political or administrative, Pelletier discovered. There were practical sides to such a life that no amount of training in militancy prepared one for. For example, even in a large and cosmopolitan city, Pelletier found herself conspicuous as a single woman travelling alone. Furthermore, because most of her wardrobe had been left behind at the Swiss border and the clothes she wore had not prospered after the long march over the frontier in the summer heat, she was desperately in need of a wash and change. Genteel clothing was not designed for scrambling across borders to avoid frontier posts as she had done between Switzerland and Germany. Since she could not register at a hotel for fear of police checks, Pelletier decided to find a public bath. But her German was so poor that what she took to be an advertisement for public baths turned out to be a massage parlour and steam bath. Anxious to escape notice and fearing police informers everywhere she went, she nevertheless found herself an object of intense curiosity to the staff who gathered round 'this foreign woman'. She was duly washed and massaged and, while she lay naked on the table, the masseuse bombarded her with questions. Trying to sound dignified in the circumstances, Pelletier told them that she was a Russian doctor named Rosenblum and was going to volunteer medical assistance in the cholera epidemic in the USSR. When she finally escaped from the massage parlour, she left her shirt behind in her panic. This was the sort of contretemps, she reflected, never discussed either in spy novels or in theories of revolution. She began to feel that there were more ways than one of being a martyr to the cause.

For the rest of her journey Pelletier was joined by two Italian anarchists whom the Berlin communists had assigned to her as travelling companions. They set off north with only the barest notion of where, or how, they were going. By train to the sea, a two-day boat crossing, a midnight border crossing in an open cart, a dash across fields on foot, with Pelletier gravely hampered by her skirts, ended in their taking refuge in a miserable peasant hut for a

week while they waited for further help in pursuing their clandestine journey. Pelletier succeeded in offending the woman of the house by complaining about her sordid accommodation. She refused to sleep in the filthy bed provided and had to make do with a chair. Her German was too poor to communicate adequately with her hosts or even to discover the reason for their delay. They were interrogated by local party officials over their credentials. Whereas the anarchists passed easily, Pelletier only succeeded in rendering her questioners more suspicious. Her landlandy accused her of the ultimate political crime: she was a bourgeoise because she had complained about the dirt and had scarcely eaten the food offered. She was informed that she would not be allowed to pass into Russia, whereas the two anarchists could go. Pelletier raged with frustration.

This incident highlighted a genuine problem concerning Pelletier's perception of her class status. She had never identified with the bourgeoisie, though her chosen profession placed her squarely in that class. As we know, she was often contemptuous of middle-class feminists. However she did consider herself a member of an intellectual elite and in that respect superior to her own class origins. Nor was she immune from intellectual arrogance. Part of her discomfort in the Soviet Union lay in the fact that she lacked a circle of like-minded friends with similar interests with whom she could share her experiences. She suffered from: 'being separated from my *milieu*, from being with people of an inferior cultural level, who see in me nothing more than an old woman and who treat me as such' (p. 73).

It was to Pelletier's credit that she learned something from her tactless behaviour to her hostess, whose accommodation, while poor, was at least at the service of the party. Pelletier recognized that she had behaved thoughtlessly and had the good grace to acknowledge her landlady's point of view. Wiser counsels prevailed among the officials and she was not sent home. On further acquaintance, Pelletier began to see that the landlady was a remarkable woman:

She was devoted to the Party and risked a great deal giving us asylum. Her husband had been killed in the war; she had four children whom she scarcely managed to feed. ... It was magnificent; this woman was an obscure heroine, like many I would encounter in Russia; but what a hard glint in her grey eyes. She

made me shudder when she said: 'Death to the bourgeoisie.' She reminded me of Mme Defarge, the knitter in Dickens novel *A Tale of Two Cities.*(p. 50)

Pelletier, who was usually allergic to performing household tasks because of their 'traditional' connotations (one recalls her hatred of mending socks), swept and cleaned her hostess's house. The latter appeared surprised that one could simultaneously care about the revolution and try to make one's immediate environment more agreeable. Pelletier went so far as to suggest to her landlady that political militancy did not preclude one from attempting to enjoy life. On the other hand, confronted with Madame Defarge, as she thereafter called her, Pelletier came to a conclusion about herself: 'I understood that I was only a theoretical revolutionary and that it is necessary to have these coarse people for hard necessity' (p. 50). One detects more than a note of condescension here.

Their journey was not suitable for the prudish or squeamish. In the course of it Pelletier often slept in dormitories with men or passed as the wife of a comrade. She travelled under the most primitive conditions and on the whole complained most of dirt and, as a bit of a gourmet, of bad food. But she was remarkably resilient. The final stage began when they were all loaded on to a goods wagon, shared with an immigrant family and a group of soldiers:

There we were in a frightful cattle car, painted red, some thirty people. The right-hand corner was occupied by the immigrant families; they carried sacks of linens which gave out a sickening odour; there were little children with them. On the left-hand, or aristocratic, corner, the comrades from the Legation and me; in the centre the Red Army soldiers returning from Germany. (p. 71)

They spent the daylight hours pleasantly enough. With the doors of the cattle car wide open, they could see a marvellous countryside rolling by – immense pine forests interspersed by villages with little wooden houses. The emigrés sang dolorous songs of an evening, all of which had a certain charm. Less charming was the absence of toilet facilities on the train. The passengers accordingly leapt out at stations to relieve themselves. Pelletier, not of an athletic build, and disliking assistance, scrambled down from the goods wagon with difficulty and was laughed at. In addition the nights were cold. She had no blankets and was

too proud to ask for any. It was probably a relic of her early poverty, plus her desire not to appear to be a helpless woman, that made her so loath to ask for favours. Her wanderlust at such moments was quite extinguished and she yearned for home: 'Oh Paris, my Paris, where at least I ask nothing of anyone. If the 'commandant' offered me a passport for France, I would take it joyfully; I hadn't even arrived in Russia and the desire to see it had already vanished' (p. 73). Pelletier's previous travels had all been within Western Europe and, although she was well acquainted with some of the worst districts of Paris and was no stranger to poverty, she was unprepared for the material and cultural deprivation that she encountered in Russia in the 1920s.

Moscow

When she finally arrived in Moscow, Pelletier had been travelling for six weeks. Her account of life in the capital embraced both a tourist's eye view and a degree of political analysis. She visited monuments, factories, museums, the university, orphanages and simply walked about the city. She was struck by the grandeur of the remaining traces of tsarist Moscow, the cupolas and palaces, contrasted with the ruined, half-paved streets, and buildings pockmarked with bullet holes, evidence of the recent revolution. Food was an important preoccupation and *Mon Voyage aventureux* speaks movingly about her gastronomic experiences. The menu at the Luxe, the hotel where foreign visitors were lodged, consisted, according to Pelletier, of 'very bad soup', pork stew in which the meat tasted rotten, good black bread and all the tea one could drink. Bread and sweetened tea became her staple diet. When she heard that many Muscovites thought that the inhabitants of the Luxe led a soft life, boarded and lodged at the state's expense, Pelletier commented drily: 'If I were the government . . . I would invite them to dine at the *Luxe* in turn: they would see, or rather they would eat, and there would be no more complaints' (p. 94).

Pelletier's Moscow sojourn coincided with the period of the *paioc* or voucher system. Foreigners were issued with tickets giving them the right to a certain number of designated articles. Money was rarely used. Accustomed in Paris to eating where she liked, Pelletier chafed under the limitations imposed by the scheme. On

the first occasion that she succeeded in exchanging some French francs for roubles, she went to dine in a *stolovaia*, or capitalist restaurant, establishments which were tolerated if not enthusiastically encouraged by the regime. She feasted off beefsteak, Russian pickles, potatoes, cake and tea. No wine, that was too astronomically expensive. Thus fortified she saw life generally, and Moscow in particular, in a far rosier light. However, when she recounted her escapade to her fellow boarders at the Luxe, they reproved her. Lenin might tolerate these restaurants, but good communists should be content with what the state gave. She found this level of revolutionary piety absurd. How could they reduce Marxism to where one ate one's beefsteak and confuse this with loyalty to the regime?

The *paioc* system had the untoward effect of turning Pelletier into something resembling a capitalist entrepreneur. Although her basic needs were cared for, she soon ran out of ready cash. A comrade suggested that she sell off some of her possessions at the public market where former members of the bourgeoisie disposed of their jewels and knick-knacks. Pelletier's stock consisted of a shirt, a few bars of soap and several packets of cigarettes. She sold everything in ten minutes and made a profit of 50,000 roubles. She then dragged her protesting companion straight away to the *stolovaia*. Though he did not shrink from profiteering on the market, he demurred at eating in a non-soviet establishment. Pelletier, by contrast, tucked into her food with gusto. At this rate she could finance her stay in perpetuity: 'With this money I could treat myself forever to chocolate and buns in the *crémerie*. I felt myself gripped by the fever for speculation (p. 186).

The petty restrictions imposed by bureaucracy were, on the whole, comic. More serious were the signs of revolutionary terror. Many people whom Pelletier met in Moscow seemed obsessed by what she initially took to be a paranoid fear of surveillance. Dreadful rumours of the secret police circulated freely. 'If I were in Paris I would call this a delirium of persecution' (p. 93). With her anarchist connections, Pelletier developed fears for her own safety. Two plainclothes officials visited her at the hotel and grilled her on her political orthodoxy. They appeared to believe nothing she told them, implying that she had come to the USSR to live at the state's expense. Although another lodger told her that such interrogations were standard, she felt shaken and angry: 'Oh Paris, my Paris,' she

lamented again. 'Things there are far from rosy, I know it only too well, but all the same, when I have paid my rent and closed my door, I am answerable to no one' (p. 113). She felt deeply depressed: how could individuals be treated with such contempt? What principally distressed her was the idea of perpetual surveillance and having her every motive questioned. It was also of course the case that she was under surveillance in France, but there it was practised more discreetly. She may well have been unaware of the degree of police interest she inspired in her beloved Paris.

Pelletier's unease about the role of the secret police was allied to her growing doubts about revolutionary violence and her awareness that she was a 'theoretical' revolutionary (p. 181). She recognized that she lacked the stomach for bloodshed. A new acquaintance who had been a member of the revolutionary tribunal and had taken part in the terror dramatized the problem for her: 'I only knew of terror from books; my opponent in debate had been an officer; he had fought in the war; and human life, which seems to me the most precious thing on earth, does not count for him' (p. 188). During a sleepless night, she recalled the discussions of revolutionary terror in the political circles she had frequented in Paris. Why was she filled with such dismay by these Russian revolutionaries? 'Hadn't I in the course of my life as an activist heard hundreds of similar conversations? How many people had I not heard gunned down by words . . . In Paris this made me laugh because I knew it was only a game – it would never happen, or in any case it was a long way off' (p. 188). But here it was not a game. Terror stalked the streets, the more menacing for being discreet. Not for this regime the open tumbrils of the French Terror of 1793. But the reality was that: 'Under the dark streets of the town, there are cellars where people weep, lament and die. Oh yes, I definitely needed a whole course in revolution' (p. 188).

Education, Industry and Religion

Not everything seemed so bleak, however, as the underside of power revealed by terror. Pelletier visited the university, museums, orphanages, factories and churches and saw much to admire. At the university, according to *Mon Voyage aventureux*, in spite of a

shortage of facilities, she was impressed by the courses in elementary science for workers: 'For these young people, the Revolution will have been a great blessing. . . . Thanks to communism they will become different men [sic], even those who do not finish their studies' (p. 108).

The revolution, she was aware, had produced both losses and gains. She met an anti-communist student and her mother who were in no doubt that the dictatorship of the proletariat represented the invasion of the barbarians. On the other hand, at a pastry shop which she was fond of visiting, Pelletier met a young woman who had worked in Paris as a pastry cook; having returned to the Soviet Union, she was studying part-time to become an engineer. Such opportunities would have been impossible in France, where engineering was dominated at the all-male Polytechnic by sons of the bourgeoisie: 'Thanks to Bolshevism, which has suppressed the class structure and destroyed prejudices, she has made a new and happier life for herself. Thousands of men and women of the masses have had enlightenment by the effects of the Revolution' (p. 121).

However, Pelletier was equally astounded by the cultural distance many Russians needed to travel before they could leave feudalism behind them. She found religious observance, to which she was always hostile, to verge on the idolatrous. Everywhere in Moscow she saw little chapels filled with icons protected by glass. This glass, in turn, was covered by a thick coat of grease: 'It was the residue left by the devout kisses of thousands of the faithful. All day long people come in, kneel and place their lips on this disgusting grease' (p. 102). How could such people, Pelletier wondered, ever understand the theory of communism? French workers who were infinitely more cultivated did not understand it. The Russian Revolution was the fruit of a tiny minority of activists who imposed their will on the majority. At least, she felt, the Bolshevik minority, unlike the aristocrats before them, was not just out for itself (p. 102). Little by little, communism would clean up – degrease, as she put it – the people. Pelletier had no faith in the transforming power of the masses; she called them, in a culinary metaphor, the 'amorphous dough only good to take the shape that a small number of intelligent and daring people wish to give it' (p. 102). She related that the Marxist slogan 'Religion is the opium of the people' was interpreted by many Russian peasant as meaning

that 'opium' was a Russian saint. The revolution was far from accomplished.

For all Pelletier's irritation against soviet officialdom, her fear of the secret police, contempt for an illiterate peasanty and depression at the standard of living, she continued to defend communism both to anti-communists and to anarchists. She was entirely unconvinced by the arguments of the anarchists who held that the poor state of Russia was a result of the revolution and that anarchy would have brought prosperity. How would the distribution of goods and services by organized without some form of central control? She commented sceptically on the anarchists' high estimate of human nature:

> When I see men in the streets who blow their noses into their fingers, and who kiss the ground when they pass an icon, I can't imagine them living in anarchy. Anarchy could only aggravate the situation. The absence of police would unchain criminal instincts; people would kill and rape in the street in broad daylight. (p. 140)

In spite of these strictures, Pelletier admired the Russian anarchists, many of whom had fought and died in the revolution, and was dismayed by their persecution under the soviet regime. In 1927, for example, she wrote an article on Makno, the Ukrainian anarchist who had fled to Paris.[13] However her early interest in anarchist theory and her lifelong commitment to individual liberty sat uneasily with an acceptance of authoritarian revolutionary government. Much of the value of her account of Soviet life is in its testimony to her doubts and to the frequent incompatibilities of principle she saw around her: 'In spite of everything, I love this Russia which has attempted a social revolution. However I have observed too much to have illusions and not to see, behind the rhetoric, realities which are not pretty' (p. 131).

Feminism

How did women fare under communism? When she first crossed the Russian border Pelletier had seen a woman soldier – to her, a touchstone of female emancipation. Had not she herself advocated just such a reform in France? Later in a military parade she saw

some two hundred women soldiers, their sex only discernible by a different style of shoe. Women medical doctors also served in the army, an aim which she had failed to achieve in France. With regard to personal appearance, the Russians were far more emancipated than the French. In Moscow her short hair did not cause remark: 'Many women have short hair and masculine hair styles. ... In Moscow, one enjoys great freedom with regard to dress, one can wear what one likes. Russians show themselves as being more civilized than the French in this respect' (*Mon Voyage aventureux*, p. 133).

Pelletier met women in professional life and women, like her pastry cook, who were retraining in hitherto all-male professions. To Western eyes, women had unheard of liberty in public places. She saw girls smoking in the street, or asking men for a light, without raising any imputations that they were being flirtatious. Women were not followed: 'a girl can sit down on a park bench; wait on a streetcorner at any hour; no one bothers her' (p. 144). On the political front, she was impressed by her visit to the Women's Section of the Communist Party, a large organization with commensurate staff which among other things ran an information service for women nationwide to increase their political awareness (p. 145).

All this was enormous progress, but Russia had still not achieved the 'integral feminism' of which Pelletier dreamed. In law, she accepted, women were equal in everything, but in practice many of the old prejudices lingered. There were few women in the highest levels of government, with the exception of Alexandra Kollontai. At the International Congress, aside from the wives of 'great men', such as Madame Lenin, there were no women on the platform except for secretaries (p. 156). Most women Pelletier spoke to seemed to accept this inferiority, and some, out of loyalty to communism, denied it existed. Others argued that women were not found in the higher reaches of government because they lacked political experience. Given the strong tradition of women in Russian socialist circles, Pelletier thought this a weak excuse. She felt that the creation of women's sections in the Communist Party had isolated them (pp. 146–8). This, one recalls, was her objection to setting up women's sections in France. Marginalization could further be seen in the topics that women's political groups concerned themselves with. They were largely to so-called

women's issues, the care of children, for example, whereas men's political meetings covered a far greater range.

Pelletier's dislike of sex stereotyping was not without its comic side. One of the more appealing features of *Mon Voyage aventureux* concerns her willingness to tell the tale of her own discomfiture. In this case, her troubles began when the lodgers at the Hotel Luxe were required to donate a day's labour as payment for the board and lodging they had received from the state. Pelletier, along with other women from the hotel, was assigned to work in a dressmaking establishment. She declared this to be quite unacceptable: 'I didn't come to Moscow to work in a sewing room. Dressmaking is the symbol of female slavery' (p. 150). Instead of this 'women's work', she pleaded to be allowed to join two male guests with whom she was acquainted, a journalist from *L'Humanité*, and the Hungarian ambassador. Accordingly she was marched off with the men to a railway station where they spent the day loading railway sleepers on to wagons. An icy wind blew across the railyards through a drenching rain. The Hungarian ambassador, who was tubercular, looked dreadful. Pelletier, not unnaturally, found the work exhausting. They kept on with their 'travail terrible' until four o'clock; then marched home again still in the rain. Pelletier's tailored dress was soaked with heavy mud; her shoes, too light for the occasion, caused her to trip in the badly paved streets; she was depressed and bone tired (p. 151). But after she had sought shelter in a restaurant and solace in a cup of hot chocolate, her spirits rose. All in all, if she had not enjoyed her day of sexual egalitarianism, it was better than doing 'women's work'.

While in Moscow, Pelletier was fortunate in obtaining several interviews with Alexandra Kollontai, who represented the 'communism of the left' within the government.[14] Kollontai discussed with Pelletier her new book on sexual equality; many of its themes paralleled those of *L'Émancipation sexuelle de la femme*, though Kollontai suggested they were too advanced for most Russians. In spite of the closeness of their views on women's sexual emancipation, Pelletier disagreed with Kollontai on the issue of reproduction. The latter had asserted that reproduction was a social obligation of the citizen to the state. This to Pelletier was another example of potential tyranny under collectivism. Still, to have seen and spoken with Kollontai was an event.

Pelletier saw enormous possibilities for women in the Soviet

Union but she had no desire to remain in Russia, even if women were more liberated there. In the end she preferred her Paris to the more egalitarian society of the USSR. She quailed before the material difficulties of existence, feared the winters and above all she disliked the sense of being under surveillance in the most trivial aspects of her private life. In Moscow she lacked the intellectual and social confidence that characterized her attitude in Paris. Her spoken Russian was too limited to make more than basic contacts, and interpreters were hard to find. The Hotel Luxe with its chilly dining room and preoccupied clientele was no substitute for the camaraderie that she had built up in a number of Parisian circles. Before she set out for the Soviet Union she had seriously considered settling there permanently, but she concluded that this life was not for her. Her decision to return to France was less ideological than emotional. 'Ah, Paris, my Paris' was a cry from the heart. Though deploring so many aspects of French life, she was a Parisian through and through. She relished the variety of Paris, its restaurants, theatres and crowds. Wiser than her childhood hero Napoleon, Pelletier decided to return home before the first snows fell.

The Return Journey

The voyage back to Paris was infinitely easier than the voyage out, though not without its moments of risk and drama. Initially, Pelletier was afraid that she would be refused a passport by the Soviet authorities. When she went to collect her documents and travel allowance from the commintern, the commissar reproached her for leaving a country that stood in need of her medical skills. He also complained about her masculinized appearance: 'Women should not resemble men; they have a mission to charm, etc. etc.', she noted in *Mon Voyage aventureux* (p. 187). Pelletier was horrified. Had she travelled three thousand kilometers at great danger to herself in order to hear the same platitudes that were uttered by reactionaries in Paris? More seriously, she also felt afraid. This anti-feminist Bolshevik had the power to keep her in Russia for ever. However, she did at length receive her papers, and when safely on her journey home reflected on her adventures with a paraphrase from *Candide*: 'I wonder', said Candide, 'whether it

would not be better to be hanged, dissected, to row in the galleys etc. rather than to be bored in this quiet life.' The Russian trip had been difficult, sometimes dangerous and only intermittently enjoyable, but overall she had not been bored, though there had been moments of tedium. She had gained valuable experience and, like Candide, she had not found her ideal to be what she imagined.

On the return journey in the train, singing revolutionary songs with her fellow travellers, she felt part of a great victorious movement (p. 193). But when at length, she arrived safely in Paris, she felt she was living a dream. At any moment the city would melt away and she would awaken in the Hotel Luxe:

> After a few hundred kilometres, I underwent a bizarre psychological change. It was as though a curtain had suddenly been draw shut; it hid my journey, which then entered into the past. I felt profoundly depressed. I arrived in Paris at midday. In the cab which went along the Boulevard Sébastopol and crossed the Seine, I felt as though I were in a dream. I had to pay close attention to the houses to convince myself of their reality; for they seemed to me to be part of a dream from which I would soon awake in my bed in the Hotel Luxe. (p. 201)

Conclusion

In the last chapter of *Mon Voyage aventureux*, and in a pamphlet published in 1922, *Capitalisme et communisme*, Pelletier summed up the political lessons of her journey.[15] She undertook a comparison between the French Revolution of 1789 and the Russian Revolution of 1918. The former had not really aimed beyond a change in the form of government, substituting a republic on the Roman model for a monarchy. Enlightenment ideology did not add up to an economic and social policy, save in the case of Robespierre, with whom Pelletier strongly identified. By contrast, the Russian Revolution represented an overturning of the whole economic and social system founded on private property. Its very failures were in part a function of its ambitious aims. Though she had read Lenin's analysis before her journey, she acknowledged that her visit had dramatized for her the terrible problems of transforming Russian society. The very people whose lives the revolution wished to improve, namely the peasants, had turned

against it. But if socialists despaired of the revolution, they would only leave those whom Pelletier referred to as 'le peuple stupide' to rot in the counter-revolution. She illustrated this pessimistic judgement by an anecdote about Robespierre's death:

> Perhaps similar feelings of despair haunted the mind of Robespierre when he awaited death, lying on a table in the Hôtel de Ville, his jaw smashed. It is related that someone, a passer-by, filled with pity, pulled up the stockings of the famous defeated revolutionary and that Robespierre said to him: 'Thank you *Monsieur*.' 'Monsieur' and not 'citizen' since he knew he was carrying the revolution away with him to his tomb.[16]

European socialists, Pelletier felt, must not allow the revolution of 1918 to perish like the revolution of 1789. It must be supported in spite of its limitations: 'The experience of the Russian people will be of service to the whole world. In spite of its errors, and even of its faults, all enlightened minds have a duty to make it succeed.'[17]

Thus, nothwithstanding her reservations, Pelletier continued to uphold soviet communism as a superior alternative to capitalism. It was less wasteful and in tune with adaptation and genuine efficiency. There were clearly vices in the soviet system such as an overweening bureaucracy. She considered that the *paioc* system and the payment of subsistence wages did not solve the problem of incentives. But she defended the genuine achievements she had witnessed in the Soviet Union. Industrial production had been rationalized, educational opportunity had been vastly expanded. The new marriage laws, which permitted divorce, had liberated women from the worst forms of legal oppression.[18] Her principal fear was that communism did little to mitigate the tyranny of custom or public opinion over the individual. The ideal state which she envisaged would offer communism in production and allow the greatest liberty in the individual's mode of life. Fundamentally, Pelletier remained a libertarian anarchist while believing that efficient production and distribution could best be organized by central planning.[19]

The Russian journey forced Pelletier to clarify her attitude towards violent revolution. Tensions between her Hervéisme, feminism, pacifism and even her neo Malthusian interests had already been evident before the war. One recalls that her socialist colleagues had accused her of 'reformism'. Yet it was also the case

that in her short Hervéiste period she had preached armed revolt and the overthrow of the republic as a precondition for social change. Had Pelletier merely been engaged in gesture politics? *Mon Voyage aventureux* suggests that when confronted with a society rocked by violent change, she came to realize the extent to which she and her left-wing colleagues in France had played at revolution. Pelletier's encounter with the woman she called Madame Defarge illuminates this point. While admiring the latter's revolutionary dedication and undoubted courage, Pelletier feared her ferocity. This reaction was based less on squeamishness (we have seen that she was personally courageous and capable of confronting danger) than on a horror of fanaticism, related, one suspects, to memories of her mother. Those who could pursue a goal at any cost lacked the sceptical and rational frame of mind that characterized her understanding of social progress. Furthermore, she dissented from one of the consequences of the French and the Russian revolutions, namely terror. For all its achievements, Soviet communism pointed towards the creation of a new tyranny. Finally, throughout her Russian journey, Pelletier was sensitive to the effect the revolution had had on individuals. Many had had their lives transformed for the better; but she did not dismiss those whom she met, mostly bourgeois intellectuals, whose world had been laid waste. It was a mark of Pelletier's independence of mind that, with every predisposition to endorse the Soviet experiment, she retained a critical perspective.

In this context the question of Pelletier's class affiliation assumes added relevance. We have seen that, though successful in joining the professional classes, she never defined herself as bourgeois, especially not as a bourgeois woman; rather she considered herself a *déclassée*, one who had left her own class and was virtually classless. One of the ironies of the Soviet visit was that from the perspective of revolutionary Russia she was frequently labelled as middle class and, most objectionable of all, as a middle-class lady (for example, her clothes in comparison to most Russian women's appear to have been relatively stylish). It is clear that Pelletier identified strongly with the French intellectual élite. She believed in a meritocracy of intellect. She was a rare example of the working-class intellectual seeking the levers of power to free both her class and her sex.[20] And though she saw her own intellectual training as being in the service of oppressed groups, this very

training alienated her from these groups. A similar paradox operated in her attitude towards the Republic: she was theoretically committed to the overthrow of the French Republic, but she also had a deep emotional affinity to it.

In her utopian novel, *Une Vie nouvelle*, Pelletier described a revolution taking place in France, followed by a period of total social breakdown when rape and pillage rage unchecked. The situation is only brought under control by a benevolent dictator who restores order and institutes a communist society. Such fictional scenarios suggest that after the war years and her Russian voyage, Pelletier held an increasingly bleak view of human potential. Her commitment to individual liberty was at war with her social pessimism. She hoped that the fundamental revolution in sexual relations which she sought would break the cycle of violence and repression exemplified by previous political revolutions. However, in reality, the post-war years in France increasingly showed a spirit of reaction rather than of liberation. We can recall Pelletier's dry acknowledgement of her own historical inappropriateness: 'I was decidely born several centuries too early.'[21] Nevertheless, throughout these decades, she retained her remarkable energy and her fascination with the sheer variety of human experience. As she wrote in *Mon Voyage aventureux*, 'Human life ... seems to me the most precious thing on earth' (p. 188).

8

Post-war Political Reaction and Feminist Politics, 1922–1932

Whereas in the post-war years Pelletier's material and social circumstances improved, after the early enthusiasm over the Russian Revolution her political horizons darkened. From her perspective, the forces of reaction were rallying on at least three fronts, exemplified by the rejection of women's suffrage in the French senate in 1922, the passing of anti-neo-Malthusian legislation between 1920 and 1923, and finally by a general movement against rationalism and anti-clericalism expressed in the new strength of both the Catholic church and spiritualism. Maintaining faith in the progessive evolution of human culture became a daunting, even a Quixotic task.

The 1920s and 1930s saw Pelletier more solidly established in her medical practice.[1] Her clientele of women patients expanded. She advertised in socialist and feminist newspapers as treating 'women's illnesses', almost certainly a euphemism for contraceptive advice and abortion, as well as for general gynaecological matters.[2] References to the detailed knowledge and practice of abortion occur in *Le Droit à l'avortement*, in *La Femme Vierge* and in *Trois Contes*, as well as in numerous letters to Arria Ly. Yet one cannot depict Madeleine Pelletier as the compassionate feminist doctor, rescuing women from unwanted pregnancies. On one occasion she told a chilling anecdote about refusing an abortion to a woman whom she considered to be one of the hated 'demi-

émancipées'. 'I remember a little incident', she wrote to Ly, 'à propos le féminisme en décolleté' [feminists in low-cut dresses]:

> A woman employee of the Post Office, a cut above the average, called herself a feminist. This did not prevent her, of course, from curling her hair, wearing feathered and flowered hats and using lipstick etc. When among men, she simpered – 'Certainly she asked for her rights,' she said, 'but one mustn't go too far, or wish women to become men, like some do . . . women should remain women.'
>
> Then there was a postal strike; she took a very active part. One night a worker on the picket lines came to fetch her in a car, saying there was a very urgent problem for which her help was needed. She got up, dressed, got in the car next to this man whom she knew well. They arrived near to their workplace: he led her up to a third floor, where to her great astonishment she found herself in a little bedroom. The man locked the door, threw her on the bed and raped her. – Pregnancy; she came to me in tears asking me to abort her. As you may well imagine, I refused; even if abortion were permitted I would have done the same, because I thought that she had got no more than she deserved. May all feminists who are only half-feminists be treated the same.

Pelletier signed the letter defiantly: 'Salut féministe, Dr. Pelletier, vierge incorruptible.'[3]

This story, with its vengeful feminist curse at the end, showed Pelletier in an uncompromising and vicious mood. The anecdote suggested, among other things, that she was known as an abortion-ist even though she refused on this occasion to perform one, with the disclaimer, 'even if abortion were permitted'. It also demons-trated that her aversion to the 'demi-féministes' was stronger than her approval of trade union activism, which this young woman seemed to exhibit; that her indignation was entirely turned against the girl rather than against her attacker; and that loyalty to feminism was Pelletier's sole criterion for a woman's integrity. What must strike the reader as a disturbing lack of compassion in this instance reveals the depth of Pelletier's anger at those women who, while paying lip-service to feminism, refused to alter any-thing fundamental in their relations with men.

Pelletier's arrogation of power to herself to decide whether someone was 'worthy' of an abortion sat uneasily with her declarations of principle on the right to abortion: 'Certainly

abortion can be defended. Firstly it is the woman's right. She is free
to control her body and if the born child is sacred, the foetus in her
belly belongs to her. She ought to be able, at will, to keep it or
reject it.'[4] Even within the politics of birth control, Pelletier found
conflicts between her elitist/authoritarian tendencies and her liber-
tarianism. However, she also defended abortion on therapeutic as
well as libertarian grounds:

> Abortion causes neither cancers nor ulcers. Whoever says the
> contrary must be a hostile doctor. Abortion may cause metritus and
> salpyngitis but properly carried out it is less dangerous than
> childbirth, since in the case of grave illnesses, it is carried out legally.
> Abortion avoids the risks women run from the sexual act and to a
> certain extent liberates them.[5]

The incident of the Post Office worker showed a powerfully
vindictive streak in Pelletier and suggested some of the tensions
underlying her work as a doctor and a feminist. Resentment of
those who failed to liberate themselves, and who failed to make the
sacrifices which she considered that liberty entailed, emerged
powerfully in this letter, as in her attacks on 'demi-féministes' and
the working class elsewhere.

In 1926 Pelletier bought a car, learned to drive and passed the
test for her licence, probably one of the first women in France to
do so. She rejoiced in the liberty the automobile brought, though
she complained of the expense of her Citroen C4F. The personal
mobility conferred by the automobile and the protection it offered
its owner from the intrusive commentary of strangers, which she
had always dreaded when travelling, made it a boon. At about the
same period she acquired a small property at Gif-sur-Yvette, a
village some ten miles south-west of Paris, between Chevreuse and
Orsay, which she visited at weekends. There she kept a few
animals, dogs, poultry etc., looked after by a local woman during
the week. There, too, she found the leisure to write the novels and
short stories which occupied her later years.[6] The fact of owning a
small village house, as well as renting her Paris flat, suggests a
considerable level of financial security, a new-found prosperity.
But in most other respects her letters reveal a sense of both
personal and political disappointment; for example she complained
to Arria Ly: 'In France women like you and me have no place; 'les

poules de luxe' [luxurious chicks] are preferred.' This echoed a similar complaint to Ly as early as 1916: 'Society doesn't like women who distinguish themselves from the herd; men insult them, women detest them. In the end one must resign oneself to what one cannot prevent and I would not, all the same, change my skin with that of a bleating sheep.'[7]

Pelletier claimed to have few friends who shared her ideas, but she may well have exaggerated. Some like Hélène Brion and Eugène and Jeanne Humbert visited her at Gif. Eugène Humbert, a neo-Malthusian and member of the Ligue de la Régénération Humaine, was, like Pelletier, a pacifist; he had served a jail sentence for avoiding conscription during the 1914–18 war. At the Club du Faubourg (see chapter 10) Pelletier had a wide circle of friends and acquaintances who engaged in the polemical debates she relished. In 1922 and 1923, she gave pro-Bolshevik lectures at the club. Nor did her political activity flag. In 1924 she participated in the campaign for the legislative elections on behalf of the Communist Party. In 1932 she attended the World Congress against Imperialist Wars in Amsterdam and joined Mundia, a pacifist group. Between 1926 and 1936 she contributed numerous articles to a variety of left-wing periodicals: *l'Insurgé*, *Plus Loin* and *Le Semeur contre tous les tyrans*.[8] She summed up her activity at this period in her autobiography:

> Naturally my opinions remain with me. I give them substance in pamphlets that I publish from time to time, in articles that appear in little newspapers and in public lectures. Nowadays, women vote almost everywhere; there is only France which in spite of its claims appears in reality as a very conservative country.[9]

The Death of Women's Suffrage

As the foregoing quotation indicates, the major political disappointment of Pelletier's career was the defeat of the women's suffrage campaign at the hands of the Senate in 1922. It represented a crushing blow for all those French feminist groups which had identified their aims so closely with attaining the vote. Though women's suffrage appeared again on the parliamentary agenda in the inter-war years (it was also defeated in the Senate in 1928 and

1931), 1922 marked its demise as a live political issue. Not until 1944 did de Gaulle give women the vote by decree.[10] But in 1922, whereas twenty-five nation states had already granted women's suffrage in national elections, incuding the Soviet Union, Rhodesia, India, the USA, Great Britain, Austria, Germany, Palestine and Ireland, France did not live up to the Republic's commitment to equality and liberty.

After the war, though Pelletier briefly relaunched *La Suffragiste*, she was less active in organized feminism. Her pre-war militancy had not endeared her to many bourgeois feminists who had repudiated civil disobedience as a weapon to gain the vote.[11] Moreover, Pelletier had spent the year before the fatal vote in the Senate involved with her Russian journey. Until the defeat of the suffrage bill in 1922, she, like other French feminists, must have believed that the granting of the suffrage was imminent. It is fair to say that their optimism had seemed well founded. The victories of the women's suffrage movement internationally made it seem merely a matter of time before France fell into line with other advanced industrial countries. The Buisson Report of 1909 had come out strongly in favour of women's suffrage. Even the Pope, Benedict XV, had in 1919 announced his approval for the principle. By 1920, therefore, French Catholic women's groups felt able to support the campaign for women's votes. On 20 May 1919, the Chamber of Deputies overwhelmingly voted for a women's suffrage bill. But in November 1922 all these hopeful auguries proved groundless; the Senate overturned the decision of the Chamber of Deputies, voting 134 for and 156 against. Among the strongest opponents of the bill were the presumed allies of the suffragists, the Radicals and the Radical–Socialists.[12]

The background to the suffrage vote revealed how social attitudes on the woman question in the Third Republic transcended party lines. For example, the Bérard report on women's suffrage of 1919, submitted to a special senate commission, deployed arguments against women's enfranchisement which seemed to indicate that all the rational arguments of feminists in the previous fifty years had gone unheeded.[13] Women were still held to be incapable of rational thought or political responsibility. Of the fourteen-point summary, there was only one (number eleven) of political substance, namely the contention that: 'The Catholic mentality of the majority of French women, combined with the hostility of the

church towards the republic and liberty, mean that women's suffrage would lead to clerical reaction.' The Radicals' fear of the 'black peril' survived intact as a determining element in rejection. However, Bérard's other points exposed, with a touching lack of self-consciousness, the masculinism of French republican culture.[14] Point fourteen was typical, stating that: 'Women are different creatures than men, filled with sentiment and tears rather than hard political reason: their hands are not for political pugilism or holding ballots, but for kisses.'

If this was the level of serious debate in the Senate, suffragists might well despair. An additional factor in rejection was the lack of urgency of the issue to the male electorate. Whereas in Great Britain, Germany and the USA the women's suffrage movement had found allies among disenfranchised males, the early universal suffrage for men in France (1848) meant that they had little common cause with disenfranchised women. Finally with the exception of the anarchists, or feminists like Pelletier also influenced by English liberalism, there was little emphasis in France on individual rights.[15] Women were not perceived to exist as individuals but as 'the sex'. Pelletier writing to Ly in 1932 concluded: 'Universal suffrage is a dead letter. One isn't proud to be a Frenchwoman.'[16]

In 1925, Pelletier left the Communist Party.[17] Aside from disagreements with colleagues on feminist issues, it seems likely that active involvement in male politics must have come to seem entirely futile after the impasse on women's suffrage. Nor did other parties of the left offer much hope. The Radical–Socialists, for example, had proved generally obstructive on the suffrage issue. Whereas in its earlier ideological phase, the party had espoused the emancipation of women, in its political phase it lost interest in a group which would bring it few votes. Pelletier remained a socialist in the broad sense, but no political party offered a platform to achieve the aims that she sought.

Pelletier saw the suffrage defeat less in the context of the political structures of the Third Republic than as part of a depressing tendency to reactionary ideas in French life in general. It was true that many things had improved for women after the war, yet fundamental attitudes seemed as hidebound as ever. Women could cut their hair short and even on occasion wear trousers; they had entered many male professions; but in the arena of sexual politics,

little seemed to have changed. For example, though there were now many women working in offices, newspapers and the civil service, in order to obtain promotion, Pelletier claimed, they had to sleep with the bosses.[18] Sexual harassment remained an important deterrent to women's advancement. And even emancipated women were only superficially liberated. A woman aviator who had recently flown the Atlantic was quoted as saying: 'What I will do [in the future] depends on my husband.' Pelletier found this risible: 'To conquer the Atlantic and to be a man's slave!'[19] Servility, she felt, was still imprinted on women's consciousness. Feminism had proved to be more complex than the suffrage issue alone.

Neo-Malthusians at Bay

In one sense, the anti-suffragist votes in the Senate could be interpreted as reflecting increased unease about the French birth-rate, with its corollary disquiet about women in any other role than as breeders. To Bérard and his colleagues in the Senate, it was axiomatic that a woman who went to the polls could not be a good wife and mother, a truth, it was alleged, that women themselves accepted:

> The immense majority of Frenchwomen, 'so full of good sense' do not want to vote, do not want to leave home for the political arena: they know their families would suffer as a result.
> Women's 'primordial role' was to attend to 'the incomparable grandeur of maternity and the family'.[20]

The 1920s saw an intensification in pro-natalist campaigning and major legislative success in anti-contraceptive and anti-abortion measures.[21] As suggested in chapter 6, anti-neo-Malthusianism or pro-natalism had a long history. The change in France's position from being the most populous of European states in 1800 to a birth-rate which had halved by 1939 had long roused alarm. The carnage of World War One had raised the spectre of depopulation ever more acutely. In general, pro-natalists laid the blame for the declining birth-rate on a combination of left-wing or 'liberal' causes (anarchism, feminism, socialism, neo-Malthusianism) rather than, say, on militarism.

When Pelletier published *Pour l'abrogation de l'article 317; le droit à l'avortement* in 1913, she had challenged the article of the penal code of 1810 which made abortion an indictable offence for the patient, or for anyone who assisted her, medically or otherwise. Possible penalties under Article 317 included death or hard labour. The draconian nature of the law inevitably made abortion a clandestine activity (without having a visible deterrent effect) and put women at risk from unscrupulous or incompetent practitioners. Statistics listed in the *Compte Général de l'administration de la justice criminelle* from 1871 to 1931 showed that the highest crime rates for women were connected with reproduction: that is, abortion, concealment of births and infanticide.[22] When Pelletier campaigned for the abolition of Article 317, it was partly in order to decriminalize behaviour resulting from women's biological function. She strongly condemned infanticide, arguing that all live infants should be declared legitimate and that they should be protected and educated by the state. In addition, she urged that legalized contraception and early abortion were a social necessity.

The pro-natalists raised a different objection to Article 317. They considered that its penalties were so severe that few juries cared to convict. Their first major victory was the passage of the Act of 31 July 1920 which decreed that whoever gave contraceptive advice, or any assistance with regard to abortions, was subject to six months to three years in prison and a fine of between 100 and 3,000 francs.[23] This law attempted less to punish women seeking contraception or abortion, than those who provided information or assistance to them. It was far more repressive on the issue of complicity than the previous Article 317. The real targets of the 1920 Act were the neo-Malthusians, among them the well-known birth control campaigner, Doctoresse Pelletier.

The pro-natalists followed their legislative success of 1920 with the Act of 27 March 1923, which further lessened penalties against women who had had abortions – abortion became a misdemeanor rather than a crime. Cases were taken out of the hands of fatally sympathetic juries and given to magistrates, while the abortionist risked one to five years in prison and a fine of 500 to 10,000 francs. Nevertheless, women who had had, or attempted to have, abortions faced six months to two years in prison or a fine of 100 to 2,000 francs. But in general, certainty of punishment was favoured over extreme penal severity.[24]

The consequences of these new laws were not long in making themselves felt: convictions rose and acquittals fell. From the neo-Malthusian perspective, more worrying than the convictions was the growth in clandestine abortions and their often serious medical consequences. Though statistics were notoriously unreliable, it was estimated that by 1937 there were between 300,000 to 500,000 abortions a year, many carried out in totally inappropriate conditions.[25] If the top figures quoted were true, there would have been nearly as many abortions as live births. The pro-natalists and neo-Malthusians had some points in common, namely the perception that if citizens were to be encouraged to reproduce, they needed economic incentives. The moves towards a generous system of family allowances in the late 1930s (the 1939 Code de la Famille) stemmed from this concern. In addition, as Pelletier had long argued, a high birth-rate was meaningless if one also had a high infant mortality rate. Both sides of the political spectrum began to agree on the necessity for public hygiene measures.[26]

One striking aspect of pro-natalist propaganda at this period was its appeal to militarist and racist sentiment. For example, Ludovic Nadeau, a leading campaigner, argued that measures were needed, not only to augment the *masse nationale*, but especially to ensure that France remained a white nation, capable of controlling its black and Arab colonies. While admitting that many blacks had died for France in the war, Nadeau added: 'Foreigners who are perfectly bearable in small numbers, become dangerous when one sees them rise up at every street corner.' Such was the rate of indigenous French depopulation, he claimed, that if contemporary trends continued, in fifty years time it was calculated that not a single inhabitant of unmixed French origin would be found in France. A further rationale for a growing population rested on the need for soldiers to maintain the colonial empire. A vigorous population base was needed to pursue military aims.[27]

Such arguments lend weight to the view that pacifist feminists like Madeleine Pelletier who both denounced war and argued for birth control policies were in no sense pursuing a series of separate issues. Militarism, pro-natalism and anti-suffragism could be seen as facets of an all-embracing male order.[28] By the 1920s, Pelletier was identified as a leading neo-Malthusian and considered particularly formidable because of her medical expertise and because she linked birth control to women's rights. Paul Bureau, like Nadeau a

prominent pro-natalist, was in little doubt that her theories on reproduction could, if realized, signal the end of French civilization: 'Feminism and the principle of moral equality ... is a new element ... but its interior force is so great that it could ... reduce our moral disorganization to the worst extremes.'[29] Bureau cited Pelletier as an example of the most 'advanced', intelligent, dangerous and ruthless feminist thinkers. He quoted from *L'Émancipation sexuelle de la femme* Pelletier's assertion, 'over our bodies our right is absolute', to demonstrate the lengths to which feminist ideas led. It is evident that by the 1920s Madeleine Pelletier had been targeted as a dangerous adversary by the pro-natalist movement.

Pelletier herself candidly linked her justification of abortion to her more general philosophic and political views.[30] Opposed to all forms of violence and murder, she denied it to be inconsistent to sanction the destruction of the human foetus, while upholding the value of human life in other spheres. By arguing that the soul did not exist, that the personality was material in origin, she was able to suggest that abortion was consistent with her pacifism and with her rejection of capital punishment; man was 'born, like all animals, from the union of a spermatozoide and an ovum. At what instant does the soul lodge in a human being? Must one endow a fertilized egg with a soul? And suppose this egg is expelled, what happens to the soul? Think of the number of ova souls peopling the universe.'[31]

This materialist conception of the mind allowed Pelletier to advocate abortion with consistency. As she had written in *Le Droit à l'avortement*: 'Birth should be the criterion of individuality. Every child born should have the right to society's protection; the unborn do not exist and the law should have no jurisdiction over them' (p. 138). But she seemed to acknowledge a potential problem in delayed terminations and advocated abortion only up to three months after conception. Writing before the debates on childbirth and abortion raised by technological advances in the 1970s and 1980s, she felt that women incapable of making a decision by three months did not deserve consideration for termination. Nevertheless, the mere fact of giving women such a choice and of arguing the case against religion, within the context of contraception and abortion, would have confirmed the pro-natalists in their view that: 'Feminism and the princple of moral equality ... could

reduce our moral disorganization to the worst extremes'.

The Impact of Freud

During the inter-war period, Pelletier began to read Freud and to apply his theories on sexuality to the woman question. Although in France the psychiatric establishment had been initially hostile to Freudian theory, his work began to appear in French from 1922.[32] We recall that Pelletier's interest in sexual psychology dated from her days as a psychiatric intern, and that her article 'Sadisme et masochisme' (1910) had linked abnormal psychology to broader social issues. She seized on Freud's work as a means of explaining women's resistance to their own liberation as well as throwing light on women's sexuality. She early incorporated the idea of female masochism into her view of the socially induced nature of women's oppression. An understanding of sexual psychology became a key to liberating women, a view which she developed in two texts, *L'Amour et la maternité* and *La Rationalisation sexuelle*.[33]

Pelletier concentrated her analysis on the psychological effect on women of their traditional subordination, an inferiority founded in human animality rather than being a necessity of civilization. Thanks to the age-old pattern of dominance and submission, she thought that women's sexual feelings had on the whole been successfully repressed by social institutions, particularly by religion: 'the deep gulf that separates the sexes is above all the work of society.' Differences in sexual behaviour, like differences in other forms of behaviour, became largely a question of social conditioning. Yet in spite of thinking that women's sexual feelings had been socially manipulated, and observing the degree of repression women exercised about their sexuality, rarely admitting for example, to sexual feelings even to doctors, Pelletier considered the female sexual drive to be less strong than the male. The acceptance of an inequality in the sexual drive may have stemmed from a desire to justify her own renunciation of sexuality: 'Sexual appetites are very unequal in the two sexes; in men, love is an imperious necessity; in women it is a vaguely defined desire while they are still virgins. Society, which exalts male sexuality, diminishes still further that of women by making them ashamed of it.' Her

positive prescription for human sexuality was to separate the physical need from moral or social judgements. 'It is a physiological function like nutrition or circulation.' She envisaged a future where the ideal couple would function as a pair of equal comrades, where love and affection would be stronger than animality and where women would be freed from the burden of child-care by state education: 'An egalitarian society will raise children in order to give them the best possible life. Their intelligence will acquire all the development of which they are capable. Native intellectual inequality will be the only sort to remain, and that much diminished by a well-regulated education.'[34]

It seemed to Pelletier that political and educational reform could only be genuinely advanced by an understanding of the way in which social determinants (for instance, marriage customs, property laws for women) became mental facts and taught women to see themselves as inferior. To the extent that women naturally shared the values of the societies in which they found themselves, they internalized their own sense of inferiority out of these social values. Thus ideas about sexuality were both personal and social, subjective and objective. Whereas Pelletier's early work on associationist psychology envisaged sexual malfunction as a peripheral symptom of a more general mental disease, her focus in the 1920s and 1930s, under the influence of Freud, was to give sexuality a central place in human motivation.

Freud's views on sexuality, she thought, had allowed women to admit that they, like men, had sexual feelings: 'It's not very highly evolved, but what can you expect? Man is an animal. A cat on heat cries out with desire. Myself, I did without men with ease, because it wasn't possible to have one without being humiliated.' Then, referring to a book on female masochism: 'I was revolted but I think that basically it is true and that [masochism] is the fundamental reason for the half-feminism of flirtatious women who say they must remain feminine.'[35] The idea of female masochism allowed Pelletier to explain the difficulty she had always found in radicalizing women. If women's subjection was a source of perverse sexual pleasure, then emancipation appeared much more problematic.

In 1935, Pelletier published her last work on psychology and feminism, *La Rationalisation sexuelle*. It represented a detailed engagement with Freudian theory based also on her anthropolo-

gical training. In it Pelletier offered an account of Freud's *Intro-
ductory Lectures in Psychoanalysis*, assessing the significance and
limitations of Freudian theory for feminism.[36] She focused on
Freud's identification of a unique aspect of human sexuality as
opposed to animal sexuality, namely the feature of disguise
surrounding the reproductive instincts:

> Whereas animals mate in public, people, especially in civilized
> countries, look for secrecy. Thus one doesn't see sexuality; chil-
> dren, who know nothing about it, don't see it anywhere. Only
> adults, who know, see through the things behind which it hides . . .
> Sexuality is hidden; it is as forbidden to speak openly of it as to
> show its instrument. One can frankly avow that one is hungry or
> thirsty; one can at a pinch admit that one wishes to free oneself of
> the waste products of food; but never that one feels a sexual need.[37]

Employing an associationist psychology, she outlined some of the
mechanisms of repression and compression by which sexuality
manifested itself:

> Mental compression is analogous to physical compression, and
> ideas, like gases, look everywhere for a way out . . . almost in spite
> of oneself, the idea springs up to do that which is forbidden, to
> show one's genitals, for example, or to look at those of one's
> parents. . . . The result is not action but, on the contrary, a dreadful
> fear, fear of oneself. The child asks himself if he isn't a monster, a
> criminal like those he had read about in the newspapers. Naturally
> this morbid ideology remains a secret . . . And the child sometimes
> suffers dreadfully without anyone suspecting it.[38]

Pelletier's experience in psychiatric hospitals had shown her
examples of patients in whom the breakdown of inhibitions
signalled the emergence of formerly repressed sexual wishes. The
above account of the child's fears of its hidden desires ('the child
sometimes suffers dreadfully') suggests that Pelletier may have
remembered such a 'morbid ideology' from her own childhood,
and that Freud's writing could have lifted the weight of this secret
guilt. Yet while admiring Freud's insights, Pelletier pinpointed the
difficulty that social reformers encountered with psychoanalysis.
The centrality of sexuality as a motive of virtually every form of
behaviour appeared both potentially reductive and deterministic.

For example, Pelletier suggested, according to popularizations of Freudian doctrine, revolutionaries could be construed as men who had unresolved Oedipal complexes, not as rational individuals rebelling against social injustice. The notion of behaviour being influenced by rational choice or objective social factors was implicitly jettisoned in favour of the hidden workings of repressed instinctual drives.[39] Pelletier wrote:

> Viennese psychology universalizes sexuality far too much. According to it, all feelings, including the love of the soldier and the rebel for his leader, must be sexual. In my opinion it is an error stemming from language. In order to veil the sexual act, civilized modesty speaks of it in vague terms which don't precisely express it. 'Love' can be maternal, filial, religious, scientific, political, etc. . . . and it can also be no more than the sexual act itself, for example in the expression, 'to make love'. Nothing is more certain than that all feelings are related in the human heart. To love one's parents or one's lover is still love. But it's stretching things too far to claim that a Russian Bolshevik loved Lenin with sexual love.[40]

If people were no more than their sexuality, and all social action was but a manifestation of repressed or disguised sexuality, then the ideal of social and rational progress to which Pelletier had dedicated her life was illusory. Nevertheless she was prepared to acknowledge the hold which unconscious ideas held on mental life as a way of explaining resistance to rational argument, or even to clearly perceived self-interest. And she praised Freud's achievement in redefining the nature and scope of the sexual instinct: 'We are beginning to understand that . . . sexuality . . . is a natural law; that, badly interpreted, it can be the cause of pain, of madness and of death; and that we must examine it not with the prejudices inherited from the past, but in the light of reason, and make it a subject of scientific study.'[41] For Pelletier, Freud's work held out the promise of bringing the whole area of sexual laws and customs under scrutiny and conscious control. Since she had become increasingly convinced of the power of irrationality in sexual, political and religious discourse, Freudian theory offered hope in a cultural climate increasingly hostile to positivism.

Pelletier's writing on sexual emancipation can be usefully contrasted with her own sexual puritanism and also her pragmatic

views on prostitution. The problem of prostitution, on which she both wrote and lectured to feminist groups, illustrated her unorthodoxy on this issue as on so many others on the feminist agenda. Prostitution and the laws relating to the medical inspection and regulation of prostitutes had long been a focus of women's philanthropic protest. Middle-class feminists had tended to argue for the abolition of the sexual double standard by encouraging male chastity rather than 'lowering' or liberating women's sexual behaviour. The legacy of Josephine Butler and the deregulationists implied a restrictive morality for both sexes.[42]

Pelletier was unusual in the context of French feminism in granting women the right to sexual expression on the same basis as men. Prostitution, therefore, raised a number of questions for her. Prostitution could be considered as a sign of progress, Pelletier suggested, because whereas in primitive societies men satisfied their sexual appetites by raping women, in the case of prostitution the man at least made a contract and paid for a service rendered. Nevertheless, though the market economy might be an advance over the rule of mere force, the reality of prostitution was a miserable one to which many women were driven as a last resort, impelled by starvation. Recounting the case of a young girl who had committed suicide because of her extreme poverty, Pelletier quoted the concierge who found her: 'She was too well behaved, much too well behaved', implying that the girl should have gone on the street.[43]

Given women's poor wages and economic insecurity, it was not surprising that they sought to improve their position by selling their sexual favours. But the attempts by the government to limit venereal disease by forcible medical inspection was doomed to failure, as male clients were not subject to the same controls. The 'cure' for prostitution was not greater medical or penal control but economic independence. When women could earn a decent wage and when they could enjoy their sexuality on the same basis as men, prostitution would disappear. 'When sexuality is considered as being merely a natural function for both men and women, there will be no more prostitution.'[44]

It is evident that although she was celibate in her own life and although she opposed prostitution and regulation, Pelletier did not align herself with the many middle-class feminists who sought to impose a tighter moral orthodoxy on both men and women. While

not rating the sexual instincts highly, she also thought it futile and unjust to attempt to suppress them. Similarly, although she campaigned against alcohol abuse, she did so because alcohol was both a symbol of and contributed to the degradation of the proletariat, not for any inherently moral reason. Alcoholism flourished in conditions of social misery. The same could be said of the commodification of sex in prostitution.

Religion

The conservative post-war climate in France was marked for Pelletier not only by the rejection of women's suffrage and the new anti-abortion laws but also by the revival of religion. Deeply anti-clerical, and convinced that religion and political conservatism were synonymous, Pelletier detected in the revived power of the Catholic church in France and in the growing popularity of spiritualism a further shift to the right. Spiritualism's main attraction, she thought, lay in assuaging the fear of death for which the scientific world view brought no solace: 'The frightful perspective of inevitable annihilation darkens all of one's life; it may leave an uncultivated peasant resigned but it terrifies a Pascal . . . the idea of non-being becomes insupportable.'[45] Pelletier had in fact attended spiritualist sessions, probably in the company of Caroline Kauffmann, who, much to Pelletier's distress, embraced spiritualism in her old age, a conversion which spelled the end of their friendship of twenty years. Pelletier believed that Kauffmann was breaking faith with feminism by her adherence to this form of mysticism: 'I broke with Caroline Kauffmann because of spiritualism. It seems that she has the privilege of seeing astral traces. But I see nothing at all – no agreement possible.'[46] Though Pelletier was characteristically uncompromising in her rejection of Kauffmann, she betrayed both unease and sorrow at this break with an old and valued friend. Pelletier was fifty-two years old in 1926, when Kauffmann died. She may have seen in Kauffmann's decline, a portent of her own future.

Pelletier's attacks on spiritualism were arguably linked to her childhood experiences of religion. Ever since escaping the maternal home, she had dedicated her life to the positivist ideal. It seemed to

her that spiritualism was an intellectual regression, as was the yearning for religious consolation:

> Religions may have done good in the past: but they have also done a great deal of harm. Without speaking of the cruelties of theocracy, they have had the effect of holding back thought and turning humanity away from science, which alone can render life happier.[47]

Pelletier's was the increasingly lonely voice of scientific positivism in a post-war climate where scientism appeared to many arid and comfortless. Her own position was one of stoic rationalism – life had no meaning beyond itself. But she clearly understood the temptation to religious belief inspired by the fear of death. Her real indictment of religion was in its hidden political agenda: she believed that, in whatever guise, it was a weapon of the ruling elite to control the masses:

> Faced with the pressure from the fourth estate claiming its right to a happy life, the bourgeoisie had begun to think that it was wrong to combat religion and that the Voltairean frame of mind, an excellent weapon for gaining power, is useless for retaining it. The bourgeoisie has, therefore, begun to restore the old beliefs.[48]

Thus while emphasizing Pelletier's anti-clericalism, an attitude which remained consistent throughout her life, one should not imply that she was indifferent to religious issues. Her primary hostility to religion may have lain in her difficult relations with her mother, added to her adult judgement that Catholicism – by its ideology and structure – and now spiritualism, were necessarily hostile to women's emancipation. But she never denied the attractions of religious feeling, reverting to memories of her first communion on several occasions.[49] That she herself had experienced the desire to believe in personal immortality was clear in the War Diary, where the horror of personal annihilation emerged powerfully.

By the 1930s, Pelletier's letters evinced no confidence in the reality of social progress and saw rationalism in retreat. The church was regaining power, as shown by the fact that the traditional separation of church and state in the state school system was at risk:

Alas, what you fear is true: anti-clericalism is defeated ... priests appear in public ceremonies next to senior civil servants. Official relations exist with the Vatican and it may even be that the papal nuncio takes precedence over other ambassadors. ... Priests are asking for state aid for their schools. This reactionary activity goes back to before the war, but since the war, and above all since the Russian revolution, the all-powerful bourgeoisie has given up its anti-clericalism with the thought that religion is useful to defend itself with.[50]

The reaction against scientific positivism in French intellectual life in the inter-war period has been well documented. An anti-positivist tendency extended from right-wing nationalism on the one hand to spiritualism at the other extreme. All her life, Pelletier had seen two classes of the oppressed bound by religion: women and the poor. In Moscow, when she had witnessed peasants kissing the grease-covered glass cases sheltering icons, she had felt this demonstrated not piety but a return to the Dark Ages. She believed that rationality was a means to free individuals from the dominance of instinct. As civilization evolved, human beings would exercise more rational choice over their lives. Free will, for a materialist, did not consist in possessing a soul, but in the ability to choose consciously between concrete alternatives. For all her commitment to revolutionary change, Pelletier was, intellectually speaking, a child of the secular Third Republic, waging the rationalist war against what she believed to be a tide of religious superstition.[51]

Always fond of drawing comparisons from other civilizations and other species to illustrate her theories of cultural evolution, in her later years Pelletier turned to the study of animals. At her little house at Gif, she kept four dogs as well as some chickens, rabbits and guinea pigs. She recalled how the dogs, each with a distinct personality, competed fiercely over food, even when they had more than enough to eat, and over the favours of the one female, demonstrating a jungle morality and a fierce territorial sense. To Pelletier, her dogs were the canine example of an unevolved culture:

The morality of dogs is not admirable: fierce egoism, cowardice, cruelty, respect of brute force. It reflects a state of nature where beings can only survive by devouring one another. The same savagery existed at the origins of human society. Fine feelings,

friendship, pity for the weak, and generosity are the conquests of civilization and of an intellectual culture.[52]

Animals might represent a lower order of culture but Pelletier was deeply troubled by cruelty towards them and by their neglect. This theme had surfaced in her play *In Anima vili* (1920), where doubts were expressed about animal experiments. The sight of abandoned animals in Paris wrung her heart. 'A future society would forbid the murder of animals; one would no longer have the right to poison the unhappy cat who has ceased to please, the dog one wishes to get rid of. Animal aid would be a part of the national budget; well-furnished refuges would shelter abandoned dogs and cats.'[53] She described the treatment of stray dogs in Paris:

> Every dog found in a Parisian street is transported to the pound where it is killed. The howls of these animals, tortured by hunger before being sacrificed, make the pound a place of horror before which the heart sinks if one is not a brute. It makes one think of the dungeons of the Middle Ages from whose depth the groans of miserable prisoners struck the ears of passers-by.[54]

For Pelletier these canine prisoners evinced suffering as real as the political prisoners whose fate had haunted her in the USSR. Brutality to animals or to human beings was not an isolated event; it showed the temper of a whole society: 'The child who delights in burning a miserable rat alive, who tears birds' nests apart, who stones cats to death, will become a coarse and brutal man who will make any weak person in his power suffer.'[55]

Conclusion

The 1922 suffrage defeat represented a terrible blow to organized feminism in France. When one recalls that Pelletier had been, with Hubertine Auclert, one of the most militant proponents of women's suffrage in French feminist circles, one can scarcely exaggerate the disappointment she and others like her must have suffered. Nevertheless, it is remarkable how little she dwelt on this rejection and how soon she moved on to other issues that she identified as integral to feminism. Whereas she had considered that women's suffrage was a crucial objective in gaining equality for

women, she had never regarded it as enough to secure full emancipation. Women needed to achieve citizenship but their oppression transcended questions of their civil status.[56] After 1922 she turned to an examination of women's sexual and psychological subjection, concluding that although women were clearly oppressed by unjust laws, they were also, to some extent, the slaves of their own minds. In Pelletier's writing in the 1920s and 1930s one finds an expansion of her feminist agenda, moving from her early concentration on legal/political reform to unshackling female psychology. In addition, given the context of a reactionary political climate, she began to turn to fiction. Political activism was replaced in her later years by utopian descriptions of a new world for women and for men.

9

From Activism to Fiction, 1925–1935

Throughout her career, Madeleine Pelletier published a wide variety of pamphlets, articles and longer texts, all on broadly political or social topics. However, towards the end of her life she turned to fiction, producing three short stories, two plays and at least two novels.[1] Given the fact that she saw herself above all as a polemicist, her recourse to fiction in the fifteen-year period from 1920 to 1935 marked a clear shift in direction from her earlier work.

Pelletier's imaginative writing represented an attempt to take stock of her life by putting the career of a propagandist and militant into a fictional perspective. A central theme which emerges from these works is that of the solitary intellectual from a working-class background, frustrated by contemporary society, a version of her own predicament as she perceived it. Fiction allowed Pelletier to write more subjectively and more emotively than was possible in the ironic, Voltairean and 'virile' style she adopted for most of her polemical work. Even her unpublished autobiography, 'Doctoresse Pelletier', is reticent on most personal issues. It conveyed the account she wished to construct of a public figure – the feminist militant, the 'virilized' woman. But Pelletier's dramas, short stories and novels record her more private hopes and fears, and offer, albeit in an encoded way, valuable glimpses of her inner life.

Fiction also allowed Pelletier to find imaginative compensation, not only for disappointments in feminist and socialist militancy, but for what she felt were her more personal defeats: her failure to rise in the psychiatric services and her increasing isolation from many former socialist and feminist colleagues. She felt profoundly her relative lack of success both in politics and medicine and that her considerable abilities were under-used and largely unrecognized. In her utopian and autobiographical novels in particular, these limitations and disappointments could be rectified. Her fiction can also be classified as militant propaganda in a different form. French literature has a long tradition of philosophical or political fiction; novels of ideas from Voltaire to Sartre and Beauvoir constitute an important literary genre. Given the fact that in the 1920s and 1930s, Pelletier was faced with effective censorship of her theories on sexual emancipation and neo-Malthusianism, the banning of direct propaganda on these subjects may have persuaded her to rework her material into fictional form.

Pelletier, it must be said, appears to have had little success as a writer of fiction. It is unlikely that her two plays were ever performed. She had difficulty in finding publishers for her novels, nor do they seem to have sold widely, if at all. In 1926 she wrote to Marguerite Durand, who had many acquaintances in the literary world, asking for help in finding a publisher. In 1928 she complained of further difficulties to Arria Ly: 'I am very upset about my novel. A novelist, M. Bonmariage, asked me if he could arrange for its publication; he would find an editor and the two of us would sign. I accepted and since, no news. I am afraid he may have stolen it.[2] Six years later, in 1932, however, she referred to two novels in preparation or about to be published: *La Femme vierge* (The Virgin Woman) and *Un Monde nouveau* (A New World), actually published as *Une Vie nouvelle* (A New Life):

> 'Une Monde nouveau' is a sort of voyage in Icarie. I describe a communist society, as I understand it to be. The other, 'La Femme vierge' is a sort of autobiography but with changes. I die, moreover in Germany, killed in a riot, and that is not the fate that I myself yearn for.[3]

Pelletier had some qualms that her autobiographical novel might offend those who saw themselves or their relatives depicted in it:

In my novel, 'La Femme vierge', you will see Caroline Kauffmann
appear. I hope her family won't bear a grudge against me because of
it. I say nothing bad about her for that matter. Certainly she was
idealistic, intelligent, sincere, but obsessed, for God's sake – she had
visions . . . and she wasn't kind, oh, no.[4]

Kauffmann, her friend of so many years standing, had first given
Pelletier prominence in the feminist movement. Their falling out
over the question of spiritualism must have remained on Pelletier's
conscience.

Judged by most literary canons, Pelletier's novels appear mecha-
nical in construction, showing a heavy didactic emphasis. Her
fiction tended to develop the consciousness of a single character,
neglecting secondary figures. On the other hand, her descriptive
writing undoubtedly had strengths; she could evoke the life of the
poor or the feel of Parisian streets powerfully. She had a good
satiric eye; some of the passages on political or feminist groups are
genuinely comic. Most strikingly, the pages which recorded ver-
sions of her childhood have an almost Dickensian intensity.
Pelletier rightly felt that her life had the makings of significant
drama; had she foreseen her own end, she would have felt so even
more strongly.

From the historical/biographical perspective, Pelletier's fiction,
as well as representing part of her political enterprise, also contains
clues to, if not certainties about, her life in areas not always
possible to document precisely. It provides evidence of how she
interpreted her life and the society around her, filling out her
habitual context of closely argued polemic with images and
impressions. As such her imaginative writing forms part of the
broadly historical record. Though Pelletier had no connections
with Parisian literary circles (it is intriguing but curious to think of
her as inhabiting the same Paris as Proust, Gide, Hemingway and
Gertrude Stein, for example) she read widely in philosophy,
politics, feminism and fiction.[5] References to Voltaire, Balzac,
Zola, Dostoevsky and Tolstoy occur in her writing, as well as
comments on newer fiction such as *L'Enfer* and *La Garçonne*.[6] She
reviewed Céline's *Un Voyage au bout de la nuit* (1932) which she
admired for its indictment of post-war culture, colonial exploita-
tion and the description of the Parisian medical proletariat which
she found 'cruelly true'.[7] Pelletier like Céline portrays contempor-
ary Parisian life from the underside.

Her two unperformed plays, *In Anima vili* and *Supérieur!*, which she may have been encouraged to write by Léo Poldès (a minor playwright and the drama critic for *La Guerre sociale*), shows her eye for social observation. *In Anima vili* was discussed in chapter 2 in relation to the debate on genius. *Supérieur!* (1923), based on her recollections of her working-class background and of the anarchist groups she frequented from the ages of thirteen to twenty-three, throws light on this otherwise poorly documented period. The early life of the proletarian hero, Pierre, who aspires to the status of an intellectual, is a thinly disguised account of Pelletier's own youth. As in her short stories and novels, the hero of *Supérieur!* is unfitted for his proletarian milieu by reason of his intellectual superiority. But his very qualities condemn him to be misunderstood by his family. Pelletier returned to this theme of familial alienation in both her novels. *Supérieur!* is also remarkable for its description of the anarchist groups that the hero joins. The anarchist meetings with their component of workers, long-haired youths, naturists in sandals and a half-dozen or so women *compagnons*, one of whom is a Russian ex-princess, are almost certainly based on Pelletier's own experiences in the 1890s and exploit a comic vein in her writing. The play's political argument centres on the desirability or not of collaboration with communists within the parliamentary party. Committed to propaganda by the deed, Pierre is jailed for a political murder, but is helped to escape to Russia with the blessing of his anarchist mentor, who, recognizing his 'superior' qualities, exclaims: 'Pierre must live in order to serve the idea of the revolution.'[8] In *Supérieur!*, revolutionary violence and elitism are simultaneously endorsed.

Similarly Pelletier's one published collection of short stories, *Trois Contes*, focuses on the theme of the isolated but superior individual misunderstood both in the proletarian and bourgeois worlds. The first story, 'Un Traître', which is again clearly autobiographical in its resonances, concerns the rise of a young man out of the working class through the route of socialist politics. Jacques is depicted as a fish out of water, reflecting Pelletier's own sense of fitting neither into her social class nor her gender role: 'Throughout his childhood, he had been misunderstood; his schoolmasters punished him as undisciplined. He could, if he wished, have been an excellent scholar, but he was a bit lazy;

nothing in his surroundings, for that matter, stimulated him to work' (p. 2). In spite of showing ability, Jacques leaves school at thirteen (like Pelletier) to become a bookbinder's apprentice. Three years later, quite by accident, his vocation declares itself:

> ... he perceived, as on the road to Damascus, the point of intellectual training. He had been sent to a bookshop in the Latin Quarter. In the gathering darkness of a winter afternoon, the silhouette of the Panthéon on a grey backcloth, towering over the rue Soufflot, appeared before him. Well-dressed groups of students, briefcases under their arms, spilled over the pavements. His heart contracted. He felt himself to be an ignoramus, with his working-man's jacket and his cloth-bound bundle which he carried on his back; he began to regret bitterly the wasted years at his primary school. But an inner voice said to him that he was still young and that he could make up the time. (p. 3)

'As on the road to Damascus.' Jacques's epiphinal moment of conversion towards the pursuit of intellectual goals is dramatized by the Panthéon, that temple dedicated to the cult of great men that functions as an icon of ambition in the story. Pelletier poignantly contrasts this revelation with the reality of Jacques's family life, almost certainly evoking memories of her own home:

> Dependence on his family in a debased environment had long weighed upon him. He had many times dreamt of the moment when he could finally take leave of this sad dwelling, of the continual arguments over trifles, the mockery that greeted his vague ambitions whenever he spoke of them, the ridicule made of his reading. (p. 4)

To escape this 'debased environment', Jacques moves to the Latin Quarter and succeeds in gaining an engineering qualification through a correspondence course. However, he does not forget his origins: 'In our day, when education, without being as available as it ought, is relatively easy to acquire, autodidacts are not uncommon. But many of them, in their burning desire to rise in society, give themselves over, body and soul, to the bourgeoisie, who open their doors to them' (p. 5). Jacques allies himself not with the bourgeoisie but with the socialists, against the 'plutocratic classes'.

His subsequent career in the Socialist Party traces the conflicts Pelletier also experienced between idealism and what she considered to be the careerism and opportunism of mainstream socialists: 'Intellectuals were numerous in the party, but most of them were only there in order to make a career and had little sincerity' (p. 6). Such passages echo the criticisms Pelletier had long made about the *arriviste* style of many socialists and their lack of commitment either to revolutionary or egalitarian principles. Jacques is eventually ostracized by his comrades: 'Against Jacques, the intruder, calumny was unrestricted; his talents and his intelligence were denied; he who was sincerity itself was accused of personal ambition' (p. 7).

These accounts reflect a legacy of bitterness towards the SFIO which Pelletier had joined with such high hopes in 1906. Not only does the party turn its back on Jacques but he also finds himself rejected by the common people who accuse him of being a bourgeois intellectual, an accusation familiar to Pelletier. Thoroughly disillusioned, he decides on his revenge. After the war, during which he had seen pacifist colleagues become fervid nationalists and militarists, Jacques betrays his socialist principles in order to achieve political success. Once launched on the road to opportunism, he is rapidly elected a conservative deputy, then minister. Now a scourge to socialism, his personal ambition is amply satisfied: 'Certainly he was far from having fulfilled his life; luxury, honours, the respect of others, he paid for all these with his dearest convictions. If formerly he had at moments of enthusiasm dreamt of realizing his ideas, now that he had power, he could only keep it by lying to himself' (p. 10).

Jacques's dramatic political about-turn was based on the career of Pelletier's former mentor, the revolutionary socialist Gustave Hervé (1871–1944), as well as on those socialist deputies like Basly, whom she had pilloried in *La Guerre sociale*. At the outbreak of the First World War, Hervé abandoned his pacifist and internationalist position in favour of an extreme nationalism. For the remainder of his career, he adopted a rightward political trajectory.[9] Jacques, the traitor, followed a path forsworn by Pelletier, that of accommodation. In 'Un Traître', the conflict between principle and ambition is shown as irreconcilable. Yet satisfied ambition seems to Jacques worth having, even at the sacrifice of his dearest beliefs. This story well may have expressed

Pelletier's occasional regret that she had not followed the path of political opportunism.

Another tale in the collection, 'L'Enfant' (The Child) develops the themes of class antagonism and the individual's revenge on society. Based on a case history known to Pelletier (another version appears in *Le Droit à l'avortement*), the narrative dramatizes in particular the problem of illegitimacy, recalling vividly Madeleine Pelletier's mother's origins. Rather than embracing the establishment, the misunderstood individual prepares to wreak havoc, in the form of revolutionary violence, on the bourgeois enemy. The 'child' in question is the offspring of a wealthy young woman who, not having succeeded in contracting the obligatory bourgeois marriage, takes a lover; on finding herself pregant, she decides to bear the child. Her own mother, outraged in her ideas of respectability, advises her to take poison in order to save the family name. After the birth, the grandmother relents and takes mother and son to live with her. Some twenty years later, the narrator recounts meeting the child, Fidelio, now a grown man, at a Bolshevik meeting:

> Ah no. He never went to see his grandmother – that dirty little bourgeoise who had humiliated him and made him suffer during his childhood. He loathed her with all the power of hatred, but more than her, he hated contemporary society, so riddled with prejudice, which made children suffer by the supposed sin of their mother. And my eyes became fixed on his tie where sparkled the hammer and sickle: the emblem of the Soviets. (p. 20)

Though marred by melodramatic language, this story touches on a number of themes central to Pelletier's view of social injustice: women's enslavement in the marriage market, the bourgeois obsession with respectability, the needless sacrifice of women to a life of tedium (one sister in the story commits suicide) and the fate of illegitimate children. Fidelio's identification with the proletariat logically follows from his sense of being one of the world's outcasts. Pelletier could not have forgotten that her mother, Anne de Passavy, carried the mark of her illegitimacy both literally, in the brand on her neck, and metaphorically, in her rage for divine justice. Her daughter was profoundly aware of the sense of shame branding such children:

The caste prejudice which still powerfully exists today blames the child for a crime which is only his misfortune. Having issued from his mother's body, he is worth as much as the child of a queen or a millionaire. Individuals can be unequal in intelligence, in energy, in merit, but wombs are equal. There are neither noble nor ignoble ones. It is life, later on, that marks out differences, honours genius, recognizes effort, esteems moral value, but on the day of birth all babies are equal.[10]

The third story in this collection, 'La Mort aux chats' (The Cat Killer), offers a sombre account of old age and solitude in the modern city. Prefaced by a quotation from Spinoza, 'Mankind ends its life in despair', the story reflects Pelletier's concern with human and animal vulnerability. In the opening paragraphs she evokes a prison-like medieval cityscape in twentieth-century Paris, a network of little streets behind the Panthéon.

The sun had set behind the Luxembourg and it is almost dark in the network of little alleyways behind the Panthéon, forgotten by the pickaxe of the modernizing demolition workers. The rue L'Homond is lined with dusty convents which shelter the childhood of poor orphans; the famous Jesuit monastery dominates it from high above, the high and naked walls of its chapel spreading their shadows over the whole street. To the right is the rue Rataud, a street with an iron gate which in former times was closed at night. During the day, the rue Rataud is made fragrant with the scent of the ash trees which overhang the crumbling wall of the École Normale Supérieure. To the right, the rue Cheval-Vert, the rue des Irlandais; the Irish college perpetuates an atmosphere of the Middle Ages, its walls covered with a black patina seeming to date from the days of Raymond Lulle and Abélard [thirteenth and eleventh-century scholars]. (p. 11)

Through these silent and normally deserted streets, shunned even by the students and professors of the Latin Quarter, a figure moves in the gathering dusk:

Often in the uncertain light of evening and in the sparse gas lights which have just been lit, a shadow appears which clings to the walls. It is an old woman, thin and badly dressed. On her arm she carries two heavy baskets all tied up with rope; she is known as the Cat Killer. (p. 12)

The old woman of the story passes her time seeking out the stray cats of the neighbourhood, in building sites and waste ground, and feeding them. She runs a private animal rescue service. Living entirely alone save for her twenty-two cats, and in terror of neighbours' complaints, she becomes ever more isolated and secretive: 'She opened the door to no one. Only the gas meter man was allowed in once a month. She spoke to tradesmen through the keyhole.' When her neighbours discover that she not only collects stray cats but kills the severely injured ones with chloroform, they suspect her of being a witch and of performing dreadful experiments. But the Cat Killer acts according to no particular theory. Hers is a spontaneous compassion for the sufferings of animals:

> She had never taught more than the rudiments to little children: she barely knew a bit of spelling and arithmetic. When she wasn't busy with her animals, she did her mending or read popular novels. She destroyed only sick cats, in obedience to a doctrine which she had worked out for herself and according to which death was preferable to suffering. (p. 15)

An account in *L'Assistance*, a pamphlet arguing for a range of improved social security measures, of a similar figure who also attracted public scorn, suggests that Pelletier took her model from life:

> The care of unfortunate animals is left to the initiative of a few good people who are willing to concern themselves ... popular understanding is so brutal and rudimentary that charitable people who have pity on animals, far from receiving praise, find only scorn and abuse. This woman who feeds stray cats, they say, is certainly crazy. To waste one's time and money on animals, says another, is stupid...[11]

'La Mort aux chats' illustrates the personal cost of nonconformity. The old woman's neighbours consider her mad. The narrative describes her defensive and eccentric behaviour, conditioned by her struggles to follow her conscience against the tide of popular opinion. The story ends with her suicide. An internal monologue describing her decision to kill herself suggests that the thought may not have been far from Pelletier's own mind:

Why suffer? In a few more days at most I will die. Life is ugly; suffering everywhere and people only add to it by their cruelty ... The poor little cat who plays around me quite happily, I find the next day with a crushed paw, half killed by a vicious lout. Life is an evil; and death is a blessing, especially the death I give without suffering by chloroform. No more illness, no more persecution, no more ingratitude, a sound and dreamless sleep forever. (p. 16)

The spectre of old age for poor and single women clearly haunted Pelletier.[12] She saw them, feeble, poor and a prey to loneliness, ending their lives in squalid conditions. The Cat Killer was only odd in trying to alleviate her own loneliness by extending her compassion to those beyond herself. The narrative's sombre tone is powerfully enhanced by the images of the closed convents and dark streets at the story's beginning.

In her two novels, Pelletier developed themes which had first emerged in *Trois Contes*, particularly the situation of the *déclassé* intellectual unable to gain acceptance for his or her ideas. In the first of these, *Une Vie nouvelle*, Pelletier evokes the Paris of her childhood and youth, the proletarian and criminal milieux of her anarchist phase, political circles in which she had moved and a vision of a future communist state. The novel probably owed a great deal to Chernyshevsky's *What is to be Done?* (1863), which inspired generations of Russian and European socialists. Like its Russian model, the strongest writing in *Une Vie nouvelle* is to be found in the description of the pre-revolutionary era.

The role of imaginative writing in expressing the unfulfilled ambitions or desires for power of women writers, as well as their sense of subjection, has for some years been a focus of feminist criticism.[13] Pelletier's novel offered her this imaginative compensation, but significantly the narrational focus is on the male protagonist, not the main woman character. Whereas Charles Ratier, the hero, is ambitious and intelligent, Claire Mélin, his female counterpart, is depicted as little more than an efficient reproductive mechanism. Even in her communist utopia, where women are in theory free and equal, Pelletier cannot conceive of a female character who is capable of distinction.

Une Vie nouvelle opens in the tenth year of a French communist state after World War Two. Europe is divided into two blocs:

France, Russia, Germany, Sweden, Norway, Denmark and Switzerland are all communist, other countries including Britain are under Fascism. The narrative moves between the lives of Claire Mélin and Charles Ratier. Claire, a secretary in a government ministry, is representative of ordinary women in the new post-revolutionary world. We first see her walking up the Boulevard Michel Bakunin (previously the Boulevard Saint Michel) on the way to the maternity hospital to give birth to her fourth child. The boulevard, once lined with shops and cafés, now boasts colossal palaces decorated with columns and bordered with flowers. Cafés have been replaced by houses of recreation where refreshments are sold but no alcohol or tobacco, where women can enter as easily as men and where free cinema, radio and television are available. Claire recalls that fifteen years previously she could not have gone to a café alone: 'Now she was free like all women; in this café she felt like any other person' (p. 15).

Claire's life illustrates the new position of women under communism, particularly with regard to maternity. Easy going and unambitious, she chooses from time to time to have a child which entitles her to a year's paid leave. Her children are looked after by the state from birth, though mothers can have the care of their own children if they wish. In an entirely practical spirit, Claire fulfils her demographic duty and is amply rewarded for her trouble. 'She goes to the maternity hospital as she might go to a clinic to undergo a minor operation.' Her willingness to bear children for the state and her entire indifference to the product allows Pelletier to answer critics who argued that women's sexual freedom would lead to depopulation. Given the right financial and social incentives, women would reproduce in abundance. In the new society, sexual intercourse is seen as a purely physical function, satisfying natural appetites and without moral significance. The sexual double standard has been abolished. Thus Claire's moral status is transformed. Formerly her healthy sexual appetites would have made her the equivalent of a prostitute; now in spite of having numerous lovers, she is an honest woman. The abolition of the double standard and the new sexual honesty have other beneficial social effects. In the new world, pornography no longer exists, the need for it having disappeared. Most workers spend their leisure hours in further education establishments, not in pubs or brothels. It is a society devoted to self-improvement.

Though, by giving away her child without perceptible conflict, Claire acts in an ideologically correct manner, her existence of vegetative comfort bores both narrator and reader. At heart, in spite of the new regime of sexual equality, she is a woman of the old world, interested in flattery and clothes. The portrait of a free individual, transformed from the slavery of poverty and prepared to transform himself by intellectual effort, is reserved for the male protagonist, Charles Ratier.

Ratier's early career corresponds closely to Pelletier's own, especially his political trajectory and his commitment to lifelong education. He had grown up in Paris, 'rue Mouffetard' (the same setting as 'La Mort aux Chats' and close to Pelletier's surgery on rue Monge). The Ratier family, mother, father, and six children (the *famille nombreuse* beloved of the pro-natalists) live in the most abject poverty in two small rooms. Charles's father, a bricklayer, drinks heavily; his mother struggles to help the family survive by taking in washing. The bitterness of the family home remains Charles's abiding memory of domestic life. Pelletier's hostility towards the concept of the family was without doubt based on such recollections of dirt, overcrowding, bickering, noise and violence.

Even though Charles shows scholastic promise, he is forced to leave school at twelve years of age. His parents have no understanding of his ambitions. The theme of parental incomprehension surfaces in all Pelletier's accounts of working-class childhood. Charles goes to work as a garage mechanic and, when he is sixteen, is taken up by a prostitute named Lily. A series of unlucky events combine to radicalize him politically. Arrested for taking part in a burglary with Lily's criminal-anarchist friends, he is sentenced to four years in prison, followed by a further six months for helping another girlfriend to procure an abortion. An enforced spell in hospital with tuberculosis, where as a poor patient he is treated with contempt, further opens Charles's eyes to class inequality. Medical treatment in hospitals is described as symptomatic not just of bad medical practice but also of contempt for the poor. As Pelletier had written in *L'Assistance*:

The great wards of hospitals today are a remnant of barbarism. The patient, already worried by his own condition, has to bear witness to the death agony of a neighbour. Universal egoism allied to

profound discouragement is required for hospital patients not to die of fear; especially the seriously ill who have every reason to think that the terrible fate of their comrades will soon be theirs. These vast hospital wards are vestiges of past ages when as many as six ill persons were put in the same bed to croak. Promiscuity favours contagion: to such an extent that certain patients admitted to hospital for a minor illness, contract a serious one and die.[14]

On his release from hospital Charles joins the Communist Party. Then the political landscape is shattered by a Second World War. Pelletier built a second European cataclysm into her plot (seven years before the event) as the mechanism to bring about the communist revolution. From this point the novel shifts to the world of the future. Having anticipated the unversality of television, car and air travel, Pelletier also imagines a war prosecuted by a form of atomic weapon. French defeat sparks a revolution; famine, disease and filth stalk the cities; crime and rape flourish. This period of acute social breakdown is only halted by the coming to power of a benevolent dictator, Egemon. Gradually under his direction civil accord returns; buildings and flats are forcibly cleaned by government teams, the streets cease to be threatening: 'one no longer met people in rags, and by living in material cleanliness, the people began to improve morally. They quarrelled less, language improved, swearwords fell out of use bit by bit' (p. 130).

As a skilled worker, Charles Ratier finds avenues open to him under the new regime which would have been impossible under the old order. He becomes a mature student at the School of Medicine. Launched in his new studies, he recalls an earlier attempt to qualify for a higher degree, when his involvement in political meetings led to his failure in examinations. This may be a reference (there seem to be few others) to Pelletier's failure at her psychiatric *concours*. (That examination certainly coincided with her enthusiastic, and time-consuming, involvement with the SFIO and Solidarité.) The life of a student is the closest one gets to an ideal world in Pelletier's fiction. For her, student life had marked her liberation from her family and an initiation into a world of intellectual freedom. *Une Vie nouvelle* further illustrates her belief that education should be a lifelong process, not restricted to a few years of one's youth. Through his studies Charles is recuperated as

a socially useful person; he regains a sense of purpose and self-esteem.

Une Vie nouvelle projects a collectivist dream of social organization which allows maximum development for the individual. Among the technical improvements devoted to social ends after the revolution are easier travel, communal housing and the educational stimulus of television. The new vision of urban life is based on a combination of Fourier-style *phalanstéries*, scenarios from Chernyshevsky and an admiration for soviet-style, centrally planned housing complexes; it projects huge subsidized apartment blocks with libraries, central kitchens, laundries and cinemas arising along the Seine. Crucial to Pelletier's dream of new housing for the poor was the notion of cleanliness. The impact of the conditions in which she had passed her childhood and the way she saw many of her working-class patients live led her to imagine, by contrast, flats cleaned by government-appointed teams, laundry and mending done gratis (and no more housewives mending socks); the people cleaned up (*dégraissé*) once and for all. Her domestic ideal was one where individuals had maximum privacy, but where it was possible to find a communal, not a familial, life. Humanity in the future would live in hotels.

Traces of Pelletier's anthropological training and its hierarchical implications emerge in the novel. France still has colonies, but only for the improvement of 'backward' peoples. Complete racial equality is practised. Pelletier had evolved from many of her early anthropological views, but she maintained the concept of cultural rather than racial hierarchies. In France, for example, the countryside represented backward culture. Agriculture is accordingly industrialized and the peasantry, depicted as a lesser breed, have been moved into towns and their villages razed to the ground. 'Thus the peasantry, that force for stagnation, was destroyed' (p. 183). In this utopia, Pelletier eliminates conflict through authoritarian means, a model scarcely compatible with her views on individual liberty. Finally, the most significant change in the new world – female emancipation – is an established fact. Complete intellectual equality reigns: 'Talented women are very numerous; they are to be found in the higher reaches of industry and administration and there are three in the Council of Ten (the ruling politburo)' (p. 172).

Meanwhile, under the new order, science too makes strides:

there are flights to the moon. Intelligent reptiles are discovered on other planets, who convert human beings to vegetarianism. Ratier, now trained as a biologist, participates in the scientific revolution by discovering a version of DNA, '*la plasmogénie*'. He develops a technique which allows people to have their vital organs perpetually renewed. Life having been infinitely prolonged and natality restricted, everyone now has three or four professions in their lifetime. Thus, after a long career as a biologist, Charles takes up political science and at the age of one hundred is appointed president of China, following the revolution in that country. 'Charles has the future before him and every hope of soon going to organize a new world' (p. 247).

In this science-fiction fantasy, Pelletier, at the age of fifty-eight, shifted the desire for immortality from the religious to the material plane. In the most cheerfully improbable episode, even the Pope is converted to communism and has an organ transplant in order to live longer – accepting that earthly life has more to offer than the afterlife. The need for religion vanishes as the fear of death recedes. The final section of the novel achieves a certain euphoria. Charles, the former jailbird, overcomes his past. His exceptional talents are developed and rewarded. It is indeed a 'new life'. Yet the ambivalence between authority and liberty is striking in the novel. Whereas the model for government in the new France is dictatorial (if enlightened), the model for individuals is that of change, adaptation and freedom. For all its narrow and doctrinal aspects, *Une Vie nouvelle* tries to invent a more generous vision of human culture. But, like Rousseau, Pelletier concludes with the unhappy paradox that the mass of people must be 'forced to be free'.

Pelletier's second novel, *La Femme vierge*, achieved a fictional representation of her own life, so close to other accounts that it can be taken in its early sections as a legitimate biographical source. The narrative of the heroine's childhood in the filthy fruit and vegetable shop, her slatternly yet powerful mother and sceptical but weak father reflected the ideological and emotional conflict that fed Pelletier's adult political commitment. The maternal paradox of a strong managing woman insisting on a traditionally passive woman's role for her daughter is central to Pelletier's analysis both of female potential and of the contradictions of women's experience.

The protagonist, Marie Pierrot, who possesses the same initials

as her author, follows a career as a revolutionary feminist and socialist. She experiences the double bind of sexual and class oppression, which are represented as the foundations of her subsequent career. The menarche highlights her parents' contrasting reactions, her father attempting an explanation, her mother rejecting the distasteful subject entirely. 'These first revelations as to the reality of life left a bitter taste' (p. 22). In another incident, at about the same period, the sacristan attempts to fondle the girl in the church library. The text builds up clusters of associations: mother/lack of love; religion/sexuality/furtiveness; father/ scepticism/humour. A dream ascribed to the child on the fourteenth of July (when her mother refused to allow her to attend the fireworks or to ride on the wooden horses of the merry-go-round) to the effect that she is pursued by a man who wants to cut off her thumb seems a classic Freudian formulation.[15] Whether Pelletier in fact dreamed it, or whether she constructed the dream after reading Freud, the inference of the phallic symbol of power being attacked is inescapable.

Marie early declares her determination not to marry and to struggle for sexual equality. Like Pelletier she follows a path of feminist and socialist activism. Deciding on teaching as a profession that would give her financial independence, she discovers that women teachers are no more emancipated in their attitudes than her mother had been. Thus when she catches Marie reading a socialist newspaper in the staff room, the headmistress reproves her for her political ambitions, declaring: 'Wife and mother – the whole of a woman's life is encompassed in those two words' (p. 85). The headmistress offers the same incoherent message as Marie's mother had given: lead an independent life but embrace a servile ideology.

Similarly, the description of Solidarité des Femmes which Marie next joins, and which is virtually identical to accounts in 'Doctoresse Pelletier', shows an all-woman milieu lacking precisely that solidarity for which it strives. The 'lamentable group of old women' (p. 95) led by Caroline Kauffmann engage in intense rivalry. Solidarité members attempt to keep Marie away from other feminists like Hubertine Auclert and Madame Oddo. Marie comes to the conclusion that most members of Solidarité are but feeble feminists. They lack any clear historical or theoretical understanding of women's subordination. Holding convictions based on a

confused amalgam of private griefs and disappointments, they are
what Pelletier had called 'feminists by feeling' (*les féministes par
sentiments*). In her view, this sort of purely personalized feminism
meant that women were incapable of seeing beyond their own
situations into the structures or ideologies that controlled them.
They looked for tiny improvements (better divorce laws, better
pensions for widows) without wishing to challenge male hege-
mony. Women's feeling of injustice had to be raised to a general or
intellectual level. Women who could not see beyond their anger at
the husbands or lovers who deserted them to the power structures
which made such betrayals commonplace were not hopeful agents
of change.

Like 'Un Traître' and *Une Vie nouvelle*, *La Femme vierge* traces
a career in socialist politics, underscoring the dilemmas of Pelle-
tier's own experience: accusations of class collaboration because
she also belongs to feminist groups, advice to grow her hair and to
read Bebel. Socialists, she reflects, may be politically advanced, but
they are not sexually liberated. Nevertheless she rises rapidly in the
party and her motion for women's suffrage is accepted by the party
congress. But this early success is followed by growing pessimism,
symbolized first by the suicide of Lafargue and his wife Laura
Marx, then by the assassination of Jaurès, and finally the outbreak
of the Great War.[16] In the book, these episodes mark the end of the
early period of political optimism.

In the post-war period, however, Marie's political ambitions,
instead of being continually frustrated like Pelletier's, find an
outlet. The form this transformation takes is suggestive. She moves
to Berlin where women under the Weimar Republic have the vote
and where she makes the acquaintance of the socialist, Karl
Liebknecht, who helps plan her new political career.[17] At this
stage, Marie Pierrot seems to take on the combined personalities of
Clara Zetkin and Rosa Luxemburg. She joins the SPD and, thanks
to proportional representation, becomes a deputy to the provincial
parliament. However, she is obliged to concentrate her political
energies on the so-called feminine questions such as mother- and
child-care. Women, she discovers, are still marginalized within
male politics.

The novel ends in a revolutionary apotheosis. While Marie
watches a Spartacist demonstration in Berlin, government troops
fire on the crowd. Three hundred people are left dead, among them

Marie, killed by a stray bullet. Pelletier must have had in mind Rosa Luxemburg's murder in 1919. Pelletier's personal regrets about her failure to advance further in the Socialist Party are reflected in this ironic ending. Like Luxemburg, Pierrot is accorded a magnificent funeral.[18] But unlike Luxemburg, she dies entirely accidentally and meaninglessly, a bystander not a participant in the revolution.

In Paris, Kauffmann, by now obsessed by spiritualism and given to visions, believes she sees Marie's ghost, proclaiming the socialist future. This scene suggests a parody of the messianic dreams held by earlier revolutionaries like Louise Michel: '"It is I, Marie, I am not dead, no one dies. I see the new world advancing. Work, work, march towards the light over the graves of the fallen – the new world is approaching..." The poor old woman fled, terrified' (chapter 24). The ghost of Marie, assigned to the deranged mind of Kauffmann, creates an ironic, not an inspirational ending. As Marie Pierrot herself had reasoned after Lafargue's suicide, the messianic impulse in socialism was a chimera: 'To believe human beings capable of a grand plan that went beyond the limits of their existence was to over-estimate them. No, there was no light; there was only the life of each individual' (p. 198).

Although all the transformations Marie envisaged did not take place, her career was one where a woman's ambition was fulfilled in the public sphere. In *La Femme vierge*, Pelletier for the first time imagined a woman in a powerful role.

The extent to which writing reveals or suppresses gender differences has been a major focus of recent literary/historical debate. Whereas many earlier women writers such as Wollstonecraft, the Brontës, George Sand or George Eliot sought a single non-gendered standard by which to be judged as authors, many twentieth-century feminists have celebrated a gendered identity in women's writing. In France, writers like Cixous, Irigaray and Kristeva, have, under the influence of Lacanian psychoanalysis, looked for a distinctively feminine writing or language to translate the as yet unexpressed female experience.[19] Pelletier's literary production can be located within this debate. As in her career as a whole, her writing reveals not only conflicts about gender but also about class. Writing was for Pelletier both an assertion of her ideas in the public domain and an act of personal liberation. Her closely argued texts, her ironic descriptions of the

milieux she frequented, and her diaries and letters, were a means of
self-projection as well as of the projection of the ideas themselves.
Trained in the scientific disciplines, Pelletier used the language and
the metaphors of contemporary scientific discourse as a political
tactic to lend conviction to her less than orthodox views. Author-
ity stemmed from the adoption of 'male' positivist and scientific
paradigms. Thus feminism was inscribed within an evolutionary
discourse in order to make it seem convincing in the same way that
Marx described economic 'laws' to prove the inevitable triumph of
socialism. In a positivist climate, scientific paradigms were seen as
effective models of persuasion.

In her writing Pelletier rarely broke out of the objective mode,
nor, in an age particularly fond of declamation, did she employ
many rhetorical flourishes or figures of speech. Educated by nuns
until she was thirteen and aware she was a misfit in her school,
thanks to her poverty, Pelletier either never acquired, or seems to
have rejected, the written and spoken language of 'young ladies'.
Speaking of bourgeois feminists, she referred disparagingly to the
'dainty culture' which was given to young middle-class girls of
their period.[20] Her writing displays few traces of metaphor or even
of Romantic rhetoric – it is spare, closely argued and usually
ironic. At times she was apt to employ slang, specifically the argot
of the Paris region.[21] If we recognize that French education
strongly encouraged standardized written and spoken language,
we may conclude that Pelletier's loyalty to her linguistic roots,
when she had left so many other aspects of her past behind her,
reflected a rejection of bourgeois language and, more specifically,
of 'ladylike' language, as well as underlining her working-class
identity.

Thus Pelletier chose the style of scientific positivism, a nominal-
ly objective mode, while guarding plebeian cadences and vocabul-
ary in her speech. If she thought of her style as consciously
masculine, she would have considered it appropriate. Had she not
tried to 'virilize' women, that is, to change the whole range of their
submissive behaviour?[22] As part of this project, Pelletier wrote
analytically, in order to teach her women readers the tools of clear
argument. She avoided purple passages, commonplace in the
charged calls to action of feminist writers like Hubertine Auclert
whose prose style was conditioned by her bourgeois origins and
her Catholic education.[23] Pelletier chose to inscribe her writing in a

'male' discourse because she refused to accept the gendered dichotomy of women-feeling, men-reason. She hoped to utilize the tools of logical argument to convince men as well as women. Yet as a psychologist she knew the irrational foundations of prejudice. (One recalls the examples of war hysteria in the War Diary.) But as far as style was concerned, she maintained, on the whole, the ironic cadences of the Enlightenment.

On the other hand, Pelletier's prose could be both moving and personal. From time to time, she evoked startling and apposite images that encapsulated the emotive points of her life. Thus the fireworks on the fourteenth of July, the hymn at her first communion, the dark cellars of the Russian secret police, the Panthéon looming above the rue Soufflot, a womb-like symbol of male ambition, the dogs' pound, and the occasional religious image, such as the martyr's crucifix, juxtaposed with the revolutionary's red rose, all emerge as felt images of power, absence, loss, imprisonment or sacrifice. Some of Pelletier's most evocative writing was associated with the streets and tenements of Paris. These emerge as forces virtually crushing the individuals who live among them.

The question of a gendered style in Pelletier's writing brings one back to the unresolved question of her sexual orientation. Her fondness for cross-dressing, her resentment of feminine women and even the testimony of contemporaries strongly suggest a lesbian identity. However, it is difficult to see why she would have taken up her public persona of virginity if this had been the case. Her writing on psychosexual questions and on libertarian issues not only shows that she understood issues arising from homosexuality, but suggests that she would almost certainly have defended an unorthodox sexual choice publicly in her own case had she chosen to make it. One letter to Arria Ly obliquely addresses the question. Referring to a photograph of herself in masculine attire that she had enclosed, Pelletier added ironically: 'Don't fall in love with it. The voyage to Lesbos tempts me no more than the voyage to Cythère' (mythical home of Venus). What is indisputable is that Pelletier identified with men, wished she had been a man and saw her sex as the major misfortune of her life.[24]

As one who had overcome the crippling limitations of sex, class and poverty on her individual development, Madeleine Pelletier had absolutely no nostalgia for a 'feminine' space, privileged or

otherwise. Unlike many feminists of her generation and since, she claimed no special virtues for women. Though the masculine world of the professions and of politics had been the scene of some of her gravest disappointments, in her fiction she measured the cost of participation in the world of action, and on the whole, found it worthwhile. The function of Claire Mélin as brood mare may have been socially necessary, but it was not a role that appealed to Pelletier. Instead she identified with a life of intellectual and political activity. Finally, given Pelletier's hostility to the family, the public sphere was essential for a fully social life. In her new world of autonomous individuals, social relations, she believed, would escape the claustrophobic atmosphere of the nuclear family.

10

How Militants Die, 1933–1939

Trop longue nuit durera-tu toujours?
'Anne dite Madeleine Pelletier'

Single people have a miserable old age: all alone and feeble without any affection to support them. Long sleepless nights in an empty room, with gloomy thoughts of possible death, are perhaps the worst thing in the world.

Le Célibat, état supérieur

Unlike Rosa Luxemburg, or the fictional Marie Pierrot, Pelletier did not die a martyr to a violent revolution, but she died a martyr to her ideas, nevertheless. Though she had written to Ly that Marie Pierrot's fate in *La Femme vierge* was not the one she wished for, her own incarceration and death at the asylum of Perray-Vaucluse was a nightmare that she could not have envisaged in her most pessimistic moments.[1] Storm warnings were not lacking, however. They were evident in the continuing conflict between neo-Malthusians and pro-natalists, and in the latter's growing influence during the inter-war period.

The debate on the abortion question continued throughout the 1930s and provided the backcloth to Pelletier's eventual arrest. On the left, neo-Malthusian sentiment surfaced in two amendments considered by the Chamber of Deputies in 1933, one to give an amnesty to women who had undergone abortions and another to give an amnesty to those persons who had counselled abortions. Neither amendment was accepted. In the same year, the Communists also submitted a proposal for a change in the law to allow for 'the social protection of maternity and of childhood by the creation of a national fund for maternity and sexual education, a return to freedom of propaganda and prophylaxis on birth control issues and the legalization of abortion'. Though it stood no chance

of passing, this motion was an indication that by the 1930s the far left were won over to the neo-Malthusian position. Much more characteristic of mainstream feeling, however, were the vigorous resolutions passed in the same year by the National Confederation of the Midwives Union and the Association of Catholic Midwives against abortion and the declining birth-rate. These groups would certainly have represented majority opinion in the legislature and elsewhere.[2]

It was also in 1933 that Pelletier had her first serious brush with the law about her alleged abortion practice. On 31 January she wrote to Arria Ly detailing her predicament, though not explicitly admitting the accusation against herself:

> A terrible misfortune has befallen me; I am being charged with abortion. A stupid little domestic servant who supposedly came to me more than a year ago and whom I don't even remember. I think it is a plot of the priests. I have never been in prison and I am fifty-eight years old. I don't know what my fate will be but I neither sleep nor breathe. Could you find me some sort of post in Zagreb?[3]

With her few savings and her property at Gif worth 30,000 francs, she thought she could support herself if she were forced to flee abroad. But before Ly could reply to the first letter, Pelletier wrote again:

> Dear Friend,
>
> I am in despair. I have been summoned before the examining magistrate on an abortion charge, about which I know nothing. If things go badly and you don't hear from me next week, write to Paul Boncour. You know my life, explain to him the difficulties I had, how I studied by myself for my bac, etc. In case I need to leave France, could I earn my living in Yugoslavia?[4]

On 6 February she again referred to clerical plots, but was more hopeful about the outcome of the case. She also defended, though for her somewhat tepidly, a woman's right to abortion: 'Certainly I consider that women are free over their bodies, but these affairs of the belly disgust me profoundly.'[5] By 9 February she felt less threatened but showed signs of depression, dwelling on her sense of personal failure: 'All my life I have tried to be a journalist – no

luck. I wanted to train in cosmetic surgery. The school's director told me one had to be a male and have sex appeal to operate on over-ripe ladies.'[6] And now, said Pelletier, she had to fear the menace of prison. It was clear from the tone of these letters and their frequency that the threat of prosecution had shaken her. Yet only a week later she had rallied and vigorously defended abortion to Ly, rather testily rejecting the latter's apparent suggestion that she emigrate to the Soviet Union: 'No, Russia doesn't appeal to me: there it is enough for someone to have a grudge against me to have me chucked in a dungeon – a thousand times better, prison in France.'[7]

A letter dated 17 March indicated that the danger had receded. Arria Ly, who had evidently been much alarmed about Pelletier's case, received a reassurance from a Professor H. Cabasse ('Commissaire du Bureau de Bienfaisance') to whom she had appealed for news of her friend: 'I have just had the pleasure of meeting her [Pelletier] at the Club du Faubourg and I am happy to tell you that she seemed in perfect health.'[8] Temporarily out of danger, Pelletier once again began appearing in public. Nevertheless, since a denunciation had been made to the police accusing her of carrying out abortions, it implied that she was under suspicion. She needed to be wary. Whether or not she curbed her medical practice isn't known, but she continued to speak in public on contraception and women's sexual emancipation. One recalls that already in 1925 Pelletier had been identified by Paul Bureau, the pro-natalist campaigner, as the most persuasive 'advanced' advocate of feminism who demanded the dangerous right to 'free maternity'.[9] Though in the libertarian milieu which she frequented in Paris it is possible that Pelletier felt a false sense of security, to pro-natalists she was an enemy to be reckoned with and one they would have been more than anxious to silence.

The following year brought further depressing news. Arria Ly, to whom the letters quoted from above were addressed and who had been Pelletier's confidante, loyal friend and sparring partner on feminist theory for many years, committed suicide in 1934. Her death brought to a close in a particularly poignant way a chapter of feminist militancy.

In 1925 Ly had moved to Zagreb with her mother, Madame Gondon, after being expelled from Italy for attempting to fight a duel with an Italian officer. Ly seems to have prospered in

Yugoslavia, first giving French lessons, then becoming headmistress of the French school. She and her mother continued their feminist activity.[10] Then, in April 1934, Madame Gondon died. It appears that her daughter had long resolved on suicide in the event of her mother's death. She had the body cremated and made plans to travel across Europe to Sweden, the only country she considered sufficiently enlightened on the woman question to be worthy of receiving her mother's ashes.[11] In May or June, before setting out on her pilgrimage, she wrote to a number of friends announcing her projected suicide and enclosing handsome photographs of herself and her mother in the artist smocks and long coats they favoured as masculinized dress. Ly received several replies attempting to dissuade her from her plan. One correspondent pleaded:

> Are you sure your mother would approve of your resolution to die? ... You love your mother, since you cannot live without her. But to die is to cease to love ... to die, since for you that means to become nothing, is to abandon her memory, and the chance to prolong her life in you and around you. Suicide is not worthy of you. ... It is a weakness, desertion, an act of despair.[12]

Ly's friend and mentor, the Italian doctor Cristoforo Rizzo, also replied sympathetically. Another writer exclaimed: 'Your painful letter has literally overwhelmed me!' Was her contemplated act the consequence of a vow or the wish of her mother, this writer wondered.[13]

Not all the recipients of Ly's letters were so moved. Madame Brunschwig, editor of *La Française* and a moderate feminist, appealed to by Marie-Louise Bouglé for help in finding a flat for Ly in Paris, with the idea of offering her support at this crisis in her life, was unsympathetic. Brunschwig remained unimpressed by what she evidently considered to be Ly's histrionics: 'As for me, I am not well acquainted with Arria Ly. I knew her to be generous, but so exalted, so unbalanced that we have never been able to get along.'[14]

In spite of the pleas of her friends, Ly made her announced journey to Stockholm, and on a cold day at the beginning of December, jumped into the freezing Baltic while holding her mother's ashes. She was rescued and spent several weeks in

hospital recovering from pneumonia. On the day of her release, 19 December 1934, she climbed to the top of a sixteen-storey building and leapt to her death. Anna Andersson, a Stockholm journalist, wrote to Bouglé, with news of Ly's suicide:

> I have the painful duty of letting you know of the death of Mlle Y. Gondon in Stockholm yesterday evening. She has fulfilled her promise to follow her much regretted mother. She had had permission to go to the French legation to arrange for her return journey, so she ended her life by throwing herself from the roof of a sixteen-storey building. This time she wished to be certain. I had made her acquaintance when I interviewed her for my paper. I will give you details of her funeral later.[15]

But there was no money for a funeral. The French legation in Stockholm metaphorically washed its hands of their awkward expatriate. Meanwhile a Swedish official told Ly's friends that 200 kronor were needed for burial expenses. Andersson wrote despairingly to Bouglé:

> I told them that the legation ought to arrange it, but they said it was none of their business. Now that poor unfortunate is still lying in the morgue, waiting for this money that is so difficult to collect. . . . The French legation doesn't want any part of this painful case. I think it's revolting . . . The head of the morgue told me this morning that she could still be kept a certain time. But it's all very sad. I await your answer. Otherwise she will be buried here by the police.[16]

Andersson asked that a subscription might be raised in order to avoid a pauper's funeral. Bouglé, a working woman of very limited means, wrote to Cécile Brunschwig and Maria Vérone for help; the former refused a donation, the latter did not reply. We have no record of correspondence with Pelletier. Brunschwig relented to the extent of agreeing to insert an article about Ly in *La Française*: 'I believe the poor woman has been mentally ill for a long time, for she wrote me unbalanced letters. Nevertheless I know she rendered services for feminist propaganda in Yugoslavia and if you would like me to dedicate a note about her in *La Française*, I will do so.'[17] Somehow Bouglé raised 28 francs and sent it off: 'If then the French legation won't concern itself with Arria Ly's burial, we

will be forced to let her follow her destiny to the end. Arria Ly no longer has any family at all.'[18]

 Arria Ly's life, death and even her pauper's funeral represented in an extreme form the alienation which overtook certain talented women whose very gifts drove them to despair.[19] For all her lack of balance, she was a gifted individual, but one who nourished a corrosive and self-destructive anger against the masculinism of her culture. Lacking Pelletier's carapace of irony, Arria Ly's feminism was primarily expressed in acts of outraged feeling, such as physical attacks on men, and finally in her own self-destruction. We may recall that in 1914, while suffragist hopes were still high, Hubertine Auclert's funeral had attracted an impressive crowd of feminist mourners. Durand, Bonnevial, Vérone and Kauffmann all spoke at her burial at Père Lachaise and the event received front-page coverage.[20] In 1926, twelve years later, Caroline Kauffmann died in obscurity, six mourners following her funeral cortège. And now, in 1934, Arria Ly, the most notable provincial French feminist, had gone to a pauper's grave. It was like an obituary for feminism in the post-war era. For Pelletier, Arria Ly's suicide was one more dismal indication of the fate of talented women in France.[21]

Le Club du Faubourg

One of Pelletier's chief intellectual and social resources after the war was the Club du Faubourg, a debating society founded by Léo Poldès, the pseudonym of Leopold Szeszler. Before the war Poldès had been the drama critic for *La Guerre sociale* and a minor dramatist (he had had two plays produced). He ran the club and edited the journal of its proceedings between 1918 and 1939.[22] The Faubourg was a forum for free discussion – in Poldès' words, 'outside and above all political parties'.[23] Debates were organized with speakers representing differing points of view on contentious topics. In the manner of freemasonic meetings, any subject could be discussed provided a speaker was found for an opposing view. Unlike the freemasons, the Club du Faubourg publically advertised its debates. Pelletier found it a useful and stimulating platform from which to develop her ideas when she no longer had the resources of *La Suffragiste*, 'Solidarité or influence in the

SFIO: 'I speak at the "Faubourg". This is a club which meets some three days a week; there are a lot of people, a reasonably cultivated if not enormously advanced audience. There I defend feminist theses when I have the chance.'[24]

One such debate was on the question of: 'would the triumph of feminism be useful to humanity or not?'[25] Pelletier defended the usefulness of feminism to 'one half of humanity' and was opposed by a Monsieur Ryner, a devotee of the theory of separate spheres, who said he believed in equality but that women should be saved from politics which were a dung-heap whose practitioners lacked all ideals. In another debate (June 1927), which Pelletier reported for *La Fronde*, the Russian anarchist, Makno was opposed by speakers attacking the pogroms against the Jews in the Ukraine.[26] Overall, the Club de Faubourg gave Pelletier helpful publicity as well as the social context of polemical discussion in which she had always flourished.

In 1935, the club came under fire from the authorities for a meeting Poldès had planned for 8 June. Posters had been printed advertising the following arresting programme:

1. Maria de Naglowska, Prophetess and Grand Priestess of Love of the Temple of the Third Era, speaking on: Black Magic and Golden Magic: Sorcery and Magic: What is woman to man: What is dry coitus? What is magic coitus?

AND

2. The well-known 'oratrice' [speaker] *Doctor Pelletier* will defend her new book *La Rationalisation sexuelle* with a debate on Devirginization. Is the wedding night legal rape? Should young girls be scientifically 'devirginized' before marriage? Depopulation and civilization. Opposing speaker Jacques Ditte, barrister.[27]

The poster, whether by virtue of its first or its second speaker, attracted the attention of a naval officer, Commander Guibaud, who complained to the police about the salacious nature of the advertisement. Poldès, having been cautioned, accordingly modified his advertisement and held the meeting. Pelletier defended her book, 'Sexual Rationalization', and was vigorously opposed by Ditte, who, in Poldès's words, 'In his capacity as a Frenchman, a Catholic and a patriot energetically condemned the neo-

Malthusian doctrines in conjuction with vice and pornography.'[28]

In spite of what was claimed to be the balanced nature of the discussion, Commander Gibaud brought a case for pornography against the Club du Faubourg on 26 August 1935, alleging that his modesty had been shocked by the proceedings. Poldès believed that Gibaud was being used by an extreme right-wing group the Revue International des Sociétés Secrètes. At the trial, which took place on 26 April 1936, Poldès gathered a number of supporters to testify to the virtuous nature of his club. Madeleine Pelletier, who appeared as a witness, gave the following testimony:

> I was astounded to learn that a naval officer was prosecuting the Club du Faubourg on the subject of my book. The subtitles which shocked him are in fact extracts from my work, 'Sexual Rationalization', which has never been the subject of any prosecution. These are the expression of my opinions. For many years in my capacity as a militant feminist I have struggled to make my ideas triumph. It is possible to combat my activities. None of my adversaries have ever reproached me with writing pornography. I am not about to begin now. In any case, my book 'Sexual Rationalization' is only a revised version of my 'Sexual Emancipation of Women' which appeared before the war. That book was never prosecuted. I wish to thank the Club du Faubourg for granting me the right to debate my ideas against those of the Abbé Viollet and my other adversaries.[29]

The court found Poldès guilty, though he was given only a token fine. He saw his condemnation as part of a wide-ranging attack on civil liberties: 'Today the Faubourg, tomorrow it could be anyone. Chains for writers, the gag for orators, handcuffs for artists.' He was being attacked, Poldès suggested, not for pornography but for defending libertarian, and specifically neo-Malthusian, ideas.

The Club du Faubourg trial showed Pelletier still campaigning vigorously in public life, happy to defend the club and her newest foray into sexual politics, *La Rationalisation sexuelle*, her last major published work.[30] Once again she had attained a certain notoriety on neo-Malthusian issues. But sometime in 1937 she suffered a stroke which left her largely housebound, as a subsequent letter indicated: 'I have a great need of distraction. Come and see me from time to time,' she wrote to a friend.[31] Thanks to her disability, Pelletier's public activity was virtually at an end.

Little documentation survives for the years 1937 and 1938 on

Pelletier. We do not know, for example, her reaction to the coming to power of the left with Léon Blum's Popular Front in 1936. Blum, it may be noted, acted on feminist issues by including three women as under-secretaries of state, though women were still not electors. But the Front, wrecked by economic instability, only lasted two years. On 12 April 1938, Daladier took over as Prime Minister, shifting the Third Republic decisively to the right. Extreme nationalism, allied to anti-semitism, became increasingly respectable in government circles. It was thought diplomatic, for example, to exclude Jewish ministers from a reception for Ribbentrop, the German Foreign Minister, in December 1938. And under Daladier strong pressure began once again to be exerted against neo-Malthusians.[32] In this aggressively nationalistic, xenophobic and pro-natalist climate, Pelletier was to find herself in legal difficulties for a second time over abortion.

The 25 April 1939 catastrophe struck. On that day the police raided her surgery and arrested her cleaning woman and her midwife on the charge of performing abortions under Pelletier's direction. The event was reported in the press under the title 'Faiseuses d'Anges', Makers of Angels, an unflattering euphemism for abortionists, as follows:

MAKERS OF ANGELS

Investigation at the Home of a Parisian Woman Doctor

By the authority of M. Linnais, examining magistrate of the Parquet de la Seine, investigations were carried out yesterday by the service of judicial delegations, notably at the domicile of Doctor Madeleine Pelletier, aged 64 years, 75bis rue Monge. For many years the doctor has carried out abortions. Half-paralysed for the past two years, she had authorized first Mathilde Violette, 49 Avenue des Batignoles at Saint-Ouen, then her cleaning woman, Marguerite Lafabrie, 35 rue de la Harpe, to carry out the operation. These two women have been arrested. Because of her state of health, Dr Pelletier has been released.[33]

But this was not the end of the matter. Though the press report described Pelletier as physically incapacitated, Linnais had her examined by a psychiatrist to judge her mental competence. The latter gave as his opinion that 'she should be considered totally

irresponsible'. On 2 June, about six weeks after the initial police investigation, Pelletier was committed by *placement d'office* to the insane asylum of Perray-Vaucluse (now the Centre Hospitalier de Perray-Vaucluse) at Epinay sur l'Orge. The police charge book carried a laconic entry for April 1939, closing her case and ending with the note: 'Sent to a special hospital.' There Pelletier was to remain until her death six months later on 29 December 1939.[34]

The question of Pelletier's sanity or insanity at the time of her committal cannot be definitely established, particularly since her hospital records cannot be obtained and may have been lost in the war. There is a strong presumption that her committal was politically inspired and her physical debility, which seems to have included some paralysis and perhaps impediments to her speech, may have given plausibility to the charge of mental incapacity.[35] However from the evidence of letters and the memoir she dictated while in hospital, her mind appears to have been unaffected by her illness. Pelletier's feminist friends were in no doubt about the political nature of her incarceration. What are we to think of the psychiatrist's judgement of 'totally irresponsible'? The psychiatrist may have been offering a layman's, not a clinician's, version of 'irresponsible'. There is no evidence that Pelletier was not in control of her own actions and decisions. The psychiatrist reminds one of the police officers who once arrested Hubertine Auclert: 'We regard Hubertine Auclert as suffering from madness or hysteria, an illness which makes her look on men as her equals.'[36] Albistür considers Pelletier's incarceration as a form of secret imprisonment avoiding public trial. 'In preference to a trial drenched in publicity, the law chose to lock her in a psychiatric asylum.'[37]

This distinction was crucial. A trial would have involved a charge and, if she had been found guilty and convicted, a sentence with a definite time span. Committed to the asylum, Pelletier, even if her health had been good, risked, in effect, a life sentence. It was true that under the law of 1838 the state prosecutor could be approached to hold an inquiry into the patient's committal, calling on further medical expertise, but it was a difficult and expensive option. Though this avenue was explored by Pelletier's friends, they ran into a financial impasse. As most of the patient's assets had been confiscated by the state to pay for 'treatment' there was no money available for an appeal. On 20 July 1939, a friend wrote to Hélène Brion:

I have been to see Berthon [a lawyer] as soon as he got back from the south, that is to say on Tuesday the 18th. One can't do anything for Pelletier unless one undertakes a lawsuit, with sworn testimony, expert medical examination, etc. For that one would need 3,000 francs. It is impossible to get back the sum confiscated [when Pelletier] entered Vaucluse, which has probably been paid over to the asylum. But a certain M. Deville owes Pelletier about 10,000 francs, left by his wife who died last year. Perhaps he will agree to turn them over to the lawyer. We are going to see. What makes everything more complicated is that Pelletier can't risk giving anyone a power of attorney.

That is why Mme Jackov, whom I have seen, and who seems a fine person, has not been able to sell any of the effects at rue Monge for Pelletier's benefit. But she is going to stay in permanent contact with the lawyer on the one hand and Pelletier on the other. As for a press campaign, meetings etc., Berthon, is not in favour.[38]

It is not known whether Monsieur Delville paid over the 10,000 francs. But failing some arrangements to give a friend power of attorney, which could have given the impression that she wasn't competent, only the hospital would have benefited from the legacy. Pelletier's lawyer, evidently a cautious man, thought a press campaign inadvisable. It might, however, have been her only hope.

From a wider perspective, it can be suggested that Pelletier fitted into a well-established traditon of female deviance and its correction. Studies of nineteenth- and twentieth-century psychiatric practice demonstrate that women were routinely sent to insane asylums for behaviour which in a man would probably have attracted a prison sentence.[39] It is true that for both sexes psychiatric hospitals in France fulfilled to a great extent a public order function. They had become the repositories for social misfits: vagabonds, imbeciles, the old and the poor. Even supporters of the law of 1838 agree that one function of psychiatric internment was a policing role. However the gendered definitions of what constituted insane behaviour cannot be ignored. Women who failed to conform to the wife and mother stereotype were especially vulnerable. The not untypical case of a Mademoiselle L, a patient at the Salpêtrière asylum in the nineteenth century, is instructive. She had slapped a policeman for propositioning her and was interned in the asylum. Her subsequent anger only marked her out as increasingly crazy, because her violent characteristics were regarded as 'masculine'.[40] Similarly Arria Ly was

briefly sent to a psychiatric hospital in Italy for attempting to fight
a duel with an officer who had insulted her, a fate that would never
have overtaken a man. Louise Michel, Pelletier had noted, was
threatened with internment in an insane asylum if she did not curb
her political activities. When she was editor of *La Suffragiste*,
Pelletier had publicized the case of Mademoiselle Verlain who had
been sent to an asylum by her former lover, a politician, because
she had threatened his career with scandal.[41] Pelletier had fictional-
ized this anecdote in *La Femme vierge*. A certain Mademoiselle
Chevrottin joins Solidarité in the wake of a disastrous love affair:

> She was a seamstress who became the mistress of a government
> minister. When he paid her off, two years later, she exposed him
> publicly and he lost his government post. He in turn arranged for
> her to be put in an asylum where she remained for two years.
> Eventually released, she started her own business and joined
> Solidarité. She was motivated, however, not by any general concep-
> tions about equality, but purely by her personal case.[42]

Thanks to her experience in psychiatric hospitals, Pelletier was
well aware of the potential for abuse when medical judgements
took over from open judicial enquiry:

> Our insane asylums today are prisons much more than they are
> hospitals ... Against evildoers, prison is still the least cruel treat-
> ment. A scale of crimes and punishments safeguards individual
> liberty better than the arbitrary [pronouncements] of a medical
> commission ...

As though anticipating her own case, she continued:

> It is always dangerous to put the future of one individual person in
> the hands of other men. Each individual should be safe from the
> egoism of all. Partiality is less likely when there is a scale of
> punishments corresponding to the seriousness of the offence.
> Arbitrary judgements are more likely when the doctor or the judge
> only has to give his personal view of an individual.[43]

There seems every likelihood that Judge Linnais, under pressure
from the pro-natalists to make an example of a notorious neo-
Malthusian campaigner and feminist, found a psychiatrist not

averse to testifying that a semi-paralysed, elderly woman, who was too ill to prosecute through the courts but who was assumed to be guilty, could be termed 'totally irresponsible'. One may wonder whether Dr Madeleine Pelletier would have been sent to a mental hospital in the last six months of her life if she had not been embroiled in an abortion case? No question of her mental competence seems to have been raised between 1937, when she had her stroke, and 1939 when she was arrested. From the evidence of the police report, Linnais accepted her physical disability at the time of the first hearing. There is the strongest presumption that in sending Pelletier to Perray-Vaucluse, Judge Linnais responded to pro-natalist demands for punitive action.

In the spring of 1939, Europe was gearing itself up for war. Pelletier's period at Perray-Vaucluse partly coincided with the 'phoney war' (September 1939 to May 1940). The French Communist Party, having adopted a pacifist line to accord with the Nazi–Soviet Pact, was dissolved by the Daladier government and went underground.[44] It was not the moment for someone who had described herself as a Bolshevik and a neo-Malthusian to find many public defenders, which may explain Berthon's caution. In addition, the French sense of vulnerability to German military power expressed itself in part by heightened pro-natalist rhetoric. For example, on 26 April 1939, the day after Pelletier's arrest, *Le Figaro* reported 'A solemn appeal from the cardinals of France in favour of natality'. They called for 'measures to halt the murderous advance of the toll on the birth-rate' and blamed 'the love of pleasure and of liberty, the fear of suffering, and egoism, which are the real enemies of the large family.' Who more than Madeleine Pelletier had argued that women, like men, had a right to liberty, to sexual pleasure, to self-development and ought not to be made to suffer in childbirth? The cardinals may or may not have known of Pelletier's work, but their denunciation of abortion as the core of a problem stemming from a lack of religion both in education and in public life, accused neo-Malthusianism and feminism of being not only anti-religious but also anti-patriotic.

In spite of her partial paralysis Pelletier was perfectly aware of her situation and, as her letters from Perray-Vaucluse made clear, felt a deep sense of degradation. The dreadful irony of her predicament, the first woman psychiatric intern in France, the arch-rationalist, interned in an asylum for the insane, can scarcely

be over-emphasized. The hospital where she found herself had been built in 1869 and was in an idyllic setting, a rolling, verdant countryside south of Paris; the patients were housed in a group of handsome, mansarded buildings – surrounded, however, by high stone walls. A chateau-like administrative block was connected to dormitories or pavilions, buildings with large windows of elegant proportions, by a series of covered walkways. Though locked away from the public gaze, life would have been public in the extreme for the inmates. The wards consisted of long open rooms; patients shared communal washing basins with one tap, and in the dining room were wooden troughs stretching the length of the table, for placing food.[45] We have no record of what treatment, if any, Pelletier received, although the fact that she was allowed to dictate letters and her memoirs suggests that some sympathy was shown to her situation. Thanks to this encouragement, important traces of Pelletier's stay at Perray-Vaucluse survive: two letters, almost certainly dictated, a list of her scientific works (as though she wished to be remembered in this context), her memoir 'Anne dite Madeleine Pelletier', transcribed by Hélène Brion, and an illegible scribble on a bit of exercise paper.

Monsieur Berthon's misgivings about a press campaign did not prevent two short articles about Pelletier from appearing in the press, one in June and the second in August. The writers were in no doubt that she was effectively a political prisoner and a victim of pro-natalist propaganda:

> Thus it is that we learn of the odious manoeuvres that have followed the accusation against Doctor Madeleine Pelletier. It will be recalled that 'the state of her health' prevented our comrade being arrested. Now her paralysis left no hope of cure. How could the law, that is to say the pro-natalist government ... that is to say the police satisfy the hounds awaiting their quarry ... It was wonderful for the repopulation enthusiasts to be able to revenge themselves on neo-Malthusianism and thus to be able to console themselves for the innumerable small-fry who escape their nets by refusing individually and secretly to reproduce in the way decreed by the public interest.

The writer suggested that although the twentieth century lacked the arbitrary imprisonment and torture chambers of the *ancien régime*, yet psychiatric hospitals were an effective alternative: 'We

have insane asylums within a taxi-ride's distance, with their silent cells and their strait-jackets which don't cause bruising.' It is so simple; one only has to declare the accused person mad.[46]

That Pelletier was ill and enfeebled there was little doubt. Judge Linnais had recognized as much in his original acquittal, probably realizing in addition that few judges would convict someone in her physical state. A mental hospital was, however, not the usual place to provide care for stroke patients, as a short article, 'On behalf of "La Doctoresse Madeleine Pelletier"', pointed out in August, recalling Pelletier's contributions to socialism and to the feminist movement:

> That old propagandist for our ideas – she who contributed to *La Guerre sociale* in its first [revolutionary] phase – is still interned in a madhouse in spite of the fact that her state of health does not require the treatment meted out to those sort of patients.
>
> Madeleine Pelletier is a victim, like so many others, of pro-natalist propaganda.
>
> A victim without defenders, SHE who for so long and so valiantly gave her support to revolutionary avant-garde groups.
>
> Madeleine Pelletier languishes miserably in the Asylum of Vaucluse, station Perray-Vaucluse. For those who can go to see her and comfort her we give the visiting hours: Sundays and Thursdays from 1 to 3.[47]

Pelletier's visiting card only showed five visits during the entire six months of her stay, all from the faithful Hélène Brion, though other friends may have accompanied her.[48]

One might have expected that Pelletier's professional status would have earned her a degree of support from her medical colleagues at the time of her incarceration. As far as one can determine, the reverse was true. Whereas feminists tried to publicize her plight, the medical faculty was conspicuously silent. This can partly be explained by the well-documented social conservatism of medical doctors in France, where pro-natalist sympathies exacerbated the conservative and anti-feminist temper of the medical profession. Even thirty-five years later, during debates leading to liberalization of the abortion laws, there was substantial opposition from doctors.[49] It was one of the ironies of Pelletier's career that she became a physician because medicine was one of the few professions, apart from teaching, open to women, yet while it

did free her from the social prison of her childhood, in many ways medicine was socially and politically antipathetic. Pelletier must constantly have breached the profession's low level of tolerance to unconventionality. A working-class, self-made woman, a religious sceptic, a socialist and a revolutionary feminist was unlikely to find more than a few sympathetic medical colleagues.

In September, Pelletier dictated a letter to Brion from Perray-Vaucluse, expressing fears that no progress has been made in effecting her release, but showing that she followed political events:

Vaucluse, 21 September 1939

My dear Heleine [original spelling],

You will not see me again. I am grieved. Formerly you told me that I incarnated feminism. Rescue me from this horror. I know that the war causes great hindrances. I continue to believe that there will be a settlement and that the war will not spread – even though Stalin wants a world revolution.

I have read the newspapers with some difficulty. Not a single bomb dropped on Paris.

If you have returned to Pantin, don't fail to come and see me. You can't imagine how terrible it is to be in an insane asylum when one has all one's mental faculties.

Go and see Berthon as well. Yvonne assured me that she had done what was necessary. I was reassured for a time, but in fact I have heard nothing. I begin to think that she lied to me, in order to make me be patient. My mind is as vigorous as ever. That is why I suffer so. Come to my aid, I beg you.

Amitiez [original spelling]

Docteur Pelletier[50]

In spite of her misery and debility, Pelletier was still alert to the outside world. And when one recalls her inveterate dislike of dependency and of seeking favours, her appeal to Brion has a particular poignancy.

On 23 November 1939, Brion visited Pelletier again after a gap of over four months. It was on this occasion that she took down Pelletier's lucid and witty recollections of her childhood, titled in the manuscript, 'Anne dite Madeleine Pelletier'.[51] This memoir paralleled closely the details of her early life in 'Doctoresse

Pelletier' and *La Femme vierge*. Pelletier had certainly lost neither her memory nor her ability to express herself. Particularly striking was her account of the construction of her political consciousness out of the Hegelian contradictions between her royalist, Catholic mother, her anti-clerical father and the Republican neighbourhood in which she grew up. For example, she recalled how after her father had shown her the new horseless trams and the Post Office under construction:

> My young mind mulled this over. My mother always said that the Republic was worthless. But I thought that these things were lovely and full of value. For the rest, Père Bessart contradicted my mother's opinions. He taught me 'le Chant du Depart' which I was careful not to sing within maternal earshot. He used to say to me: Oh, Your mother is full of prejudices.[52]

In interpreting her own life, Pelletier always looked for the larger political significance of her experience. This may explain why, although the memoir is about her early deprivation, it lacks bitterness or self-pity and even conveys a sense of happiness. Pelletier rebelled against her early environment, but her roots were also the source of her remarkable strength. Her fanatical but intelligent mother, her ironic if ineffectual father, the shoemaker who loathed Jesuits, the republican *marchande de crêpes*, the café owner reputed to be a freemason (hated by her mother), the society of devotional ladies – all offered the growing child a rich social world. There was also, however, a sense of shame about home and envy of more fortunate schoolmates:

> I admired the B's house; their daughters were boarders and had coats with fur collars. Their house was clean; ours repulsive with dirt. I admired their brightly polished red tile floors – my mother's were repellent. We didn't dare to open our house door wide for fear that the neighbours might see this filth.[53]

From the evidence of her second letter to Brion (5 December 1939) it would appear that Pelletier had planned to continue dictating her memoirs, but no second instalment was forthcoming. Dated four weeks before her death, this letter showed that she retained her interest in current events. Like its predecessor, it was dictated:

Someone has just read to me from the newspapers that the Swiss may mobilize women. Do you remember my article in *La Suffragiste* in 1907 [actually 1910]? It had an extraordinary success for the journal but everyone, even in Germany, ridiculed me. Gustave Hervé, at that time held in the Santé prison, gave me a mighty ticking off. He was director of *La Guerre sociale* whose subsequent fate you know of [that is, shift to the right]. This is how, in France, women who distinguish themselves from an intellectual point of view are treated. Arealy [*sic*] committed suicide, and *I* am in a madhouse. Come and see me, I beg you. My general state is bad; I constantly have intestinal blockages. I can't eat the food here. I am reduced to a bit of bread and purée. Come on Thursday; they are allowing me to write my memoirs.

Bonnes amitiés, (for) Dr Pelletier.[54]

Pelletier managed one more message from Perray-Vaucluse, this time an illegible scrawl in pencil, her last attempt to reach out beyond the enveloping walls. Brion did visit again, on 21 December. Eight days later, on 29 December, Pelletier died. Her other close friend, A. Hamel-Jackov, who had been in touch with the lawyer and with Brion, was called to the asylum: 'I have just returned from the Asile de Vaucluse, where I had been called by the Director. The unfortunate Madeleine Pelletier is no more. The burial won't take place before Tuesday.' Jackov then expressed her fear that the nuns at the asylum might have prevailed on Pelletier to take Catholic rites or to ask for a religious funeral:

> In going to the asylum, I was afraid that the sisters and co. might have drawn from a weakened Pelletier some promise which would have been the negation of her entire life. But nothing of the sort occurred. If the Prefecture gives me enough money (it has 13,000 francs from Madeleine Pelletier), I suggest having her cremated.[55]

As Jackov remarked, for Pelletier, a lifelong anti-clerical, to have accepted the ministrations of the church 'would have been the negation of her entire life'. From her childhood, the image of Catholicism had been tainted, not only by her mother's fanaticism, but also by its promises which the child concluded would never be fulfilled. She had noted, too, the lack of congruence between morality and religion; her mother's faith did not make her a kinder

person, or inhibit the priest from seducing a young parishioner. Yet the whole theatre of religious worship remained engraved on her mind: 'The church seemed splendid to me. Behind the alter there was a big pale blue hanging, the colour of the Holy Virgin and pink and blue flowers everywhere.' She also remembered the hell-fire sermon and her mother's re-enactment of it for her father's benefit: 'She had great natural eloquence and was pitiless in her sermons: the damned, in spite of their supplications, rolled from abyss to abyss down a vast cavern filled with miasmal fire. I dreamt about it all night.'[56] In religion Madame Pelletier had found the promise of justice that was so lacking in her own experience as a woman and as an illegitimate child.

Pelletier's first communion, with its disillusionment on the score of mystical transcendence, was a touchstone for her development and can be read as part of her reaction against the other complex mystifications involved with the physical revelations of puberty. As an adult, having rejected religious faith, she turned to scientific positivism and revolutionary socialism for her visions of a better world. Yet even here she held reservations. Because she recognized the implications of evolutionary theory when applied to human events, she saw that there was no predetermined scheme of values, no teleological certainty. Even scientific socialism could not lay claim to an assured future. There was only one's own life to which one must give as much significance as possible.[57] The importance of religious belief for Pelletier, as it emerged from her childhood recollections, was that it offered an early promise of a new order beyond her miserable home. Her conclusion that the promise was false was ultimately of less significance than the emotive content of the experience, a paradoxical blend of hope and disillusionment:

> Mon Bien Aimé ne paraît pas encore
> Trop longue nuit durera-tu toujours?
>
> (My beloved still has not come
> Too long night, will you last forever?)

This couplet, from a hymn of her childhood, the last words dictated in her memoir to Hélène Brion, appears a fitting epitaph. Pelletier had waited and fought all her life for a new dawn on earth, but by human rather than divine agency. Jackov was right to

recognize that her resistance to the well-meant religious pressures of the nuns was important. Pelletier retained her integrity even in the massively alienating context of the asylum.

As in Arria Ly's case, Pelletier's friends found difficulty in paying for the funeral; the authorities proved slow in disbursing her money: 'I send you the enclosed bill for the funeral wreath. Difficulties are being raised for payment because the bill isn't in my name. Neither will they pay the remainder (169 francs), unless I give them bills for each item . . . how stupid can you get.'[58] Her estate was almost certainly swallowed up by hospital costs.

A Passion for Liberty

Madeleine Pelletier's final months in the asylum were ironically appropriate to her own analysis of the difficulties facing exceptional individuals in a conformist society. The philosopher whom she had probably most admired, John Stuart Mill, had accurately identified the threat that eccentricity, or even mild deviance, posed to most people's concept of social order:

> But the man, and *still more the woman* who can be accused of doing 'what nobody does' or of not doing 'what everybody does' is the subject of as much deprecatory remark as if he or she had committed some grave moral delinquency. Persons require to possess a title, or some other badge of rank, or the considerations of people of rank, to be able to indulge somewhat in the luxury of doing as they like without detriment to their estimation. To indulge somewhat, I repeat: for whoever allow themselves much of that indulgence, incurs the risk of something worse than disparaging speeches – they are in peril of a commission 'de lunatico', and of having their property taken from them and given to their relations. (Emphasis added)[59]

The 'contemptible and frightful ease', as Mill termed it, with which people could be declared insane, differed in detail but not in substance between France and England and between 1859 and 1939.

The probability that Pelletier continued to carry out medical abortions, even in the increasingly hostile moral climate of the 1930s and after her near-prosecution in 1933, indicated a combina-

tion of courage and recklessness. She may have been motivated partly by financial considerations, but the fact that towards the end of her life she was possessed of modest means suggests that money was not her main motive. Pelletier's most radical gesture lay not in political activism, though her work in politics was impressive, but in liberating women from unwanted pregnancies. Abortion was her revolutionary act, a refusal to accept that women were determined by their biological function. From the point of view of French pro-natalist orthodoxy, she was both subversive and dangerous. Within the context of her own evolutionary theory, Pelletier paid the price of being in advance of the moral climate of her day. Though rigorously puritanical in her own life, and practising a profession that was on the whole socially and political-ly conservative, she used her medical knowledge to subvert masculine dominance over women. Pelletier's feminist career showed entire consistency in her primary aim, to make liberty possible to ordinary, not exceptional, women. This commitment to the generality of women, her understanding of the restrictions of women's lives in the context of poverty and maternity, and her awareness of their physical degradation through ill-health con-trasted sharply with her intellectual elitism and her inability to suffer fools gladly: 'But I remain a feminist. I will remain one until my death, even though I don't like women as they are now any more than I like the working class as it is. Slave mentalities revolt me.'[60] Though Pelletier had strong links with anarchism and extra-parliamentary socialism, admired Robespierre, and advo-cated 'equality pushed to the limit', she was also, paradoxically, a socialist with a strong elitist tinge. Merit, rather than birth or money, was to be the criterion to distinguish individuals in a future socialist society.

Pelletier's career in medicine and politics pursued one overriding objective, the liberation of women from social, psychological and physical subordination. To a great extent this programme coin-cided with socialism, but she recognized that women's situation was not comparable to that of the working class, though working-class women were certainly the most disadvantaged. In crucial respects Pelletier remained a product of the French Third Repub-lic. Nourished on the heroic myths of the French revolutions of 1789, 1848 and 1871, in a working-class republican culture, she rose in the educational meritocracy through her own determina-

tion and abilities to achieve both professional status and political recognition. Like many feminists of her generation, Pelletier took the republican slogans of Liberty, Equality, and even Fraternity, with entire seriousness, and applied them to the largest group excluded from participation in the civil life of the French republic, women. For such feminists, faith in republican ideology entailed a commitment to make the Rights of Man a reality for all. Maria Vérone, who stood up in the Senate gallery after the defeat of the women's suffrage bill in November 1922 and shouted 'Vive la République quand-même', exemplified this belief in the ideals of the revolution which transcended the conservative institutions of the Third Republic.[61]

Among the feminists of her generation, Pelletier was unusual in attempting to bridge the gap between socialism and feminism. I have argued that there was some inconsistency in her socialist career, in relation not to socialist aims, but to the means by which she believed a socialist society could be achieved. Social evolution remained a primary model in both her socialist and her feminist theory, hence the importance of her early exposure to neo-Lamarckian, anthropological models. Even in her active Hervéiste period, while preaching revolutionary socialism, she nevertheless continued to lobby parliament and stood as a parliamentary candidate. This ambivalence between revolutionary anti-parliamentary activism and parliamentary participation was highlighted by her Russian journey. There she confronted the frightening legacy of revolution, the terror, but she continued to support revolution as an agent of social transformation. A similar ambivalence dogged Pelletier's attitude towards both libertarian and authoritarian models of social organization.

Attempting to live her life in a principled manner, to carve out a sense of purpose and morality for herself and to fight for her personal rights on a number of fronts, Pelletier was impatient of the faint-hearted and the conventional. She enjoyed debate and controversy and saw no particular merit in conciliation. She could, as she remarked to Arria Ly, be a terrible adversary. Though she had many friends among both men and women colleagues, she identified with the 'masculine' fields of intellect and activity. She was often scornful of women like her fellow members of Solidarité, who showed a less robust disposition than herself, and she hated flirtatious women. In spite of the fact that she had chosen celibacy

and forsworn motherhood, for both political and personal reasons – the effect of Madame Pelletier's many miscarriages on her daughter in the enforced intimacy of their tiny home cannot be over-emphasized – she was fully aware that maternity was potentially both a blessing and a burden. Not participating in the core biological experiences of most women, Pelletier saw her own position as one of protest, not as a desirable norm. She was not hostile to motherhood, but to the cost to women of excessive childbearing. She was also scarred by the claustrophobic and inhibiting structure of family life as she had known it and as she saw it operating in both working-class and bourgeois families. In this she might have echoed André Gide's celebrated imprecation: 'Families I loathe you.'

Pelletier's writing and career display a complex blend of elitism, compassion and impatience for the very victims of social injustice she hoped to serve. Yet her commitment both to women and the working class survived a difficult and conflict-ridden career. She could have succeeded far better, both in politics and in medicine, had she kept her feminist ideas to herself. But as she declared in her autobiography: 'I remain a feminist. I will remain one until my death.' The evidence from Perray-Vaucluse is that she did just that.

Epilogue

It would not be far-fetched to suggest that Pelletier might be judged fortunate to have died when she did. The war years represented the high-water mark of pro-natalist influence, and the Vichy government, installed in July 1940, seven months after her death, dealt harshly with neo-Malthusians. Abortionists were characterized as 'assassins of the Motherland'.[1] Pétain blamed the French defeat in part on the low birth-rate: 'Too few children, too few weapons, too few allies, those are the causes of our defeat.'[2]

Under Vichy the death penalty for performing abortions was reintroduced and, in one instance, applied. Marie-Louise Giraud, a working-class woman from Cherbourg, former waitress turned abortionist, was denounced to the authorities in 1942 and pleaded guilty to having performed twenty-six abortions. Condemned to death by the presiding judge, Paul Devise, she was executed by guillotine, 8 June 1943. In 1945, at the Liberation, Devise was declared to have been insane, having, it was said, suffered from senile dementia for several years. During the war, sentences of twenty years hard labour for abortionists became common.[3]

Eugène Humbert, shoemaker, anarchist, journalist, secretary to the League for Human Regeneration, and Pelletier's friend and neo-Malthusian associate, was arrested during the German occupation and sentenced to two years in prison for neo-Malthusian propaganda. Falling ill, he was carried from Amiens prison to hospital, where he died in an air raid of 24 June 1944.[4]

Pelletier had remarked in her autobiography that she was born

several centuries too early. On the abortion issue she was too pessimistic. Her work and that of the neo-Malthusians was driven underground during the war, but the question of women's right to control their own reproduction did not disappear. However not until the 1970s, in the aftermath of the 1968 student uprisings, did significant numbers of French women dare to express their views on reproduction issues. In a dramatic instance of civil disobedience and feminist solidarity which would have delighted Pelletier, 343 prominent Frenchwomen, among them Simone de Beauvoir, Jeanne Moreau and Catherine Deneuve, signed a manifesto asserting that they had had illegal abortions and published it in the *Nouvel Observateur* in October 1970:

> A million women have abortions every year in France. They do so under dangerous conditions because of the need for secrecy, whereas this operation carried out under medical supervision is entirely straightforward. Silence has been kept about these million women. I declare that I am one of them. I declare that I have had an abortion.[5]

The signatories were challenging the authorities to act against them, though in fact the statute of limitations meant they could not be prosecuted. In any case, the law had fallen into disrepute, thanks largely to the impossibility of enforcement. Moreover, the post-war baby boom had decreased anxiety about the birth-rate. After intense lobbying and campaigning, pressure for reform culminated in the new law on abortion which came into effect on 17 January 1975. Its provisions were more limited than the proponents of free abortion wished (abortions could only be performed in the first ten weeks of pregnancy) but it demonstrated a remarkable change in the French social climate. Just as it would have been inconceivable in the 1930s to mobilize 300 women to declare publicly that they had had abortions, so in the inter-war years one cannot imagine the Chamber of Deputies exercising its collective conscience over the fate of women whose health was ruined by back-street abortions as it did in 1974–5 debates.

Because the ban on birth control had been lifted in 1968, the abortion issue could be discussed within the context of the principle of contraception which had already been accepted. In the Chamber of Deputies, the impossibility of law enforcement and

the social inequities of the law were stressed. Monsieur Poniatowski, Minister of the Interior, pointed out that if the law had been rigorously imposed in the past, fifteen million women would have gone to prison in the previous half-century. The former Justice Minister, Jean Taitinger, suggested that, as well as being archaic and unenforceable, the law of 1920 penalized the most underprivileged of society. It was the poor and those without influence who were most likely to be prosecuted. By 1975 the moral arguments in favour of the liberty of the individual, and the ability of legislators to think of women as individuals, had evolved.[6] It can further be supposed that the fact that women had had the vote since 1944 was not without its influence on the deputies. Reproduction was an issue which directly affected women and on which they could, in the long term, be expected to exercise their electoral voice.

One interesting aspect of the abortion issue was the way in which it demonstrated the continuity of French political debate. Thus an article entitled 'Liberté et égalité' in *Le Monde* in January 1975, hailing the decision of the Constitutional Council to the effect that the new abortion law did not infringe the French constitution, clearly evoked the language and example of the revolution of 1789. The columnist argued that the council's decision was in accordance with the Declaration of the Rights of Man of 1789 which made liberty the goal of all political association. The new Act made liberty possible by allowing each person the free disposition of their own body and the choice of maternity.[7] It had taken 186 years for women to be included in the 'Rights of Man'.

Madeleine Pelletier, the scourge of the pro-natalists, had grounded her feminism in the language and concepts of French republicanism. The right to choose maternity and to have the 'free disposition' of one's body was more than a question of health or welfare; it gave women in law the same status that men had enjoyed since the Revolution. This was not the only item on her feminist agenda, but it was crucial. Her mother had said that 'women are nothing at all; they marry, cook and raise their children'. In attempting to broaden the range of women's possibilities, Pelletier struggled all her life to allow women to become independent, not relative, creatures. The choice for or against reproduction, with the right not to bear children against one's will, might be a painful and difficult one for women to make, but it

formed part of the concept of natural rights inaugurated by the Enlightenment.

In summing up Madeleine Pelletier's remarkable career, one is struck by her relative obscurity. For over a generation she remained unknown, to be rediscovered in the 1970s.[8] One explanation that suggests itself was that Pelletier did not fit easily into either politicians' or historians' ideas of what early twentieth-century feminism was about. French feminists were defined by socialists, and have continued to be characterized by historians, as bourgeois. Middle-class feminists with socialist sympathies were dismissed by socialists as diversionary or even as class enemies. Evidence of this tendency emerges, for example, in the memoirs of the feminist trade unionist Jeanne Bouvier (1876–1935), who recalled that in trade union circles feminists were not approved of: 'Feminists were referred to as "bourgeoises", but the husbands of these feminists, if they were members of a political or philosophical party of the left, were not "bourgeois".'[9] It is evident that this was a gendered mode of defining women's political place. One need only reverse the terms of the argument, as Bouvier did, to see that this was so. No one refers to the middle-class Marx and Engels as 'bourgeois masculinsts', nor was their class origin held against them when they took up a position in the political arena. For women it was otherwise. Pelletier presented a particular anomaly in terms of her class status. Of working-class origins, but having joined a middle-class profession she was never prepared to accept the bourgeois feminist/socialist split decreed by socialist theory.

Secondly, because she was poor and self-educated, Pelletier did not become a core member of the French academic/intellectual establishment. Here a further comparison with Simone de Beauvoir may prove instructive. Though Beauvoir and Sartre, throughout their long careers, considered themselves to be iconoclasts, they could in fact be said to incarnate the French intellectual establishment. Their role in French cultural life was comparable to that of the Bloomsbury intellectuals in Britain. Beauvoir, from a somewhat impoverished but securely upper middle-class background and as a graduate of the prestigious École Normale Supérieure had the assurance and the connections arising effortlessly from a bourgeois childhood and an intellectual milieu. Pelletier possessed none of this assurance. Every inch of intellec-

tual and social ground she gained had to be fought for. Because of
her social as well as her sexual marginalization, the agenda which
Pelletier set for feminism, her brilliant analysis of the complex
levels of women's social, political, economic and psychological
oppression, reached only a small audience. Though articles, books
and pamphlets poured from her pen, she never achieved wide-
spread recognition. This can arguably be ascribed as much to her
class origins as to her sexual militancy.

When Beauvoir wrote *The Second Sex* in 1949, she was already
known as a member of the Parisian existentialist circle. *The Second
Sex* was not written primarily as a feminist work, but as an
existential analysis of women. Its feminist implications emerged in
spite of Beauvoir's expressed reluctance to debate yet again 'the
woman question': 'For a long time I have hesitated to write a book
on woman. The subject is irritating, especially to women. Enough
ink has been spilled in quarrelling over feminism, and perhaps we
should say no more about it.'[10] Even with the success of *The
Second Sex* and its catalytic effect in sparking off second-wave
feminism, Beauvoir herself did not identify women's issues as a
significant political priority for at least another twenty years. For
Beauvoir, feminism remained one among a number of political
causes (freedom of expression, Vietnam, Algeria, etc.) on which
she campaigned, though by the 1970s feminism had become more
central to her political analysis than formerly.[11] By contrast,
Pelletier, characterizing herself as an integral feminist, saw the
question of women's condition as central, not additional, to all
other social, political and economic questions. It seems to me that
in this she was particularly prescient. It was not in Pelletier's
analysis that women's condition was merely another problem
among others, like taxation or foreign affairs, but that gender
relations determined the experience of human beings at every level
and had to be understood if genuine social change was to occur.

Pelletier has remained marginalized among feminists, historians
and political theorists. The double bind of sex and class meant that
even her intelligence and determination could not win her an
adequate platform for her ideas. To live as a feminist militant and
to campaign for such issues as women's suffrage, dress reform, the
right to work, birth control, the deregulation of prostitution and
non-gendered education was a daunting but exhilarating project.
We remember, that, as a child, she had wanted to be a general. In

her adult life she was perhaps a general without sufficient troops, but a militant always. Over a long career, she articulated the intellectual and political case for women's freedom. She dramatized the difficulties but also the possibilities confronting women; her writing represented a continual questioning of gender issues. She was deeply politicized, believing that social change would only come about through political action. At the same time she recognized how women were hampered by hidden psychological shackles. From the perspective of the end of the 1980s, it appears that Pelletier defined and analysed many of the major conceptual and practical problems facing women in their efforts to attain freedom with equality. Her significance for socialism was perhaps as important as her significance for feminism. Socialists have not fully dealt with the challenge that a gendered analysis of human relations poses. Pelletier's commitment to sexual equality stemmed from her personal experience of both class and gender oppression. 'As a child the aphorisms expressing the low value accorded to women that arose every day in conversation shocked me profoundly.'[12] Pelletier's life testifies to the creative use she made of the spontaneous sense of outrage she had first felt as a child.

Notes

Abbreviations

AdMP	'Anne dite Madeleine Pelletier' (Bibliothèque Marguerite Durand)
AN	Archives Nationales
APP	Archives de la Préfecture de Police, Paris
BMD	Bibliothèque Marguerite Durand
BSAP	*Bulletins de la Société d'Anthropologie de Paris*
DP	'Doctoresse Pelletier: mémoires d'une feministe' by Madeleine Pelletier (Fonds Marie-Louise Bouglé)
FMLB	Fonds Marie-Louise Bouglé, in the Bibliothèque Historique de la Ville de Paris
IFHS	Institut Français d'Histoire Sociale

See the bibliography for further details of publication and archives.

Introduction

1 Press clipping, August 1939, Dossier Pelletier, BMD.
2 Madeleine Pelletier, 'Doctoresse Pelletier: mémoirs d'une féministe' (DP) p. 1, FMLB.
3 Galignani's *New Paris Guide for 1873* gives this street as rue du Petit Carreaux. Pelletier in her memoir of 1939, 'Anne dite Madeleine

Pelletier' (AdMP), BMD, called it rue de Petits Carreaux. For an up-to-date account of the same quarter see the Michelin *Tourist Guide* (1980), pp. 103, 126, and the Michelin *Plan de Paris* (1986).

4 AdMP, p. 3.

5 Monet, who had happened to stroll through Pelletier's neighbour-hood during the gala, recalled his feelings: 'I liked flags very much . . . At the first Fête Nationale of June 30th, I was walking along rue Montorgueil with my painting equipment. The street was decked out with flags, and swarming with people. I spied a balcony, mounted the stairs and asked permission to paint. It was granted . . . Ah, those were good times though life was not always easy.' William C. Seitz, *Claude Monet* (New York, 1960, and London, 1984), p. 108. See also Ronda Kasl, 'Edouard Manet's "Rue Mosnier": le Pauvre a-t-il une patrie?' *Art Journal*, spring 1985, pp. 49–58, for a comparison of Monet and Manet's paintings on a similar theme.

6 Galignani, *Guide 1873*, pp. 301–3.

7 Marina Warner, *Monuments and Maidens: The Allegory of the Female Form* (London, 1985), pp. xix–xxiii and 18–37. Warner cites as a principal reason for female allegory 'the common relation of abstract nouns of virtue to feminine gender in Indo-European languages' (xxi).

8 'Berthelot, Pierre Eugène Marcellin', in *Dictionary of Scientific Biography*, ed. H. Berger and C. B. Bellot , vol. 2, pp. 63–72; Eduard Farber, *Great Chemists* (New York, 1961), pp. 677–85; 'Loi portant autorisation de déposer au Panthéon les restes de Marcellin Berthelot et ceux de Mme Marcellin Berthelot' no. 49215, *Bulletin de Lois de la République Française*, no. 2829, XIIe série, 24 March 1907, p. 146.

9 Madeleine Pelletier, 'Un Traitre', *Trois Contes* (Paris, n.d.).

10 See Maïté Albistur, introduction to 'Catalogue des Archives Marie-Louise Bouglé', Bibliothèque Historique de la Ville de Paris.

11 Simone de Beauvoir, *The Second Sex* (1949) (Penguin, Harmondsworth, 1983), p. 152.

12 James F. McMillan remarks on this question: 'The fact that the feminists did not score striking successes does not show their irrelevance, or testify solely to their ineffectiveness as a political lobby. Rather it points to the degree to which the forces of anti-feminism were deeply embedded in French society.' *Dreyfus to de Gaulle* (London, 1985), p. 59.

13 As a young woman, however, Beauvoir was certainly aware of the work of the birth-control, or neo-Malthusian, movement in France. She particularly admired Nelly Roussel (died 1922), sister-in-law to Paul Robin, founder of the movement. In arguments with her father, Beauvoir maintained that abortion should not be classified as a crime. Claude Francis and Fernande Gontier, *Simone de Beauvoir* (Paris, 1985), pp. 65–6.

1 An *Enfant Terrible*

1 Anne R. Kenney, 'A militant feminist in France: Dr Madeleine Pelletier, her ideas and actions', paper read to the Berkshire Conference on the History of Women, Mount Holyoke College, August 1978. I wish to thank Charles Sowerwine for making this paper available to me. The principal studies on Madeleine Pelletier are found in: Marilyn Boxer, 'When radical and socialist feminism were joined: the extraordinary failure of Madeleine Pelletier', in *European Women of the Left*, ed. Jane Slaughter and Robert Kern (London and Westport, Conn. 1981); Steven C. Hause with Anne R. Kenney, *Women's Suffrage and Social Politics in the French Third Republic* (Princeton, 1984); Claude Maignien, introduction to *L'Education féministe des filles* by Madeleine Pelletier (1914) (Paris, 1978); Charles Sowerwine, *Les Femmes et le socialisme* (Paris, 1978), trans. as *Sisters or Citizens? Women and Socialism in France since 1876* (Cambridge, 1982).

2 DP, p. 1.

3 Archives de Paris, V4E 2610.

4 The precarious social and economic status of small shopkeepers is discussed by Heinz-Gerard Haupt, 'The petite bourgeoisie in France, 1850–1914, in search of the juste milieu?', in *Shopkeepers and Master Artisans in Nineteenth-Century Europe*, ed. G. Crossich and H. G. Haupt (London and New York, 1984); Georges Dupeux, *French Society, 1789–1970*, trans. Peter Wait (London, 1972), pp. 161–2.

5 Boxer, 'Radical and socialist feminism', p. 53. Charles Sowerwine suggests from the evidence of her father's signature that Guy Pelletier may have been barely literate: 'Madeleine Pelletier (1874–1939), femme, médecin, militante', *L'Information psychiatrique*, 9, November 1988.

6 AdMP, p. 2.

7 See Elzbieta Ettinger, *Rosa Luxemburg, A Life* (London, 1987), pp. 166–7, 193.

8 AdMP, p. 9.

9 Ibid., p. 1.

10 For the political and gender debate in French education see: Linda L. Clark, 'The primary education of French girls: pedagogical prescriptions and social realities, 1880–1914', *History of Education Quarterly*, 21, winter 1981, pp. 411–28; Sandra Ann Horvath, 'Victor Duruy and the controversy over secondary education for girls', *French Historical Studies*, 9(1), spring 1975, pp. 83–104; Françoise Mayeur, *L'Éducation des filles en France au XIXe siècle* (Paris, 1979).

11 Theodore Zeldin, *France 1848–1945*, vol. 2: *Intellect, Taste and Anxiety* (Oxford, 1977), p. 1026.

12 AdMP, pp. 2–4.

13 Ibid., p. 4.

14 See James F. McMillan, *Housewife or Harlot, The Place of Women in French Society, 1870–1940* (London, 1981), chapter 1, for the context of sex discrimination under the Third Republic.

15 Jules Michelet, *Priests, Women and Families*, trans. C. Cocks (London, 1846), p. 153; Zeldin, *France*, vol. 2, p. 1026; Bonnie Smith, *Ladies of the Leisure Class* (Princeton, 1981), introduction and p. 61.

16 AdMP, p. 5.

17 Ibid., pp. 4, 5.

18 Ibid., p. 10.

19 Pelletier, *La Femme vierge* (Paris, 1933), p. 8.

20 AdMP, p. 8.

21 Ibid., pp. 5, 9.

22 DP, p. 2.

23 AdMP, p. 8.

24 See Hause with Kenney, *Women's Suffrage*, p. 49.

25 AdMP, p. 8.

26 Pelletier's response to her puberty crisis recalls Beauvoir's axiom: 'One is not born a woman, one becomes a woman.'

27 Pelletier, *La Femme vierge*, chapter 8.

28 DP, p. 2.

29 V. Kiernan, *The Duel in European History* (Oxford, 1988).

30 DP, p. 2a.

31 Ibid.

32 For the symbolic meaning of clothes in *la belle epoque* see: Philippe Perrot, 'Le Jardin des modes', in *Misérable et glorieuse, la femme au XIXe siècle*, ed. Jean-Paul Aron (Paris, 1980), pp. 101–16; Smith, *Ladies*, chapter 4 on the elaboration of dress and domestic artefacts.

33 Letter to Arria Ly, 2 November 1911, FMLB.

34 Madeleine Pelletier, 'Du Costume', *La Suffragiste*, July 1919.

35 DP, p. 4.

36 Boxer, 'Radical and socialist feminism', p. 58.

37 Madeleine Pelletier in *La Suffragiste*, January 1912.

38 Letter to Arria Ly, 2 November 1911, FMLB.

39 Letter to Arria Ly, June 1932, FMLB.

40 Letter to Arria Ly, June 1908, FMLB.

41 See Zeldin, *France*, vol. 2, chapter 11.

42 Patrick Bidelman, *Pariahs Stand Up!: The Founding of the Liberal Feminist Movement in France, 1858–1889* (London, 1982), p. 4; see also McMillan, *Housewife or Harlot*, chapter 1.

43 For background in French anarchism and its links with socialism and

feminism see: Richard J. Evans, *The Feminists* (London, 1977), chapter 3; Jean-Pierre Machelon, *La République contre les libertés* (Paris, 1976), pp. 399–443; and McMillan, *Dreyfus to de Gaulle*, pp. 26–30.

44 DP, p. 3.
45 See Edith Thomas, *Louise Michel* (Paris, 1975), p. 11.
46 DP, pp. 4, 6a.
47 Ibid., p. 4a.
48 Ibid.
49 Ibid, p. 5.

2 Meritocracy and Elitism

1 Georges Dupeux, *French Society*, pp. 168, 169. He quotes André Seigfried's observation that: 'Even an anti-clerical Frenchman feels happier about his wife if the curé is keeping an eye on her – especially if she's pretty.'
2 Boxer, 'Radical and socialist feminism', p. 67. For a discussion of the formation of medical professional elites in the nineteenth century see: Jan Goldstein, *Console and Classify: The French Psychiatric Profession in the Nineteenth Century* (Cambridge, 1987), pp. 8–40.
3 DP, p. 11a.
4 Ibid., p. 5.
5 Edmée Charrier, *L'Évolution intellectuelle féminine* (Paris, 1937), chapter 2; Caroline Schultze, *La Femme-médecin au XIXe siècle* (Paris, 1888); Mayeur, *L'Éducation des filles en France*, p. 33.
6 Charrier, *L'Évolution intellectuelle*, p. 141.
7 I am grateful to Charles Sowerwine for making available to me photocopies of Pelletier's scholastic and examination records as well as a copy of his 'Chronologie de sa carrière médicale'. Pelletier's dossier at the medical faculty indicates that by the time she was a medical student her mother had died, at least she lists herself as an orphan. In the Baccalauréat de l'enseignement secondaire classique (Lettres-Philosophie) she received a distinction. The year following her baccalauréat she studied for and passed the Certificate of Studies in Physics, Chemistry and Natural Science (PCN), 19 July, 1898: Dossier Pelletier, Archives de la Faculté de Médecine de Paris, Archives Nationales, AN AJ16 6932.
8 For an account of women's struggles to enter medicine see E. Moberly Bell, *Storming the Citadel* (London, 1953), and Schultze, *La Femme-médecin*, p. 15.

9 Schultze, *La Femme-médecin*, p. 13.
10 Charrier, *L'Évolution intellectuelle*, table 6 and pp. 150–2.
11 Charrier, p. 308, and Dossier Pelletier, AN AJ16 6932, for results of individual examinations. Between 1900 and 1903 Pelletier published five articles on anthropology (see bibliography) in addition to her dissertation, *L'Association des idées dans la manie aïgue et dans la débilité mentale* (Jules Rousset, Paris, 1903); see also Charles Sowerwine, 'Femme, médecin, militante', p. 10.
12 Madeleine Pelletier, *L'Enseignement et la culture intellectuelle* (Paris, n.d.).
13 George Weisz, 'Reform and Conflict in French Medical Education, 1870–1914', in *The Organization of Science and Technology in France, 1808–1914*, ed. Robert Fox and George Weisz (Cambridge, 1980), p. 93.
14 Madeleine Pelletier, *Une Vie nouvelle* (Paris, 1932), chapter 2.
15 Letter to Arria Ly, 27 March 1927, Dossier CP4249, Série 83 féministe, FMLB.
16 Letter to Hélène Brion, 19 September 1929, IFHS.
17 Letter to Arria Ly, 16 February 1932, Dossier CP4249, Série 83 féministe, FMLB.
18 See Marthe Bertheaume, *Les Femmes médecins* (Paris, 1923), Schultze, *La Femme-médecin*, p. 19 and Frances Clark, *The Position of Women in Contemporary France* (London, 1937), p. 42.
19 DP, p. 8.
20 Ibid., p. 11a.
21 Both Pelletier's complaints about the Medical Faculty and the difficulties she experienced at L'École d'Anthropologie point to a structural feature of French scientific-academic life: 'The faltering but still powerful system of personal patronage . . . tended to bind young men more closely to master than to peers within the discipline . . . a powerful patron could give decisive help in the advancement of a career, often by providing access to what was effectively his own publication.' Robert Fox, 'The *Savant* confronts his peers: scientific societies in France, 1815–1914', in *Organization*, ed. Fox and Weisz, p. 281. See also Goldstein, *Console and Classify*, for the operation of patronage in medicine and psychiatry, pp. 120–51.
22 See 'Séance d'ouverture, 19 mai 1859', *Bulletins de la Société d'Anthropologie de Paris* (*BSAP*), 1860. The École d'Anthropologie grew out of this society and was founded in 1875: Paul Lester, 'L'Anthropologie', *Histoire de la science* (Encyclopédie de la Pléiade) (Paris, 1959), p. 1379.
23 Paul Broca in *BSAP*, 1861, p. 304, quoted by Stephen Jay Gould, *The Mismeasure of Man* (London, 1981), p. 83.

24 For background on French anthropology and craniometry see Zeldin, *France*, vol. 2, pp. 774–9; Gould, *Mismeasure of Man*; Elizabeth Fee, 'Nineteenth-century craniology: the study of the female skull', *Bulletin of the History of Medicine*, 53, 1979, pp. 413–33; Yvette Conry, *L'Introduction du Darwinisme en France au XIXe siècle* (Paris, 1974); Robert Young, *Mind, Brain and Adaptation in the Nineteenth Century* (Oxford, 1970).

25 Gould, *Mismeasure of Man*, chapter 3.

26 Elizabeth Fee, 'The sexual politics of Victorian social anthropology', *Feminist Studies*, 1(3–4), winter–spring 1973, pp. 23–39.

27 For a full discussion of the evolution debate in France see Conry, *Darwinisme*, and Robert A. Nye, *Crime, Madness and Politics in Modern France* (Princeton, 1984), especially chapter 4.

28 Gillian Beer, *Darwin's Plots: Evolutionary Narrative in Darwin, George Eliot and Nineteenth-century Fiction* (London, 1983), pp. 13–18. Also the introduction to Charles Darwin, *The Origin of Species*, ed. J. W. Burrow (Harmondsworth, 1959), on use and disuse theory; and Charles Darwin, *The Illustrated Origin of Species*, ed. R. Leakey (London, 1979) for nineteenth-century views on heredity; Paul Heyer, *Nature, Human Nature and Society: Marx, Darwin, Biology and the Human Sciences* (London, 1982).

29 Quoted from Gould, *Mismeasure of Man*, pp. 104–5.

30 Two works of Charles Letourneau that arguably had particular relevance to Pelletier were *The Evolution of Marriage and of the Family* (London, 1891) and *Property, its Origin and Development* (London, 1892).

31 Letourneau, *Evolution of Marriage*, pp. 341–60.

32 DP, p. 29a.

33 See Jonathan Rée, *Proletarian Philosophers* (Oxford, 1984), chapter 1, for the development of dialectical materialism as a central tenet of Marxism.

34 R. Anthony, obituary for Léonce Manouvrier, *BSAP* 8, VIIe série, 20 January 1927.

35 Madeleine Pelletier, 'Sur un nouveau procédé pour obtenir l'indice cubique du crâne', *BSAP*, 7 March 1901, pp. 188–93; 'Recherches sur les indices pondéraux du crâne et des principaux os longs d'une série de squelettes japonais', *BSAP*, 15 November 1900, pp. 514–29; 'Étude de la phylogenèse du maxillaire inférieur', *BSAP*, 1 May 1902, pp. 537–45.

36 Fee, 'Nineteenth-century craniology', pp. 416–19.

37 Ibid., p. 424.

38 Pelletier, 'Recherches sur les indices pondéraux', p. 516.

39 Pelletier, 'Étude de la phylogenèse', p. 544.

40 See Karl Pearson, 'On the correlation of intellectual ability with the size and shape of the head', *Proceedings of The Royal Society*, 69, 1902, pp. 333–42. This paper was reported on in the *Revue Scientifique* (20 December 1902) so that its conclusions were available to French readers.

41 Fee, 'Nineteenth-century craniology', pp. 429–432.

42 Monsieur Pieron, obituary for N. Vaschide, *BSAP*, 7 November 1907 (p. 443).

43 N. Vaschide and M. Pelletier, 'Les Signes physiques de l'intelligence', *Revue de Philosophie*, 1 October 1903 and 1 February 1904; and their earlier progress report, 'Contribution expérimentale à l'étude des signes physiques de l'intelligence', *Comptes Rendus de l'Académie de Science*, 7 October 1901, pp. 551–3.

44 Alice Lee, Marie Lewenz and Karl Pearson, 'On the correlation of mental and physical characters in man', part 2, *Proceedings of The Royal Society*, 71, 1902, pp. 106–14.

45 Rée, *Proletarian Philosophers*, p. 29.

46 Lee, Lewenz and Pearson, 'Correlation', p. 108.

47 Madeleine Pelletier, 'La Question du vote des femmes', *La Revue Socialiste*, September–October 1908, see *L'Éducation féministe des filles*, ed. Maignien, p. 49.

48 Ibid, pp. 22–3.

49 For early feminist freemason campaigns see Bidelman, *Pariahs Stand Up!*, p. 84, and Sowerwine, *Sisters or Citizens?*, pp. 111–12. See also Margaret Jacob, *The Radical Enlightenment* (London and New York, 1981), pp. 109–37, and Dudley Wright, *Women and Freemasonry* (London, 1922), pp. 141–2.

50 Wright, *Women and Freemasonry*, p. 145.

51 'Préface', *L'Acacia: Revue des études maçonniques* (1906).

52 Madeleine Pelletier, 'La Tactique féministe', in *L'Éducation féministe des filles*, ed. Maignien, pp. 148–9.

53 Madeleine Pelletier, 'Les Femmes dans la Maçonerie [*sic*]', *L'Acacia*, June 1906, p. 441. Legrain was, like Manouvrier and Letourneau, a member of l'École d'Anthropologie. His report on the Brussels Conference on Anthropology of 1892 shows him defending transformist and opposing to Lombrosian theories of criminality. Paul-Maurice Legrain, 'L'Anthropologie criminelle au Congrès de Bruxelles de 1892', *La Revue scientifique*, October 1892, pp. 487–97.

54 Sowerwine, *Sisters or Citizens?*, p. 112.

55 For a discussion of the born criminal debate see Nye, *Crime, Madness and Politics*, chapter 4, and Gould, *Mismeasure of Man*, chapter 3.

56 Nye, *Crime, Madness and Politics*, p. 105.

57 Legrain, 'Anthropologie criminelle', pp. 487–97.

58 John Stuart Mill, *On Liberty* (1859),(Oxford, 1974), p. 84.
59 Mill, *The Subjection of Women* (1869), (Oxford, 1957), chapter 3.
60 Madeleine Pelletier, *Les Femmes peuvent-elles avoir du génie?* (Paris, n.d.), p. 2.
61 Ibid., p. 3.

3 Psychiatry and Medical Practice

1 M. L. Néron, 'La Femme-médecin est-elle heureuse?', *La Fronde*, 20–26 November 1901; Charrier, *L'Évolution intellectuelle.*
2 Zeldin, *France*, vol. 1: *Ambition, Love and Politics*, p. 31. Before the war, Pelletier had a number of different surgeries. Her first was 80 rue de Gergovie, 14th arrondissement (1906), then rue Radier, 9th arrondissement (1907), then 55 rue Damrémont, 18th arrondissement (1909–14). Préfecture de police, 'Liste des docteurs exerçant à Paris'. I am grateful to Charles Sowerwine for this reference.
3 Maignien, introduction to Pelletier, *L'Éducation féministe*, p. 11.
4 Madeleine Pelletier, 'Contre l'alcoolisme: médecin de nuit', clipping, Dossier Pelletier, BMD.
5 DP, pp. 13–13a.
6 Letter to Arria Ly, 13 June 1913, Dossier Arria Ly, FMLB.
7 See 'Dossier Pelletier, Faculté de Médecine, pp. 5, 22, 25, and Jacques Postel and Claude Quétel, *Nouvelle histoire de la psychiatrie* (Paris, 1983), p. 722.
8 DP, pp. 12–12a.
9 Dossier Docteur Anne, Madeleine Pelletier, Asile de Ville-Evrard, 1 February 1905, p. 2.
10 Hélène Brion, 'Madeleine Pelletier', *L'Encyclopédie féministe*, BMD.
11 'Toujours l'hominisme', *La Fronde*, 2 December 1902.
12 Ibid.
13 'Les Femmes et l'internat', *La Fronde*, 4 December 1902.
14 DP, p. 13.
15 'Les Femmes et l'internat'.
16 *Annuaire de l'internat en médecine des hôpitaux psychiatriques de la Seine, 1986–1987* (Association Amicale des Internes et Anciens Internes, Paris, 1987), p. 62.
17 Dr Toulouse, 'La Femme et les fonctions publiques', in the Dossier Pelletier, BMD.
18 'Mlle Constance Pascal', *La Presse médicale*, no. 8, 26 January 1938, p. 150.
19 For the debate on mental illness, social control, deviance and the psychiatric profession see: Henri Baruk, *La Psychiatrie française de*

Pinel à nos jours (Paris, 1967); Robert Castel, *L'Ordre psychiatrique* (Paris, 1976), trans. as *The Regulation of Madness* (Cambridge, 1988); Stanley Cohen and Andrew Scull (eds), *Social Control and the State* (Oxford, 1983); Michel Foucault, *Madness and Civilisation*, trans. Richard Howard, (London, 1965), and *Les Machines à guerir* (Paris, 1977); Goldstein, *Console and Classify*; Robert Nye, *Crime, Madness and Politics* and *The Origins of Crowd Psychology: Gustave Le Bon and the Crisis of Mass Democracy in the Third Republic* (London, 1975); Elaine Showalter, *The Female Malady* (New York, 1985); and Yannick Ripa, *La Ronde des folles: femme, folie et enfermement au XIXe siècle (1838–1870)* (Paris, 1986), p. 147, trans. as *Women and Madness* (Cambridge, 1990).

20 'Commémoration du centenaire, Centre Hospitalier Spécialisé de Villejuif', Villejuif, 11 December 1984, p. 2.

21 Castel, *L'Ordre psychiatrique*, pp. 235–7.

22 Ibid., p. 269.

23 Dr R. von Krafft-Ebing, *An Experimental Study in the Domain of Hypnotism* (New York, 1889. Charcot's lessons at the Salpêtrière were famous for their exhibitionism. Hysterics would 'perform' before an audience of interested spectators. Goldstein, *Console and Classify*, pp. 323–31, and Showalter, *Female Malady*, pp. 148–59.

24 For the inefficacy of the 'moral treatment' see Castel, *L'Ordre psychiatrique*, p. 243, and Goldstein, *Console and Classify*, chapter 3, for 'fear' cures for monomaniacs. Ripa, *La Ronde des folles*, pp. 147–8, also offers evidence of the cold shower treatment.

25 Dr Briand, 'Les Vingt-cinq premières années de l'asile de Villejuif', in 'Commémoration du centenaire', p. 12.

26 Ibid., p. 15.

27 Charles Sowerwine, 'Madeleine Pelletier, chronologie de sa carrière médicale', unpublished.

28 Postel and Quétel, *Nouvelle histoire*, p. 722.

29 DP, p. 15.

30 Briand, in 'Commémoration du centenaire', p. 33.

31 See also Showalter's persuasive analysis of the painting *Pinel Freeing the Insane* in *Female Malady*, pp. 1–3.

32 Showalter, *Female Malady*, pp. 82–4; see also Ripa, *La Ronde des Folles*, pp. 129–54.

33 Madeleine Pelletier, *L'Association des idées dans la manie aigüe et dans la débilité mentale* (Paris, 1903), the second edition appearing as *Les Lois morbides de l'association des idées* (Paris, 1904); *L'Écho de la pensée et la parole intérieure* (Paris, 1904); 'Le Sérum marin dans la thérapeutique des aliénés', presented to the 20 May meeting of the Société de Biologie, *Archives de biothérapie*, 1905, pp. 49–64; 'Les

Membres fantômes chez les amputés délirants', written with Dr A. Marie, *Bulletin de l'Institut Général Psychologique*, 5(3), 1905; 'Craniectomie et régénération osseuse', written with Dr A. Marie, *Bulletin de la Société d'Anthropologie*, 1905.

34 Madeleine Pelletier, 'Etre Apache', *La Guerre sociale*, 9 June 1909; Goldstein, *Console and Classify*, pp. 240–75.

35 John Stuart Mill, *An Examination of Sir William Hamilton's Philosophy* (London, 1865), p. 8. It was translated into French by E. Cazelles in 1869.

36 *L'Association des Idées*, p. 27.

37 Ibid., p. 36.

38 Sowerwine, 'Femme, médecin, militante', p. 15.

39 Newspaper clipping, Dossier Pelletier, BMD.

40 *L'Informateur des aliénistes et des neurologistes*, I, 1906, pp. 41–2; III, 1908, pp. 97–8. *La Revue scientifique*, 4e série, 8(25), 20 December 1902.

41 Pelletier, *Une Vie nouvelle*, chapter 9.

42 *Journal Officiel de la République Française*, 2 August 1906, p. 3505. I would like to thank Charles Sowerwine for pointing out the comparison with Mlle Pascal and for making the above documentation on her available.

43 Madeleine Pelletier, 'La Prétendue Infériorité psycho-physiologique des femmes', *La Vie normale*, year 2, no. 10, December 1904, p. 5.

44 Ibid., p. 6.

45 Ibid., p. 7.

4 Militant Feminism

1 For a contrasting interpretation see Sowerwine, *Les Femmes et le socialisme*, pp. 129, 139.

2 Simone de Beauvoir, *The Second Sex* (first published 1949), trans. H. M. Parshley (Penguin, Harmondsworth, 1972), p. 19.

3 See Bidelman, *Pariahs Stand Up!*, pp. 108–10, and Hause with Kenney, *Women's Suffrage*, p. 16.

4 Hause with Kenney, *Women's Suffrage*, pp. 118–19, and Andrew Rosen, *Rise Up Women* (London, 1974), pp. 24–48.

5 For both Kant and Hegel, women represented the natural, cyclical, private and non-transcendent sphere. Bachofen (whom Pelletier read), though suggesting that female political power had existed in prehistoric times, saw matriarchy as an archaic golden age to be overcome in the progress towards patriarchal civilization.

6 See Evans, *The Feminists*, pp. 129–30, and McMillan, *Housewife or Harlot*, chapters 2 and 4.

7 DP, p. 2.

8 Hause with Kenney, *Women's Suffrage*, p. 31.

9 Bidelman, *Pariahs Stand Up!*, pp. 108–10.

10 Hause with Kenney, *Women's Suffrage*, p. 16.

11 Ibid., pp. 28–31, 37–9, and Sowerwine, *Les Femmes et le socialisme*, pp. 77–84.

12 DP, pp. 10–10a.

13 'Le Féminisme et ses militantes', *Documents du progrès*, July, 1909, pp. 19–26. Many feminists were opposed to the dismantling of sexual stereotypes. As Mlle Claire de Pratz argued in an English suffragist magazine, Frenchwomen exercised great influence because 'the Frenchman is devoted to the cult of Women. He adores "la femme": Frenchwomen therefore must keep the influence they already exercise as wife, mother and sister ... To be *féministe* they must first be *féminine*.' 'French women and English women', *Votes for Women*, February 1908, p. 64.

14 For a discussion of improvements in Frenchwomen's civil position, see Hause with Kenney, *Women's Suffrage*, pp. 94–6.

15 Evans, *The Feminists*, pp. 44–137.

16 DP, pp. 14–14a.

17 Ibid., and press clipping, February 1906, Dossier Pelletier, BMD.

18 DP, p. 24a.

19 Hause with Kenney, *Women's Suffrage*, p. 41.

20 Dossier Caroline Kauffmann, FMLB.

21 Albistur, 'Catalogue', p. 35.

22 B/a 1651, 21 April 1899, APP.

23 For accounts of Auclert's career see Hause with Kenney, *Women's Suffrage*, pp. 102–9, Sowerwine, *Les Femmes et le socialisme*, pp. 14–17, the Archives de la Préfecture de Police, and for a full-length study, Steven C. Hause, *Hubertine Auclert* (New Haven, 1987).

24 B/a 885 (136616), APP.

25 Hause points out, in his *Hubertine Auclert*, that Pelletier seems not to have participated in the actual overturning of the ballot box, though she accompanied the group earlier in the day; Kauffmann and Auclert took part in the final assault (pp. 197–8). Hause with Kenney, *Women's Suffrage*, p. 102; B/a 885 (136616), 4 June 1908, APP.

26 Sowerwine, *Les Femmes et le socialisme*, pp. 127–8; Albistur, 'Catalogue'.

27 For the issue of suffragist 'violence' or lack of it in France see Steven C. Hause with Anne R. Kenney, 'Women's suffrage and the Paris elections of 1908', *Laurels*, 51(1), spring 1980, and Hause, *Hubertine*

Auclert. At no stage did French suffragists offer violence to persons and the attempts to damage property were purely symbolic.

28 Hause with Kenney, *Women's Suffrage*, pp. 57–8, 86–8.
29 22 August 1911, Correspondance Pelletier–Ly, Dossier CP4249 (Série 83 féminisme), FMLB.
30 7 November 1913, CP4249 (Série 83 féminisme), FMLB.
31 DP, pp. 39a–41.
32 1 July 1913, CP4249 (Série 83 féminisme), FMLB.
33 Hause with Kenney, *Women's Suffrage*, pp. 93–4; Albistur, 'Catalogue', p. 38.
34 Hélène Brion, 'L'Encyclopédie féministe', 5A-331, p. 38, BMD.
35 Albistur, 'Catalogue', p. 38.
36 Ibid.
37 Dossier Arria Ly, FMLB.
38 Letter to Arria Ly, 27 June 1908 (Série 83 féminisme), FMLB.
39 Pelletier, 'Le Féminisme et ses militantes', July 1909.
40 Ibid., p. 21.
41 Letter to Arria Ly, 27 June 1908 (Série 83 féminisme), FMLB.
42 Hause with Kenney, *Women's Suffrage*, pp. 165–6, 216–17; Hélène Brion, *La Voie féministe* (Paris, n.d.), prefaced by Huguette Bouchardeau.
43 Hélène Brion, 'L'Encyclopédie féministe', a collection of hand-pasted entries on women in history and feminism, BMD.
44 Hause with Kenney in *Women's Suffrage*, p. 134, list under a hundred members for 1900–1.
45 DP, p. 16.
46 Ibid.
47 Edouard Le Page, *L'Éclair*, 9 April 1910, clipping, Dossier Pelletier, BMD.
48 DP, p. 17.
49 13 November 1911, FMLB.
50 DP, pp. 18–18a.
51 Ibid.
52 See Hause with Kenney, *Women's Suffrage*, p. 175, for an analysis of this point.
53 Ibid., p. 78.
54 DP, p. 21.
55 Ibid., pp. 21–21a.
56 Hause with Kenney, *Women's Suffrage*, pp. 78–80.
57 DP, p. 23.
58 Hause with Kenney, *Women's Suffrage*, p. 7, and Madeleine Pelletier, 'Ma Candidature à la députation', extract from *Documents du progrès*, July 1910.

59 Madeleine Pelletier, 'La Question du vote des femmes', *La Revue socialiste*, September–October, 1908.

60 Hause with Kenney, in *Women's Suffrage*, p. 109, say that French delegates did not attend this demonstration. Though mainstream French feminists did not accept the invitation of the Women's Social and Political Union, Solidarité des Femmes did send representatives, as evidenced by Pelletier's testimony in 'La Question du vote des femmes', letters from Billinghurst to Kauffmann (see below) and a brief reference to French delegates in a press clipping 'Women's Triumph', 22 June 1908, M. R. Billinghurst Papers, Fawcett Library. For a description of the suffragist rallies see Rosen, *Rise Up Women*, pp. 102–8.

61 May Billinghurst was a notable figure in the women's suffrage campaign. In spite of being disabled and confined to a wheelchair, she engaged fully in militant actions. In January 1913 she was found guilty, along with another suffragette, Grace Mitchell, of pouring a 'black fluid' down a number of pillar boxes; slightly damaged postcards were produced at the trial as incriminating evidence. Billinghurst fully admitted the charge and said her action was intended to call attention to the exclusion of women from the suffrage. No women were allowed to attend her trial. She was sentenced to eight months in Holloway prison. Refusing food, she was force-fed three times daily, first with a nose drip and when that became impossible thanks to the damage to the nasal passage, by having her mouth prized open and breaking a tooth so that a tube could be inserted. As a consequence of this treatment, her health became so precarious that she was released after nine days. *London Standard*, 9 January 1913, Billinghurst Papers, Fawcett Library.

62 May Billinghurst to Caroline Kauffmann, 3 July 1908, Dossier Caroline Kauffmann, II, FMLB.

63 'Woman Suffrage Demonstration: "A Mob at Westminster"', *The Times*, 1 July 1908, p. 14.

64 For the connection between the British women's suffrage movement and working-class politics see Evans, *The Feminists*, pp. 175–6, Hause with Kenney, *Women's Suffrage*, pp. 118–19, and Rosen, *Rise Up Women*, chapters 2 and 3.

65 Pelletier, 'La Question du vote', p. 12.

66 Ibid., p. 13.

67 Letter to Ferdinand Buisson, 15 September 1908, Dossier Ferdinand Buisson, FMLB.

68 Hause with Kenney, *Women's Suffrage*, pp. 101–3.

69 Charge Book 1907–9, entry for 10 May 1908, APP.

70 DP, pp. 25a–26.

71 Ibid., p. 26a.
72 Ibid., pp. 26a–27.
73 Ibid., p. 28.
74 *The Times*, 17 July 1908.
75 Hause with Kenney, *Women's Suffrage*, pp. 101–4; Sowerwine, *Les Femmes et le socialisme*, p. 142 n51.

5 Feminist Electoral Campaigns and Socialist Politics

 1 See Evans, *The Feminists*, pp. 173–4, Hause with Kenney, *Women's Suffrage*, pp. 80–1, 148–50, 162–5, McMillan, *Housewife or Harlot*, pp. 87–90, Sowerwine, *Les Femmes et le socialisme*, pp. 125–43, 146–9 (translated as *Sisters or Citizens*).
 2 Sowerwine, *Les Femmes et le socialisme*, p. 139.
 3 Pelletier, 'Ma Candidature', p. 12.
 4 Ibid.
 5 Pelletier, 'La Tactique féministe', see *L'Éducation féministe des filles*, ed. Maignien, pp. 145, 147.
 6 Sowerwine, *Les Femmes et le socialisme*, pp. 14–15, 54–5.
 7 Ibid., p. 58. For a discussion of the tension between a utopian socialist analysis of women's subordination and the Marxist view see S. Joan Moon, 'Feminism and socialism: the Utopian synthesis of Flora Tristan', in *Socialist Women: European Socialist Feminism in the Nineteenth and early Twentieth Centuries*, ed. Marilyn J. Boxer and Jean H. Quataert (Oxford and New York, 1978).
 8 Paul Lafargue, *The Evolution of Property from Savagery to Civilisation* (1890) (London, 1975).
 9 DP, pp. 29a–30.
10 Ibid., pp. 32–32a.
11 Ibid., p. 34.
12 Madeleine Pelletier, 'Organisons la femme', *Le Socialiste*, 4 October 1908; Charles Sowerwine, 'The organisation of French socialist women, 1880–1914: a European perspective for women's movements', *Historical Reflections/Réflexions historiques*, 3(2), 1976, pp. 3–24.
13 DP, p. 30.
14 Ibid., pp. 33a–34.
15 Madeleine Pelletier, 'Le Féminisme à la Chambre des Députés', *Les Documents du Progrès*, September 1911, p. 157.
16 Sowerwine, *Les Femmes et le socialisme*, p. 130.
17 Pelletier, 'Ma Candidature', p. 12.
18 Pelletier, 'Le Féminisme à la Chambre', p. 157. Sowerwine, *Les*

Femmes et le socialisme, pp. 130–1. Hause with Kenney, in *Women's Suffrage*, p. 80, describing Pelletier's lobbying of parliament, say that she 'hectored' René Viviani into arranging a meeting with Socialist deputies. Hause, like Sowerwine, points out that the suffragists were promised action. 'The socialist party is going to occupy itself with the reform that you advocate' (Jaurès). Hause implies, however, some unspecified failure of feminist militancy at this stage. 'It was the sort of unequivocal promise that fell frequently from socialist lips but rarely led to suffragist action.'

19 *The Times*, 24 December 1906.

20 Pelletier, 'Le Féminisme à la Chambre', pp. 156–7.

21 Sowerwine sees little connection between Pelletier's work in the socialist party and her suffragist activity. He notes that she did not pursue the question of women's suffrage in the CAP (the executive of the SFIO) where she did not appear to have pressured the socialist party over its failure to follow up the Limoges resolution. 'Cette négligence, on peut en être surpris, ne fit jamais l'objet d'une attaque explicite de la part de Madeleine Pelletier': *Les Femmes et le socialisme*, p. 132. One wonders how to interpret Pelletier's lobbying of Jaurès with a group of woman's suffrage demonstrators unless it was an explicit attack on this very issue. Sowerwine does state that Pelletier lobbied Jaurès, but casts doubts on the subject of their interview with the rhetorical question: 'Lui rappellèrent-elles la promesse qu'il avait faite six mois plus tôt et qui n'avait pas été tenue?' (ibid., p. 132). He appears to view direct appeals to the parliamentary party as somehow equivocal. It was surely the parliamentary leadership's response that was equivocal.

22 Hause with Kenney, *Women's Suffrage*, p. 184, and Sowerwine, *Les Femmes et le socialisme*, p. 132, mention the presence of British suffragettes in the Paris demonstration as an indication of the weakness of French suffragism. Sowerwine contrasts Pelletier's appeal to proletarian feminists unflatteringly with the fact that she swelled her ranks with English feminists. The socialist party that Pelletier had joined in 1906 had few women members, only 1,060 by 1914. In her suffragist activism, Pelletier gathered together whatever material she could. She did, as we saw in the previous chapter, admire the tactics and organization of the English suffragettes. The gesture of international solidarity on the part of feminists should not be underestimated, as it is not in socialist history, where internationalism is portrayed as a source of strength, not weakness. Pelletier alone, as Richard Evans has shown, could not effect a change of attitudes towards female membership in the party. Guesde himself rejected all suggestions that his party should actively recruit women. Evans, *The Feminists*, p. 173.

23 Sowerwine, *Les Femmes et le socialisme*, p. 132.
24 DP, p. 38.
25 Sowerwine, *Les Femmes et le socialisme*, pp. 134–5.
26 Evans, *The Feminists*, pp. 160–3.
27 Ettinger, *Rosa Luxemburg*, pp. 102, 189–90.
28 Sowerwine, *Les Femmes et le socialisme*, pp. 135–7, comments on Pelletier's lack of interest in women's sections. Evans contrasts the French and German attitudes towards recruiting women to their socialist parties as reflecting the differences in each country's industrial base. Though the rate of female employment in both countries was roughly the same, in France small-scale artisanal industry relied on the unpaid female labour of family members. Artisans were the backbone of the French socialist movement and for sound economic reasons they endorsed the Proudhonian conception of women's place in the home. 'French socialists were frequently embarrassed by the paucity of women socialists in their country at a time when there were hundreds and thousands of them in Central Europe. But they never translated their embarrassment into action.' Evans, *The Feminists*, pp. 174–5.
29 Pelletier, 'La Tactique féministe', see *L'Éducation féministe des filles*, ed. Maignien, p. 153.
30 DP, pp. 35a, 36.
31 Sowerwine, *Les Femmes et le socialisme*, pp. 137–8; DP, pp. 33–33a.
32 *La Guerre sociale*, 30 January and 20 March 1907, 24 June and 1 July 1908.
33 See Madeleine Pelletier in *La Guerre sociale*: 'Comment préparer la révolution', 14 August 1907; 'Danger du parlementarisme', 16 September 1908; 'Défendrons-nous la République?', 3 February 1909; 'La Tactique d'attentat', 14 July 1909.
34 Madeleine Pelletier in *La Guerre sociale*: 'Députés ouvriers', 6 October 1909, p. 3; 'La Fin du Guesdisme', 6 January 1909, p. 2.
35 Pelletier, 'Défendrons-nous la République?', p. 2.
36 See Pelletier in *L'Éducation féministe des filles*, ed. Maignien, p. 152.
37 Madeleine Pelletier, 'Par delà Guesde', *La Guerre sociale*, 4 September 1907.
38 Madeleine Pelletier, 'L'Inévitable épuration', *La Guerre sociale*, 30 October 1907.
39 Pelletier, 'Députés ouvriers'.
40 The Parat case, raising as it did the possibility of a woman enjoying or at least co-operating in her own victimization, represented a feminist problem for Pelletier, which she explored with the tools of psychiatric analysis. The Parat affair bears comparison with the modern Nussbaum–Steinberg case: see Beatrix Campbell, 'The trial of terror', *Guardian*, 2 January 1989.

41 Madeleine Pelletier, 'Sadisme et masochisme', *La Guerre sociale*, 6 March 1910.

42 Madeleine Pelletier, 'Faut-il repeupler la France?', *La Guerre sociale*, 16 March 1910.

43 Madeleine Pelletier, 'Les Suffragettes et *L'Humanité*', *La Guerre sociale*, 17 November 1909.

44 *La Guerre sociale*, 14 July 1909.

45 Pelletier, *La Suffragiste*, June 1910; 'Guesdistes et insurrectionels', *La Guerre sociale*, 10 November 1909. Pelletier was the second woman to serve on the CAP. The first, Angèle Roussel, a Guesdiste, elected as assistant secretary in 1907 was not identified as a feminist. Sowerwine, *Les Femmes*, pp. 134, 140–1. Sowerwine further points out that women's suffrage was never discussed at the CAP from 1909–10 when Pelletier was a member. Though he agrees that on 1 June 1910 a socialist resolution was proposed to parliament calling for women's suffrage he continues: 'Et s'ils allèrent jusque-là, ce fut sans que Pelletier ni la CAP interviennent.' *Les Femmes*, p. 141. One may recall that the parliamentary resolution arose out of the resolutions passed at the two previous national congresses and proposed by Pelletier herself. The CAP, on the other hand, was an administrative, not a policy-making body.

46 In *Documents du progrès*, July 1909, pp. 19–26. Much of the optimism about progress with women's suffrage at this period rested on the Buisson Report on Women's Suffrage to the Chamber of Deputies which appeared in 1909 and to which Pelletier contributed evidence. Buisson, a Radical Socialist, had compiled a 400-page defence of women's right to vote. His report encouraged the hope among French suffragists that parliamentary action would follow promptly. Hause with Kenney, *Women's Suffrage*, pp. 128–30.

47 DP, pp. 37a–38.

48 AN F7 13961, 2 February 1916.

49 For a discussion of the Lacanian perspective on Pelletier see Sowerwine, 'Femme, médecin, militante', p. 6. One also notes the signature Pelletier affixed to her letters to Arria Ly: 'Dr. Pelletier, vierge et non-martyre', see 22 August 1911 (Série 83 féminisme), FMLB.

50 Pelletier, in *L'Éducation féministe des filles*, ed. Maignien, p. 66.

51 Bonnie Smith, *Ladies*, p. 79, examines the language of fragility and procreation suggested by ballooning skirts, huge sleeves, etc. Also Perret, 'Le Jardin des modes', in *Misérable et glorieuse*, ed. Aron, p. 108.

52 Pelletier, *L'Éducation féministe des filles*, p. 94.

53 DP, p. 39.

54 Ibid.

55 Ibid., p. 42.

56 For the electoral tactics of different feminist groups, see Hause with Kenney, *Women's Suffrage*, pp. 145–51, and Sowerwine, *Les Femmes et le socialisme*, pp. 142–3.

57 In Sowerwine's view, Pelletier played down her feminism and her revolutionary socialism in her election address, *Les Femmes et le socialisme*, p. 143. The latter was necessarily the case since she was not standing as a Hervéiste but as a mainstream Socialist. To suggest that she was not perceived as a feminist is a view drawn perhaps from a comparison with Marguerite Durand who, in Pelletier's and indeed the press's account, functioned as a 'feminine feminist', whereas Pelletier emphatically did not. Hause with Kenney, *Women's Suffrage*, p. 150, also argue that Pelletier was not a feminist in the elections. A reading of her 'Discours' does not bear this out, though she also wished to be considered as a serious socialist. 'Discours prononcé par Madeleine Pelletier dans le préau de l'école rue de Florence, samedi 23 avril, 1910' (MS by Hélène Brion), Dossier Pelletier, BMD. Pelletier's candidacy was supported by Charles Rappaport of the SFIO and Rodolphe Broda of *Les Documents du progrès*: *L'Humanité*, 23 April 1910, *Le Socialiste*, 17 April 1910.

58 Pelletier, 'Ma Candidature', p. 14.

59 Oddo Deflou, 'Le Bilan féministe des élections', clipping B/a 1651, APP. The figures quoted by Deflou for the count were: in the provinces, Arria Ly 511 (Toulouse), Elisabeth Renaud 2,721 (Vienne); in Paris, Mme [*sic*] Pelletier 349, Mme Kauffmann 150, Mme Maguerie 97 or 92, Mme Marguerite Durand 34. Renaud's remarkable result in the Vienne was due to an energetic campaign fully backed by the Socialist Party, the situation Pelletier had yearned to bring about in Paris. Edouard Le Page, *L'Eclair*, 9 April 1910, Dossier Pelletier, BMD. Sowerwine, *Les Femmes et le socialisme*, pp. 143–4.

60 Sowerwine, *Les Femmes et le socialisme*, pp. 141–2. On Hervé see *Dictionnaire biographique du mouvement ouvrier français*, ed. Maitron, vol. 13, pp. 47–53.

61 DP, p. 41a.

62 Letter to Arria Ly, 22 August 1911 (Série 83 féminisme), FMLB.

63 DP, p. 44a.

64 For accounts of the Couriau Affair see: Sowerwine, *Les Femmes et le socialisme*, pp. 157–60, and 'Workers and women in France 1914: the debate over the Couriau Affair', *Journal of Modern History*, 55, September 1983, pp. 411–41; Hause with Kenney, *Women's Suffrage*, p. 279; Patricia J. Hilden, 'Women and the labour movement in France, 1869–1914', *Historical Journal*, 29(4), 1986, pp. 809–32; Boxer, 'Radical and socialist feminism', pp. 59–60.

65 *L'Equité*, 15 December 1913, press clipping, BMD.

66 In 1912 Pelletier stood in the seventh arrondissement, also a conservative stronghold, and obtained 306 votes. Sowerwine, *Les Femmes et le socialisme*, p. 146; *L'Humanité*, 30 April, 3 May, 5 May 1912; *La Suffragiste*, June 1912.

67 Madeleine Pelletier, *L'Émancipation sexuelle de la femme* (Paris, 1911).

6 Writing and the War

1 Madeleine Pelletier, *L'Émancipation sexuelle de la femme* (Paris, 1911); *Le Droit à l'avortement* (Paris, 1911), second edition, *Pour l'abrogation de l'Article 317* (Paris, 1913); *Philosophie sociale; les opinions, les partis, les classes* (Paris, 1912); *Justice Sociale?* (Paris, 1913); *L'Éducation féministe des filles* (Paris, 1914).

2 Pelletier probably became involved with the neo-Malthusian group, La Ligue de la Régénération Humaine, founded in 1896, thanks to its anarchist, freemasonic and anthropological connections. See Francis Ronsin, *La Grève des ventres: propagande neo-Malthusienne et baisse de la natalité française XIX–XXe siècles* (Paris, 1980), chapter 7. Pelletier's police report for February 1916 confirms some of these interlinkages: 'In the pre-war period ... she gave lectures on neo-Malthusianism, namely at the Libre Discussion of the twentieth arrondissement, at the Groupe Anarchiste Individualiste of the second and twelfth arrondissements, at the Milieu Libre de la Pie, at St. Maur ...' AN F7 13961.

3 Hause, *Hubertine Auclert*, p. 15.

4 Evans, *The Feminists*, pp. 124–5; Zeldin, *France*, vol. 1, p. 343.

5 *L'Émancipation sexuelle de la femme*, p. 5.

6 Ibid., p. 19.

7 The title which Pelletier gave to the second edition referred to Article 317 of the Penal Act of 1810 which decreed penal servitude of five to ten years both for persons performing abortions and for women undergoing abortions. Sentences were rarely imposed however. In 1923, Article 317 was modified and the sentences somewhat reduced. However abortion cases were no longer tried by juries but by judges, who tended to be far less sympathetic. See D. V. Glass, *Population Policies and Movements in Europe* (London, 1967), pp. 158–9, and Zeldin, *France*, vol. 1, p. 359.

8 Sowerwine, 'Femme, médecin, militante', pp. 19–20. Other feminists of the period believed Pelletier carried out abortions. Sowerwine quotes Mme Benoist-Guesde as confirming this opinion. *Les Femmes et le socialisme*, p. 148 n66. In her letters to Ly, Pelletier frequently

defended abortions though she never actually admitted carrying them out.

9 *Le Droit à l'avortement*, see *L'Éducation féministe des filles*, ed. Maignien, p. 124.

10 Ibid., p. 124.

11 Ibid., p. 129.

12 Ronsin, *La Grève des ventres*, pp. 11–25.

13 Jacques Bertillon, *La Dépopulation de la France* (Paris, 1911). The pro-natalists stepped up their rhetoric, especially after the heavy population losses of World War One. See, for example, Louis Boucoiran, *La Famille nombreuse* (Bourg, 1921), or Paul Bureau, *Towards Moral Bankruptcy* (London, 1925), who warned: 'Feminism could . . . reduce our moral disorganisation to the worst extremes', or Ludovic Nadeau, *La France se regarde: le problème de la natalité* (Paris, 1931), who raised the spectre of a France swamped by foreign immigration and left with a dying native population. In the context of the 1930s, pro-natalism was closely allied to xenophobia and nationalism.

14 Paul Robin, *Pain, Loisir, Amour* (Paris, 1907), p. 8. Paul Bureau, in *Towards Moral Bankruptcy*, quotes Pelletier extensively as an example of the worst excesses of anarchism, neo-Malthusianism and feminism, pp. 95, 140–1.

15 Marie Fleming, *The Anarchist Way to Socialism: Élisée Reclus and Nineteenth-Century European Anarchism* (London, 1979), chapter 6, especially p. 231. Reclus felt that neo-Malthusianism was aimed at an elite and would result in integration rather than revolution.

16 Angus McLaren, 'Abortion in France: women and the regulation of family size, 1800–1914', *French Historical Studies*, 10, 1978; Zeldin, *France*, vol. 1, p. 359; Karen Offen, 'Depopulation and feminism in fin-de-siècle France', *American Historical Review*, 89(3), June 1984; Philip E. Ogden and Marie-Monique Huss, 'Demography and pro-natalism in France in the nineteenth and twentieth centuries', *Journal of Historical Geography*, 8(3), 1982, pp. 283–98; John C. Hunter, 'The problem of the French birth-rate on the eve of World War I', *French Historical Studies*, 1962, pp. 490–503. See also Benjamin F. Martin, 'Sex, property and crime in the Third Republic; a statistical introduction', *Historical Reflections/Réflexions Historiques*, 11(3), 1984, pp. 323–49. Table 1, p. 327, shows that the highest crime rates for women were connected with reproductive matters, that is, abortion and infanticide.

17 Jane Rendall, *The Origins of Modern Feminism: Women in Britain, France and the United States, 1780–1860* (London, 1985), p. 17; McLaren, 'Abortion in France', p. 475.

18 Quoted in Ronsin, *La Grève des ventres*, pp. 184–5. The socialists were often suspicious of if not hostile towards neo-Malthusianism. They objected to Malthus's picture of a static world economy and of the poor seen as responsible for their own misery by their reproductive fecklessness. In addition, Guesde, Lafargue and Hervé largely accepted the general pro-natalist thesis about national decline. See Léon Gani, 'Jules Guesde, Paul Lafargue et les problèmes de la population', *Population*, 34(4–5) (July–October, 1979), pp. 1023–43; Alfred Sauvy, 'Les Marxistes et le malthusianisme', *Cahiers internationaux de sociologie*, 41, July–December, 1966, pp. 1–14, and André Armengaud, 'Mouvement Ouvrier et néomalthusianisme au début du XXe siècle', *Annales de Démographie Historique*, 1966, pp. 7–19.

19 Quoted in Ronsin, *La Grève des ventres*, p. 184.

20 Ronsin, from the perspective of the 1980s, suggests like Pelletier that not only were large families the result of ignorance, poverty and alcoholism, they were also the cause. *La Grève des ventres*, p. 22. Another point of view is provided by the pro-natalist Paul Bureau, in *Towards Moral Bankruptcy*, pp. 140–1: 'Therefore the best educated among the neo-Malthusians are now beginning ... to assert that the right of abortion is a natural attribute of the emancipated woman and the corollary of the right of free maternity.' Bureau quotes Pelletier as saying: 'Over our bodies our right is absolute, since it extends even to suicide.'

21 Quoted in Ronsin, *La Grève des ventres*, p. 184.

22 Pelletier, *L'Émancipation sexuelle*, pp. 80–1.

23 Françoise Giroud, *Une Femme honorable* (Paris, 1981), pp. 219–51.

24 Letter to Arria Ly, 13 November 1988, Correspondance Pelletier–Ly, FMLB; also *La Suffragiste*, January 1912, 4e année, no. 24.

25 Steven C. Hause with Anne R. Kenney, in *Women's Suffrage*, chapter 4, analyse the fragmentation of French feminism which duplicated the division of male politics under the Third Republic. In their view, Pelletier was the most advanced and outspoken French feminist before the First World War.

26 Evans, *The Feminists*, pp. 107–8.

27 War Diary, 28 August 1914, Dossier Pelletier, BMD.

28 DP, p. 46a.

29 For a discussion of the effects of the war on socialists and feminists, see Sowerwine, *Les Femmes et le socialisme*, chapter 7.

30 *Le Populaire*, 17 October 1932, quoted in Marilyn J. Boxer, 'Socialism faces feminism: the failure of synthesis in France, 1879–1914', in *Socialist Women*, ed. Boxer and Quatert, p. 93. Elizabeth Renaud (b.1846), from a working-class background, was a teacher, socialist and founder member with Louise Saumoneau of the 'Groupe Fémi-

niste Socialiste', founded in 1899. Renaud supported herself and her two children after her husband's death by running a pension de famille. Sowerwine, *Les Femmes et le socialisme*, pp. 87–92, 141–53 and 262–66.

31 I wish to thank Charles Sowerwine for making both the police report (AN F7 13961) and a full typed transcript of the War Diary from the BMD available to me.

32 DP, pp. 46–7.

33 Letter to Arria Ly, 21 December 1914, Correspondance Pelletier–Ly, FMLB.

34 Ibid.

35 War Diary, p. 2.

36 Ibid. p. 1.

37 Spy mania was attested to by another contemporary observer, the English journalist, G. H. Perris, see *The Campaign of 1914 in France and Belgium* (London, 1915), p. 197.

38 See Sowerwine, 'Femme, médecin, militante', p. 6.

39 Quoted in Perris, *Campaign of 1914*, p. 149.

40 For some contemporary accounts of the battle of the Marne see Perris, *Campaign of 1914*, F. Maurice, *Forty Days in 1914* (London, 1919), F. Feyler, *La Guerre Européenne: Avant-propos stratégique* (Lausanne, 1915).

41 War Diary, pp. 9–10. Her informants were correct about their battle orders emanating from the very government which had retreated to Bordeaux: 'At the moment of the opening of a battle upon which the safety of the country depends, it must be recalled to every man that this is no time to look backwards. All efforts must be made to attack and repel the enemy. A troop which can no longer advance *must at whatever cost, hold the ground won, and let itself be killed on the spot rather than retreat.*' Quoted in Perris, *Campaign of 1914*, pp. 174–5.

42 For a discussion of Luxemburg, Zetkin and Balabanoff's reactions to the war, see Ettinger, *Rosa Luxemburg*, pp. 193–6.

43 Pelletier's police report shows her attending a meeting of the PSU, 10 June 1915, 76 rue Mouffetard, where she defended the international character of socialism. On another occasion, it was alleged, she interrupted a patriotic speaker and walked out. On 22 January 1916 she attended a pacifist meeting at the Café Voltaire. The police spy gave it as his opinion that 'she has decided to take up her militant role and to mix with the contemporary pacifist movement'. AN F7 13961.

44 Letter to Arria Ly, 21 December 1914, Correspondance Pelletier–Ly, FMLB.

45 Letter to Arria Ly, 7 February 1916, Correspondance Pelletier–Ly, FMLB. Ferdinand-Frédéric-Henri Moisson (1852–1907), a pharma-

cist by training, was best known for his work in inorganic chemistry. He succeeded in isolating fluorine and invented an electric furnace, a technological tool of the first order. He received the Nobel Prize for chemistry in 1906. He was noted for the effectiveness of his teaching. Alex Berman, 'Moisson', *Dictionary of Scientific Biography* (New York, 1974), vol. 9, pp. 450–1.

46 Pelletier, *La Femme vierge*, p. 198.

7 The Russian Pilgrimage

1 Letterhead 12 May 1921, 'Docteur Anne Pelletier, Licencié es – sciences, Médecin des Postes et Télégraphes', FMLB. Her appointment was confirmed by the decree of 7 March 1906, to take effect on 21 March 1906: *Notification* 21 March 1906, Dossier Pelletier, Ministère des Postes et Télécommunications. My thanks to Charles Sowerwine for this reference.

2 Letter to Arria Ly, 6 June 1921, FMLB.

3 Letters to Arria Ly, 23 April 1919, 6 June 1921, FMLB.

4 Sowerwine, *Les Femmes et le socialisme*, pp. 148, 271.

5 Letter to Arria Ly, 13 May 1921, FMLB.

6 Ibid.

7 Letters to Arria Ly, ibid. and 6 June 1921, FMLB.

8 Madeleine Pelletier, *Mon Voyage aventureux en Russie communiste* (Paris, 1922). This memoir is a revealing document both personally and historically. But like her unpublished autobiography, 'Doctoresse Pelletier', it suffers from lack of precision. Pelletier posted notes, photographs and diaries back to Berlin from Moscow, none of which arrived. Her account, therefore, rested on unaided memory (p. 199).

9 Ibid., p. 181.

10 Madeleine Pelletier, 'Les Demi-émancipées, *La Suffragiste*, January 1912, 4e année, no. 24.

11 Ibid.

12 Pelletier, *Mon Voyage aventureux*, p. 10.

13 'Le Choc des idées, Makno', *La Fronde*, 29 June 1927.

14 Alexandra Kollontai (1872–1952), initially a bourgeois feminist, became a Marxist theorist and went into exile from 1909 to 1917 in Zurich. She wrote widely on the political, economic and psychological subordination of women. She joined the Bolsheviks in 1915 and was elected to the Central Committee in October 1917. After the revolution, Lenin appointed her as People's Commissar for Public Welfare. Among her best-known works are *The Social Bases of the Woman*

Question (1903), *Communism and the Family* (1918) and *Sexual Relations and the Class Struggle* (1919).

15 Madeleine Pelletier, *Capitalisme et communisme* (Paris, 1922), pp. 2–4.
16 *Mon Voyage aventureux*, p. 208.
17 Ibid., p. 217.
18 *Capitalisme et communisme*, p. 5.
19 Ibid., p. 9.
20 Pelletier can be seen as an example of Gramsci's organic intellectual. For a discussion of this concept and its relevance to feminism see Roger Simon, *Gramsci's Political Thought* (London, 1982), p. 99, and Deirdre David, *Intellectual Women and Victorian Patriarchy* (Ithaca, 1987), p. 5.
21 War Diary, 28 August 1914, BMD.

8 Post-war Political Reaction and Feminist Politics

1 Charles Sowerwine, 'Madeleine Pelletier (1874–1939): Socialism, feminism and psychiatry, or Making it in a man's world', lecture delivered at the University of Bath, 2 November 1987, p. 19. I am grateful to the author for making the text available to me. See also letter to Arria Ly, 13 May 1921, headed 'Médecin des Postes et Télégraphes' as well as subsequent letters, FMLB.
2 Kenney, in 'A militant feminist in France', p. 3 and note 15, lists advertisements by Pelletier in *La Voix des Femmes*, 27 October 1921 and *L'Oeuvre*, 26 June 1922. Sowerwine agrees (ibid.) that socialist women he interviewed were sure Pelletier had regularly performed abortions, but he himself is sceptical that she did so after 1920 because of the increased risk of prosecution.
3 Letter to Arria Ly, 2 November 1911, FMLB.
4 Letter to Arria Ly, 14 February 1933, FMLB.
5 Letter to Arria Ly, 14 September 1931, FMLB.
6 Letters to Arria Ly, 4 January 1926 and 7 May 1932, FMLB; Madeleine Pelletier 'Nos Frères inférieurs, la morale des chiens', *La Fronde*, 5 November, 1926; letter to Eugène Humbert, 30 October 1929, Fonds Sowerwine, IFHS.
7 Letters to Arria Ly, 7 May 1932 and 7 February 1916, FMLB.
8 For Eugène Humbert, see *Dictionnaire Biographique de mouvement ouvrier français*, ed. Maitron vol. 13, pp. 70–1. Four of Pelletier's letters to Humbert are in the Fonds Sowerwine, IFHS. For details of Pelletier's political movements in the 1920s see *Dictionnaire Biographique*, vol. 14, pp. 230–1. See also Madeleine Pelletier, 'La Guerre

est-elle naturelle?', *La Brochure mensuelle*, November 1931, and 'Les Femmes et la Guerre', *L'Éveil des Femmes*, 13 October 1932. In the 1920s, Pelletier belonged to a pacifist freemason group: 'But I must say, I have little faith in it since I saw the freemasons' attitude in 14–18.' Letter to Arria Ly, 7 May 1932, FMLB.

9 DP, p. 49.

10 Hause with Kenney, *Women's Suffrage*, pp. 212–18; McMillan, *Housewife or Harlot*, p. 178.

11 Hause, *Hubertine Auclert*, pp. 202–5.

12 Hause with Kenney, *Women's Suffrage*, p. 243 and table of the vote of the Chamber of Deputies, p. 226.

13 Ibid., p. 237.

14 For an analysis of French republican masculinism see Bidelman, *Pariahs Stand Up!*, chapter 1.

15 McMillan, *Housewife or Harlot*, p. 185; Hause with Kenney, *Women's Suffrage*, p. 281.

16 Letter to Arria Ly, 19 July 1932, FMLB.

17 Sowerwine, *Les Femmes et le socialisme*, p. 148.

18 Letters to Arria Ly, 14 September 1931 and 10 February 1932, FMLB.

19 Letter to Arria Ly, 24 May 1932, FMLB.

20 Bérard quoted by Hause with Kenney, *Women's Suffrage*, p. 238.

21 On the abortion debate see: Monique Bonneau, 'Les Lois de 1920–1923 sur l'avortement', p. 9, Dossier Avortement, BMD; Karen Offen, who argues in 'Depopulation, nationalism and feminism' that in the context of French patriarchal culture, feminists were forced to espouse familial values in order to make any gains; Glass, *Population Policies*, pp. 665–6, 674; Ronsin, *La Grève des ventres*, pp. 140–6.

22 Martin, 'Sex, property and crime', p. 327.

23 Bonneau, 'Les Lois', pp. 9–11; Ronsin, *La Grève des ventres*, p. 145.

24 Glass, *Population Policies*, p. 674.

25 Bonneau, 'Les Lois', p. 11. See McLaren, 'Abortion in France', on the difficulty of gaining accurate information and what he terms 'domestic feminism': the wide recourse to abortion across the social spectrum. McLaren suggests that larger working-class families indicated a need for more wage earners, rather than ignorance of birth-control and abortion techniques. Pelletier's experience of working-class women patients led her to see many women as crippled by their fecundity, whether or not they were consciously producing more wage earners. Madeleine Pelletier, *L'Amour et la maternité* (Paris, n.d.), p. 3. See also Nadeau, *La France se regarde*, p. 7.

26 Bureau, *Towards Moral Bankruptcy*, pp. 140–1; Boucoiran, *La Famille nombreuse*; Nadeau, *La France se regarde*, p. 9; Philip E. Ogden and Marie-Monique Huss, 'Demography and pro-natalism in France

in the nineteenth and twentieth centuries', *Journal of Historical Geography*, 8(3), 1982, pp. 283–98. The Code de la Famille offered comprehensive policies to encourage demographic growth by the system of tax concessions and family allowances, combined with restrictive measures on contraception and abortion.

27 Nadeau, *La France se regarde*, pp. 7–9.

28 Hause with Kenney, in *Women's Suffrage*, remark with reference to the pursuit of women's suffrage: 'Feminists were also divided and their efforts for enfranchisement limited by their involvement in social problems tangential to women's rights', p. 276. This seems to betray a narrow conception of women's rights. Certainly feminists did not see these campaigns as 'tangential'. For example, alcohol abuse or lack of contraceptive facilities directly affected women's lives, whereas the suffrage was a relatively abstract goal. Pelletier's concept of 'integral feminism' involved understanding the linked forces that constituted women's subordination. See also Bonneau, 'Les Lois', p. 12, and Madeleine Pelletier, 'La Guerre est-elle naturelle?'.

29 Bureau, *Towards Moral Bankruptcy*, p. 90.

30 Madeleine Pelletier, *L'Âme existe-t-elle?* (Paris, 1924).

31 Ibid., p. 10.

32 In 1922 Jankelvitch translated Freud's *Introduction to Psychoanalysis* and in 1926 Meyerson's translation of *The Interpretation of Dreams* appeared in French. Regis Hesnard had also published analyses of Freudian ideas in 1912 and 1913. Postel and Quétel, *Nouvelle Histoire*, pp. 463–4, 490–1; Sherry Turkle, *Psychoanalytic Politics: Freud's French Revolution* (London, 1979), pp. 33–5.

33 Madeleine Pelletier's *L'Amour et la maternité* is undated but textual references to Victor Marguerite's *La Garçonne* (Paris, 1922) place it after that date. *La Rationalisation sexuelle* (Paris, 1935).

34 *L'Amour et la maternité*, pp. 5–6, 7, 16.

35 Letter to Arria Ly, July 1932, FMLB.

36 The writing of Freud's which appears relevant to Pelletier's work is: Sigmund Freud, *Introductory Lectures in Psychoanalysis*, first published 1915–17 (Harmondsworth, 1976); *Two Short Accounts of Psychoanalysis*, first published 1910 (Harmondsworth, 1976); 'Female sexuality' (1931), in *On Sexuality* (Harmondsworth, 1977), pp. 367–92.

37 Pelletier, *La Rationalisation sexuelle*, p. 4.

38 Ibid., pp. 4–5.

39 Freud, 'The question of a Weltanshauung', lecture 5, *Introductory Lectures*. For a discussion of the accusation of 'pan-sexuality' against Freud see Richard Wolheim, *Freud* (Glasgow, 1971), who rebuts the charge. For an example of politically conservative reductionism using

Freudian categories, see Bruce Mazlish, ed., *Psychoanalysis and History* (New York, 1963).

40 *La Rationalisation sexuelle*, p. 9.

41 Ibid.

42 Alain Corbin, *Les Filles de noce: misère sexuelle et prostitution* (Paris, 1978); Paul McHugh, *Prostitution and Victorian Social Reform* (London, 1980). Also Evans, *The Feminists*, chapter 4, 'Militants and conservatives', for an analysis of the conservative domestic ideology attaching to feminist social reform issues.

See also the police report, APP B/a 1651, 31 March 1914, about La Ligue Nationale pour le Vote des Femmes on the regulation of prostitution: Doctoresse Anna Delage spoke of 'the sacrifice of one sex to the libertinism of the other. Madeleine Pelletier gave several details of the different sorts of venereal diseases and their contagious nature. She showed the uselessness of sanitary inspections [of prostitutes] as they are practised at the present time.'

43 Madeleine Pelletier, 'De la Prostitution', *L'Anarchie*, 20 November, 1928.

44 Ibid.

45 *L'Ame existe-t-elle?*, p. 4.

46 Letter to Arria Ly, 4 January 1926, FMLB. See 'Doctoresse Pelletier', p. 46/b, on break with Kauffmann.

47 *L'Ame existe-t-elle?*', p. 8.

48 Ibid.

49 AdMP, Dossier Pelletier, BMD; Pelletier, *La Femme vierge*, chapter 2.

50 Letter to Arria Ly, 19 July 1932, FMLB.

51 D. Janicard, *Une Généologie du spiritualisme française: aux sources du bergsonisme* (La Haye, 1969).

52 Madeleine Pelletier, 'La Morale des chiens', *La Fronde*, 5 November 1936.

53 See Madeleine Pelletier, *La Morale et la loi* (Paris, 1926), pp. 14–16.

54 See *L'Assistance: ce qu'elle est, ce qu'elle devrait être* (Paris, n.d.), pp. 13–14.

55 Ibid., p. 15.

56 For the alignment of feminism with liberalism and its later shifts to more conservative ideology, see Evans, *The Feminists*: 'However much the feminists differed from country to country, they all shared a common fate in the inter-war years. Yet the decline of feminism was neither total nor final: nor, despite the confusion and disappointment it engendered in those who fought hardest for it, did enfranchisement signify unambiguous defeat' (p. 239).

9 From Activism to Fiction

1 Pelletier's fiction and plays include: *In Anima vili, ou un crime scientifique*, a play in three acts (1920); *La Femme vierge* (1933); *Supérieur! Drame des classes sociales en cinq actes* (1923); *Trois Contes* (undated); *Une Vie nouvelle* (1932). See the bibliography for places of publication. Pelletier made reference to another novel, 'Jeannette Sage-femme', 'forthcoming', but no record of its publication has been found.

2 Letter to Marguerite Durand, 11 January 1926, Dossier Pelletier, BMD; letter to Arria Ly, 14 November 1928, Fonds Arria Ly, FMLB.

3 Letter to Arria Ly, 21 March 1932, Dossier CP4249, Série 83 féminisme, FMLB.

4 See Letters to Arria Ly, 4 January 1926 and 29 March 1932, ibid.

5 Marilyn Boxer, in 'Radical and socialist feminism', p. 71, remarking on Pelletier's wide reading, lists references to Bachofen, Balzac, Barbusse, Dostoevsky, Flaubert, Fontenelle, Frazer, Freud, Galileo, d'Holbach, Ibsen, William James, Kant, La Boétie, Lamarck, La Rochefoucauld, Jack London, Malthus, J. S. Mill, Molière, Nietzsche, Pascal, Plato, Proudhon, Ricardo, Rostand, Rousseau, de Sade, Spencer, Spinoza, Tolstoy and Voltaire in Pelletier's writing.

6 *L'Enfer* by Henri Barbusse (Paris, 1921) and *La Garçonne* by Victor Marguerite (Paris, 1922) are novels of some topical interest and provided Pelletier with literary models. *L'Enfer* (Hell) took advantage of the new interest in Freudian ideas to offer a voyeuristic description of a wide variety of obsessional sexual behaviour. *La Garçonne* (translated as *The Bachelor Girl*, 1923) described the life of a 'new woman'. It followed the career of an upper middle-class girl who rejected her family background and the double sexual standard and became financially independent as an interior decorator. She asserted her sexual freedom by taking a series of lovers, but discovered that both her commercial and amorous successes were unfulfilling. She eventually met a truly saintly and emancipated man who 'forgave' her for her scandalous past. Though the novel purported to champion equality in sexual mores, it was in the end extremely conventional. The final scenes showed the heroine abasing herself in a kind of masochistic frenzy before her all-wise and forgiving lover. Other contemporary details include a character possibly based on Charles Letourneau, who had written a *History of Social Life* on 'the evolution of the family idea'. The novel also contained references to Freud's *Introduction to Psychoanalysis*.

7 Madeleine Pelletier, 'Le Voyage au bout de la nuit', clipping, Dossier Pelletier, BMD.

8 *Supérieur!*, p. 28.

9 See Pelletier, 'La Fin de Guesdisme' and 'Députés ouvriers', in *La Guerre sociale*, 6 January and 6 October 1909; *Dictionnaire biographique du mouvement ouvrier français*, ed. Maitron, vol. 13.

10 Pelletier, *L'Assistance*, p. 10.

11 Ibid, p. 14.

12 Madeleine Pelletier, *Le Célibat, état supérieur* (Caen, n.d.), p. 6.

13 See, for example, Sandra Gilbert and Susan Gubar's pioneering study in this area, *The Madwoman in the Attic* (Yale, 1979).

14 Pelletier, *L'Assistance*, p. 11.

15 Sowerwine, 'Femme, médecin, militante', p. 5.

16 Paul Lafargue and his wife committed suicide together as he approached his seventieth year. They were buried on 3 December 1911 at Père Lachaise, the occasion for a great international socialist gathering. Vaillant, Guesde, Jaurès, Kautsky, Keir Hardie, Alexandra Kollontai all attended. *Dictionnaire biographique*, vol. 12, p. 170.

17 Karl Liebknecht, a German revolutionary socialist, a member of the Spartacist League, was murdered, like Luxemburg, by soldiers, on 15 January 1919. See Ettinger, *Rosa Luxemburg*, pp. 247–51.

18 See photograph in Ettinger's *Rosa Luxemburg*, p. 241 facing.

19 See for example: Elaine Marks and Isabelle de Courtivron, eds, *New French Feminisms* (Brighton, 1981); Toril Moi, *Sexual/Textual Politics* (London, 1985); Janet Todd, *Feminist Literary History* (Cambridge, 1988).

20 DP, p. 11a.

21 Adrien Timmermans, *L'Argot Parisien* (Paris, 1922), stresses the degree to which argot was the speech not just of the uneducated, but of the criminal classes.

22 'To virilize ... meant ... that feminists had to oppose any measure which treated women differently because of their sex.' Anne R. Kenney, 'A militant feminist in France'.

23 Hause, *Hubertine Auclert*, pp. 126–8.

24 Letters to Arria Ly, 22 August 1911 and 7 November 1913, FMLB.

10 How Militants Die

1 Letter to Arria Ly, 21 March 1932, Dossier CP4249, Série 83 féminisme, FMLB.

2 Monique Bonneau, 'Les Lois de 1920–1923 sur l'avortement'; and see also 'Les Sages-Femmes et la lutte contre l'avortement'. Both in Dossier Avortement, BMD.

3 Letter to Arria Ly, 31 January 1933, Dossier CP4249, Série 83 féminisme, FMLB.

4 Letter to Arria Ly, 4 February 1933, in ibid. Paul Boncour (b. 1873) was a Socialist deputy. He became foreign minister in the Popular Front government.

5 Letter to Arria Ly, 6 February 1933, in ibid.

6 Letter to Arria Ly, 9 February 1933, in ibid.

7 Letter to Arria Ly, 14 February 1933, in ibid.

8 Letter to Arria Ly, 17 March 1933, in ibid.

9 Bureau, *Towards Moral Bankruptcy*, pp. 140–1.

10 Letter from Cécile Brunschwig to Marie-Louise Bouglé, 31 December 1934, Fonds Arria Ly, FMLB.

11 Albistur, 'Catalogue', p. 38, FMLB.

12 Letter to Arria Ly from Marie Paule, 12 June 1934, Fonds Arria Ly, FMLB.

13 Letter to Arria Ly from (R. Goebinger?), 24 July 1934, in ibid.

14 Letter to Marie-Louise Bouglé from C. Brunschwig (n.d.), in ibid. Cécile Brunschwig (1877–1946) led L'Union Française pour la Suffrage des Femmes (UFSF), a moderate republican feminist group, see Hause with Kenney, *Women's Suffrage*, pp. 135–9. Marie-Louise Bouglé (1883–1936), founder of the rich Bouglé archive, was the eleventh child of a bricklayer. Orphaned at fifteen, she became a stenographer typist and out of a monthly salary of 450 francs set aside 360 francs to collect items for her feminist archive. She was also secretary of the domestic servants' union. See Dominique Desanti, *La Femme au temps des années folles* (Paris, 1984), p. 249.

15 Letter to Marie-Louise Bouglé from Anna Lisa Andersson, 20 December 1934, Fonds Arria Ly, FMLB.

16 Letter to Marie-Louise Bouglé from Anna Lisa Andersson, 28 December 1934, in ibid.

17 Letter to Marie-Louise Bouglé from C. Brunschwig, 31 December 1934, in ibid.

18 Letters to Anna Lisa Andersson from Marie-Louise Bouglé, 20 and 29 December 1934, in ibid.

19 In this regard, one may mention the career of Camille Claudel (1864–1943), sculptor, sister of the poet Paul Claudel and student and mistress of Rodin. After her rupture with Rodin, she gradually became a recluse and suffered from persecution mania. When her father died, her surviving relations sent her to the asylum of Ville-Evrard, by *placement volontaire*. Her psychiatric history is revealed in Reine-Marie Paris's study, *Camille Claudel (1864–1943)* (Paris, 1986).

20 Hause, *Hubertine Auclert*, p. 216.

21 Pelletier referred to Ly's death in one of her two letters from Perray-Vaucluse, 5 December 1939, Dossier Pelletier, BMD.

22 Léo Poldès had two plays published and performed: *Le Forum, pièce*

d'actualité en trois actes (Paris, 1921), performed at the Théâtre d'Art Libre, 1920, and the Théâtre Confédéral, 1923; *L'Éternel Ghetto, pièce d'actualité sur la question juive* (Paris, 1928), performed in Paris at the Théâtre du Journal, 9 July 1927, and the Théâtre des Folies-Dramatiques, 1927. He also edited and published *Le Faubourg*, a journal of the proceedings of the club, Paris, 5 rue de Provence, from September 1918–39. Poldès published reviews and articles in *La Guerre sociale*, 11 August and 1 November 1909, 11 and 18 January 1910.

23 Léo Poldès, *Le Club du Faubourg réclame justice* (Paris, n.d. – 1936?), p. 1.

24 Letter to Arria Ly, 8 April 1932, Dossier CP4249, Série 83 féminisme, FMLB. One notes that Pelletier gave as her address here, 47 rue Claude Bernard, not 75bis rue Monge. She may have kept a flat separate from her surgery. Her police file lists rue Monge as her domicile, however.

25 Press clipping, n.d., Dossier Pelletier, BMD.

26 'Le Club des Idées, Makno' *La Fronde*, 29 June 1927, in ibid.

27 Poldès, *Le Club du Faubourg*, p. 2.

28 Ibid., p. 4.

29 Ibid., pp. 15–16.

30 Her novel, 'Jeannette, Sage-femme', advertised as 'forthcoming' in 1935 does not appear in the Bibliothèque Nationale catalogue or in *Livres Imprimés*. It may have fallen foul of the anti-contraception and abortion laws.

31 Letter from Madeleine Pelletier, 18 March 1939, Dossier Pelletier, BMD.

32 For a discussion of the conflict between far-right pressure groups and the left, as well as of the Popular Front and its defeat (1936–9), see McMillan, *Dreyfus to de Gaulle*, pp. 102–8, 114–16, and Hause with Kenney, *Women's Suffrage*, pp. 250–1.

33 Press clipping, 26 April 1939, Dossier Pelletier, BMD.

34 For the psychiatric judgement see *L'Oeuvre*, 6 June 1939. Records at Perray-Vaucluse show that Pelletier was admitted on 2 June 1939. Her dossier at Perray-Vaucluse has not been made available and may have been lost during the war. The dates of her reception at the asylum and of her death are preserved, however. The police archives (APP) also have an entry for Pelletier's arrest, in the April 1939 charge book for the fifth arrondissement. Under the entry closing the case is written, 'Envoyé à un hôpital spécial.' Though shown the entry, I was not allowed to photocopy it or to take notes.

35 Whereas Pelletier's feminist contemporaries do not appear to have doubted the political motivation behind her incarceration at Perray-

Vaucluse, historians have tended implicitly to accept the court's objectivity and competence. Charles Sowerwine in a more recent paper given at the University of Bath on 2 November 1987 has modified the view expressed in *Les Femmes et le socialisme* (1978) that 'she must have seemed strange to the judge, who had her examined and committed to the asylum at Vaucluse', and now suggests a political dimension. Hause with Kenney, in *Women's Suffrage*, pp. 252–3, remark that 'in a tragic echo of the fate of Théroigne de Méricourt', Pelletier 'died in an asylum where she was confined after a court found her mentally unfit to stand trial'. In fact 'the court' (an examining magistrate) found her physically unfit, and subsequently had recourse to the psychiatrist's judgement.

36 Police report, 29 April 1880, B/a 885 (136616) APP.

37 Maïté Albistur, 'Catalogue des Archives Marie-Louise Bouglé', p. 64.

38 Letter to Hélène Brion, 20 July 1939, Dossier Pelletier, BMD.

39 For the gendered analysis of psychiatric disorders see Showalter, *Female Malady*, and Ripa, *Women and Madness*. For the policing role of French psychiatry, see Castel, *The Regulation of Madness*, and Nye, *Crime, Madness and Politics*.

40 Ripa, *La Ronde des folles*, p. 25.

41 'Le Cas de Mlle Verlain', *La Suffragiste*, 4(28), May 1912, pp. 1–2.

42 *La Femme vierge*, pp. 109–10.

43 Madeleine Pelletier, *Les Crimes et les châtiments* (Paris, n.d.), pp. 14–15.

44 McMillan, *Dreyfus to de Gaulle*, pp. 114–15.

45 Gérard Bleandonu and Guy Le Gaufrey, 'The creation of the insane asylums of Auxerre and Paris', in *Deviants and Abandoned in French Society*, ed. Robert Forster and Orest Ranum (Baltimore, 1978), pp. 180–212. I am grateful to Monsieur Martin at the Centre Hospitalier de Perray-Vaucluse for having granted me an interview and shown me round the hospital.

46 Press clipping, June 1939, Dossier Pelletier, BMD.

47 Press clipping, August 1939, in ibid.

48 Pelletier's visiting card, Centre Hospitalier de Perray-Vaucluse, lists the dates of these visits: 29.6.39, 6.7.39, 13.7.39, 23.11.39, 21.12.39. In ibid.

49 See Peter Gay, *The Bourgeois Experience: Victoria to Freud* (Oxford, 1984), pp. 294–327; Brian Harrison, *Separate Spheres: The Opposition to Women's Suffrage in Britain* (London, 1978), pp. 61–8; F. B. Smith, *The People's Health* (London, 1979) – 'Medical doctors, with a few notable exceptions ... determinedly fought the spread of contraception', p. 573; Nye, *Crime, Madness and Politics*, pp. 166–7; Colin Francome, *Abortion Freedom, A Worldwide Movement* (London, 1984), pp. 137–40.

50 Letter to Hélène Brion, 21 September 1939, Dossier Pelletier, BMD. In translating letters, I have altered run-on sentences by inserting punctuation and occasionally expanding a word to make it clearer.

51 AdMP, 23 November 1939, Dossier Pelletier, BMD.

52 AdMP, p. 7. 'Le Chant du Départ', words by Marie-Joseph Chénier, music by E. N. Méhul, was first performed at the Paris Opera, 29 September 1794, and became the second national anthem of France. It expresses republican enthusiasm as in the lines: 'Le peuple souverain s'avance; / Tyrans descendez au cerceuil'; or 'La République nous appelle; / Sachons vaincre ou sachons périr. / Un Français doit vivre pour elle, / Pour elle un Français doit mourir.' In R. P. Jameson, *Chants de France* (London, 1923), pp. 5–8. Pelletier was right that her mother would not have cared for the song.

53 AdMP, p. 7.

54 Dossier Pelletier, BMD.

55 Letter to Hélène Brion from Hamel-Jackov, 29 December 1939, Dossier Pelletier, BMD. For the pressure to conform to Catholic ritual at death see John McManners, *Death and the Enlightenment* (Oxford, 1981), pp. 265–9. The decision to cremate Pelletier, like Arria Ly's cremation of her mother's remains, was a specifically anti-Catholic gesture.

56 AdMP, pp. 4–5.

57 Pelletier, *La Femme vierge*, p. 198.

58 Letter to Hélène Brion from Hamel-Jackov, Dossier Pelletier, BMD.

59 John Stuart Mill, 'On Liberty' (1859), in *Three Essays*, p. 84.

60 DP, p. 46a.

61 Hause with Kenney, *Women's Suffrage*, p. 248.

Epilogue

1 See Bonneau, 'Les Lois', Dossier Avortement, BMD; and Ogden and Huss, 'Demography and pronatalism'. For a discussion of the new moral order under Pétain see McMillan, *Dreyfus to de Gaulle*, pp. 131–5.

2 Ogden and Huss, 'Demography and pronatalism', p. 294.

3 Francis Szpiner, *Une Affaire de Femmes* (Paris, 1986).

4 *Dictionnaire biographique*, ed. Maitron, vol. 13, pp. 70–1.

5 Francis and Gontier, *Simone de Beauvoir*, p. 367. I am grateful to Pam Hirsh for raising the question of the Manifesto of the 343.

6 Francome, *Abortion Freedom*, pp. 137–40; *L'Interruption volontaire de grossesse dans l'Europe des Neuf, 23 October 1971, travaux et documents*, Institut National d'Etudes Démographiques, Cahier 91

(Paris, 1981), pp. 141–7; Charles Hargrove, 'The anguish of archaic abortion laws in France', *The Times*, 15 November 1974.

7 Roger-Gérard Schwartzenberg, 'Liberté et égalité', *Le Monde*, 17 January 1975.

8 Charles Sowerwine's *Les Femmes et le socialisme* in 1978 provided the groundwork for most subsequent research and was the first to highlight Pelletier's importance to both socialism and feminism. Marilyn Boxer and Anna Kenney also published work or delivered papers on Pelletier in 1978.

9 Jeanne Bouvier, *Mes Mémoires: une syndicaliste féministe: 1876–1935, Jeanne Bouvier*, ed. Daniel Armogathe and Maïté Albistur (Paris, 1983), p. 243.

10 Beauvoir, *The Second Sex*, p. 13.

11 Beauvoir, *All Said and Done* (1972) (Harmondsworth, 1987), pp. 479–95.

12 DP, p. 1.

Bibliography

Archival Sources

Archives du Centre Hospitalier de Ville-Evrard
 Dossier Dr Anne, Madeleine Pelletier

Archives de la Faculté de Médecine de Paris, Archives Nationales
 AN AJ16 6932 (Thèse, 1903)
 HS 16 6932

Archives Nationales (AN)
 Police report, F7 13961

Archives de la Préfecture de Police, Paris (APP)
 B/a 1651 (Mouvement féministe)
 B/a 885 (Hubertine Auclert)
 Charge book, 5th Arrondissement, 1907–9
 Charge book, 5th Arrondissement, 1939

Archives de Paris
 V4E 2610: Birth certificate of Anne, later Madeleine, Pelletier

Bibliothèque Marguerite Durand (BMD)
 Dossier Pelletier: includes 19 letters, press clippings and her War
 Diary; and 'Anne dite Madeleine Pelletier', MS in the hand of Hélène
 Brion
 Dossier Avortement

Fawcett Library
 May Billinghurst Dossier

Fonds Marie-Louise Bouglé (FMLB) in the Bibliothèque Historique de la
 Ville de Paris
 Dossier CP4249, Série 83 féminisme
 Dossier Ferdinand Buisson: three letters Pelletier–Buisson
 Dossier Madeleine Pelletier: includes 'Doctoresse Pelletier: Mémoires
 d'une féministe' and correspondence Pelletier–Ly
 Dossier Arria Ly
 Dossier Caroline Kauffmann

Institut Français d'Histoire Sociale (IFHS)
 Fonds Sowerwine: letters Pelletier–Humbert

Ministère des Postes et Télécomunications
 Dossier Pelletier

Published Works of Madeleine (Anne) Pelletier

Admission des femmes dans la Franc-maçonnerie (extract from *L'Acacia:
 Revue des études maçonniques*, May 1905), Paris, n.d.
L'Âme existe-t-elle?, Paris, 1924.
L'Amour et la maternité, Paris, n.d.
L'Assistance: ce qu'elle est, ce qu'elle devrait être, in series *Aujourd'hui et
 demain*, Paris, n.d.
L'Association des idées dans la manie aigüe et dans la débilité mentale,
 Paris, 1903.
'L'Attitude des insurrectionnels', *La Guerre sociale*, 19 January 1910.
Avons-nous des devoirs?, Caen, n.d.
Capitalisme et communisme (1922), Nice, 1926.
Le Célibat, état supérieur, Caen, n.d.
'La classe ouvrière et le féminisme', *La Suffragiste*, July 1912, pp. 1–3.
'Comment préparer la révolution', *La Guerre sociale*, 14 August 1907.
'Contre les radicaux', *La Guerre sociale*, 4 May 1910.
'Contribution expérimentale à l'étude des signes physiques de l'intelli-
 gence', with N. Vaschide, *Comptes Rendus de l'Académie de Science*, 7
 October 1901.
Les Crimes et les châtiments, Paris, n.d.
'Danger du parlementarisme', *La Guerre sociale*, 16 September 1908.
'Défendrons-nous la République?', *La Guerre sociale*, 3 February 1909.
Dépopulation et civilisation, Paris, n.d.
'Députés ouvriers', *La Guerre sociale*, 6 October 1909.
La Désagrégation de la famille, Paris, n.d.
'Déviations', *La Guerre sociale*, 8 December 1907.
Le Droit à l'avortement, Paris, 1911, 2nd edn, *Pour l'abrogation de
 l'article 317*, Editions de 'Malthusien', 1913.

Le Droit au travail pour la femme, see below, *La Guerre est-elle naturelle?*

L'Éducation féministe des filles, Paris, 1914, reprinted with other works and with preface and notes by Claude Maignien, Paris, 1978.

L'Émancipation sexuelle de la femme, Girard et Brière, Paris, 1911.

L'Enseignement et la culture intellectuelle, Paris, n.d.

L'État éducateur, Paris, 1931 (extract from *La Voix des femmes*).

'Être Apache', *La Guerre sociale*, 9 June 1909.

'Étude de la phylogenèse du maxillaire inférieur', *Bulletins de la Société d'Anthropologie de Paris*, 1 May 1902, pp. 537–45.

'Les facteurs sociologiques de la psychologie féminine', *La Revue socialiste*, June 1907, pp. 508–18.

'Faut-il repeupler la France?' *La Guerre sociale*, 16 March 1910.

'Le Féminisme à la Chambre des Députés' (extract from *Les Documents du progrès*, September 1911).

'Féminisme bourgeois et féminisme socialiste', *Le Socialiste*, May 1907, pp. 5–12.

Le Féminisme et la famille, Paris, n.d.

'Le Féminisme et ses militantes', *Documents du progrès*, July 1909, pp. 19–26.

La Femme en lutte pour ses droits, Paris, 1908; first published as 'La Tactique féministe', *La Revue socialiste*, April 1908.

La Femme vierge (a novel), Bresle, Paris, 1933.

'Les Femmes dans la Maçonerie [*sic*]', *L'Acacia*, June 1906, pp. 441–6.

'Les Femmes et le féminisme', *La Revue socialiste*, January 1906, pp. 37–46.

Les Femmes peuvent-elles avoir du génie?, Paris, n.d.

'La Fin du Guesdisme', *La Guerre sociale*, 6 January 1909.

'Folie et choc moral', *Archives de neurologie*, 2e série (20), March 1906, pp. 188–92.

'La Guerre à M. Vautour', *La Guerre sociale*, 20 February 1909.

'La Guerre est-elle naturelle? Le droit au travail pour la femme', *La Brochure mensuelle*, November 1931.

'Guesdisme ou syndicalisme', *La Guerre sociale*, 25 September 1909.

'Guesdistes et insurrectionnels', *La Guerre sociale*, 10 November 1909.

'L'Idéal maçonnique' (extract from *L'Acacia*), Paris, March 1906.

L'Idéologie d'hier. Dieu, la morale, la patrie, Paris, 1910.

In Anima vili, ou un crime scientifique. Pièce en trois actes, A. Lorulot, Conflans-Sainte Honorine, 1920.

'L'Inévitable épuration', *La Guerre sociale*, 30 October 1907.

'Les Institutrices et le movement féministe', *Les Documents du progrès*, May 1910, pp. 437–8.

Justice sociale?, Girard et Brière, Paris, 1913.

'La Leçon des faits', *La Guerre sociale*, 13 May 1908.

Les Lois morbides de l'association des idées, Paris, 1904.

'Ma campagne électorale municipale', *La Suffragiste*, June 1912, pp. 1–3.

'Ma Candidature à la députation' (extract from *Les Documents du progrès*, July 1910).

'Le Mal perforant dans la paralysie générale, par les docteurs Marie et Pelletier', *Revue de psychiatrie et de psychologie expérimentale*, 4e série, 9, 4 November 1905, pp. 469–76.

'En Marge du bloc; le Congrès du Parti Radical', *La Guerre sociale*, 13 October 1909.

'Les Membres fantômes chez les amputés délirants', *Bulletin de l'Institut Général Psychologique*, 5(3), 1905.

Mon Voyage aventureux en Russie communiste, Paris, 1922.

La Morale et la loi, Paris, 1926.

'La Morale et la Lutte pour l'existence', *L'Oeuvre nouvelle*, 3(29), 15 August 1905, pp. 211–28.

'Nos Ainés: Caroline Kauffmann', *La Fronde*, 17 August 1926.

'Par delà Guesde', *La Guerre sociale*, 4 September 1907.

Philosophie sociale: les opinions, les partis, les classes, Girard et Brière, Paris, 1912.

Pour l'abrogation de l'article 317. Le droit à l'avortement, Paris, 1913.

La Prétendue Dégénérescence des hommes de génie, Paris, n.d.

'La Prétendue Infériorité psycho-physiologique des femmes', *La Vie normale*, year 2, no. 10, December 1904, reprinted in *La Revue socialiste*, January 1908, pp. 45–52.

'De la Prostitution', *L'Anarchie*, 20 November 1928.

'La Question du vote des femmes', *La Revue socialiste*, September, October 1908, pp. 193–207, 329–42.

La Rationalisation sexuelle, Paris, 1935.

'Recherches sur les indices pondéraux du crâne et des principaux os longs d'une série de squelettes japonais', *Bulletins de la Société d'Anthropologie de Paris*, 15 November 1900, pp. 514–29.

La Religion contre la civilisation et le progrès, Caen, n.d.

La République portugaise et le vote des femmes (extracts from *Les Documents du progrès*, March 1911).

'Sadisme et masochisme', *La Guerre sociale*, 6 March 1910.

'Le Sérum marin dans la thérapeutique des aliénés', with Dr Marie, *Archives de biothérapie*, May 1905, pp. 49–64.

'Les signes physiques de l'intelligence', with N. Vaschide, *Revue de Philosophie*, 1 October 1903, 1 February 1904.

'Sommes-nous des républicains?', *La Guerre sociale*, 11 August 1909.

'Les Suffragettes et *l'Humanité*', *La Guerre sociale*, 17 November 1909.

La Suffragiste, Directrice Dr Madeleine Pelletier, 1910–19.

Supérieur! Drame des classes sociales en cinq actes, A. Lorulot, Conflans-Sainte Honorine, 1923.

'Sur un nouveau Procédé pour obtenir l'indice cubique du crâne',
Bulletins de la Société d'Anthropologie de Paris, 7 March 1901,
pp. 188–93.

'La Tactique de l'attentat', *La Guerre sociale*, 14 July 1909.

'La Tactique féministe', *La Revue socialiste*, April 1908, pp. 318–33.

Les Tendances actuelles de la maçonnerie, Paris, n.d.

'Le Travail, ce qu'il est et ce qu'il devrait être', *La Brochure mensuelle*, 85,
January 1930.

Trois contes, Imprimérie L. Beresniau, Paris, n.d.

Une Vie nouvelle (a novel), Figuière, Paris, 1932.

Secondary Sources

Albistur, Maïté, 'Catalogue des archives Marie-Louise Bouglé', Bibliothèque Historique de la Ville de Paris.

Albistur, Maïté and Armogathe, Daniel, *Histoire du féminisme français*, 2 vols, Paris, 1977.

Armengaud, André, 'Mouvement ouvrier et néomalthusianisme au début du XXe siècle', *Annales de démographie historique*, 1966, pp. 7–19.

Aron, Jean-Paul (ed.), *Misérable et glorieuse, la femme au XIXe siècle*, Paris, 1980.

Banks, J. A. and Banks, Olive, *Feminism and Family Planning in Victorian England*, Liverpool, 1964.

Barbusse, Henri, *L'Enfer*, Paris, 1921, reprinted 1941.

Baruk, Henri, *La Psychiatrie française de Pinel à nos jours*, Paris, 1967.

Bebel, August, *Women under Socialism*, trans. Daniel De Leon, New York, 1904, reprinted 1970.

Becker, George, *The Mad Genius Controversy*, London, 1978.

Beecher, Jonathan and Bienvenue, Richard, *The Utopian Vision of Charles Fourier*, London, 1972.

Beer, Gillian, *Darwin's Plots: Evolutionary Narrative in Darwin, George Eliot and Nineteenth-century Fiction*, London, 1983.

Bergson, Henri, *Les Données immédiates de la conscience*, Paris, 1901.

Bernard, Phillipe, 'Durkheim et les femmes ou *Le Suicide* inachevé', *Revue française de sociologie*, 14(1), 1973, pp. 27–61.

Bernheimer, Charles and Kahane, Claire (eds), *In Dora's Case: Freud, Hysteria, Feminism*, London, 1985.

Bertheaume, Marthe, *Les Femmes médecins*, Paris, 1923.

Bertillon, Jacques, *La Dépopulation de la France*, Paris, 1911.

Bidelman, Patrick, *Pariahs Stand Up! The Founding of the Liberal Feminist Movement in France, 1858–1889*, London, 1982.

Bleandonu, Gérard and Le Gaufrey, Guy, 'The creation of the insane asylums of Auxerre and Paris', in Robert Forster and Orest Ranum

(eds), *Deviants and Abandoned in French Society*, Baltimore, 1978.

Boucoiran, Louis, *La Famille nombreuse*, Bourg, 1921.

Boxer, Marilyn, 'When radical and socialist feminism were joined: the extraordinary failure of Madeleine Pelletier', in Jane Slaughter and Robert Kern (eds), *European Women of the Left: Socialism, Feminism and the Problems faced by Political Women, 1880 to the Present*, London and Westport, Conn., 1981, pp. 51–74.

Boxer, Marilyn and Quataert, Jean (eds), *Socialist Women: European Socialist Feminism in the Nineteenth and Early Twentieth Centuries*, Oxford and New York, 1978.

Branca, Patricia, *Women in Europe since 1750*, London, 1978.

Brault, Elaine, *La Franc-maçonnerie et l'émancipation des femmes*, Paris, 1953.

Brion, Hélène, 'L'Encyclopédie féministe', BMD.

——*La Voie féministe*, ed. Huguette Bouchardeau, Paris, n.d.

Bureau, Paul, *Towards Moral Bankruptcy (L'Indiscipline des Moeurs)*, London, 1925.

Castel, Robert, *L'Ordre psychiatrique*, Paris, 1976; trans. as *The Regulation of Madness*, Cambridge, 1988.

Castel, Robert, Castel, Françoise and Lovell, Anne, *The Psychiatric Society*, trans. Arthur Goldhammer, New York, 1982.

Charrier, Edmée, *L'Évolution intellectuelle féminine*, Paris, 1937.

Clark, Frances, *The Position of Women in Contemporary France*, London, 1937.

Clark, Linda L., 'The primary education of French girls: pedagogical prescriptions and social realities, 1880–1914', *History of Education Quarterly*, 21, 1981, pp. 411–28.

Cobb, R. C., *The Police and the People*, Oxford, 1970.

Cohen, Stanley and Scull, Andrew (eds), *Social Control and the State*, Oxford, 1983.

Conry, Yvette, *L'Introduction du Darwinisme en France au XIXe siècle*, Paris, 1974.

Corbin, Alain, *Les Filles de noce: misère sexuelle et prostitution, 19e et 20e siècles*, Paris, 1978.

Crossich, G. and Haupt, H. G., *Shopkeepers and Master Artisans in Nineteenth-century Europe*, London and New York, 1984.

Darwin, Charles, *The Illustrated Origin of Species*, ed. Richard E. Leakey, London, 1979.

——*The Origin of Species*, ed. J. W. Burrow, Harmondsworth, 1959.

David, Deirdre, *Intellectual Women and Victorian Patriarchy*, Ithaca, 1987.

Decaux, Alain, *Histoire des françaises*, 2 vols, Paris, 1972.

Dictionnaire biographique du mouvement ouvrier français, ed. Jean Maitron, Paris, 1976.

Duffin, Lorna, 'The conspicuous consumptive: woman as an invalid', in Sarah Delamont and Lorna Duffin (eds), *The Nineteenth-century Woman*, London, 1978.

Dupanloup. M., *La Femme studieuse*, Paris, 1869.

Dupeux, Georges, *French Society 1789–1970*, trans. Peter Wait, London, 1972.

L'Espérance, Jean, 'Doctors and women in nineteenth-century society: sexuality and role', in J. Woodward and D. Richards (eds), *Health Care and Popular Medicine in Nineteenth-Century England*, London, 1977, pp. 105–23.

Ettinger, Elzbieta, *Rosa Luxemburg: A Life*, London, 1987.

Evans, Richard J., *Comrades and Sisters*, Brighton, 1987.

——'Feminism and anticlericalism in France, 1870–1922', *Historical Journal*, 25, 1982, pp. 947–9.

——*The Feminists*, London, 1977.

Farber, Eduard, *Great Chemists*, New York, 1961.

Fee, Elizabeth, 'Nineteenth-century craniology: the study of the female skull', *Bulletin of the History of Medicine*, 53, 1979, pp. 413–33.

——'The sexual politics of Victorian social anthropology', *Feminist Studies*, 1(3–4), 1973, pp. 23–39.

Feyler, F. *La Guerre européenne, avant-propos stratégique*, Lausanne, 1915.

Fleming, Marie, *The Anarchist Way to Socialism: Elisée Reclus and Nineteenth-century European Anarchism*, London, 1979.

Forestier, René, *La Franc-Maçonnerie templière et occultiste au 18e et 19e siècles*, Paris, 1970.

Foucault, Michel, *Les Machines à guerir*, Paris, 1977.

——*Madness and Civilisation* (1961), trans. Richard Howard, London, 1965.

——*Naissance de la clinique*, Paris, 1963.

Fourier, Charles, *Design for Utopia*, ed. Frank E. Manuel, New York, 1971.

Fox, Robert and Weisz, George (eds), *The Organization of Science and Technology in France, 1808–1914*, Cambridge, 1980.

Francis, C. and Gontier, F., *Simone de Beauvoir*, Paris, 1985.

Francome, Colin, *Abortion Freedom, A Worldwide Movement*, London, 1984.

Freud, Sigmund, *Introductory Lectures in Psychoanalysis* (1915–17), Harmondsworth, 1976.

——*On Sexuality*, Harmondsworth, 1977.

Galignani, *New Paris Guide for 1873*, Paris, 1873.

Gani, Léon, 'Jules Guesde, Paul Lafargue et les problèmes de population', *Population*, 34(4–5), 1979, pp. 1023–43.

Gay, Peter, *The Bourgeois Experience: Victoria to Freud*, Oxford, 1984.

Giroud, Françoise, *Une Femme honorable*, Paris, 1981.

Glass, D. V., *Population Policies and Movements in Europe*, London, 1967.

Goldstein, Jan, *Console and Classify: The French Psychiatric Profession in the Nineteenth Century*, Cambridge, 1987.

Gould, Stephen Jay, *The Mismeasure of Man*, London, 1981.

Harrison, Brian, *Separate Spheres: The Opposition to Women's Suffrage in Britain*, London, 1978.

Hause, Steven, C., *Hubertine Auclert: The French Suffragette*, New Haven, 1987.

——'Women who rallied to the Tricolor: the effects of World War I on the French women's suffrage movement', *Proceedings of the Annual Meeting of The Western Society for French History*, 6, 1978, pp. 371–81.

Hause Steven C. with Kenney, Anne R., 'The limits of suffragist behaviour: legalism and militancy in France, 1876–1922', *American Historical Review*, 86(4), October 1981.

——'Women's suffrage and the Paris elections of 1908', *Laurels*, 51(1), 1980.

——*Women's Suffrage and Social Politics in the French Third Republic*, Princeton, 1984.

Heyer, Paul, *Nature, Human Nature and Society: Marx, Darwin, Biology and the Human Sciences*, London, 1982.

Hilden, Patricia J., 'Women and the labour movement in France, 1869–1914', *Historical Journal*, 29(4), 1986, pp. 809–32.

Horvath, Sandra Ann, 'Victor Duruy and the controversy over secondary education for girls', *French Historical Studies*, 9(1), 1975, pp. 83–104.

Hunter, John C., 'The problem of the French birth rate on the eve of World War I', *French Historical Studies*, 1962, pp. 490–503.

Jacob, Margaret, *The Radical Enlightenment: Pantheists, Freemasons, and Republicans*, London and New York, 1981.

James, William, *The Principles of Psychology* (1891), London, 1952.

Janet, Pierre, *Les Obsessions et la psychasténie*, Paris, 1903.

Kasl, Ronda, 'Edouard Manet's "Rue Mosnier": le Pauvre a-t-il une patrie?', *Art Journal*, spring 1985, pp. 49–58.

Kenney, Anne R., 'A militant feminist in France: Dr. Madeleine Pelletier, her ideas and actions', paper read to the Berkshire Conference on the History of Women, Mount Holyoke College, August 1978. Copies deposited at the Schlesinger Library and Mount Holyoke Archives.

Kent, Christopher, *Brains and Numbers*, Toronto, 1978.

Keohane, N. O. (ed.), *Feminist Theory*, Brighton, 1981.

Kiernan, V. G., *The Duel in European History*, Oxford, 1988.

Krafft-Ebing, R. von, *An Experimental Study in the Domain of Hypnotism*, New York, 1889.

Krop, Pascal, *Les Socialistes et l'armée*, Paris, 1983.

Lafargue, Paul, *The Evolution of Property from Savagery to Civilisation* (1890), n.d., reprinted London, 1975.

Lasswell, Harold, D., *Psychopathology and Politics*, Chicago, 1930.

Lee, Alice, Lewenz, Marie A. and Pearson Karl, 'On the correlation of mental and physical characters in man; part II', *Proceedings of The Royal Society of London*, 71, June 1903, pp. 106–14.

Legrain, Paul-Maurice, 'L'Anthropologie criminelle au Congrès de Bruxelles de 1892', *La Revue scientifique*, October 1892, pp. 487–97.

Letourneau, Charles, *The Evolution of Marriage*, London, 1891.

——*Property, its Origin and Development*, London, 1892.

Lombroso, Cesare, *The Man of Genius*, London, 1891.

Machelon, Jean-Pierre, *La République contre les libertés*, Paris, 1976.

McHugh, Paul, *Prostitution and Victorian Social Reform*, London, 1980.

McKeown, Thomas, *The Role of Medicine: Dream, Mirage or Nemesis*, Oxford, 1979.

McLaren, Angus, 'Abortion in France: women and the regulation of family size: 1800–1914', *French Historical Studies*, 10, 1978.

——'Sex and socialism: the opposition of the French Left to birth control in the Nineteenth Century', *Journal of the History of Ideas*, 37, 1976.

McManners, John, *Death and the Enlightenment*, Oxford, 1981.

McMillan, James, F., 'Clericals, anticlericals and the women's movement in France under the Third Republic', *Historical Journal*, 24, 1981, pp. 361–76.

——*Dreyfus to de Gaulle*, London, 1985.

——*Housewife or Harlot, The Place of Women in French Society, 1870–1940*, London, 1981.

——'Politics and religion in modern France', *Historical Journal*, 25(4), 1982, pp. 1021–7.

Maignien, Claude (ed.), *L'Education féministe des filles* by Madeleine Pelletier (including also 'Le Droit à l'Avortement', 'La Tactique féministe' and 'Le Droit au Travail'), Paris, 1978.

Marguerite, Victor, *La Garçonne*, Paris, 1922.

Martin, Benjamin F., 'Sex, property and crime in the Third Republic: a statistical introduction', *Historical Reflections/Réflexions Historiques*, 11(3), 1984, pp. 323–49.

Maurice, F., *Forty Days in 1914*, London, 1919.

Mayeur, Françoise, '*L'Éducation des filles en France au XIXe siècle*, Paris, 1979.

Mazlish, Bruce (ed.), *Psychoanalysis and History*, New York, 1963.

Mill, John Stuart, *An Examination of Sir William Hamilton's Philosophy*, London, 1865 translated into French by E. Cazelles, Paris, 1869.

——*Three Essays: On Liberty, Utilitarianism and The Subjection of Women*, reprinted Oxford, 1975.

Miller, David, *Anarchism*, London, 1984.

Moberly-Bell, E., *Storming The Citadel: The Rise of the Woman Doctor*, London, 1953.

Mullaney, Marie Marmo, 'Gender and the socialist revolutionary role, 1871–1921: a general theory of the female revolutionary personality', *Historical Reflections/Réflexions Historiques*, 11, 1984, pp. 99–151.

Nadeau, Ludovic, *La France se regarde: le problème de la natalité*, Paris, 1931.

Niceforo, Alfredo, *Les Classes pauvres*, Paris, 1905.

——*Le Profil graphique des individus et des groupes: normalité et anormalité*, Paris, 1937.

Nye, Robert, *Crime, Madness and Politics in Modern France: The Medical Concept of National Decline*, Princeton, 1984.

——*The Origins of Crowd Psychology: Gustave LeBon and the Crisis of Mass Democracy in the Third Republic*, London, 1975.

Nyström, Anton, *La Vie sexuelle et ses lois*, Paris, 1910.

Offen, Karen, 'Depopulation, nationalism and feminism in fin-de-siècle France', *American Historical Review*, 89(3), June 1984.

Ogden, Philip E. and Huss, Marie-Monique, 'Demography and pronatalism in France in the nineteenth and twentieth centuries', *Journal of Historical Geography*, 8(3), 1982, pp. 283–98.

Papayanis, Nicholas, 'La Prolétarisation des cochers de fiacres à Paris (1878–1889)', *Le Mouvement social*, 132, July–September 1985), pp. 59–82.

Pearson, Karl, 'On the correlation of intellectual ability with the size and shape of the head', *Proceedings of The Royal Society of London*, 69, 1902, pp. 333–42.

Perris, G. H., *The Campaign of 1914 in France and Belgium*, London, 1915.

Perrot, Michelle, 'Delinquency and the penitentiary system in nineteenth-century France', in Forster, R. and Ranum, O. (eds), *Deviants and Abandoned in French Society*, Baltimore, 1978.

Pilkington, A. E., *Bergson and his Influence*, Cambridge, 1974.

Poldès, Léo, *Le Club du Faubourg réclame justice*, Paris, n.d.

Postel, Jacques and Quétel, Claude, *Nouvelle histoire de la psychiatrie*, Paris, 1983.

Reclus, Élisée, *L'Évolution, la révolution et l'idéal anarchique*, Paris, 1898.

Rée, Jonathan, *Proletarian Philosophers*, Oxford, 1984.

Rendall, Jane, *The Origins of Modern Feminism: Women in Britain, France and The United States, 1780–1860*, London, 1985.

Ripa, Yannick, *La Ronde des folles: femme, folie et enfermement au XIXe siècle (1838–1870)*, Paris, 1986; translated as *Women and Madness*, Cambridge, 1990.

Roberts, J. M., *The Mythology of Secret Societies*, London, 1972.

Robertson, Priscilla, *An Experience of Women*, Philadelphia, 1982.

Robin, Paul, *Pain, loisir, amour*, Paris, 1907.

Ronsin, Francis, *La Grève des ventres: propagande néo-malthusienne et baisse de la natalité française (XIX–XXe siècles)*, Paris, 1980.

Rosen, Andrew, *Rise up Women*, London, 1974.

Rosen, George, 'The philosophy of ideology and the emergence of modern medicine in France', *Bulletin of the History of Medicine*, 20, 1946, pp. 328–39.

Roux, Aline, 'Contribution de la féminisation de la profession médicale', *Collection de Médecine Légale et de Toxologie Médicale*, 80, 1975.

Rylance, Rick, 'Vital intersections: G. H. Lewes and the meeting of physiology and philosophy in the 1860's', *Ideas and Production*, 7, 1987.

Sauvy, Alfred, 'Les Marxistes et le malthusianisme', *Cahiers Internationaux de Sociologie*, 41, 1966, pp. 1–14.

Schultze, Caroline, *La Femme-médecin au XIXe siècle*, Paris, 1888.

Scull, Andrew, 'From madness to mental illness: medical men as moral entrepreneurs', *Archives Européennes de Sociologie*, 16(2), 1975, pp. 218–61.

——*Museums of Madness*, London, 1979.

——*Social Control and the State*, London, 1983.

Seitz, William C., *Claude Monet*, New York, 1960.

Shorter, Edward, *A History of Women's Bodies*, London, 1982.

Showalter, Elaine, *The Female Malady: Women, Madness and English Culture, 1830–1980*, New York, 1985.

Simon, Roger, *Gramsci's Political Thought*, London, 1982.

Smith, Bonnie, *Ladies of the Leisure Class*, Princeton, 1981.

Smith, F. B., *The People's Health*, London, 1979.

Sohn, A. M., 'La Garçonne' in *Le Mouvement Social*, 80, 1972.

Sonn, Richard, D., 'Language, crime and class: the popular culture of French anarchism in the 1890's', *Historical Reflections/Réflexions Historiques*, 11(3), 1984, pp. 351–72.

Sowerwine, Charles, *Les Femmes et le socialisme*, Paris, 1978. (See *Sisters or Citizens*.)

——'Madeleine Pelletier (1874–1939): femme, médecin, militante', *L'Information Psychiatrique*, 9, November 1988.

——'Madeleine Pelletier (1874–1939): socialism, feminism and psychiatry, or Making it in a man's world', lecture, University of Bath, 2 November 1987.

——'The organisation of French socialist women 1880–1914: a European perspective for women's movements', *Historical Reflections/Réflexions Historiques*, 3(2), 1976, pp. 3–24.

——*Sisters or Citizens: Women and Socialism in France since 1876*, trans.

of *Les Femmes et le socialisme*, Cambridge, 1982.

——'Socialism, feminism, and violence: the analysis of Madeleine Pelletier', *Proceedings of the Annual Meeting of the Western Society for French History*, 8, 1980.

——'Workers and women in France 1914: the debate over the Couriau Affair', *Journal of Modern History*, 55, September 1983, pp. 411–41.

Spencer, Herbert, *The Principles of Psychology* (1855), London, 1890.

Spender, Dale, *Man-Made Language*, London, 1980.

Stites, Richard, *The Women's Liberation Movement in Russia: Nihilism, Feminism and Bolshevism, 1860–1930*, London, 1978.

Sullerot, Evelyne, *La Presse féminine*, Paris, 1963.

Tilly, Charles (ed.), *Historical Studies of Changing Fertility*, London, 1978.

Tilly, Louise A. and Tilly, Charles (eds), *Class Conflict and Collective Action*, Beverly Hills, 1981.

Todd, Janet, *Feminist Literary History*, Cambridge, 1988.

Toulouse, Edouard, *Émile Zola*, Paris, 1896.

——*Henri Poincaré*, Paris, 1910.

Turgeon, Charles, *Féminisme français*, Paris, 1907.

Turkle, Sherry, *Psychoanalytic Politics: Freud's French Revolution*, London, 1979.

Uglow, Jennifer S. and Hinton, Frances, *The Macmillan Dictionary of Women's Biography*, Bodmin, 1982.

Wiltshire, David, *The Social and Political Thought of Herbert Spencer*, Oxford, 1978.

Wolheim, Richard, *Freud*, Glasgow, 1971.

Wright, Dudley, *Gould's History of Freemasonry*, vol. 4, London, 1925.

——*Women and Freemasonry*, London, 1922.

Young, Robert M., *Mind, Brain and Adaptation in the Nineteenth Century*, Oxford, 1970.

Zeldin, Theodore, *France 1848–1945*: vol. 1, *Ambition, Love and Politics*, Oxford, 1973; vol. 2, *Intellect, Taste and Anxiety*, Oxford, 1977.

Index

abortion, 134–6, 140, 172–4, 179–80, 181, 213–14, 233, 236, 237
Acacia, L', 43
adultery, 133
anarchism, 21, 133, 135–6, 154, 164
Andersson, Anna, 217
animals, 189–90
Anthropological Society of Paris, 32–3, 34
anthropology
 psychiatric practice influenced by, 60
 see also School of Anthropology
Assistance, L', 200, 203
association, laws of, 65–7
asylums
 in nineteenth-century France, 58–61, 223
Auclert, Hubertine, 5, 83, 84–6, 95–6, 101, 132, 210, 218
Ayr asylum, 61

Balabanoff, Angelica, 150, 151
Barcy, 148
Beauvoir, Simone de, 5, 76, 122–3, 237, 239, 240
Benedict XV, Pope, 176

Bérard Report, 176–7
Bergson, Henri, 67
Bernard, Claude, 30
Bertheaume, Marthe, 31
Berthelot, Marcellin Pierre Eugène, 4
Berthelot, Sophie, 4
Bidelman, Patrick, 20
Billinghurst, R. M., 97, 98, 99
birth control, 15, 118, 132, 136, 179, 237
birth-rate, French, 135–6, 178, *see also* abortion; pro-natalism; neo-Malthusianism
Blackwell, Elizabeth, 27
Blum, Léon, 221
Bouglé, Marie-Louise, 5, 216, 217
bourgeois feminists, 78, 112–13
Bouvier, Jeanne, 239
Boxer, Marilyn, 25
Brès, Madeleine, 27
Brion, Hélène, 5, 92, 140, 175, 222
Britain, 76, 97–100
Broca, Paul, 32, 33, 72
Brunschwig, Cécile, 217
Buisson, Ferdinand, 100
Buisson Report, 176

Bureau, Paul, 180–1, 215
Butler, Josephine, 186

Catholicism, 10–12, 76, 77, 78
Céline, Louis Ferdinand, 194
Chamber of Deputies
 and women's suffrage campaign,
 109–11
Charcot, Jean-Martin, 60, 65
Chernyshevsky, Nikolai, 201
Citoyenne, La, 85
Club du Faubourg, 175, 218–20
Cochin, Denys, 125
Combat féministe, Le, 89
Commune, 77
Communist Party, 154, 177
Conféderation Generale du
 Travail, 92
Conseil de Surveillance de
 l'Assistance Publique, 51
Conseil International des Femmes,
 138
contraception, *see* birth control
Couriau, Emma, 128–9
craniometry, 35–40, 74, 76
criminality, theories of, 45
Curie, Marie, 138–9

Darwin, Charles, 33
degeneracy theory, 45, 46
Deneuve, Catherine, 237
Desraismes, Maria, 42, 84
Devise, Paul, 236
Dickens, Charles, 159
dress, 18–19, 121–4
Droit des Femmes, Le, 84
Dubuisson, Paul, 62, 70
duelling, 16
Dupont, Louise Beverley, *see*
 Remember, Madame
Durand, Marguerite, 5, 18, 83, 114,
 127, 129, 142, 153
Duruy, Victor, 26, 28

Éclair, L', 127
education, 26, 122–3
electoral activity, 100–2, 125–8
'elephant problem', 36
Equité, L', 129
essentialism, 68
evolution, theory of, 33

family, the, 133
Fawcett, Millicent, 97
Federal Congress of the Seine, 111
Fédération Française des Sociétés
 Féministes, La, 82
fencing, 16–17
freemasonry, 41–4
French League for Women's
 Rights, 79
French Revolution, 97, 168–9
Freud, Sigmund, 122, 182–7
Fronde, La, 18, 51, 54, 56, 57, 84,
 127, 129

Garrett, Elizabeth, 27
Gaulle, Charles de, 6
genius, theories of, 44–8
Germany
 Federation of German Women's
 Associations, 139
 Social Democratic Party (SPD),
 112–13
Gide, André, 235
Gif-sur-Yvette, 174
Giraud, Marie Louise, 236
Gondon, Louise, *see* Ly, Arria, 88
Groupe des Femmes Socialistes, 92
Groupe Féministe Socialiste (GFS),
 82
Groupe Français d'Etudes
 Féministes, 86
Guerre sociale, La, 102, 114, 115,
 116, 218
Guesde, Jules, 105
Guesdistes, 105, 107, 114, 116

Hamel-Jackov, A., 230
Hause, Steven, 132
Hervé, Gustave, 114, 115, 120, 124, 128, 136–7, 197
Hervéistes, 111, 114–15, 120, 121, 126, 128
Humanité, L', 119
Humbert, Eugène, 175, 236
Humbert, Jeanne, 175
Hyde Park
 suffrage rally in, 97–8

infanticide, 179
International Congress on the Condition and Rights of Women (1900), 78

Jaurès, Jean, 96, 109, 111, 115, 120
Jaurèsians, 107, 108, 114
Joffroy, Alix, 29, 54, 69

Kauffmann, Caroline, 5, 81, 82, 83, 84, 86, 87, 95, 96, 97, 108, 109, 150, 187, 194, 218
Kenney, Anne R., 7
Kollontai, Alexandra, 165, 166

Lacan, Jacques, 109, 209
Lafargue, Laura, 113
Lafargue, Paul, 105
Laloë, Jeanne, 5, 100, 102–3, 125
Lamarck, Jean Baptiste de Monet, Chevalier de, 33
Le Bon, Gustave, 33–4, 68, 92
Lee, Alice, 39
Legrain, Paul-Maurice, 44, 45, 62
Letourneau, Charles, 32, 34–5, 72
Lewenz, Marie, 39
Libertaire, Le, 154
Ligue Féminine de l'Éducation Physique, La, 86
Lombroso, Cesare, 44, 46
Longuet, Jean, 140

Lutte féministe, La, 92
Luxemburg, Rosa, 9, 112, 115, 150, 151
Ly, Arria, 5, 15, 18, 84, 86, 87–91, 93–4, 134, 153, 154, 172–3, 177, 193, 214, 215–17, 223–4, 234

Manouvrieur, Léonce, 34, 35, 72
Marne, Battle of the, 145, 147
Marx, Karl, 35, 106
masochism, 118, 183
maternity, 138
Meaux, 147
medical schools, 27–8
Meslier, Adrian, 96, 108
Michel, Louise, 5, 21–2, 44, 75, 77, 83, 128, 151, 224
Mill, J. S., 47, 66–7, 68, 232
Minke, Paule, 77
Monde, Le, 238
Monet, Claude, 2
Moreau, Jeanne, 237
Mundia, 175
Musée Social
 suffrage rally at, 95–6

Nadeau, Ludovic, 180
Napoleon Bonaparte, 2
Napoleonic Code, 27, 85, 86, 133
neo-Malthusianism, 115, 116, 134–7, 178–82, 236
Nietzsche, Friedrich, 46, 48
Nouvel Observateur, 237

Oddo-Deflou, Jeanne, 5, 86, 127–8

Panthéon, 3–4
Parent, Victor, 61
Partie Socialiste Unifié, 154
Pascal, Constance, 57, 70–1
paternity law, 86
Pearson, Karl, 38, 39, 70

Pelletier, Anne (*née* de Passavy, Madeleine's mother), 8–13
Pelletier, Louis (Madeleine's father), 8, 9, 10
Pelletier, Madeleine
 and abortion, 172–4, 214–15, 221–2, 233
 and anarchism, 21, 94
 anthropological studies, 31–41
 arrest under abortion law, 221–2
 articles in *La Guerre Sociale*, 115–19
 attitude to: animals, 189–90; communism, 169; families, 235; marriage, 20; maternity, 235; religion, 230–2; revolution, 120–1, 169–70; terrorism, 115, 119; working class, 9, 233
 baccalauréat taken by, 25–7
 barred from Internship for Insane Asylums examination, 54–7
 on bourgeoisie, 117
 celibacy, 20, 91, 138
 childhood, 8–13, 228–9
 on class, 107
 class affiliation, 170–1
 and Commission Administrative Permanente (CAP), 120, 124, 128
 death, 230
 dress, 17–19, 121–2, 155
 early political activity, 15–23
 on education of girls, 122–3
 electoral activity, 100–2, 125–8
 elitism of, 137–8, 233
 in England, 97–8
 enrols at Sorbonne to read natural sciences, 151
 enrols with Red Cross, 142
 fails examination for post of asylum doctor, 69–71

 fictional writing, 192–212
 and Freudian theory, 182–7
 funeral, 232
 and German socialism, 112–13
 income, 132
 letters to Brion from Perray-Vaucluse asylum, 228, 229–30
 medical practice in 1920s and 1930s, 172–3
 medical studies, 27–31
 Moscow journey, 154–68
 pacifism, 92
 in Perray-Vaucluse insane asylum, 222–30
 popular language used by, 93–4
 primary education, 13
 prose style, 210–11
 as psychiatric intern, 62–4
 psychiatric research, 64–8
 psychiatric studies, 53–4
 puberty, 13–15
 reopens surgery after World War I, 153
 and revolutionary socialism, 115–25, 154–5, 162
 on sexual emancipation of women, 133
 sexual orientation, 211
 and socialism, 104–31, 234
 stroke suffered by, 220
 and suffrage movement, 95–100, 108–11
 tries to join ambulance corps, 141–2
 and violence, 118–19
 in World War I, 140–52
Pelletier, Madeleine: works
 L'Amour et la maternité, 182
 'Anne dite Madeleine Pelletier' (memoir dictated to Hélène Brion), 228–9, 231
 L'Association des idées, 64–7, 73
 'Doctoresse' Pelletier', 81, 102

'L'Écho de la pensée et la parole interieur', 67–8
'*L'Éducation féministe des filles*, 122–3
L'Émancipation sexuelle de la femme, 130–1, 133, 134, 166
'L'enfant', 198–9
'Être Apache', 117
'Faut-il repeupler la France?', 118
'Le Féminisme et ses militantes', 120–1
Les femmes, peuvent-elles avoir du génie?, 45–6, 47
La Femme vierge, 9–10, 14, 17, 152
'La Génie et la femme', 45, 47
In Anima vili, 190, 195
'Les membres fantômes chez les amputés délirants', 67, 68
Mon voyage aventureux en Russie communiste, 154
'La Mort aux chats', 199–201
Pour l'abrogation de l'article 317. Le droit à l'avortement, 134, 179, 181
La Prétendue Dégénérescence des hommes de génie, 45, 46–7
'La Prétendue Inferiorité psycho-physiologique des femmes', 71–3
'La Question du vote des femmes', 40, 97
La Rationalisation sexuelle, 182, 183–4, 219–20
'Sadisme et Masochisme', 118, 182
'Les Suffragistes et *L'Humanité*', 118–19
Supérieur!, 117, 195
'La Tactique de l'attentat', 119
'La Tactique féministe', 75–6, 116, 118

'Un Traître', 195–8
Trois Contes, 195–200
Une vie nouvelle, 30, 73, 171, 193, 201–6
War Diary, 140–52
Perray-Vaucluse asylum, 222–30
Pognon, Marie, 5, 79
Poldès, Léo, 195, 218–20
police surveillance, 83–4
Popular Front, 221
positivism, 188, 189
Potonie-Pierre, Eugénie, 5, 82
prejudice, 71–3
Prolétaire, Le, 85
pro-natalism, 178–81, 225, 227, 236
prostitution, 186–7
Proust, Marcel, 18
psychiatric hospitals, *see* asylums
psychiatry
 French, in early twentieth century, 60

Radicals, 106, 115, 176, 177
Ratier, Charles, 30
Reclus, Elisée, 136
religion, 187–9
 gender division in attitudes to, in Third Republic, 10
Remember, Madame (pseudonym of Louise Beverley Dupont), 83, 87–8, 153
Renaud, Elizabeth, 5, 81, 82, 140, 150
repression, 184–5
republicanism, 10, 78–9, 234
Revue International des Sociétés Secrètes, 220
Richer, Léon, 79, 84
Rizzo, Cristofor, 90, 216
Robespierre, Maximilien de, 106, 168, 169
Robin, Paul, 115, 136, 137
Romanticism, 77

Roussel, Nelly, 5
Rouzade, Louise-Léonie, 5
Russian Revolution, 153, 168–9

sadism, 118
Sainte-Anne asylum, 62, 69
Sand, George, 18
Santé prison, 124
Sartre, Jean-Paul, 239
Saumoneau, Louise, 82, 140
School of Anthropology, 32, 45, 70
Section Française de
 l'Internationale Ouvrière
 (SFIO), 105, 107, 108–9, 125,
 130
 Commission Administrative
 Permanente (CAP), 120, 121,
 124
 Limoges conference (November
 1906), 109
 Nancy conference (August
 1907), 111
 and women's suffrage, 108–11
Senlis, 148
sexuality, 182–7
Showalter, Elaine, 64
socialism, 105–31
 attitudes towards feminism, 78,
 96, 239
Socialist International
 conference of Congress
 (17 August 1907), 111–12
Socialist Party, *see* Section
 Française de l'Internationale
 Ouvrière (SFIO)
Solidarité des Femmes, La, 70, 75,
 76, 81–3, 92–3, 101, 140
Soviet Union
 feminism in, 164–7
 Pelletier's journey to, 154–60
 Pelletier's stay in, 160–7
spiritualism, 187

sport, 16
Stocker, Helen, 140
Stritt, Marie, 139
suffrage, 5–6, 78, 81, 85, 86, 95–6,
 108–11, 190–1
 campaigns in inter-war years,
 175–8
 demonstrations in Britain, 97–
 100
Suffrage des Femmes, Le, 84
Suffragiste, La, 87, 153, 176
Szeszler, Leopold, *see* Poldès, Léo

Taitinger, Jean, 238
Third Republic, 10, 233–4
Times, The, 98, 109
Toblowska, Mademoiselle, 56
Toulouse, Edouard, 54, 56, 58, 62,
 69
trade unions
 women and, 129–30
transformism, 33
Tristan, Flora, 5

United States, 76

Valsayre, Astié de, 16, 17
Vareddes, 147
Vaschide, Nicholas, 38, 39, 40, 60,
 70
Vérone, Maria, 100, 142, 217, 234
Vichy government, 236
Ville-Evrard asylum, 62
Villejuif, 38, 54, 56, 59, 60–1, 62–3
Voix des Femmes, La, 154

Women's Socialist Conference, 128
Women's Social and Political
 Union, 98
World Congress against Imperialist
 Wars, 175
World War I, 140–52

and feminism, 140
and socialism, 140, 150
writing
 gender differences in, 109

Zetkin, Clara, 112, 150, 151
Zola, Émile, 54

Index by Justyn Balinski